THE WHITE HOUSE

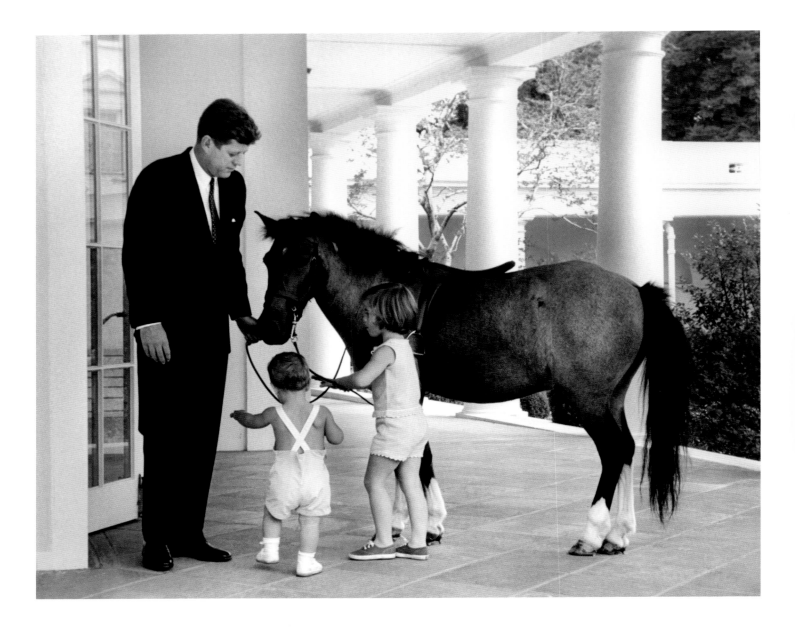

THE WHITE HOUSE

THE PRESIDENT'S HOME IN PHOTOGRAPHS AND HISTORY

VICKI GOLDBERG

IN COOPERATION WITH THE

WHITE HOUSE HISTORICAL ASSOCIATION

FOREWORD BY MIKE McCURRY

LITTLE, BROWN AND COMPANY Ⓛ Ⓑ NEW YORK · BOSTON · LONDON

For Daniel, Joshua, Miriam, Rebecca, and Tara

ALSO BY VICKI GOLDBERG

Light Matters

American Photography: A Century of Images (with Robert Silberman)

The Power of Photography: How Photographs Changed Our Lives

Margaret Bourke-White: A Biography

Photography in Print: Writings from 1816 to the Present (editor)

Little, Brown and Company
Hachette Book Group
237 Park Avenue, New York, NY 10017
www.hachettebookgroup.com

First Edition: October 2011

Little, Brown and Company is a division of Hachette Book Group, Inc. The Little, Brown name and logo are trademarks of Hachette Book Group, Inc.

The publisher is not responsible for websites (or their content) that are not owned by the publisher.

The White House Historical Association acknowledges the support of the Honorable Walter H. Annenberg White House Publications Fund for this book.

LIBRARY OF CONGRESS CATALOGING-IN-PUBLICATION DATA

Goldberg, Vicki.
 The White House : the president's home in photographs and history / Vicki Goldberg, with the White House Historical Association.—1st ed.
 p. cm.
 Includes index.
 ISBN 978-0-316-09130-5
 1. White House (Washington, D.C.)—History. 2. White House (Washington, D.C.)—History—Pictorial works. 3. Presidents—Dwellings—Washington (D.C.) 4. Presidents—Dwellings—Washington (D.C.)—Pictorial works. 5. Washington (D.C.)—Buildings, structures, etc. 6. Washington (D.C.)—Buildings, structures, etc.—Pictorial works. 7. Photography. I. White House Historical Association. II. Title.
 F204.W5G65 2011
 975.3—dc22 2010053637

10 9 8 7 6 5 4 3 2 1

SC

Printed in China Interior design by Lance Hidy

FRONTISPIECE: President Kennedy, Caroline, and John Jr. with Caroline's pony, Macaroni, on the White House colonnade, June 22, 1962. Robert Knudsen.

Vice President Lyndon Johnson gave Caroline Kennedy a pony named Macaroni, in honor of the tune "Yankee Doodle." The pony inspired a portrait, in noodles, by the National Macaroni Manufacturers Association, and a song, *My Pony, 'Macaroni,'* by composer and pianist Bill Snyder—the song set in 4/4 time with woodblocks (hooves) and trumpets (whinnies). Macaroni roamed the White House grounds freely.

CONTENTS

THE PRESIDENTS AND FIRST LADIES

U.S. PRESIDENTS	DATES IN OFFICE	FIRST LADIES
George Washington	1789–1797	Martha Dandridge Washington
John Adams	1797–1801	Abigail Smith Adams
Thomas Jefferson	1801–1809	Martha Wayles Jefferson
James Madison	1809–1817	Dolley Payne Madison
James Monroe	1817–1825	Elizabeth Kortright Monroe
John Quincy Adams	1825–1829	Louisa Catherine Johnson Adams
Andrew Jackson	1829–1837	Rachel Donelson Jackson
Martin Van Buren	1837–1841	Hannah Hoes Van Buren
William Henry Harrison	1841	Anna Symmes Harrison
John Tyler	1841–1845	Letitia Christian Tyler
		Julia Gardiner Tyler
James K. Polk	1845–1849	Sarah Childress Polk
Zachary Taylor	1849–1850	Margaret Smith Taylor
Millard Fillmore	1850–1853	Abigail Powers Fillmore
Franklin Pierce	1853–1857	Jane Appleton Pierce
James Buchanan	1857–1861	Harriet Lane
Abraham Lincoln	1861–1865	Mary Todd Lincoln
Andrew Johnson	1865–1869	Eliza McCardle Johnson
Ulysses S. Grant	1869–1877	Julia Dent Grant
Rutherford B. Hayes	1877–1881	Lucy Webb Hayes
James Garfield	1881	Lucretia Rudolph Garfield
Chester A. Arthur	1881–1885	Ellen Herndon Arthur
Grover Cleveland	1885–1889	Frances Folsom Cleveland
	1893–1897	

U.S. PRESIDENTS	DATES IN OFFICE	FIRST LADIES
Benjamin Harrison	1889–1893	Caroline Lavinia Scott Harrison
William McKinley	1897–1901	Ida Saxton McKinley
Theodore Roosevelt	1901–1909	Edith Carow Roosevelt
William Howard Taft	1909–1913	Helen Herron Taft
Woodrow Wilson	1913–1921	Ellen Louise Axson Wilson
		Edith Bolling Wilson
Warren Harding	1921–1923	Florence Kling Harding
Calvin Coolidge	1923–1929	Grace Goodhue Coolidge
Herbert Hoover	1929–1933	Lou Henry Hoover
Franklin Delano Roosevelt	1933–1945	Anna Eleanor Roosevelt
Harry S. Truman	1945–1953	Elizabeth (Bess) Wallace Truman
Dwight D. Eisenhower	1953–1961	Mamie Doud Eisenhower
John F. Kennedy	1961–1963	Jacqueline Bouvier Kennedy
Lyndon B. Johnson	1963–1969	Claudia Taylor (Lady Bird) Johnson
Richard Nixon	1969–1974	Patricia Ryan Nixon
Gerald Ford	1974–1977	Elizabeth Bloomer Ford
Jimmy Carter	1977–1981	Rosalynn Smith Carter
Ronald Reagan	1981–1989	Nancy Davis Reagan
George H. W. Bush	1989–1993	Barbara Pierce Bush
William J. Clinton	1993–2001	Hillary Rodham Clinton
George W. Bush	2001–2009	Laura Welch Bush
Barack Obama	2009–	Michelle Obama

FOREWORD

IN THE YEARS since I last worked in the White House, my consulting practice has been based in a lovely historic building on Pennsylvania Avenue that, among other claims to fame, once served as the residence and studio of Mathew Brady during the Civil War. Tradition has it that on a cold February morning in 1864, Abraham Lincoln walked to the building and sat in what is now our conference room (with a wonderful north-facing skylight) for several portraits, including the one later used to make the image on that five-dollar bill in your wallet. The very spot is now surrounded with other images, including several of me with one of Mr. Lincoln's successors, our forty-second president.

Brady, often credited as the father of photojournalism, would not be surprised to learn that images of our presidents have become indelible in our national memory (not to mention wonderful souvenirs). With the invention of photography, the camera went to Washington in an effort to document a nation still seeking its identity, and not long after the middle of the nineteenth century, photographs became a major means of acquainting the nation with its leadership.

This is a book about the way nineteenth-, twentieth-, and twenty-first-century photography has shown us the White House and the American presidency — how the camera has reported on, reflected, and influenced the public's interest in and opinion about the head and seat of government. Several hundred images, beginning with those from the 1840s, trace the changing nature of photographic coverage of the president, his family, his residence, and the circumstances of White House life — major events such as wars and funerals, and less earth-shaking ones such as the White House Easter Egg Roll and the private Christmas of the White House dogs.

Photographers (and eventually newsreels and television) documented speeches, proclamations, pets, servants, recreation, birthdays, and historical changes in transportation, communication, and technology — virtually every aspect of the modern presidency. In these pages, a Union battalion poses in front of the White House during the Civil War, and White House reporters race about wildly on news of Japan's surrender at the end of World War II. The famous temperance preacher Billy Sunday cavorts acrobatically on the White House steps, and Socks, President Clinton's cat, presides briefly at the lectern in the press briefing room.

Photographs in this book reflect the grandeur of the White House as a seat of power and a magnificent stage, as well as a home and refuge from the spotlight. A modern, dramatic view of the North Portico at dusk relays the magic of the house as a symbol, while a photograph of a bulldozer inside the house during reconstruction reveals just how much energy went into preserving its magical appearance. But some images convey the history of how the White House has adapted to the changing ways in which a president communicates with the American people. One that speaks to me is the photograph of one of my predecessors, James Hagerty — Eisenhower's press secretary — reading a teletype in a bathroom in the West Wing. Space was tight in the 1950s, as it is now. These pictures tell you something about the routine of work at the White House.

My experience as press secretary for President Bill Clinton and as a member of the board of the White House Historical Association gives me great appreciation for how the public image of the president can be shaped by a news cycle and perceived over time. What the public was allowed to see, how the media treated the presidency and pursued it, and how presidents courted publicity, or sometimes didn't, became ongoing components of the continuing narrative of our national leadership. The best way a press secretary can serve the president, in my view, is to advocate for the public's right to know what happens inside the White House and to protect the right and responsibility of a free press to bring us that story. Obviously, the president's message doesn't get far without passing successfully through the filter of the press. A large part of White House operations is devoted to getting information, ideas, and arguments out to the American people. But photography has been

a unique element in that channel of communication because the camera gives us some of the best and most unvarnished views of what happens inside the presidency, and within the workings of our executive branch of government.

A noted author and photography critic, Vicki Goldberg brings her trained eye and special perspective to the White House and its photographic history. Her text conveys the fascinating history of the building and its

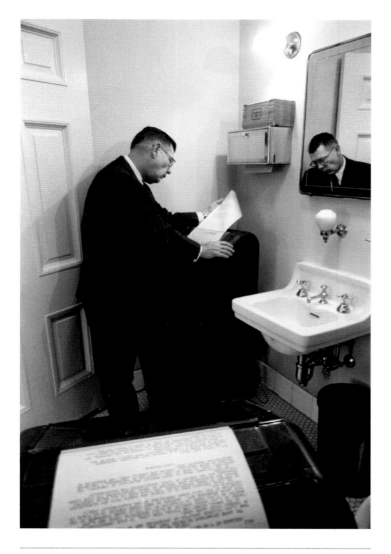

Press Secretary James Hagerty, February 1957. Thomas J. O'Halloran.

The White House has periodically been declared too small for everything that goes on in it. As White House communications became more crucial and complex, overcrowding caused Press Secretary James Hagerty to move office equipment into a washroom.

occupants through the visual evidence the camera has so generously provided over the past hundred and seventy years.

An unorthodox historical blend of center-stage and behind-the-scenes perspectives reveals that both candid and posed images can be timeless, and we learn that nothing is new about intense public interest in the lives of our presidents — or in the efforts of White House staffs through the decades to "manage" the images that reach the public.

The White House Historical Association celebrates its fiftieth anniversary in 2011; its first White House guidebook was published in 1962. It has been gathering photographs ever since. The images in this book largely came from the collection of the White House Historical Association, supplemented by the collections of the Library of Congress and presidential libraries. Today, the association's photograph collection has more than 8,000 images representing the 1840s to the present; some are well-known classics and many others are unpublished or have not been published for decades. Most are public-domain photographs published once many years ago, some in specialized publications — so the pictures, and their stories, essentially are new.

The importance of Vicki Goldberg's book lies largely in her careful selection and interpretation of images from the association's photography collection. She creates new and interesting insights into both familiar and unfamiliar photographs and takes a serious look at American history through the lens of photography, on occasion accented and enlivened with humor. Goldberg presents the history of photography's close association with the White House, its occupants, and the way the visual media presented them to the country.

A hybrid of history and photographic criticism, the book touches on two hundred years of history in America, the world, and photography, while tracing changing communications and a changing society. It is a mix of family and government, high position and housekeeping, private life and public image. Here is how the camera looked at the White House and its doings through the years, and how citizens had their curiosity tweaked, and sometimes slaked, about the place our presidents call home.

Mike McCurry
Washington, D.C.
2011

THE WHITE HOUSE

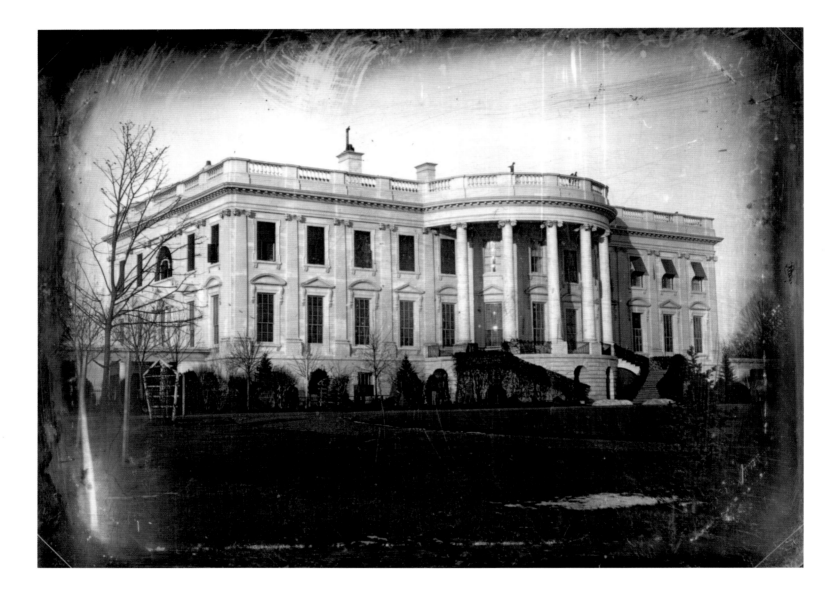

INTRODUCTION: THE WHITE HOUSE

GEORGE WASHINGTON never slept here. He was first elected in 1789 and selected the site for the President's House, consulting architect James Hoban on its design and construction. His second term ended in 1797 before the building was completed. John Adams, elected in 1796, visited the city of Washington in June of 1800 but had to take lodgings in Georgetown because the house wasn't yet habitable.[1] Construction of the city had been slow because it was difficult to lure skilled workmen to a new capital situated in a sparsely settled region far from a major population center. Irish and Scottish artisans, with a large force of slaves and free blacks, labored mightily to build democracy's most important house. When Adams finally moved in on November 1, 1800, the interior was only partially finished, yet the White House quickly came to stand for something greater than its material presence. It was, and is, an emblem of the president and the nation he has been chosen to govern.

Once America established its independence by decree and force of arms, it had to invent itself. It had no king anymore (and didn't miss one), no head of state, no constitution or capital, no Buckingham Palace or Versailles to house and represent the new land's leadership. Two years after Washington, the favored choice for president, was elected in 1789, the Residence Act gave him the power to establish the capital. Between 1774 and 1800, Congress convened in eight different cities, including New York and Philadelphia, that supplied grand houses for the president; but the center of government—a government that amounted to an experiment—would rise in a city built from scratch in the newly created District of Columbia, on land ceded by Maryland and Virginia. It would soon be named in the first president's honor.[3]

In 1791 Pierre Charles L'Enfant, the French engineer who designed the city, included in his plan a palace fit for a king. Washington eventually dismissed L'Enfant for insubordination related to his conflicts with the commissioners appointed by the president to oversee the plans for Washington, D.C. James Hoban's more modest design won an architecture competition in 1792, and L'Enfant later denounced it as "hardly suitable for a gentleman['s] country house [and] wholly inconsistent for a city habitation [and] in no aspect…becoming the State Residency of the chief head of a sovereign people."[4]

The Residence Act of 1790 specified that the government offices, including the President's House and Capitol, be ready by November 1, 1800. Upon her arrival on November 15, Abigail Adams described her new unfinished home as a "great castle."[5] Constructed of stone and larger than any other house built in the nation before the Civil War, the White House did seem grand when compared to the best houses commonly made of brick or wood. Rather than calling the residence a "palace," President Washington preferred "the President's House." (Washington refused to be called "Your Majesty" though some thought he should be.) Martin Van Buren's political opponents accused him of trying to turn the White House into "a Palace as splendid as that of the Caesars," and when William Henry Harrison campaigned against him (and won) in 1840, he said Van Buren had converted the house into a gilded palace with more than two pairs of hills on the grounds "designed to resemble…an Amazon's bosom."[6] About the mid-nineteenth century,

OPPOSITE: **South Front of the White House, daguerreotype, c. 1846. John Plumbe Jr.**

This is the earliest known photographic image of the White House. The daguerreotypist John Plumbe recognized the need (and the market) for national symbols. By early 1846, he was taking pictures of all the public buildings in Washington, which had not been done before — pictures of architectural specimens "whose intrinsic worth," wrote one journalist, "is hardly exceeded by their worth as specimens of the most wonderful art ever discovered."[2]

presidents used "the Executive Mansion" on official stationery, but colloquially, the residence became "the White House." Theodore Roosevelt made the name official, directing that all government correspondence use the title in referring to the executive residence.[7]

Yet the house was, in effect, material evidence of America's break with the traditions of state leadership. In 1821 the Swedish diplomat Baron A. L. Klinckowström remarked to a member of Congress that the White House struck him as "neither large nor awe-inspiring," to which the answer came that "the building served its purpose, that if it were larger and more elegant, perhaps some President would be inclined to become its permanent resident, which was something to be aware of."[8] The president in office might change every four years, but the house persisted, a constant sign of what the country stood for. However, even if its symbolism remained intact over the years, its structure had to evolve. The White House has been a work in progress for a long time, requiring frequent repairs and modification. Four years after it was first occupied, Jefferson had to fix a leaky roof, and he added the first terrace wings and made changes to the interior layout.[9] And then in 1814 the British burned it down.

When British troops marched on Washington, they triumphantly entered the White House, enjoyed a meal that had been left in haste at the president's table, and set the building on fire. A summer thunderstorm that lasted two hours saved the walls, but the fire left the residence a blackened shell. The blaze was a metaphor for the destruction of the nation, but the nation refused to consider itself destroyed and instead regrouped, rose

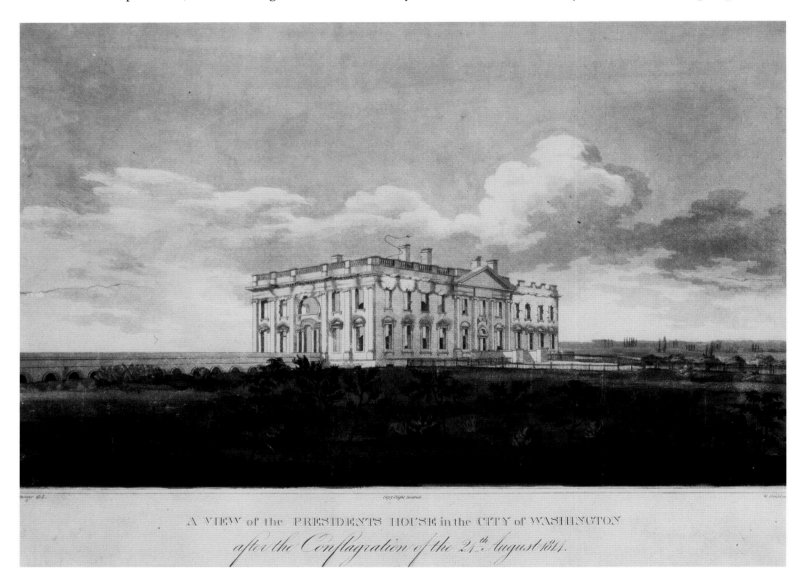

A VIEW of the PRESIDENTS HOUSE in the CITY of WASHINGTON after the Conflagration of the 24th August 1814.

up, overcame its conquerors, and soon rebuilt its most important house.[10]

Both the architecture and the location of the White House proclaimed the new nation's principles. Its classical design clearly referenced the first republics in ancient Greece and Rome and their (and the Enlightenment's) ideals of reason and order. Hoban based the design specifically on Palladian and Georgian sources and created an Irish country house for Washington. The fact that the Capitol, home of the legislature, stood at one end of Pennsylvania Avenue and the President's House at the other was symbolic of the separation of powers set forth in the Constitution.[11]

Founding a nation is only part of the process of establishing one. Symbols are needed to solidify a sense of nationhood in the minds of citizens and an identity beyond the country's borders. Early in America's history, its leaders adopted a national flag, the eagle as part of a national Great Seal, and Washington as a national seat of government. The house, effective shorthand for the presidency, became paired with the newly elected leader in cartoons from at least the time of Andrew Jackson. Cartoonists, later overshadowed by press photographers, depicted the White House as an iconic backdrop. Curiously, despite its place in the hearts of citizens, the White House did not achieve postage stamp status until 1938 and did not first grace legal tender until 1928, when the south facade appeared on the back of the twenty dollar bill. In 1998 this was changed to the north facade.

Painters understood their mission to be the capture of the national character of the American landscape; renowned artist Thomas Cole noted in 1841 that American scenery should be "of surpassing interest" to all

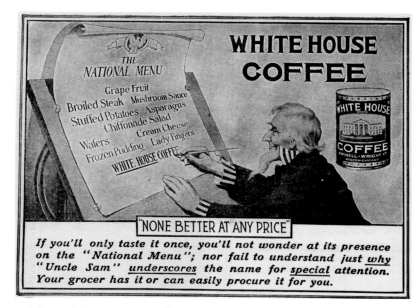

Ad for White House Coffee, c. 1886.

Americans, as all of it belonged to each of them.[12] The landscape itself was the nation's oldest and most distinctive monument, especially the breathtaking sights at Niagara Falls and the stunning natural formations discovered later in the West. As for man-made monuments, the White House and other government buildings were the most obvious candidates.

In 1887 a magazine writer described the White House as "the Mecca of all European travelers; the object of more critical observance, both at home and abroad, than any other dwelling-house that ever was built in any country or age. The fact that it is owned by sixty millions of intelligent people does not detract from its charms, nor render its successive occupants any the less objects of pride, solicitude, and curiosity."[13]

Beginning in the late nineteenth century, manufacturers of soap, coffee, and lingerie, of almost anything from cigarettes to shaving cream, put photographs or drawings of the White House and its residents in their ads or on their labels. Images of or relating to the house turned up in the morning paper at breakfast, in the photo albums and stereo viewers on parlor tables, at the market, and in the kitchen too.

The White House did not belong to its occupant but to the people who had elected him. In 1946, when Harry S. Truman proposed adding an office building to the house, a *Washington Post* editorial reminded him that "the White House is not the president's property. Indeed, the president's lease may be a very short one."[14]

OPPOSITE: *The Burned White House*, engraving, 1815. William Strickland.

This image of the house, reproduced in engravings, responded to citizens' dismay over the British invasion of Washington and the news that the seat of government had been put to the torch. The heat had bent and twisted the lightning rod, but the exterior walls were still standing. It is often related that the house was painted white during its reconstruction to cover the evidence of fire, but the walls were already whitewashed when they were first built in 1798, in order to protect the porous stone from freezing.

Jefferson opened the house to citizens, but it was Andrew Jackson who redefined the idea of "the people." An orphan with little formal education, Jackson broke the tradition of gentleman presidents, and having campaigned for an expanded right to vote and against corruption in Washington, he attracted the backing of both the poor and the well-to-do and won the first popular election and a popular mandate in 1828. Thousands of his followers, most of them needy and many of them dirty, converged on Washington for his inauguration and followed him from the Capitol to the White House, and into any part of it they could cram themselves.

The gentry, quite used to these receptions, arrived to be met by a phalanx of people they were definitely not accustomed to. Society ladies fainted, clothes were torn and noses bloodied, men in muddy boots stood on damask-covered chairs to get a better look. "High and low, old and young, black and white poured in one solid column into this spacious mansion. Here was the corpulent epicure grunting and sweating for breath — the dandy wishing he had no toes — the tight-laced Miss, fearing her person might receive some permanently deforming impulse."[15] The White House staff lugged a huge stock of liquor out to the lawn to lure the crowds outside, but several thousand dollars' worth of china and cut glass had already been broken. Jackson, nearly crushed by the mob that wanted to shake his hand, climbed out a rear window and went off to dine.[16]

It was the people's day, and so it continued to be in Jackson's White House. Not everyone thought the people were good company. One writer remarked that the president's 1837 New Year's reception reminded him of Noah's ark: "All sorts of animals, clean & unclean."[17] But an idea that had been broached before was made highly visible, even palpable, in Jackson's administration: the president's mansion belonged to the electorate, dirty or not.

Some voters would take the notion that the house belonged to them quite literally. In the month after Lincoln's death, such confusion reigned that visitors roamed the house picking up silver and china for souvenirs. This was far from the only time the people helped themselves to memorabilia. Small pieces of fabric, excised with scissors, occasionally disappeared from the edges of the White House curtains.[18]

In a 1908 article in *Harper's Weekly* titled "The Monarchical Manners of the White House," David Sinclair complained that Theodore Roosevelt had done away with the "great tri-weekly crushes in the East Room" and substituted fewer receptions in a smaller room, though "the East Room of the White House has always been the one apartment open to every well-behaved person in the world." The issue of the imperial presidency has dogged the government from the beginning — TR, who liked to make his entrances to a trumpet fanfare, was said to be "a President with a republican imagination guided by the monarchical instinct."[19] Roosevelt's 1902 White House "restoration" created an idea of the residence as the stage of a world power, and presidents would at times be measured according to how well they fit this modern image of the leader on that stage. As for the architecture and decor (and occupants, events, entertainment, nooks, and crannies), photography has changed the terms, making the Executive Mansion democratically, if vicariously, accessible to every citizen.

No one could have foreseen how large either Washington's population or the apparatus of administration would become. In 1800 America's population had been approximately 5 million; by 1902 it had reached nearly 80 million.[20] The house seemed to shrink in comparison. In 1897 *The Chautauquan* noted that President Grover Cleveland's wife "does not have as much room as many an ordinary housewife in a village town," and that Washington's population had grown so large that the president's evening receptions were impossibly crowded and ladies would not wear their best gowns and jewels to the White House.[21] That same year, Colonel William Crook, the supervisor of the president's clerks and domestic staff, wrote in a letter that every important government bureau had better furnishings than the White House. In fact, the house was in bad shape. The kitchen was outdated, the bathrooms too few, and the floors unsteady; major repairs and redecoration were required, not for the last time.[22]

When William McKinley was assassinated in 1901 and Vice President Theodore Roosevelt assumed office with a wife and six children in tow, it was clear that the cramped family quarters were inadequate. TR eventually obtained congressional appropriations totaling $475,445 for repairs, refurnishing, and new construction; work began in 1902. The well-known architectural firm of McKim, Mead & White, headed by Charles

McKim, oversaw an interior renovation and an exterior enhancement of the house. The columned terraces added by Jefferson were rebuilt on the east and restored on the west, and an executive office annex was added to the west; the president's secretaries and clerks had previously been in cramped quarters on the east end of the Second Floor. The new West Wing had a room for the president and his thirty-eight assistants, a number that included several typists, known in those days as "typewriters."[23] This building was intended to be temporary, but after several expansions, the West Wing still stands today.

The surrounding landscape changed dramatically after the 1902 renovation. Greenhouses and conservatories were popular in the nineteenth century, primarily for growing plants and flowers out of season; a conserva-

tory, which also houses plants, is a place for reading, meditating, or simply relaxing. By 1890 a complex of greenhouses and conservatories "creating enchanting vistas" had been built at the White House, so many that it was no longer possible to see the house's western side.[24] McKim felt they marred the classic profile of the White House, but Edith Roosevelt, the president's wife, wanted them preserved. Reluctantly, the first lady agreed to the demolition with the condition that a greenhouse would be built elsewhere on government grounds.[25]

Numerous photographs documented the Roosevelt restoration. Photography had long been acknowledged as an indispensable documentary instrument, and it played a major role in a report to Congress that accounted for the money spent on TR's renovation.

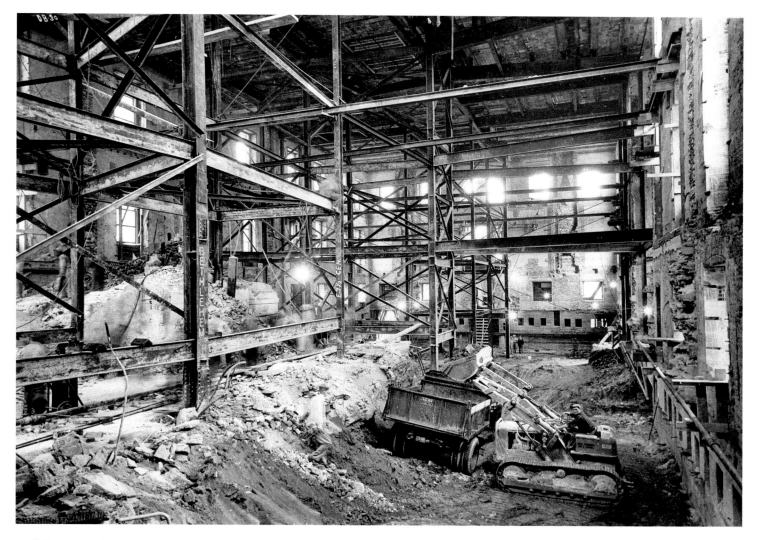

Bulldozer in the White House, c. 1950. Abbie Rowe.

In 1934 the executive offices of the president underwent a great expansion, completing the West Wing exterior. The present Oval Office was built as part of this expansion. In the next decade, Franklin Roosevelt supervised repairs and improvements to the White House, adding new kitchens and workspaces, and in 1942, with a world at war, the new East Wing was built over a secret underground air-raid shelter. When Harry S. Truman moved in after Franklin Roosevelt's death, he heard the house creak and groan so much at night that he liked to say that past presidents were haunting the place. He was all too aware that it was soon to fall about his ears. A Secret Service report on the safety of the White House during World War II proved the house was a firetrap and unsafe. Truman called in engineers to finish the job of condemning the structure. Early in 1948, the president wrote to his sister, "The engineer said that the ceiling in the state dining room only stayed up from force of habit!"[26]

The house was in such bad shape that the engineering report recommended it be torn down and rebuilt from scratch, but Truman, who was intensely interested in history, opposed razing the walls. If the great symbol disappeared for even a moment, it would dismay and discourage most of America, so the exterior walls were kept intact while the interior below the Third Floor was gutted. To shore up the stone walls that had stood on clay all those years, 126 pits were dug and filled in with reinforced concrete, and a steel structural framework with its feet in these pits was erected within the walls. Even the old walls' brick lining had to be removed; a Mason himself, Truman was delighted to see that the inner surfaces of many of the stones bore Masonic symbols put there by eighteenth-century workmen.[27]

Truman, who referred to the house as "the great white jail" or "the great white sepulcher of ambitions," really loved the place and its past. He asked Congress to establish a commission to supervise the reconstruction and ensure the preservation of its historic and architectural features, and he himself inspected the work regularly.[28] There was a lot to inspect. A new concrete sewer line was laid, and a new elevator and an entirely new ventilation system were installed.

While the interior was being excavated, the exterior was also being torn up with a certain circumspection, which is to say that the familiar (and comforting) appearance of the White House was kept as intact as

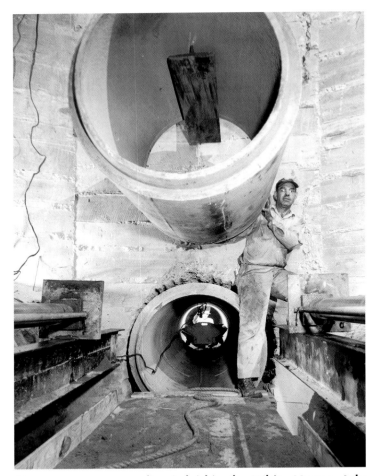

New concrete sewer line is laid in the White House, July 6, 1950. Abbie Rowe.

possible and its accompanying trees were carefully protected.

As much of the house as could be preserved was, and bits and pieces of it were turned into souvenirs. In 1951 a program was set up to distribute to the public pieces of wood, stone, or metal that had no real tangible worth but that many citizens would find valuable as mementos of this most historic building. The public was offered the chance to apply for items such as enough old pine to make a gavel or a cane; enough brick or stone for a fireplace; enough stone for two bookends; or a brick, a piece of lath, a nail, or other small item. The least expensive items cost $0.50 and the most expensive were the fireplace mantels at $100. One hundred thousand applications came to the White House by mail, and almost thirty thousand remnants of the nation's house were sent to various corners of the land.[29]

The reconstruction took four years and four months

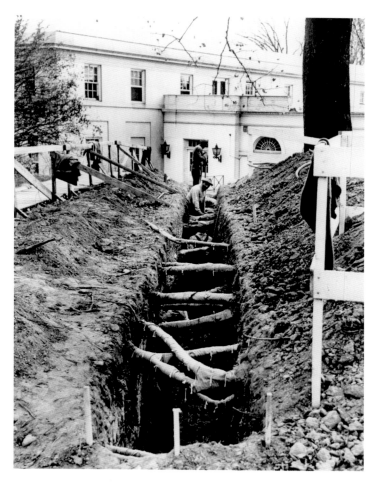

Sycamore roots preserved, 1950, Abbie Rowe.

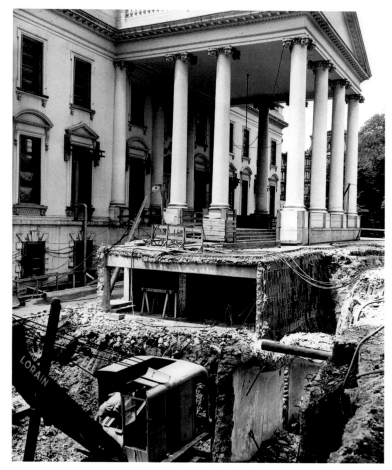

North Portico excavation, July 11, 1950. Abbie Rowe.

and was finally finished in 1952. The house looked the same on the outside and, at first glance, mostly the same, if more prepossessing, on the inside. The most obvious change Truman made in the interior was to endow the new staircase with a platform a few steps above the floor, ideal for making impressive entrances and posing for impressive photographs. Though it wasn't immediately apparent, the changes to the building went far beyond fortifying its structure. Before the renovation, the White House had sixty-two rooms, twenty-six halls, and fourteen bathrooms. When the work was finished, there were more than one hundred rooms, forty halls and corridors, and nineteen bathrooms. Most of the new rooms and bathrooms were on the third floor or in the two new basements and included a laundry room, storage rooms, a dental and a medical clinic, a barbershop, and a staff kitchen. Truman, fully cognizant of major advancements in communications technology, had a television

broadcast room installed; in 1952 he led the three television networks of the time, NBC, CBS, and ABC, on an immensely popular television tour through the newly refurbished house.[30]

Truman directed the modernization of the house from the bottom up; what resulted was a house that looked from the outside like the one John Adams moved into in 1800, but was really built almost entirely during Truman's administration. Before the renovation, Truman had proposed to add large additional office space to the West Wing, but public opposition was intense and Congress voted down the appropriation. He had planned and installed a balcony over the South Portico in 1947–1948 to provide a quiet outdoor retreat for the first family. He got around Congress by using existing appropriations for the White House to build the controversial balcony, now an integral part of the house known as the "Truman Balcony."[31]

In 1960 the White House was designated a National Historic Landmark.[32] When Jacqueline Kennedy moved in, she recognized that there were practically no nineteenth-century furnishings. Truman had selected copies, and not necessarily fine ones, often upholstered with modern fabrics. Determined to restore the state rooms to their authentic and beautiful past, she sought the appointment of the first White House curator and formed an expert Fine Arts Committee for the White House to acquire, whether by donation or purchase, furniture and art that earlier presidents had owned or that represented periods in the building's history. Some pieces were found in storage — Mrs. Kennedy combed the house and found some forgotten sculpture in the downstairs men's room — some pieces had departed with departing presidents, and some had been sold to private collectors or auctioned off in the nineteenth century to raise funds for new purchases, as there was no public money appropriated for this purpose.[33] To avoid political disputes about using public money, Mrs. Kennedy established the White House Historical Association, which published the first guidebook to the White House in 1962 with a text she approved and photographs she chose. The guidebook sold half a million copies within six months, and the nonprofit WHHA spent the net income to acquire items for the White House collection.[34]

In the early 1960s, just before dissent and demonstrations (and assassinations) reached fever pitch, and despite fears of nuclear war, there lingered in the land the glow of being mighty enough to win a world war and produce an economy that seemed to promise future generations ever better lives. The White House was a permanent sign of national pride in having founded the first modern democracy, as well as a capsule history of that democracy's progress. In 1962, when Jackie Kennedy's "restoration" — she didn't like the word "redecoration" — had made the house's history a focus of study and its ambience more impressive, all three television networks broadcast a tour that she herself led and largely narrated. More than 46 million Americans tuned in, a record audience for a television broadcast, and soon afterward people in more than fourteen other countries did so too. Mrs. Kennedy was awarded an honorary Emmy.[35] The elegant wife of the president made history through her efforts to restore the nation's home, and in 1988 the American Association of Museums accredited the White House as a museum.

By now nearly every corner of the White House — every beam that ever held it up, every occupant and animal that lived there, every worker, important visitor, entertainer, vehicle, state dinner, wedding and funeral, piano, painting, dinner plate, and candlestick — has been photographed. Most Americans know the house, its occupants, and its appurtenances through photographs. Cameras never tire; they don't even pause to take a breath. The White House News Photographers Association has been around since 1921. Army, navy, air force, and National Park Service photographers were assigned from time to time to cover presidential activities, and in 1941 Franklin Roosevelt asked the Park Service to assign a photographer to document official public events. The Park Service sent Abbie Rowe, who covered much more than the original assignment.

John F. Kennedy hired Cecil Houghton as the first official White House photographer. Houghton, who took the searing picture of Lyndon Johnson being sworn in as president on *Air Force One* after Kennedy's assassination, was an Army Signal Corps photographer; it was Yoichi Okamoto, Johnson's official presidential photographer, who was the first civilian staff member in that position.[36] The importance of photographs of the president has never declined. In recent years, Washington insiders seek the "photo op" — getting oneself, by hook or by crook, into a photograph or a television image in the presence of the president.

The importance of the White House is as great as ever it was. It serves as the linguistic equivalent of the president, his administration, or the government, as in "The White House says." The house is now approximately five times as large as James Hoban's first proposal, which barely escaped being declared too palatial. It has acquired many extensions, including underground space and some that are classified, and it reportedly covers 55,000 square feet in six stories, with 132 rooms, 35 bathrooms, 412 doors, 147 windows, 28 fireplaces, 8 staircases, 3 elevators, 5 full-time chefs, a tennis court, a bowling alley, a movie theater, a beauty salon, a physician's office, a florist's shop, a swimming pool, and a putting green.[37]

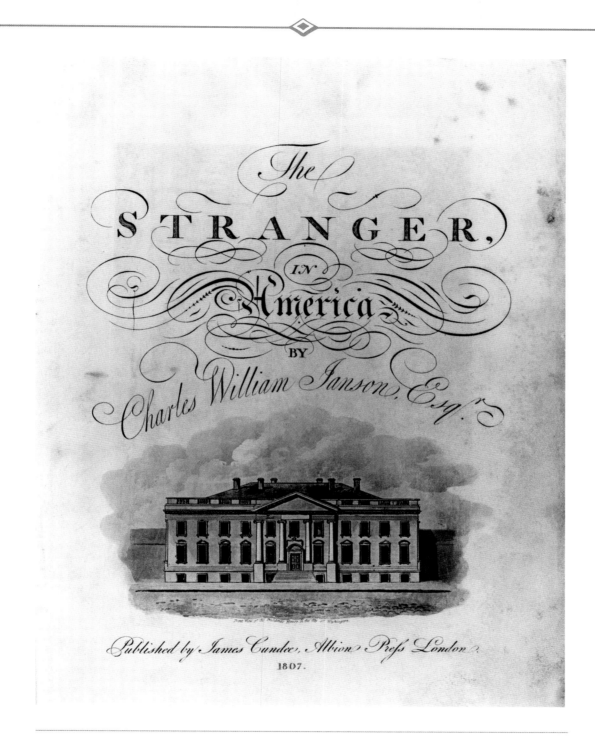

The

STRANGER,

IN

America

BY

Charles William Janson, Esqr.

Published by James Cundee, Albion Press London.
1807.

Front view of the President's House, engraving, 1807. Artist unknown.

When an English traveler named Charles William Janson wrote a book in 1807 called *The Stranger in America,* the title page was an engraving of the President's House, which already stood for the nation. Janson wrote that the house "is certainly a neat but plain piece of architecture." The grounds, he added, were so unfinished that navigating them at night was perilous, the fence was "of the meanest sort," and "this parsimony . . . is a disgrace to the country."[38] This plate is the earliest published image of the house.

B-4047

South view of the White House, 1861. Mathew Brady.

James Hoban, the original architect of the President's House, designed the South Portico in 1824. In 1903 the architectural critic Montgomery Schuyler pointed out that the President's House, like a planter's mansion, had its larger and more important facade facing the river rather than the highway.[39] As the city of Washington grew, the north facade assumed primacy as the main entrance. After 1902, visitors and guests entered on the east with the exception of heads of state, who are still greeted at the north door.

The casual postures of the two figures up front (who were most likely placed by the photographer to better the composition) suggest that the White House is not just an awesome object but a part of Washington's everyday life. Even more telling is the wall marked with graffiti, a medium that has been around for centuries.[40]

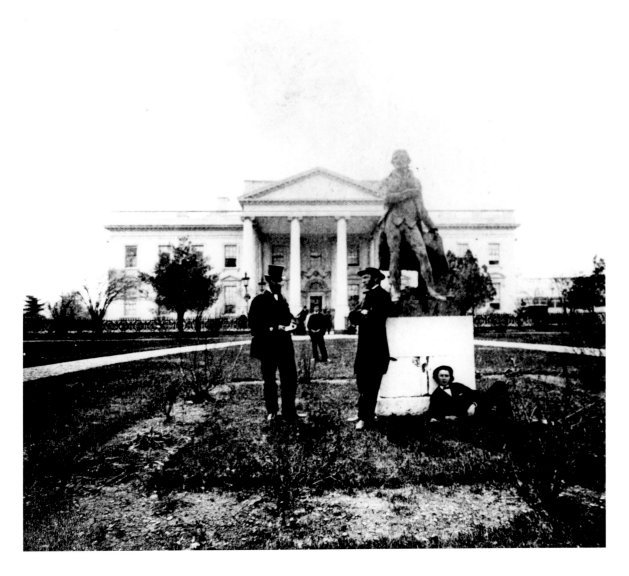

North Portico of the White House with the Jefferson statue, c. 1845–1870. Photographer unknown.

In 1829–1830 James Hoban designed and built the North Portico. The portico had its critics, for all aspects of the house had fervent (and vocal) admirers and detractors at every step. In 1884 journalist E. V. Smalley wrote, "There is a deal of architecture in Washington . . . an amazing jumble of styles borrowed from all nations and all ages; but among it all there is no building quite as satisfying to my eye as the White House, with a reservation to the preju-dice of the northern portico . . . but happily the portico is half hidden by the foliage of noble trees. There is no sham or pretense about the house; none of the straining after striking effects, which is the fault of so many of our mod-ern constructions; no effort to look like a temple, or a cathedral, or a castle. It tries to be a spacious and dignified dwelling and nothing more, and in this it is entirely suc-cessful." [41]

The statue of Jefferson with the Declaration of Inde-pendence in his hand, by David d'Angers, was presented to the Senate in 1833 and was set on the lawn before the North Portico by order of President James Polk in 1847. When the Marquis de Lafayette, the Frenchman who had fought with Washington in the American Revolution and had become a lifelong friend of Jefferson, saw the statue in the sculptor's studio in France, he is said to have thrown his arms around it and exclaimed, "Mon ami! Mon cher ami!" It remained at the White House until 1874, when the Ulysses S. Grant administration returned it to the Capitol. [42]

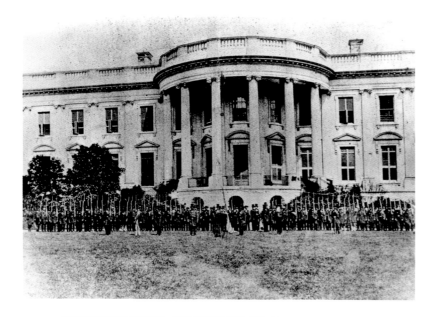

Cassius M. Clay Battalion on the South Lawn, April 1861. Photographer unknown.

During the Civil War, the White House was an obvious focus of attention for the North. When Lincoln called for militia at the beginning of the war, Northern troops streamed into Washington, partly because the city was suspected of having Southern sympathies and the president wanted to be certain it was secure. Indeed, when the first battle of Bull Run (July 1861) ended with the Union troops (and Mathew Brady) in a chaotic retreat to Washington, many of the city's residents openly expressed their approval of the Confederate victory.[43] In 1864 Confederate raiders came within five miles of the city before being repelled.

Here, in April of 1861, shortly after Fort Sumter was fired on, the still untested troops are looking smart — their rifles in perfect alignment and their faces turned to the camera. Behind them the imposing South Portico of the President's House lends the weight of federal government to their cause.

Sentry on duty before the White House gates, c. 1864. Photographer unknown.

Congress had established a permanent company of guards for the President's House in 1842, but of course security was tightened during the Civil War. A bodyguard was assigned to Mrs. Lincoln when she left town, the first time ever for a president's wife.[44] Here the photographer has turned guard duty at the White House into a gentle romance of light and shadow. He took full advantage of the sweet contrast between the complex natural pattern of blurry leaves and the elegant rationality of iron fence and classical architecture.

This image is one half of a particularly fine stereograph. The stereograph, made by a twin-lens camera with the lenses placed approximately as far apart as two human eyes, originated in Europe and began its commercial life in America early in the 1850s. In this era fixated on realism in art, stereographs offered a heightened three-dimensional reality, and in no time, they were all the rage.

In nineteenth-century America the most popular stereograph subjects were Niagara Falls, Yosemite, and Washington, D.C., in that order[45] — the three most outstanding American monuments, tangible signs of a singular place among nations. Americans still needed to define their particular identity, and what is more breathtaking and more definitive than the nation's landscape and government?

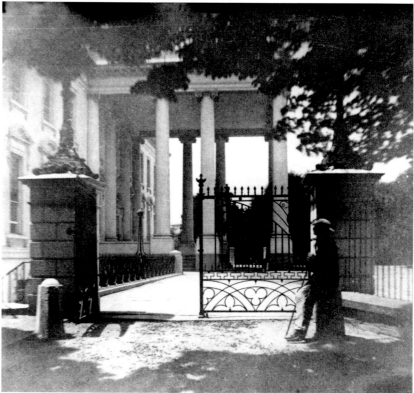

East Room from Second Floor corridor, steel beams introduced to support the floor, July 20, 1902. Photographer unknown.

This image suggests some sort of cathedral of rubble: the East Room, stripped down to its bare bones, soars past its missing ceiling, its vertical and horizontal elements remain perfectly true (save for a crane that cannot stand upright), its long beams rush back to the brilliantly lit arch, and an immensely long ladder reaches up out of the picture to a yet-higher place.

Theodore Roosevelt's White House, rebuilt and redecorated, was still in plan the house the first president had approved when the nation had barely emerged into history, though the interior had been changed by the architect, Charles McKim, more than most people realized. The White House had become closely associated with the nation's history as Americans had become increasingly conscious of their past, and in 1902, as explorer and ethnographer George Kennan put it, the White House was "a monument to American history . . . and a building closely connected by association and tradition with some of the Nation's noblest dead."[46]

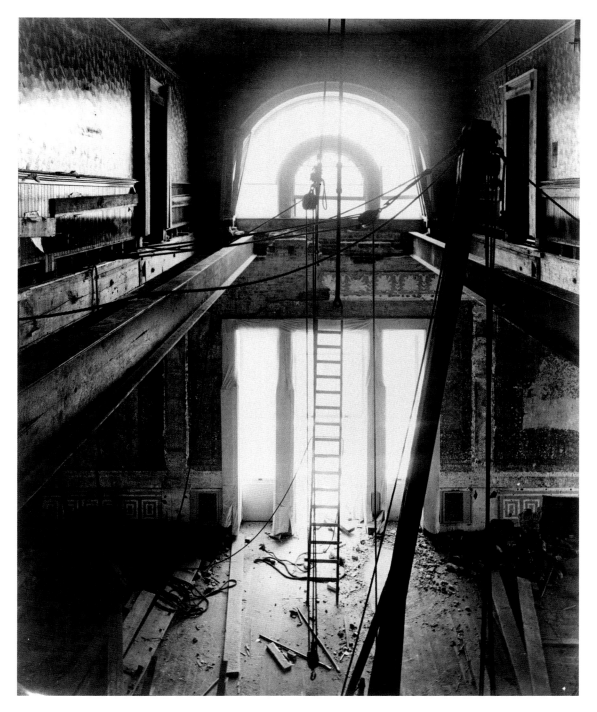

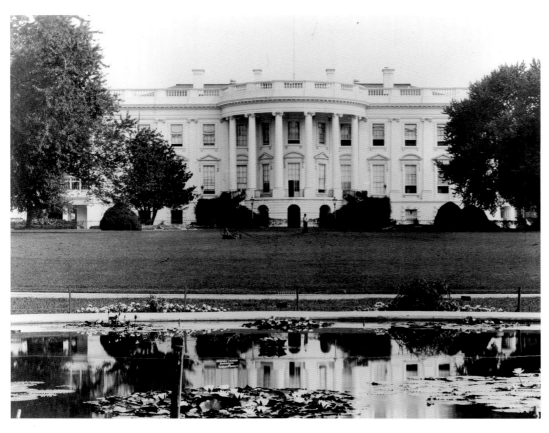

Photograph of the south facade reflected in pool, c. 1904. John F. Jarvis.

The White House is a serious house with a serious face (or two of them), but landscaping, lighting, and the right photographer can also endow it with romance. Early in photography's history, the new medium was referred to as "the mirror of nature," and photographers soon recognized the lure and beauty of mirroring the world twice over.

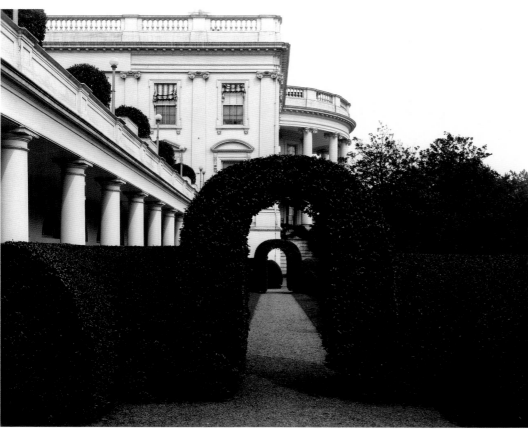

Arch in the West Garden, c. 1910. Frances Benjamin Johnston.

Frances Benjamin Johnston had unusual access to the White House for many years and had plenty of time, combined with plenty of talent, to find the best and the least common views. The White House gardens and grounds were designed and tended with great care.

Construction on the South Portico, c. 1927. Photographer unknown.

Theodore Roosevelt's renovated White House (1902) looked good — Roosevelt himself said, "The changes in the White House have transformed it from a shabby likeness to the ground floor of the Astor House into a simple and dignified dwelling for the head of a great republic"[47] — but the structural work was hastily done. By 1925 it was clear that the roof trusses might not hold. Calvin Coolidge authorized a major roof reconstruction, replacing the old wooden roof structure with steel. A new roof was put in place, the old attic was remade as a full fire-resistant third floor, and a rooftop solarium was built to provide a private space.[48]

Fire in the West Wing, Christmas Eve, 1929. Hugh Miller.

Barely two months after "Black Tuesday," that devastating day on Wall Street, President Herbert Hoover and his wife hosted a party for children of the White House staff. While the children were romping through the White House halls, a fire caused by an overheated flue broke out in the West Wing attic. When Hoover was quietly notified, he instructed the Marine Band to play something jolly, then hurried to the West Wing to try to rescue important papers. Mrs. Hoover stayed to keep the party going. The president entered the burning building but was quickly hustled out. The fire, stoked by papers in almost every room, rushed through the wing, gutted the building, and injured fifteen firemen, but the White House was preserved intact.[49]

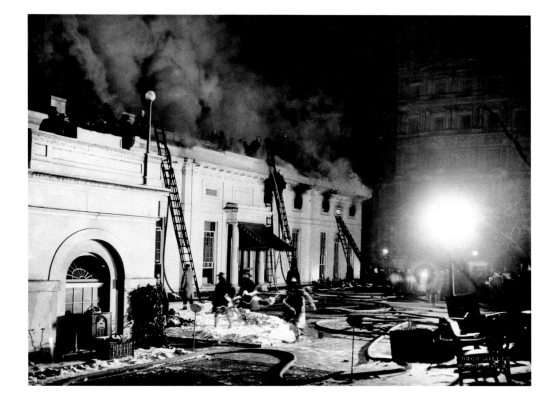

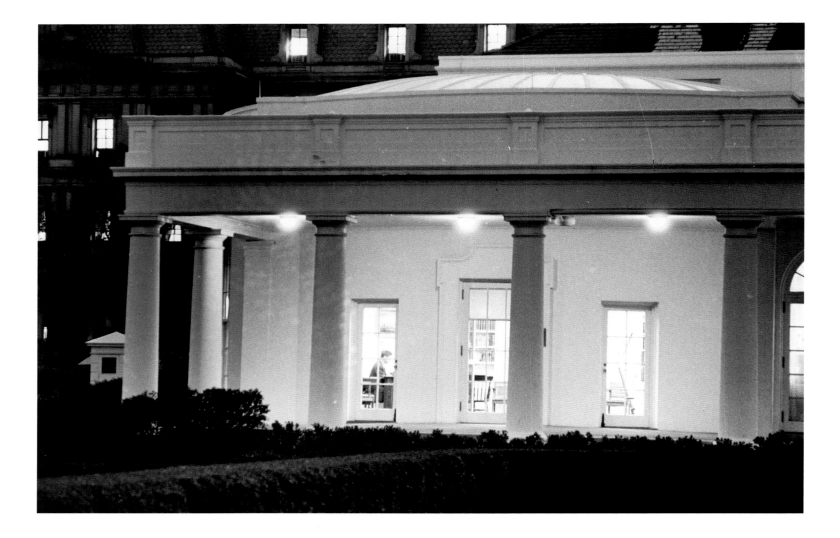

Exterior view of the West Wing at night, 1962. Photographer unknown.

The presidency is more than a full-time job. John F. Kennedy was in the Oval Office in the West Wing long after dark in this photograph taken in the year of the expansion of the United States' military role in Vietnam and the Cuban Missile crisis.

Workmen inside new White House ventilation system, July 19, 1951. Abbie Rowe.

Painting the Cross Hall of the White House, August 17, 2009. Chuck Kennedy.

The White House has had its good days and its bad, both politically and materially. On both accounts, efforts are made to present a good face to the public.

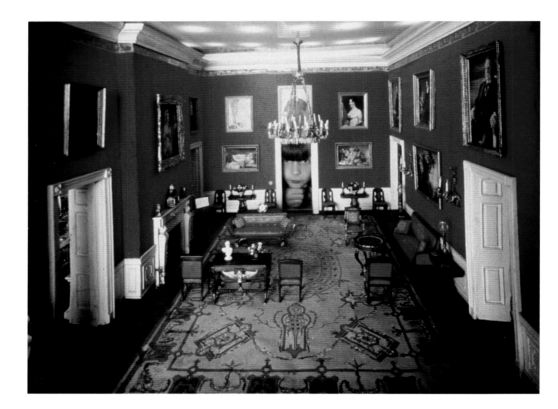

The Red Room, 1994. Kathleen Culbert-Aguilar.

The Red Room, in the miniature with a child looking in, gives a good idea of the expertise involved in faithfully reproducing the minute detail of the house on a tiny scale. This photograph appeared as the frontispiece to Gail Buckland's *The White House in Miniature*.

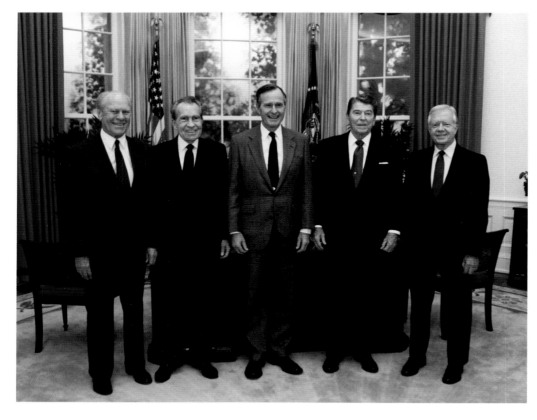

Five ex-presidents in the Reagan Library Oval Office, Simi Valley, California, November 4, 1991. David Valdez.

(From left: Gerald Ford, Richard Nixon, George H. W. Bush, Ronald Reagan, and Jimmy Carter.)

Most Americans know the White House only in replica, which is to say through photographs and re-creations on television and in films, as in the television series *The West Wing*. Some people just can't get enough of the house and want a more robust copy than they can get in a photograph.

In the contemporary slippery realm of reality, where Washington outsiders who can't get close to the president have delighted in cozying up to a life-size cutout of the chief executive, five living ex-presidents posed in a replica of the Oval Office, a continental divide away from the original. Ex-presidents evidently miss the place; copies of the oval room exist in several presidential libraries. Here in California, Ford and Carter staunchly stood with feet apart, while the other three adopted a modified version of the second position in ballet. Only Reagan, who as president seemed to smile inwardly even at his most serious, did not grin.

Pastry chef Roland Mesnier supervises as his gingerbread White House is carried inside through the North Portico, 2000. Tina Hager.

White House clones have sprouted not just in unlikely places but in unlikely materials. This gingerbread "Brown House" was destined to disappear. Roland Mesnier, the chef-architect, worked at the White House for twenty-five years, under five presidents, and concocted Christmas gingerbread house copies of Mount Vernon, Bill Clinton's childhood home, and this imposing edifice. The view here is of the south gingerbread facade of a pastry house that was too large to fit in the elevator or up the stairs and had to be carried outside from the Ground Floor, placed in a van, and driven around to the front portico.[50]

Laura Bush examining a model of the White House at the Republican National Convention, September 2, 2008. Shealah Craighead.

This dollhouse-scale White House was painstakingly and lovingly replicated by John and Jan Zweifel and is exact in every detail, down to tiny paintings, porcelains, and working televisions.[51] It has been exhibited at the Smithsonian, in several presidential libraries, and when it toured the fifty states, more than 42 million Americans came to look at it.

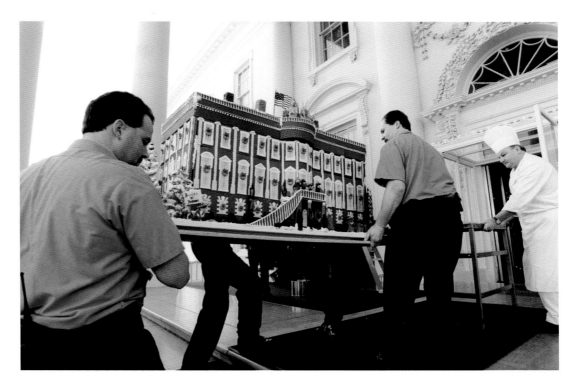

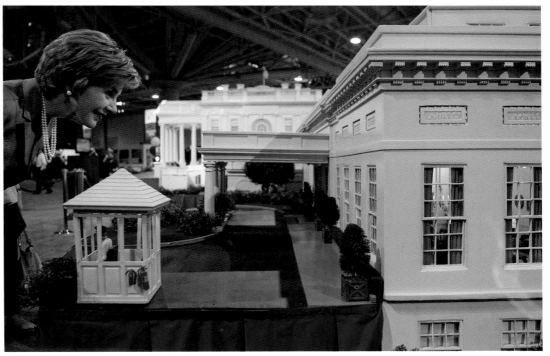

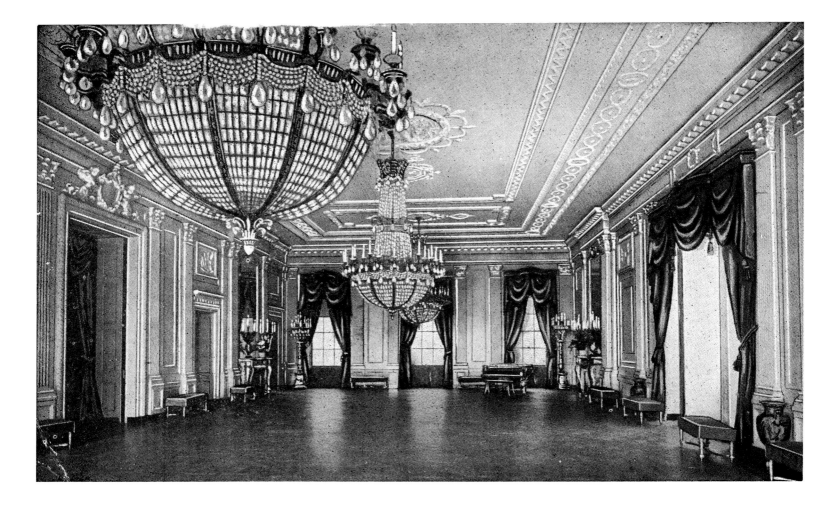

CHAPTER 1: THE EAST ROOM

THE EAST ROOM is nearly as richly historic as the White House itself. After 1829, foreign dignitaries and delegations of Native Americans were received there, treaties were signed there, famous entertainers appeared there, and weddings and funerals were solemnly held there. War was even renounced there — by Calvin Coolidge in 1929, when he ratified the Kellogg-Briand Pact. John F. Kennedy met with religious leaders there after the Birmingham bombings of 1963, Lyndon Johnson signed the Civil Rights Act there in 1964, and President Reagan and Soviet general secretary Mikhail Gorbachev signed the Intermediate-Range Nuclear Forces Treaty there in 1987. The East Room has hosted endless press conferences and splendid state dinners, some of them less than informative and some of them hard on the arteries. For more than two centuries, crowds of citizens have turned up at presidential receptions there. The East Room was, and remains, the stateroom that more of the populace has seen than any other in the White House.

It is by far the largest room in the house, measuring 80 feet by 40 feet, with 22-foot-high ceilings. The fact that more history has been written in the East Room than in any other in the house owes a good deal to its size: it's the only room capacious enough for celebrations and events of such import that they deserve a large audience. Citizens have flocked there when invited to New Year's and Fourth of July receptions, hoping for a glimpse of the president and a touch of his hand, eager to see where leadership dwells and how it presents itself, and excited to say back home that they have been to the source.

The East Room has been the site of many receptions, some of them elegant — in 1866 Benjamin Perley Poore, respected Washington correspondent of the *Boston Globe,* said, "It is the only place in the metropolis where the ladies can pass in review all the new toilets, and see what the leaders of fashion have designed since last season."[1] Concerts, dances, and plays have all graced this room as well. Some administrations have expanded the offerings: Tad Lincoln, the president's son, played with his pet goats there, shocking visitors; Garfield's son Irvin would race bikes with friends there; Theodore Roosevelt's children roller skated in the room, and their father invited an audience to witness a jiujitsu match there.[2]

Its beginnings were more pedestrian. When John Adams moved into the White House late in 1800, the first president to live there, the building was still far from finished. Abigail Adams, his wife, wrote their daughter that the house was on a grand scale but not a single apartment was ready. Indeed, the stairway to the Second Floor hadn't even been begun, there were no indoor bathrooms, and water had to be carried in from five blocks away — and since there were no fences to hide the presidential laundry outside, Mrs. Adams had made "the great unfinished Audience Room" into a drying room to hang wet clothes.[3]

Abigail Adams's "great unfinished Audience Room"

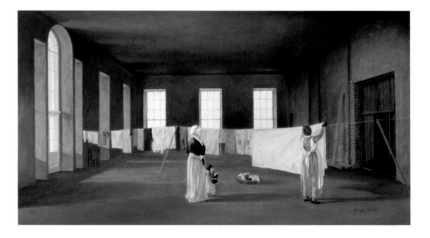

Abigail Adams Supervising the Hanging of the Wash in the East Room, oil on canvas, 1966. Gordon Phillips.

that came to be called the East Room was then a bare hall of unpainted brick — not a bad place to hang laundry. When Thomas Jefferson moved in, in 1801, he divided up the unfinished room with canvas to make an office and bedroom for his secretary, Meriwether Lewis, later famous for the Lewis and Clark expedition. Gilbert Stuart's portrait of George Washington, bought in 1800 and the only object to survive the 1814 fire, is today an iconic fixture in the East Room. It hung in the State Dining Room in James Madison's day.[4]

When the British marched on Washington in 1814, Dolley Madison saved the painting of Washington, ordering her servants to take it to safety,[5] which was fortunate because the British troops, after dining on the meal that had been hastily abandoned in the White House dining room, set the place on fire.

Architectural work on the East Room was finished by 1818, the walls plastered and sealed with whitewash and the four fireplaces topped with temporary wooden mantelpieces. Still, the room had bare floors and windows and plain metal chandeliers.[6] Its historic importance was yet to come. It was mostly used for storage and as a kind of catchall, and its doors were usually closed. In 1823 a writer reported in the *New York Advertiser* that he'd inventoried the East Room, which contained only "13 old mahogany armed chairs (representing probably the old 13 states), most of which have bottoms, indicating that but few of the states would ever be found unsafe

and useless; and all of them were destitute of any covering, showing that the republican plainness of the revolution should ever be preserved."[7] When Andrew Jackson moved in, he finally furnished it.[8]

For years after the White House opened with its main room unfinished, that room was considered a prime target for critical sniping. In 1856 the *United States Magazine* noted that "politicians have frequently made this room the text for many a philippic on the stump against the incumbent of the house.... In the contest between Martin Van Buren and William H. Harrison [1841]: the splendors of its furnishing, according to Mr. O [sic], far surpassed Windsor Palace and Versailles, and was but little, if any, behind a fairy structure. The simple fact was that it was about as shabby an affair as could be imagined, looking as if it had been furnished by a second-hand furniture dealer from the remnants picked up from hotels & steamers."[9]

The first illustrations of the interiors of the house, not photographs but wood engravings, were published in *United States Magazine* in 1856.[10] Until 1880 it was not possible to print photographs and text together; instead, journals published engravings copied from artists' drawings or photographs. Although a daguerreotype portrait of President James Polk and his cabinet was taken inside the State Dining Room in 1846, that was a picture in a room, not of it. Early photographs, daguerreotypes particularly, of the interiors of buildings are rare.

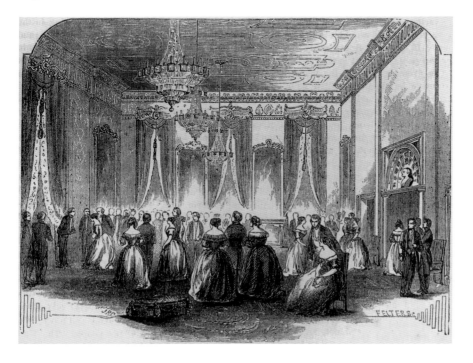

East Room, engraving, 1856. Illustration in *United States Magazine*. Artist unknown.

Reception of the Japanese embassy by President Buchanan in the East Room of the White House, May 17, 1860, engraving, Illustrated London News, *June 16, 1860. Artist unknown.*

An early depiction of the East Room, showing a Japanese diplomatic mission to America, is actually a picture of a momentous event, a news picture rather than an architectural illustration, but it gives a good idea of the way the room was decorated during James Buchanan's administration. That the *Illustrated London News* chose to picture the event indicates how news from America had become of popular interest in England and how widespread was the curiosity about the still largely unknown Japanese. There are no known photographs of this historic occasion. News photography was an extreme rarity at the time. Daguerreotype exposures were long, and even past the 1850s, if action was continuous, it had to be restaged in order to be photographed.

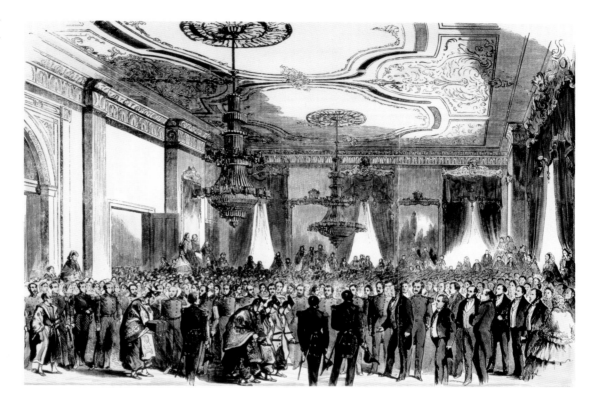

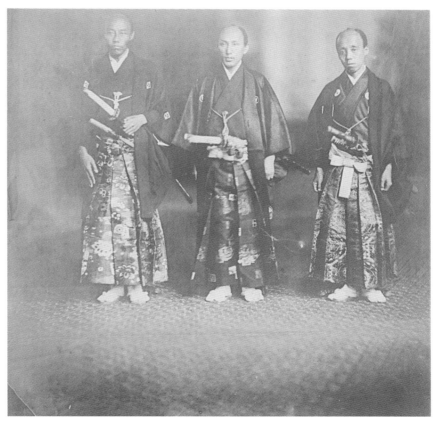

The Japanese legation, 1860. Alexander Gardner and Mathew Brady.

The embassy posed at Mathew Brady's studio. Brady or his assistants took pictures of most of the notables of his day, and by 1860 photographs of celebrities of every stripe had begun to attract a large audience. The Japanese posed whenever anyone asked them to, and photographers asked them often. Others did too, and the delegation lined up once when they came out of the White House so as to present a better view to a crowd that had gathered in hopes of catching a glimpse of them.[11]

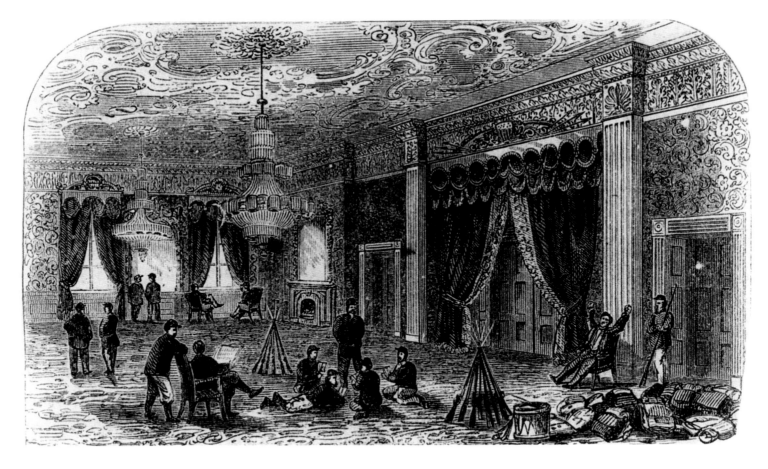

Union Troops Camped Out in the East Room, **engraving, c. 1865. Artist unknown.**

For a while during the Civil War, numerous tourists came to see the President's House, though only the East Room was usually open. Many of those visitors were Union soldiers, who had never been to Washington and who must have been especially curious about the symbolic center of the nation they were fighting for. In 1861 a security detail of soldiers known as the Frontier Guard came to Washington to protect the president and stayed briefly in the East Room, where they slept on the carpet or sofas. The artist has rendered the room somewhat more accurately than the figures of the soldiers.

There is only one known photograph of the East Room as it was spruced up and redecorated in Lincoln's day (see page 28). The room looked tired and faded when the Lincolns moved in, and Mrs. Lincoln set about refurbishing this and several other rooms. Visitors liked what they saw so much they started taking it home: gilded ornaments, even a lace curtain, disappeared from the East Room;

loops and tassels and pieces cut from silk draperies were filched from other state rooms. Between the damage wrought by large receptions with rapacious souvenir hunters and that done by the military bivouacking there, Andrew Johnson, Lincoln's vice president and successor, found the East Room's carpet ruined and the house in a state of "fearful dilapidation."[12]

OPPOSITE, ABOVE: East Room as redecorated by Andrew Johnson, c. 1869. Photographer unknown.

Johnson became president after Lincoln's assassination and moved quickly to "fit up the public portion of the house in a manner creditable to the Nation," but he didn't give a fig for the private quarters.[13] The state rooms signaled to foreign diplomats the nation's investment in its leadership and should by rights be a source of pride to the country's citizens. Johnson asked for, and got, a much more generous allocation than Congress generally gave for decoration. The East Room got new carpets, a newly painted ceiling, and new window and wall treatments. The

public rooms of the house could now be seen by tourists, and photographers began to supply detailed accounts for those who could not come in person.

Changing tastes required redecoration. Ulysses S. Grant came into office and put his seal on the "Gilded Age," a term coined by Mark Twain and Charles Dudley Warner in their 1873 novel, *The Gilded Age: A Tale of Today*. Marked by the creation of a modern industrial economy in the last quarter of the nineteenth century, the era also had its share of greed, corruption, and ostentation by way of the robber barons and their political allies in Washington. Some tastemakers thought the East Room too plain for its purposes. In Grant's administration, it was, in effect, regilded.

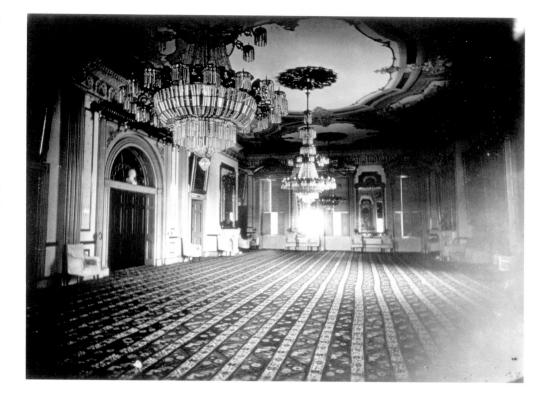

East Room, 1873. Photographer unknown.

The chandeliers that had been there since Andrew Jackson's time were replaced by enormous gasoliers. (In 1848 President James Polk had gas installed in the house, replacing candles and oil lamps.) Large Corinthian columns, a figured carpet, and heavy mirrors were added. The lush and grandiose result was labeled "pure Greek" by a Washington guidebook, but the *New York Times* said it had been "frescoed and gilded and ornamented until its former noble simplicity has been destroyed. The decorations would be suitable for a restaurant or a gambling saloon, but they are not what should be seen at the home of a republican President."[14]

Before long, hand-tinted photographs of the East Room made their way to the market. From the earliest days of photography, inventors and the public yearned for color pictures, certain that color would complete photography's seductive promise of putting reality on paper. Since the camera at that time couldn't do that, photographs were hand-tinted; portraits were often colored only in part — lips and eyes, say, or collar and cuffs. Although several experimental color processes were devised in the nineteenth century, as well as mechanical

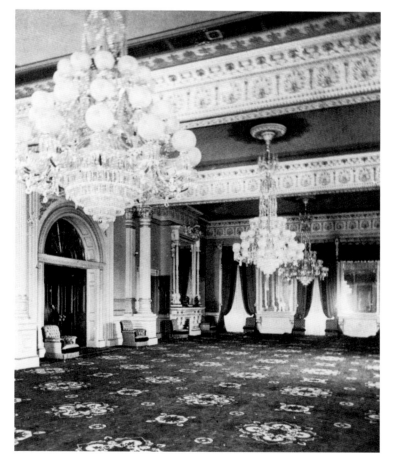

means of reproduction such as color photographic litho-graphs (made from black-and-white images), no practical way to take color photographs existed until 1907, when the Lumière brothers — Frenchmen who had produced the world's first projected moving pictures in 1895 — brought their autochrome process to market. Until then, hand col-oring was the answer. It was usually done by women.[15]

A decade after the Grants had refurbished the house, Chester A. Arthur (1881–1885) redecorated twice within six months' time. He also consigned to an auction house twenty-four wagonloads of furniture and objects, some in good condition, most not. Some contents of the East Room were carted off — mostly rugs and furniture, much of it moth-eaten and worn. The sale also offered lead pip-ing, moth paper, cuspidors, water coolers, and a lot of rat traps, including the one that caught the rat that ate Lin-coln's suit of clothes "before that memorable Good Friday."[16]

For the second round of redecoration, Arthur hired Louis Comfort Tiffany, best known today for his work in glass, but who was also a highly original interior designer at the forefront of artistic design. Tiffany designed a mural-size stained-glass screen for the Entrance Hall and chas-tened the room's lavish Gilded Age extravagance with painted touches of his signature elegance, subdued and up-to-date.[17]

LEFT: **East Room, Abraham Lincoln administration, c. 1862–1865. Photographer unknown.**

OPPOSITE: **Entrance Hall showing the Tiffany screen, c. 1882. Frances Benjamin Johnston.**

Frances Benjamin Johnston, one of the few female photo-journalists of the time, was known in the 1890s as "the photographer of the American Court." She took so many pictures at the White House she was practically the house photographer; her photographs were widely published in journals and in a booklet in 1893. From the late 1880s to the 1910s, Johnston captured remarkable images of the White House that document the lifestyles of the first fami-lies, workers, and visitors as well as its architectural design during that period. Johnston, through family connections, met the elite of Washington society and gained access to the first family.[18]

Tiffany's stained-glass screen in the Entrance Hall between the existing Ionic columns was the first sight that greeted visitors to the White House. Made of opalescent glass encrusted with jewel-like glass, it was an opulent means of providing a little privacy for the president's fam-ily. The oval in the central panel, partially visible at the left, centered on a shield with the initials U.S. in red, white, and blue and surrounded by eagles.

By 1902 the Gilded Age had signs of tarnish, and tastes, which are always fickle, lived up to their reputation. Victo-rian elegance started to look overstuffed and ornate. McKim, undertaking the renovation under Roosevelt, removed the Tiffany screen in the entry hall. The screen, installed in 1882 during President Arthur's administration, was removed and auctioned off. A real-estate agent pur-chased the screen for a resort development on the Chesa-peake Bay; it was lost in a hotel fire in 1923.[19]

McKim gutted and redecorated most of the interior, and restored the White House to a neoclassical past. Though the architects claimed it was a restoration, they seem to have cared little for historical authenticity and relied on eclectic European influences. The East Room shed its Victorian pomp and took up restraint in its stead with white paneling, yellow silk draperies, classicized bas-reliefs above the doors, fluted pilasters along the walls, and dentil moldings above (see page 22).

The public could make up its own mind about TR's

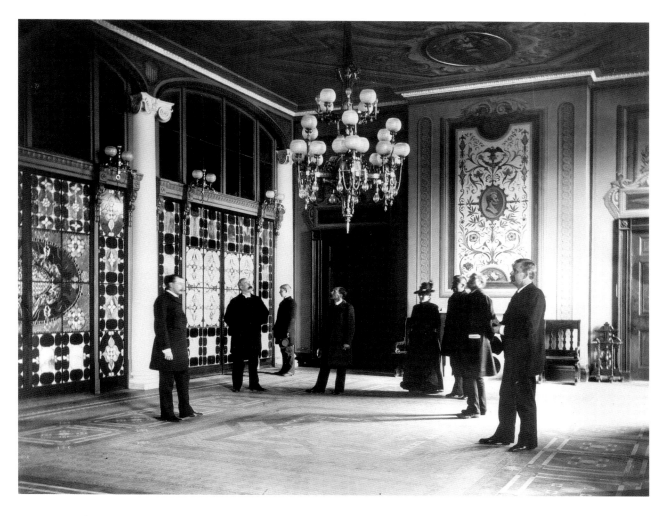

reconstruction via images that were widely available on picture postcards. Such cards had been common in Europe and became popular in America by 1893, but as the picture had to share space with the message, the entire back was reserved for the address. Nonetheless, postcards reached far and wide following the commencement of Rural Free Delivery in 1898. In 1902, when Eastman Kodak marketed a postcard-size photographic paper, individuals could make their own picture cards, and professionals quickly turned the little-letter-that-cuddles-up-to-a-photograph into a big business. Then, in 1906, Congress made it legal to put message and address together on the back so that the picture took over the front, and mailbags soon bulged with picture postcards.[20]

The East Room has seen hundreds of parties by now, including one of the most memorable Christmas parties the White House ever gave for children. On December 29, 1868, Andrew Johnson's sixtieth birthday, he held a children's ball in Washington, with dancing in the East Room.

Johnson sent nearly three hundred engraved invitations to children of White House dignitaries and staff, asking them to a party given by "The Children of the President's Family." Their parents were not invited. The president gave each of the littlest children a hug and a kiss. One observer commented that this entertainment seemed like "a marvel of social elegance, even of questionable extravagance. For in those days the child had not wholly come into his own."[21]

In 1903 Theodore Roosevelt and his wife invited children under twelve who lived in Washington to a party on the day after Christmas; five hundred and fifty came to see a singing and dancing troupe in the East Room and have punch and cookies afterward.[22] At Christmas there are still parties for children, and in 1878 Rutherford B. Hayes established the Easter Egg Roll for children on the White House lawn, a tradition that continues to this day. In recent times, Halloween has become a seasonal party when children are living at the White House.

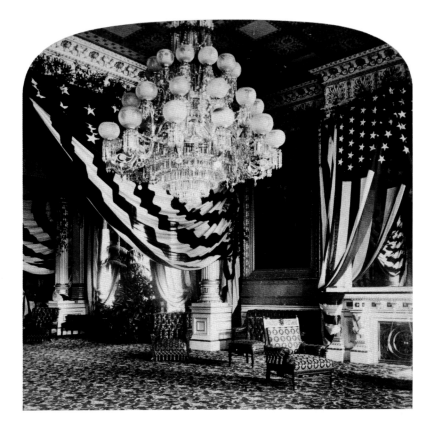

The East Room decorated for the Army and Navy Reception, Executive Mansion, one half of a stereograph, 1900. Strobmeyer & Wyman.

Within the house's walls, much was done to bolster its own symbolic force. The White House honored the country's military brass once a year with an Army and Navy Reception, beginning about 1881; this became one of the major events of the White House social season. Patriotism was the obvious theme of such a gathering, the flag its obvious backdrop. The East Room was draped repeatedly in unfurled flags, which the room's mirrors multiplied until the stars and stripes were omnipresent. The photographer has emphasized this by shooting at an angle that sets up repeated and countervailing flag patterns.

Harry Truman revived the Army and Navy Reception, suspended during World War II, but after John F. Kennedy's assassination, the tradition fell away.

The military, naturally enough, was frequently honored, even those who fought against the Union in the Civil War. Woodrow and Edith Wilson started receptions for wounded veterans in 1918.[23]

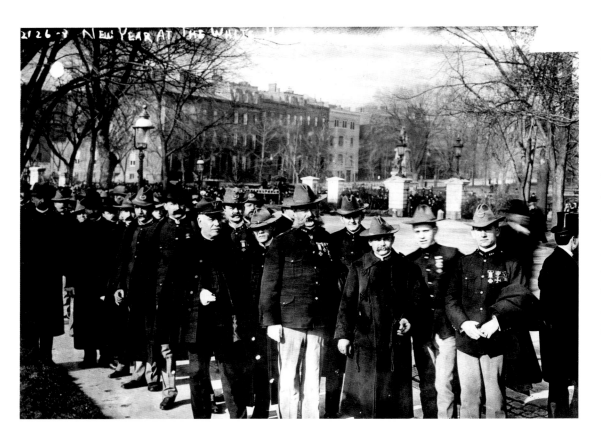

Soldiers waiting outside the White House for New Year's reception, 1901. Photographer unknown.

Every year at New Year's until 1933, when the tradition of a public reception ended, the White House opened its door to the public, including veterans of American wars. Old and not-so-old soldiers waited in the cold for the chance to see the commander in chief and the house that symbolized the nation they had risked their lives for.

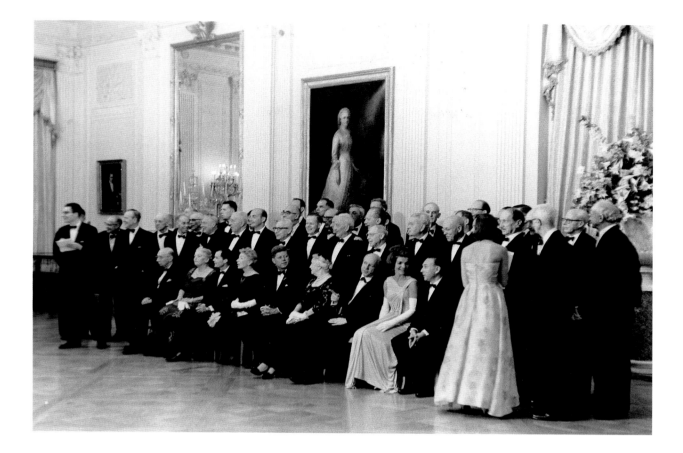

The Kennedys with forty-nine Nobel Prize winners, April 29, 1962. Robert Knudsen.

It was Kennedy's idea to host all living Nobel Laureates of the Western Hemisphere at one of the largest formal gatherings ever convened at the White House. The president used ceremonial occasions like this one, as well as entertainments, to bolster national pride and promote the arts in American culture. Presidential observers Michael Baruch Grossman and Martha Joynt Kumar have since suggested that most recent presidents recognize that public confidence in their ability to handle complex problems and, especially since Sputnik, scientific problems is bolstered when citizens see the chief of state holding his own with intellectuals.[24] Kennedy told this illustrious group he'd been informed that a Canadian newspaperman had said, "[T]his is the President's Easter egghead roll on the White House lawn." The president then remarked, "I think this is the most extraordinary collection of talent, of human knowledge, that has ever been gathered together at the White House, with the possible exception of when Thomas Jefferson dined alone."[25]

The only female Nobel laureate in this photograph was Pearl S. Buck (on the left), who received the award in 1938 for *The Good Earth* and was the first American woman to win a Nobel for literature. Mrs. Ernest Hemingway, representing her late husband, sits at the president's right; at his left is Katherine Marshall, widow of George C. Marshall. Among the distinguished guests at the dinner were poet Robert Frost, scientist Robert Oppenheimer, doctor Linus Pauling, authors William Styron, James Baldwin, John Dos Passos, Samuel Eliot Morison, Katherine Anne Porter, Lionel and Diana Trilling, and diplomat Ralph Bunche.

This group, presided over by a painting of Martha Washington by Eliphalet Andrews, is seated in the East Room for an official portrait. Obviously this is not it. The photographer — no doubt there was more than one — is off to one side rather than in the symmetrical center. The sitters haven't yet put on their best official-portrait faces, and one woman stands with her back to the camera. Perhaps she doesn't belong in the official picture at all. The informality of image and sitters is a reminder that photographers are not shy about catching people in the process of getting ready to be immortalized.

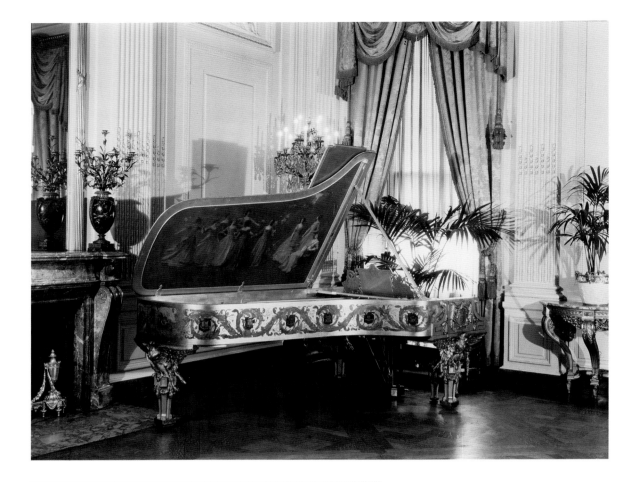

Grand piano, after 1908. Harris & Ewing.

Pianos were always present in the White House, bought either by the first families or with government funds. By the last quarter of the nineteenth century, when the American piano-construction industry was experiencing a boom, manufacturers realized that prestige would accrue to them if they donated an instrument to the White House.[26] This one, donated in 1903, was Steinway's hundred thousandth. Supported by American eagles, it was covered in dull gold leaf, and the case was decorated with the coats of arms of the original thirteen states. Beneath the lid was a painting by Thomas Wilmer Dewing of the young republic of America receiving the nine muses.[27]

Music and performance have a long history in the East Room. After 1829 the Marine Band performed regularly at East Room receptions, and it maintains that tradition to this day. The band's first performance at the White House was at a New Year's Day reception in 1801 hosted by President Adams. In April 1856, when a Seminole Indian delegation attended an East Room reception, a *Washington*

Evening Star chronicler reported that the visitors "seemed to care little for the display of fashion; and stationing themselves as near as possible to the Marine Band, were oblivious to nought else but the music, for the entire evening."[28] In 1880 John Philip Sousa was named leader of the band and served five presidents until 1892. He was the first American-born leader of the Marine Band and the composer of operettas, songs, suites, and more than one hundred marches, best represented by his *Semper Fidelis* (1888) and *The Stars and Stripes Forever* (1897).[29]

The cellist Pablo Casals played in the East Room for TR, and sixty years later, having vowed in 1946 not to perform again in protest against Franco's tyranny in Spain, was convinced to play by and for the Kennedys. Many other major performers have appeared, including the Mormon Tabernacle Choir and Peter Duchin (Johnson), Pearl Bailey (Nixon — who accompanied her on the piano), Beverly Sills (Ford), Dizzy Gillespie and Mstislav Rostropovich (Carter), Frank Sinatra and Perry Como (together) and Benny Goodman (Reagan), and Jessye Norman (George H. W. Bush).[30]

Impromptu performance by President and Mrs. Kenneth Kaunda of Zambia, April 19, 1975. Joseph H. Bailey.

That room saw so many performances, even a guest performed. After pianist James Tocco played at a state dinner in honor of President Kaunda of Zambia, President Gerald Ford, who knew that Kaunda was an accomplished guitarist, asked him to play. To everyone's surprise, he not only accepted but brought his wife and the twenty-two members of his official party up onstage. The Zambian president accompanied the group on guitar while they sang a song in his native tongue that he had composed. As an encore, he and his wife sang another one of his compositions, this one a love song. The event was unique; no one in the group could recall a visiting head of state and his wife performing at a White House dinner.[31]

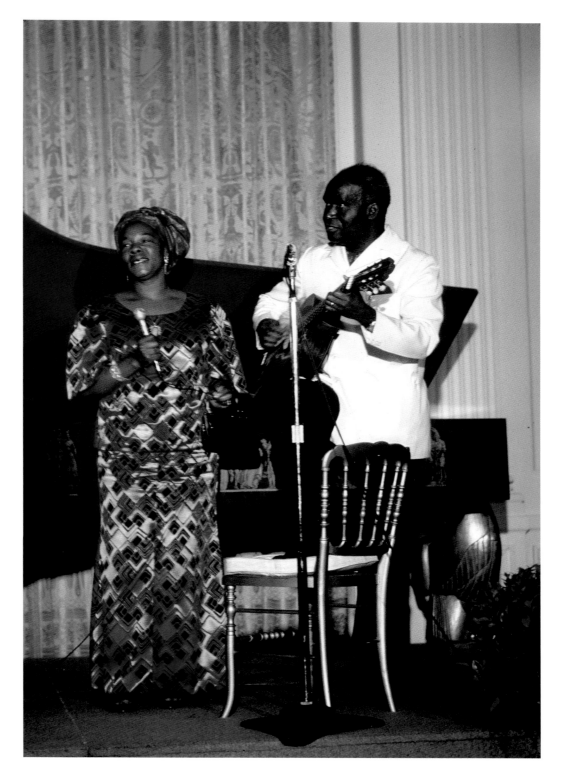

President Lyndon Johnson dances with Carol Channing, January 1967. Robert Knudsen.

Galas frequently take place in the East Room, but some, like this one, extend into the Entrance Hall. Carol Channing was invited to perform at the White House because she was a great favorite of President Johnson's, especially after his 1964 election campaign used her *Hello, Dolly!* Broadway theme song. When LBJ invited her, she and other members of the touring company cast presented an abbreviated version of the show; Channing dubbed the gig "Operation Big Daddy." After she sang a rousing encore, LBJ rose quickly, gave her a big bear hug, and swept her out onto the dance floor, where the six-foot-three-and-a-half-inch-tall president was just about dwarfed by the singer's extravagant red ostrich-feather hat perched on a tangerine-colored wig.[32]

OPPOSITE: **Princess Diana dances with John Travolta at a gala dinner at the White House, November 9, 1985. Pete Souza.**

Two stars from different universes danced in the Cross Hall at the White House: Diana, the fairy-tale princess then married to Prince Charles, heir to the British throne, and John Travolta, who had played a king of dance in the film *Saturday Night Fever.* President Ronald Reagan danced with the princess too, but the image that made the front pages of newspapers and magazines around the world was that of the glamorous princess and the crown prince of dance.

President Gerald Ford and First Lady Betty Ford, August 17, 1974. David Hume Kennerly.

After-dinner dancing in the East Room has been popular ever since the early nineteenth century, when the room wasn't even finished — although President Polk's wife, a strict Presbyterian, did not permit it.

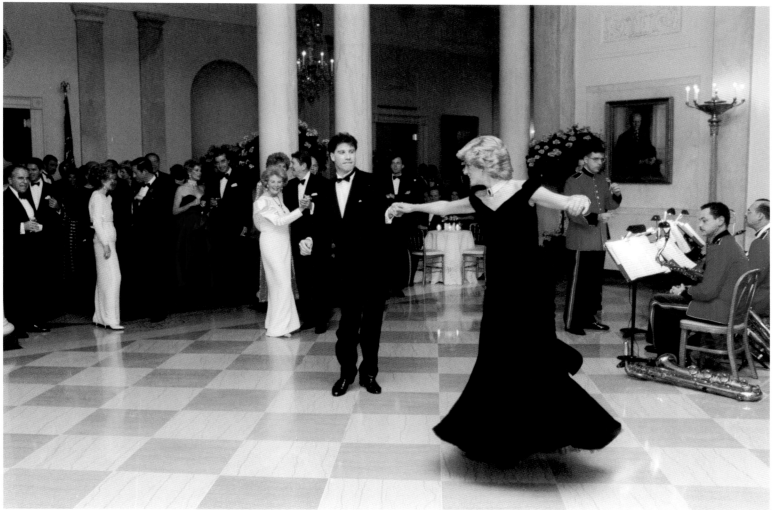

CHAPTER 2: WEDDINGS AND FUNERALS

MANY A WEDDING took place in the East Room of the White House; the public was unfailingly thrilled. The journals made every effort, in words, engravings, or photographs, to make the citizenry feel like privileged observers, and the White House was almost always glad to oblige. Before President Grant's daughter, Nellie, married Algernon Sartoris in 1874, Nellie's trousseau, including her parasols and her lingerie, was shown to reporters.[1] The day after the wedding, the *New York Graphic* announced, "It is of no use. We are utterly unable to meet the demand for today's issue." The press did not report that the president kept his eyes on the floor and wept throughout the ceremony; perhaps he cried because his daughter was moving to England, perhaps because he knew that the groom was what one of Grant's biographers refers to as "a cad and a bounder."[2]

The biggest event to create news coverage was the marriage of bachelor President Grover Cleveland to Frances Folsom in 1886. Author and historian Martha J. Lamb wrote in 1887 that when rumors leaked out that the president would not be a bachelor for long, "It is doubtful whether an earthquake in New York city or a war with Europe would have created so perfect a sensation or half as much genuine excitement.... This romantic episode adds fresh interest to the White House."[3]

James Hoban, the first architect of the White House, intended the East Room to be an "Audience Room" that also could be used as a banqueting hall when too many dined at the White House to fit in the State Dining Room. Over time, however, it became the site for weddings, celebrations, treaty signings, entertainments, solemnities, and commemorations. Nineteenth-century writers often spoke of the room as the "nation's parlor" and as being "historic," and in 1892 the *Washington Post* reported, "In this chamber have been held some of the most noted gatherings in the history of the nation."[4]

Among those noted gatherings (surely not the only ones the *Washington Post* was thinking of) were presidential funerals. William Henry Harrison was the first president to die in office — on April 4, 1841, a mere thirty days after his inauguration. There was no precedent for a sitting president's funeral, and one had to be established. One was, and it set the basic agenda, though not the details, for all such later ceremonies. Harrison's funeral was in the East Room, which became the usual site for funerals of presidents, as well as of their wives and children and, in exceptional circumstances when the president ordered it, of cabinet or military officers. The public came to the White House to pay its respects to the late President Harrison, as it would for future presidents — to mourn the loss of its leader and be reassured that the American way of government would continue undeterred.

Harrison's funeral was by invitation only. The

OPPOSITE: **Tricia Nixon in wedding dress in the Cross Hall in front of the Blue Room door, June 12, 1971. Dick Winburn, *New York Times.***

Tricia Nixon, Richard and Pat Nixon's elder daughter, married Edward F. Cox on June 12, 1971. The photographer has pulled out all the stops for this portrait of the bride. Her status as the daughter of a president is boldly and unmistakably announced by the American and presidential flags that flank her as if in attendance. Posing her in the center before a door leading into a darker room creates a picture within a picture and a double frame for the sitter: the door that surrounds her is one, the edges of the photograph another. A light behind her, shining through the sheer material of her veil and dress, creates an almost otherworldly glow about her figure, as if she were sacred, while the double circle of chandelier lights right above her head endows her with a double halo. Winburn has cleverly and economically suggested that Tricia Nixon is doubly blessed, by God and country.

Executive Mansion itself observed the era's increasingly formalized funerary customs; even the exterior of the house wore black drapery. Later the buildings that housed public offices might also don mourning drapes, as they did when President Zachary Taylor died of typhoid fever while in office in 1850.[5] When Harrison died, the public was invited in for a viewing in the Entrance Hall, where the columns and walls were hung with black crepe, and arches and niches were decorated with black crepe as well. Harrison's coffin was then placed in the middle of the East Room, where the chandeliers, mirrors, and curtain walls were covered in mourning cloth; other state rooms were evidently treated in the same way. His coffin and pall were designed in military style — he had become a national hero for defeating Tecumseh, the renowned Indian warrior, at Tippecanoe and for leading American troops to several victories in the War of 1812. Crossed swords lay on the coffin lid, one to represent the Sword of Justice, the other the Sword of State, and for good measure, a scroll with the Constitution, as well as a laurel wreath, were added to the funerary honors. Giving the public greater access to the untimely departure of the man they had voted into office, the funeral car that carried the president's remains out of the White House and down the streets of Washington was nothing but a platform on wheels, allowing spectators full views of the coffin and pall.[6]

In nineteenth-century America, funeral customs became much more elaborate and standardized than they had been in colonial days. Funerals gradually moved out of the house to churches or to funeral "parlors" established well after the century began. Coffins became ornate and were renamed "caskets," originally a term for a container of precious objects, and the bereaved might wear not only mourning dress but also mourning gloves, rings, pendants, and scarves.[7] All Washington publicly displayed the nation's sorrow over the loss of President Harrison: there was crepe on the door of almost every private house. And when later presidents died, many citizens, and even some cabinet secretaries' carriage horses, wore mourning badges.[8] Some of these customs persisted, and some still remain today.

The emotional need to pay respects to a dead leader,

to attend the obsequies at least visually, was fed first by drawings, then by photographs, then by newsreels, and eventually by television. Because of technological changes in the media and changes in their distribution, national and international coverage of John F. Kennedy's funeral in 1963 was exponentially more extensive than any before in history. Newspapers and magazines carried endless photographs of the funeral procession, the dignified widow, and the president's young daughter and son. The assassination itself had been filmed by Abraham Zapruder, a Dallas resident with a home-movie camera who was filming the presidential cavalcade at the exact place and time that JFK was shot. Still frames from the film were published in *Life* magazine. By 1963 television had become a staple in American homes. The number of sets had soared from 21 million in 1953 to 54 million in 1960 and was still growing, and limited satellite communication across continents and oceans was already in place by 1962.[9]

From Friday, November 22, when Kennedy died, to Monday, November 25, the day of the funeral, both television and radio shut off all regular programming and all commercials to talk only of Kennedy's life, death, and funeral. The Nielsen report on television viewing in this country said that during those four days, the average home tuned in for 31.6 hours. Western Europe, Moscow, and parts of Asia received limited TV reports from America by satellite, and in Munich and Rio, people were so desperate for the news that crowds grew violent when newspaper supplies ran out. All over the world, but especially in this country, people needed to know, to see how President Kennedy was put to rest. For four days, millions participated in the official mourning rites as spectators in a world where experience had shifted irrevocably toward second-hand spectatorship, largely because of the dominance of one kind of photography or another.[10]

When photography was still young, it was almost immediately recognized that it would change our relationship to time and memory. Photographs could preserve the dead in black and white, and it was not long before people could know how presidents had looked, though they might never have known them in life.

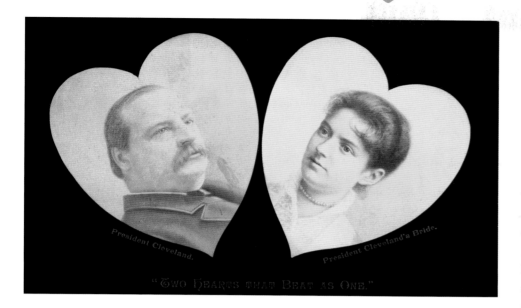

"Two Hearts Beat As One." Photo portraits of Grover and Frances Folsom Cleveland, c. 1886. Photographer unknown.

Grover Cleveland first campaigned for president as a forty-nine-year-old confirmed bachelor. After it become known that he may have fathered an illegitimate child, the Republican opposition staged parades where men pushed dolls in baby carriages while chanting, "Ma! Ma! Where's my pa? Gone to the White House. Ha! Ha! Ha!"[11] The electorate, undeterred, voted Cleveland in anyway.

Not long after he was elected, Frances Folsom, his law partner's daughter who had been Cleveland's ward ever since her father died when she was age eleven, agreed to marry him; she was twenty-one. They kept the engagement secret as long as they could, but secrets so explosive generally make a noise. Sentimental images like this one sprang up, and articles singing the young woman's praises were plastered all over the press. They were wed in the Blue Room. The public was so captivated by her that it decided it liked him better too.

Woodrow Wilson and Edith Bolling Galt, 1914. Photographer unknown.

President Wilson's first wife, Ellen, died in August of 1914, the week that World War I broke out. Wilson was so devastated that at one point he remarked that he wished someone would shoot him. Six months later, he met Edith Bolling Galt, an attractive and charming widow fifteen years younger than him. He proposed within three months. She was somewhat shocked that he would do so on such short acquaintance, but did not categorically refuse him. After that Wilson, head over heels in love, hopeful, and in rising spirits at last, sent her flowers every day. By summer they were secretly engaged. Many of his advisers wanted him to wait, for fear that the public would disapprove of his marrying so soon after his wife's death.

Nevertheless, the engagement was announced in the newspapers in early October. The couple went to Philadelphia one day after the publication to attend the World Series. There the crowds cheered them wildly — all the world loves a lover — and a photographer caught them smiling ecstatically at one another after the president threw out the first pitch. The photograph was widely published in rotogravure sections over the next two weeks and is almost certainly the source of this hearts-and-cupid picture. They were married in December.[12]

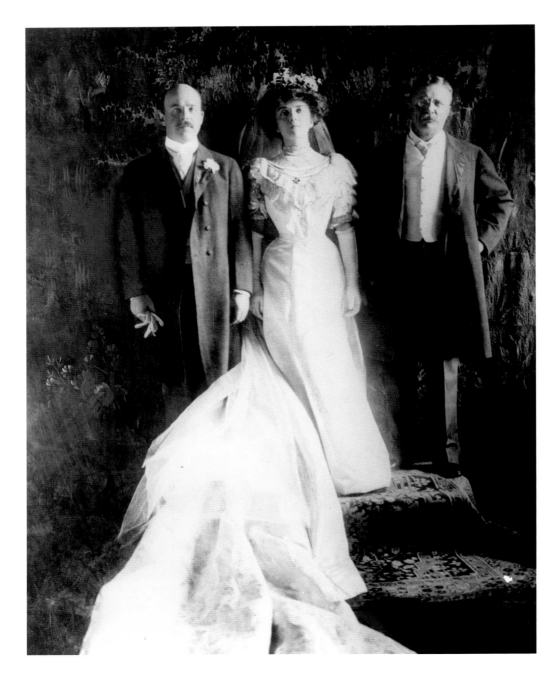

Nicholas Longworth, Alice Roosevelt, and Theodore Roosevelt, February 17, 1906. Edward S. Curtis.

From the moment she arrived in the White House (and for most of the rest of her life), Alice was a reporter's dream come true. She was beautiful, energetic, and headstrong; she chewed gum in public, smoked, played poker, drove her own car, and broke any other rule of polite society (or of her father's) she had a mind to. Her engagement and wedding were a veritable feast for newspapers and magazines. Long lists of gold and silver presents filled pages — White House aides said Alice would accept "anything but a red-hot stove." When a reporter asked her if she thought anything should still be added to the array of gifts, she answered, "Trinkets. Preferably diamond trinkets."[13]

Alice Roosevelt married in the East Room on February 17, 1906; her cousin Franklin Delano Roosevelt arranged the bride's train. When she left on her honeymoon, Edith Roosevelt, the president's second wife, kissed her good-bye with this farewell: "I want you to know that I'm glad to see you leave. You have never been anything else but trouble."[14] Alice's parrot, however, must have missed her, for he called her name for days.

In this picture, the groom, Nicholas Longworth, and President Roosevelt stand with the bride on a pedestal covered with an Oriental rug. Alice manages to look somewhat imperious by raising her chin a bit. Her father, not to be outdone, strikes a pose with one elbow out and a hand on his hip, exuding an attitude for centuries associated with dominance. Probably TR understood the significance of the gesture only instinctively, but it came naturally to him, and he set his elbow akimbo for the camera several times, as well as for the portrait painted by John Singer Sargent that has long been on display in the White House.

Roosevelt had admired portraits by Edward S. Curtis and invited the photographer to come east from Seattle to Roosevelt's residence, Sagamore Hill, in 1904 to photograph the Roosevelt children at play. Curtis had already embarked on a thirty-year-long project that became a photographic and social landmark: a twenty-volume history of the North American Indian, an enterprise TR supported.

Luci Johnson throws her wedding bouquet to her sister, Lynda, August 6, 1966. Frank Wolfe.

Public fascination with White House weddings has not abated over the years. The *Washington Post* devoted not one but two entire sections, one in July and one in August, to Luci Johnson's wedding to Patrick Nugent. In this photograph, the new Mrs. Nugent, about to leave on her honeymoon, stands on the porch outside the Blue Room on the South Portico, above the crowd, to toss her wedding bouquet.

The press paid attention to the fashions sported by the White House guests, as they had since the nineteenth century, when journals dispatched "lady correspondents" to report on what the women wore: "Mrs. Grant wore a pearl-colored silk dress trimmed with pink silk and feathers" and "Mrs. Hamilton Fish wore a chocolate-colored silk dress with rare thread lace."[15] The most striking fashion statement at Lynda Johnson's wedding to Chuck Robb in 1967 was made by Carol Channing. She came to the White House in "short, bloomer-type harem pants of yellow chiffon." The Johnson-Robb bridal dress was swiftly copied and available at Gimbel's within a few days of the wedding for $150, the long veil for an additional $135.[16]

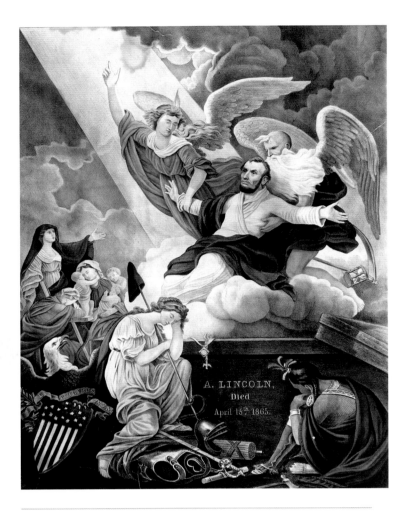

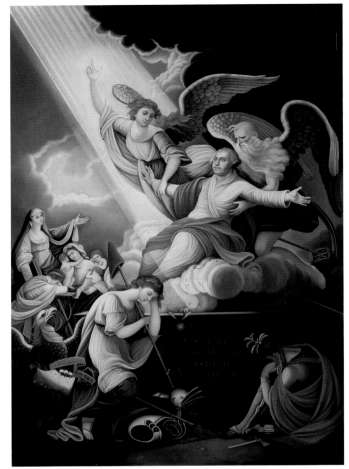

In Memory of Abraham Lincoln: The Reward of the Just, 1865. William Smith.

Assassination turned Lincoln into more than a martyr: he became a myth and a saint. William Smith's lithograph shows a scene strikingly reminiscent of traditional depictions of the Resurrection (although, according to Matthew's account, Jesus rises by himself — an angel merely lifting the lid of the sarcophagus). The sleeping Roman soldiers are replaced by Liberty, her cap on a pole, grieving over ancient war armor, and by a mourning American Indian. Lincoln is raised up toward heaven by Immortality and Father Time. Faith, Hope, and Charity attend in the background left, and Liberty is flanked by an American eagle and a rattlesnake.

This print is virtually an exact copy of the engraving (top right) by John James Barralet titled *Apotheosis of Washington,* first printed in 1802.[17] Other than the replacement of Washington's face and inscription with Lincoln's, only minor changes have been made; Smith's picture amounts to plagiarism, or what we today would call appropriation. Barralet's engraving was so popular that it was printed four times, so it's reasonable to assume that copies of it were still hanging in some houses in 1865. Smith's obvious reference to the earlier image is most likely intended to point up the equivalent greatness of the two presidents.

Apotheosis of Washington, engraving, 1802–1810. John James Barralet.

Barralet titled his engraving an apotheosis — the elevation of a great man to Olympus — but the similarities to Resurrection scenes are unavoidable and surely intentional. In images like this one, America created its own mythology, borrowing from traditions that were well known, widely understood, and could instantly communicate assurance of the goodness of the nation's leaders, and by extension the sacred nature of America itself, the first true republic in history.

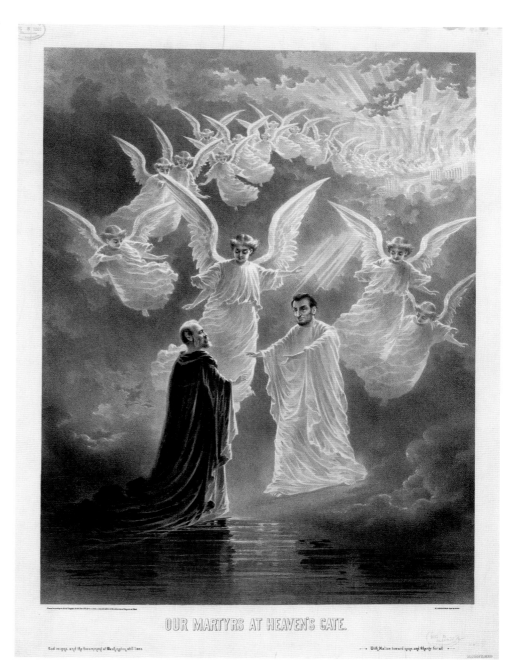

Our Martyrs at Heaven's Gate, engraving, c. 1881. D. Morgan, M.J., and Co.

OUR MARTYRS AT HEAVEN'S GATE.

Garfield is one of those largely forgotten presidents who seem to slip the traces of American history lessons. Thomas Wolfe thought there were four such men, and that was probably an underestimate. In a story called "The Four Lost Men" (1934), he wrote, "For who was Garfield, martyred man, and who had seen him in the streets of life? Who could believe that his footfalls ever sounded on a lonely pavement? Who had heard the casual and familiar tones of Chester Arthur? Where was Harrison? Where was Hayes? Which had the whiskers, which the burnsides: Which was which? Were they not lost?"[18] As Garfield was president for approximately six months before dying of an assassin's bullet, he hadn't time enough to make much impression on government. He did take a stand against political corruption and had one notable success in removing politics from federal appointments; then, in the last two months of his short tenure, he lay close to death. Garfield had the special fame of an American hero type, having made so exemplary a rise from impoverished childhood to preeminent position that he inspired a Horatio Alger "rags to riches" story.[19]

Of course, every president is known to the citizens of his administration. Besides, assassination is a pretty telling mark on a president's biography, and a country's. In this case, America's self image had received a terrible blow when a second assassination followed on the first one less than a quarter of a century earlier. Garfield was shot by Charles Julius Guiteau, a man who had begged the president daily, and unsuccessfully, for an ambassadorship to France, a position for which he was consummately unqualified. While in jail, Guiteau wrote General William T. Sherman, "Please order out your troops, and take possession of the jail at once" — another unsuccessful petition. At his trial, he said that God had commanded him to kill Garfield.[20]

By association, a measure of Lincoln's glory was transferred to the new victim. The camera is too limited to photograph myths, legends, or the afterlife, so artists step into the breach. The idea that one assassinated president should welcome another into heaven implies that a martyred president is a sainted one, and an image like this goes a long way toward manufacturing an icon out of a tragedy.

Lincoln's funeral in the East Room, April 19, 1865. *Harper's Weekly,* May 6, 1865. Artist unknown.

General Robert E. Lee, chief of the Southern forces, surrendered to General Ulysses S. Grant at Appomattox Court House, Virginia, on April 9, 1865. The next day, Lincoln reportedly spoke of a dream in which he'd heard sobbing in the White House, saw a coffin in the East Room, and asked who had died. A soldier replied, "The president. He was killed by an assassin!"[21] On the afternoon of the attack, Lincoln told one of his bodyguards he'd dreamed of assassination three nights in a row.[22] Predictive dreams of his death became a part of the Lincoln myth, making it hard to judge the authenticity of such accounts, but there had been no shortage of threats and the possibility of assassination must have been on Lincoln's mind. On April 14, at Ford's Theatre, John Wilkes Booth's bullet hit home. In shock, many in Washington thought a coup had begun. The nation plunged into unprecedented grief. At least 25,000 people filed past the catafalque in the East Room.[23]

Though Brady had taken a photograph of Lincoln's inauguration, which was outdoors, there were no photographs of the funeral. Perhaps photography would have been thought tasteless; at any rate, it would have been impossible without flash, since everything but the rug was covered in black. The columns and roof of the catafalque, designed expressly for Lincoln's funeral and never copied for another president, were so high that the central chandelier had to be removed.[24] Outside of Washington, the country got as close to the event as it could through images. The telegraph was fast, but images still took time. They weren't always entirely accurate, either — this artist put Mary Lincoln, the president's wife, in the picture, but she was too distraught and did not attend. The illustration also does not show several rows of low banked seats or standing platforms that had been built around three sides of the room to provide good views.[25]

General Ulysses S. Grant stood at the head of his commander in chief's coffin. After an autopsy, Lincoln had been embalmed in the White House itself; his coffin was open. Embalming had become an important aspect of after-death procedures during the Civil War, when embalmers, who referred to themselves as surgeons, promised bodies for shipment "free from odor or infection."[26] When Lincoln's son Willie died at age eleven in 1862, his body had been embalmed in the Green Room.

Six hundred invited guests attended the funeral. One New Yorker who was there wrote in his diary that it was a great privilege to attend "the most memorable ceremonial this continent has ever seen" and speculated that "there will be thousands of people ten years hence who would pay any money to have been in my place."[27]

Afterward, Lincoln's body was borne in procession to the Capitol, followed by a long line of dignitaries and military troops, including "a battalion of scarred and maimed veterans, with bandaged limbs and heads, with an arm or leg gone, but hobbling along on crutches, determined that their homage to their great chief

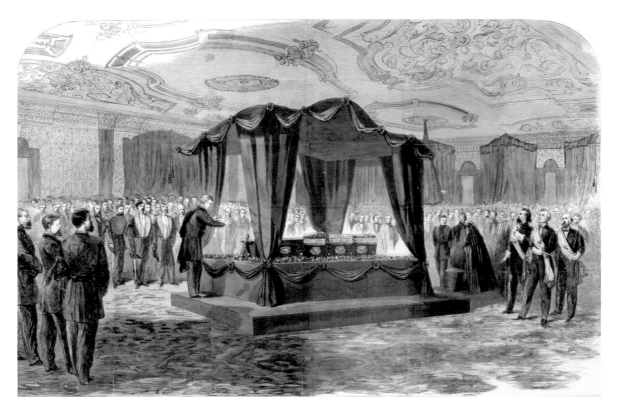

should be as sincere as that of their companions."[28] The body lay in state in the Capitol for a short while before being placed on a special train with the disinterred body of Lincoln's son Willie and sent across the country to Springfield, Illinois, where father and son were buried. Every place the funeral train stopped, people flocked in huge numbers to the station, and commemorative services were held with Lincoln's coffin open so the grieving populace could see him. This procession across some sixteen hundred miles sealed the popularity of embalming and amounted to a serial attendance at the president's funeral that would scarcely be eclipsed until television made the obsequies of another assassinated president, John F. Kennedy, visible simultaneously across the country and around the world.

Lincoln and Garfield, surrounded by a hand-colored, overturned horseshoe decorated with flowers, c. 1881. Photographer unknown.

Around 1860, when the miniature and inexpensive *carte de visite* photograph became popular, a cult of celebrity sprang up, and people began collecting images of kings, politicians, actors, authors — anyone famous, dead or alive. Long before baseball cards and fanzines, photography was in the business of commemorating heroes great and small, and ordinary people were enamored of such images. Presidents were an understandably popular category. The special connection of two assassinated leaders produced ingenious, if sentimental, mementos like this one, which encode complex messages of history, greatness, tragedy, and reverence.

The horseshoe is an unusual memorial emblem but is sometimes said to symbolize "conclusion of a cycle," as well as often being associated with luck, so that popular culture today takes this position of the shoe, with the opening at the bottom, as a sign that luck has drained away. In a time that was devoted to symbolism, the plants all have specific meanings: daisies represent farewell; poppies consolation, or eternal sleep; the blue flowers, most likely bachelor's buttons, would represent hope; the orange-red flowers growing like a vine on the right are most likely nasturtiums, often seen on nineteenth-century gravestones and interpreted as patriotism; the orange-red flowers on the left are not readily identifiable but, as they are in bud and wilting, are clearly "nipped in the bud"; ivy stands for everlasting, immortality, fidelity, and memory; the few stalks of wheat refer to the Grim Reaper. The predominant color scheme of the flowers is red, white, and blue.[29] This one small image packs a large load of information and inference, almost all of which would have been recognized at the time.

Hand-colored photographs were relatively common — a daguerreotype portrait might have the eyes, lips, and hair colored in, and occasionally parts of the attire — and some people added watercolor decorations to the pages of their family photo albums, so the combination of black and white "realities" with colorful accessories was entirely familiar.

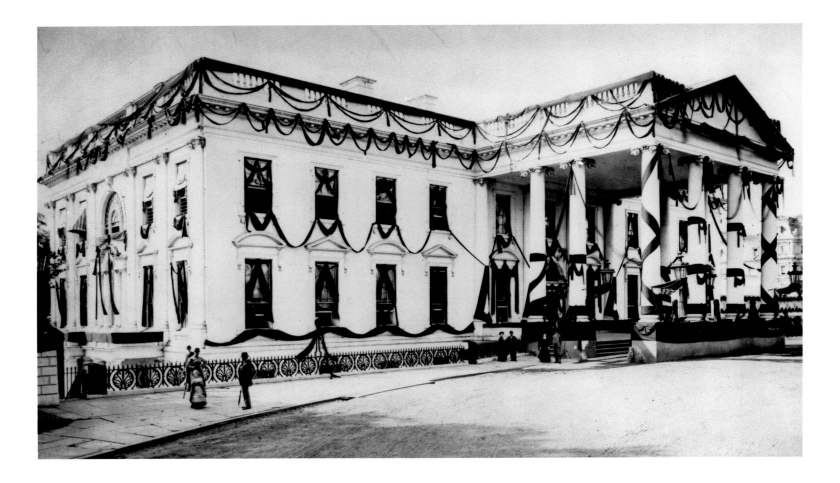

North view of the White House draped in mourning for President Garfield, 1881. Photographer unknown.

The White House wore mourning for James Garfield, who was assassinated several months after taking office in 1881. Presumably, it had looked much like this when previous presidents died, but by the time the next assassination occurred — William McKinley was shot in 1901 — a law had been passed prohibiting such display on public buildings.[30] Yet at least the interior of the house wore black bunting when John F. Kennedy was killed.

The centrality and importance of the presidency, the wave of emotion and anxiety that swept the crowds converging on the White House at the news of a president's death (and that spread across the entire nation), are reflected in the intensity of journalistic coverage of presidential funerals and the fact that a photographer could calculate that there would be a market for pictures of the house itself decked in crepe. Here, the angled view, which reveals that the funereal decoration was not confined to the facade, indicates that all four sides of the building symbolically expressed the same sorrow.

OPPOSITE: Crowd in Lafayette Park watching procession of Franklin Roosevelt's coffin to the White House, April 13, 1945. United Press International.

Franklin Delano Roosevelt, the longest-serving President in American history and the nation's leader during the two great crises of the Depression and World War II, died of a cerebral hemorrhage at the Little White House in Warm Springs, Georgia, on April 12, 1945, less than a month before the Germans surrendered. The presidential train brought Roosevelt's coffin to Washington, arriving on April 14. He had asked not to lie in state, and so his body lay in the East Room only a short while that day. The service was brief, and late that same day, the body was once more taken to the train station to be carried to his home in Hyde Park, New York, for a final funeral service and burial.

The people of Washington turned out in force to watch

the coffin roll by on a caisson in the procession from the railroad station. Knowing how large the crowd would be, many had brought mirrors to hold above their heads and give them a view — some of the women who are turned around are using the mirrors in their compacts. At least one man brought a camera, which he was holding above the crowd, so he could go home with a photograph of the event he had attended but not seen — though there would be professional photographs, like this one, that would show it to him better.

The media gave those who could not be there a listening post on the funeral. With his "fireside chats," in which he had addressed the nation directly and regularly on the radio, FDR had brought the presidency into America's liv-ing rooms, forging a national community whose members were invisible to one another but who were all focused on the same message. Now the nation — the millions who revered Roosevelt and those who hated him, all of them uncertain what was to happen at this moment in a terrible war — was united once more by Roosevelt and the radio, and people all over the country tuned in and sat silently listening to running accounts of his funeral.

This death reverberated around the world. Soviet news-papers announcing FDR's death were bordered in black. Winston Churchill, who did not go to the funeral, "spoke under the influence of deep emotion" when he addressed the House of Commons the day after the President died.[31]

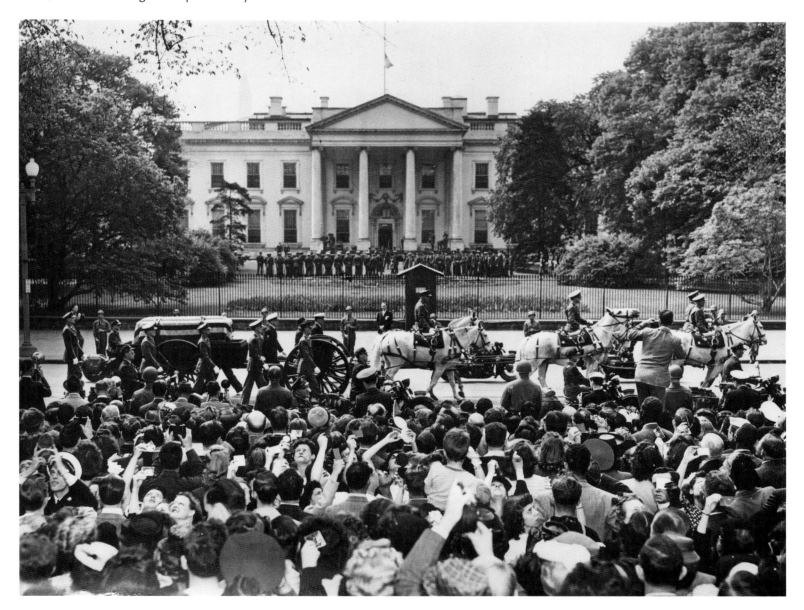

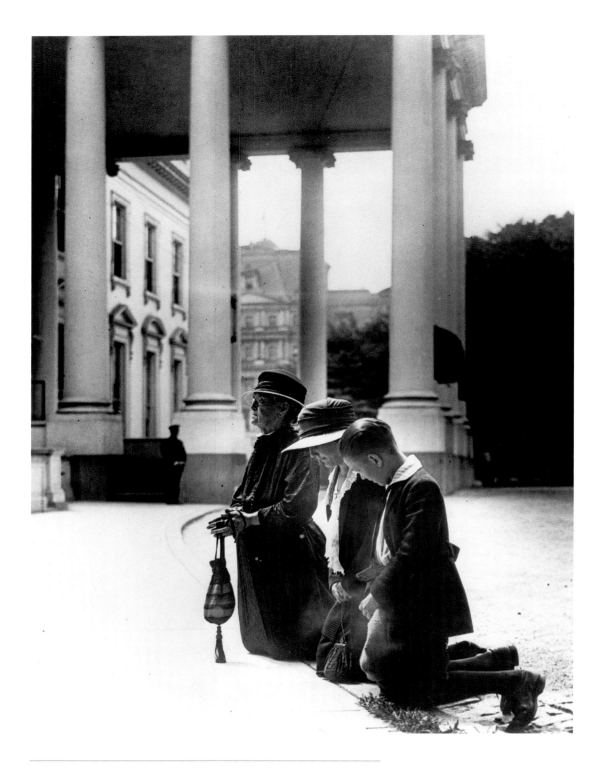

Mourners kneel outside the East Room where President Harding lies in state, 1923. Photographer unknown.

The White House was closed to the public for a time after Warren G. Harding died in 1923, but though his administration had been riddled with scandal, the public mourned its leader. In all likelihood, this picture, beautifully composed as it is, was posed. Its three reverent generations, the heights of their heads rising in exact increments toward the portico, are echoed twice by triplets of windows viewed through the columns. The line between staged and caught by a photographer with a quick eye and a quick finger is a fine one, but this looks a little too good to be true.

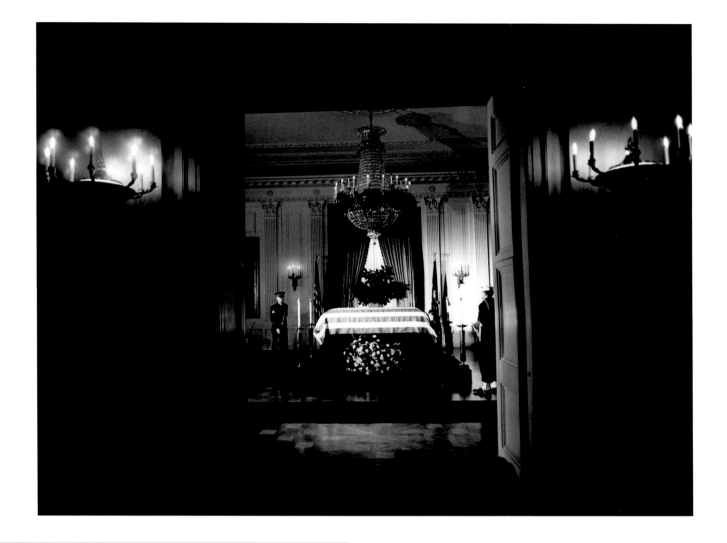

John F. Kennedy's casket seen through the East Room doorway, November 23, 1963. Abbie Rowe.

After John F. Kennedy was fatally shot in Dallas, his body was flown back to Washington and his casket placed in the East Room on the black catafalque where Lincoln's body had lain nearly a century earlier. The connection to Lincoln would have been meaningful to those who knew of it.

Television brought Kennedy's obsequies to more people than had ever in history witnessed the funeral of anyone, and his funeral rites made television the predominant and crucial medium of communication. One hundred and sixty-six million Americans in 51 million homes — some say more — tuned in at some point during the four day coverage, during which the networks cancelled all other programming and commercials. Satellite relay took brief reports to twenty-three countries, including Russia and parts of Asia. Newspapers and magazines around the world published page upon page of indelible photographs, like one of Vice President Lyndon Johnson being sworn in on the plane beside Mrs. Kennedy, and another of her three-year-old son saluting his father's casket as it passed by.[32]

The value of funerary ritual and tradition is incalculable at any time, and in crisis even more so. Such rites provide some reassurance that there is still order in a world that has been broken apart by death (and hopelessly ruptured by assassination), and they establish a sense not just of a historical past, however troubled, but also of continuity — the king is dead, long live the king — and community. The funerary forms and customs of a culture are understood throughout that culture, and when the deceased is the president, the government does the honors and thereby expresses and gives a concrete shape to its citizens' sorrow.

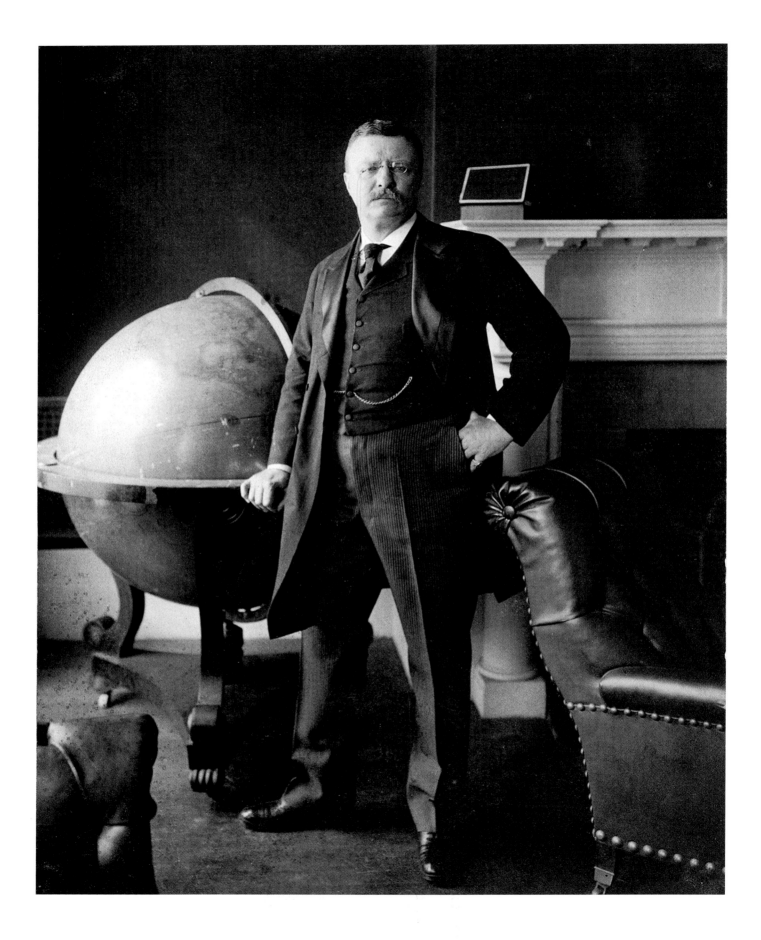

CHAPTER 3: PRESIDENTS' PORTRAITS

ON AUGUST 24, 1814, with British troops approaching Washington, Dolley Madison was at last convinced that her husband could not return on time and that she had no choice but to abandon the White House. Racing against war, she saved what she could: some silver and as many important documents as she managed to find — but she insisted on the Gilbert Stuart portrait of George Washington. As the frame was attached to the wall, it could not be removed in time; she ordered the painting removed from the frame and had the canvas rolled up and sent it away with servants for safekeeping. Not long afterward, the British arrived, found dinner set out for company, and dined heartily before burning the White House down.

Mrs. Madison understood how important the portrait of Washington was. That the father of this country should matter goes without saying, but that his likeness was cast by a foremost American painter was a visible sign of his greatness and his central place in the nation's brief history. Portraits of rulers have stood for a nation's power and supposed good governance at least since the Egyptian pharaohs. Washington was famous and revered as the man who had led the battle for liberty and as a new kind of "ruler," the elected leader of the world's first true democracy. Because citizens had voted him in as first president, voters had a personal stake in and a subtle tie to his image.

Portraits of famous men (and some women) were multiplying in the late eighteenth century. The rising middle class had spare money and curiosity and demanded pictures and more pictures. Wood engraving was revived, and then lithography was invented in 1798; both were capable of producing very large numbers of duplicates. Cut-paper silhouettes were popular, easy to make — you simply traced a shadow — and inexpensive. The invention of the camera lucida, patented in 1807, made reliable portraiture easier still: a portable device equipped with a glass prism at eye level, the camera lucida threw an image of the subject on a piece of paper, where it could be traced. The growing merchant class expressed its fascination with success of every kind (including its own) and hung images of those who made it on their walls.

In 1840, in a lecture titled "The Hero as Divinity," Thomas Carlyle proclaimed that "the history of the world is but the biography of great men."[1] The portrait of George Washington that hung in the President's House was the embodiment of that idea, a concrete symbol of a military and cultural revolution that had changed history and was the pride and raison d'être of every American citizen. Thanks to Dolley Madison's astute grasp of the portrait's significance and her determination to preserve it from marauding hands, Stuart's painting has almost always hung in the White House.

OPPOSITE: **Theodore Roosevelt in the president's room in the Executive Office Building, February 24, 1903. Rockwood Photo Company.**

The photographer has brilliantly caught Roosevelt's force and his ambition for his country in a single image. Two chairs up front bracket his figure and emphasize his centrality. They are essentially in our space, thus thrusting us into direct contact with the president, the chair on our right so close that someone might have risen from it in

haste a moment ago to acknowledge us as we entered and the president might have swung into position to confront us. He stares at us directly, his body at a slight angle. One of his legs advances in our direction; the foot and the base of the globe seem almost to be on a slant and slipping down, right toward us.

Journalism had become big business by the late nineteenth century as readership exploded, the average nearly doubling between 1880 and 1900 *(continued on next page)*

Portraits of its great men were particularly useful to a fledgling country. America was an experiment, and the results needed to be quantified. "America" and "American" were new words, yet to be defined. What was America, how should it be understood, and what was the character of its citizens? Foreigners like Mrs. Frances Trollope and Alexis de Tocqueville bent their minds to these questions in the 1830s, but not so assiduously and continuously as Americans themselves, who continued to seek accurate descriptions of the national spirit for decades. Depictions of the nation's leaders and important men, who were thought to embody the national character, were a prime source, and painters began producing portraits of them when the country was still in its infancy. Charles Willson Peale was famous in the 1780s for his "Gallery of Great Men"—paintings of Revolutionary War heroes. The founding fathers, especially John Adams, James Madison, Alexander Hamilton, and Thomas Jefferson, were such major and beloved figures that Britain produced commemorative pitchers and plates decorated with their likenesses for the American market.[2] Gilbert Stuart painted several presidents besides Washington, and in the 1830s, Asher B. Durand was commissioned to paint likenesses of the first seven presidents. Photographer Mathew Brady later noted, "From the first I regarded myself as under obligation to

my country to preserve the faces of its historic men and mothers."[5]

In April 1839, John Quincy Adams wrote, "this is the thirty-fifth time that my likeness has been taken by artists for portrait, miniature, bust, or medal."[6] By 1843, four years after the daguerreotype was patented in Britain, a week after the French government gave the new process to the world, seven photographic portraits of him had been made, all of them, he recorded in his diary on April 2, 1843, "too true to the original."[7] Politicians were willing to sit still so many times because they knew how important public images would be in a democracy and because there were only limited means of mass reproduction and distribution of such images. Three years after Adams totted up his sittings, the public still had little idea of the appearance of its elected officials, but photography was beginning to come to the rescue.

An anonymous writer in 1842 commented on images of John Tyler, who had been William Henry Harrison's vice president and became president on Harrison's death in 1841: "There are probably very few among our readers, who have any idea of the countenance and appearance of a man, who not only fills the most exalted official station in their country, but whose name, for the past year and a half, from the direction of events, has been doubtless more frequently on their lips than that of

(continued from preceding page): and almost tripling by 1909. The president became the national face of the human interest stories craved by a news-hungry public. George Juergens, writing about the Washington press in this period, says that "a republic is supposed to find its symbols of nationhood in inanimate objects like the flag and ritual gestures like the Pledge of Allegiance. Intense publicity elevates the presidency into a living symbol."[3]

TR's globe is bigger than the globes in earlier presidents' offices, as if the world had grown and America's interest and position in it had too. Viewed from a certain angle, this globe showed only North and South America with the oceans around them: an entire face of the earth reserved for the Americas alone.[4] The legs of the globe mirror TR's, and his right hand rests casually and proprietarily on the framing piece that spans its center. This picture announces that America's president is certain of and at ease with world power.

He had every reason to be. He didn't add territory at McKinley's rate, but he thrust the country into international affairs — he was invited to mediate between Japan and Russia in the Russo-Japanese war of 1904 and won the Nobel Peace Prize for doing so[8] — and he firmly established America as a major player on the world stage.

At home he oversaw a major reconstruction of the White House and the building of the West Wing in 1902. He made even more sweeping changes in the presidency and is often referred to as the inventor of the modern presidency, with its strong leadership in setting policies and introducing new legislation. Lewis Gould, McKinley's biographer, would give McKinley that honor,[9] but even if McKinley deserves it, it was TR who dramatized it in word, image, and action, and set a stamp on an idea of the presidency that subsequent presidents would not ignore. His was often called an "imperial presidency," sometimes said admiringly, more often not.

any other individual." The writer added that the portraits of Tyler that were in "very limited circulation" were essentially poor caricatures, but he proceeded to extol the frontispiece of the magazine the reader had in his hands: a steel engraving after a very fine daguerreotype. "A 'counterfeit presentment' of any human countenance, prince or peasant, executed by the unflattering fidelity of this process — a process of art which 'nothing extenuates nor sets down aught in malice,' — needs no endorsement to its accuracy of resemblance."[10]

By the mid-1840s, portraits of political leaders were beginning to be somewhat more widely distributed, though not yet in photographs. Engravings began to appear in the new illustrated periodicals and on people's walls. John Plumbe Jr. produced lithographs from his own daguerreotypes, and Nathaniel Currier and James Merritt Ives copied a couple of those images in lithographs that were carefully hand-colored. This was still a far cry from mass distribution, and in some instances a far cry from the original appearance of either the subject or the photograph.

Photography made the president's face vastly more familiar than it had ever been, but the medium never replaced painting, even of the president (the official presidential portrait is still a painting in the White House collection.) Jimmy Carter was the first president to elevate a photograph as an official presidential portrait; Ansel Adams was the photographer.[11] However, the portrait that hangs at the White House is a painting.

Photography's unprecedented accuracy convinced nineteenth-century viewers that it was the truth incarnate, making it not only an ideal conveyor of information but also an ideal manufacturer of symbols (which news photographs and some celebrity portraits continue to be, even in the digital age). In 1850 Mathew Brady published his *Gallery of Illustrious Americans,* which included images of presidents and presidential hopefuls, senators, and generals; he would later take approximately one-third of the more than one hundred known photographs of Abraham Lincoln. The importance of photographs of the nation's leaders as emblematic, and distinctly American, heroes was underlined when a House of Representatives committee urged the purchase of Brady's collection by the nation in 1871: "It is, as it was, a Photographic Pantheon, in which the votive genius of American art has perpetuated, with the unerring fidelity with which the lens of the camera does

its inimitable work…the very expression, of those in whose achievement in all walks of life the American heart takes pride, and whose memory we endeavor to glorify by whatever means it is in our power to exert."[12] The legislators were convinced; the government bought Brady's archive.

The nineteenth century believed not only in the accuracy but also in the educational and inspirational power of photographic portraits and copies of them. The report of the House of Representatives Joint Committee on the Library of Congress contended that a publicly available collection of these images of "the illustrious dead" would educate the nation, increase its pride, and elevate its taste. The authors of the report quoted "an eminent authority" as saying that a portrait "is superior in real instruction to half a dozen written biographies," and added, "nor can we doubt that the purchase by the Government of this Collection, and its exhibition in the Library, will fail to exert the most salutary influence, kindling the patriotism as well as the artistic taste of the people."[13]

Those who never saw a candidate during a campaign, or an elected official afterward (and who had never so much as dreamed of television), naturally wanted to know what their leaders actually looked like. This was all the more urgent in an era when the so-called sciences of physiognomy and phrenology were highly acclaimed. Both asserted that external attributes — facial features and the bumps of the skull — were certain indicators of a person's personality, aptitudes, and character. Accurate depiction was therefore extremely important, and paintings were often criticized precisely for inaccuracy.

Photography's invention was therefore a godsend, almost a necessity. Photographic accuracy and the image's impressive sense of reality, regarding the man himself, were so strong that "daguerreotype" became synonymous with "lasting impression." In 1848 a writer wrote a friend about Winfield Scott's presidential aspirations: "Somehow — why it is hard to say — Scott, although he has impressed the intellect, never has daguerreotyped himself, like Washington, Jackson, Harrison and Taylor [*sic*] upon the popular heart."[14] Washington, of course, had never been photographed, but he was so crucial a figure that his image was vividly impressed on every mind.

Already by 1840, one year after the invention of the

daguerreotype was announced, cameras had been sufficiently improved to reduce exposure time from twenty minutes to three (and later to a still-long matter of seconds), making portraiture possible. A couple of daguerreotypists almost immediately set themselves the profitable and patriotic task of limning the nation's highest officials.

Edward Anthony was the first photographer to exhibit a gallery of great Americans. He opened a studio in Washington, made daguerreotypes of every member of Congress between 1842 and 1844, and exhibited them in New York City at his National Daguerrean Miniature Gallery until it burned down in 1852.[15] In 1846 John Plumbe Jr. published his *National Plumbeotype Gallery* — handmade lithographic images from his photographs of famous men.

The appeal of photographic portraits of the great went beyond mere curiosity and a vicarious sense of familiarity. Americans believed that daguerreotypes revealed the inner character, even the soul, of the sitter, a belief that remained current even after daguerreotypes were not. Holgrave, the photographer in Nathaniel Hawthorne's *The House of the Seven Gables,* said, "There is a wonderful insight in Heaven's broad and simple sunshine. While we give it credit only for depicting the merest surface, it actually brings out the secret character with a truth that no painter would ever venture upon, even could he detect it."[16] Marcus Aurelius Root, writing about photography in 1864, declared a portrait "worse than worthless if the pictured face does not show the *soul* of the original — that *individuality* or *selfhood,*

which differences *him* from all beings, past, present or future."[17] The soul, the individuality, the selfhood of great Americans was the soul of America itself. Root regarded the portraits of "heroes, saints, and sages" on view in major photographers' studios as souls calling to souls, inspiration for future generations: "The pure, the high, the noble traits beaming from these faces and forms — who shall measure the greatness of their effect on the impressionable minds of those who catch sight of them at every turn?"[18] These photographs, which mainly signify history to us today, were once considered in-depth psychology, calls to emulation, and the key to the essence of America.

The following does not claim to be a history of the men who have occupied the White House or even a history of their appearances; those have been collected elsewhere. It is a selection of portraits that say something about certain presidents, about the way they were regarded and presented, and the ways photography changed that. The portraits here are worth attention for one reason or another, but some men are notably missing (though they may appear in other sections) and some of the pictures cast more light on photographic history than their sitters did on the country's. Both history and memory pick and choose; what seems valuable and memorable today may not seem so next year, yet it will still be present in text books and graven in memory. Photography creates memories and histories too and gives us more data to scan into the mind's computer; let the search engines take us where they will.

John Quincy Adams, daguerreotype copy of an original by Phillip Haas, 1843. Southworth & Hawes.

Photography's unique relationship to memory and history was almost immediately apparent. In 1843 a British writer spoke of the "rapture" we would experience could we but see photographs of Demosthenes or Brutus, Paul or Jesus.[19] Past presidents were obviously important too.

John Quincy Adams, who previously sat for a gaggle of artists over time, sat for several daguerreotypists as well, beginning at least in 1843 when this photograph was taken. It was long thought to be an original by the renowned portrait firm of Southworth & Hawes, but it is a copy made by them after 1850. Daguerreotype portraits were always reversed, and this one is not; it reverses the reversal.[20] It was not uncommon to copy daguerreotypes, even by other photographers, as the images were unique and there was no other way to reproduce them.

Adams was not the only person who disliked all the photographs of himself.[21] Daguerreotype portraits were hardly flattering all the time; a French writer said they looked like "fried whiting glued on a silver plate."[22] The sitter's head was held by a metal head rest to keep the subject still, exposures were so long that people's expressions as well as their postures tended to freeze, and some studios resorted to "eye rests," small pictures on adjustable stands for subjects to focus on so their eyes were less likely to wander.[23] Desirable as realism was, it was not always relished. Ralph Waldo Emerson thought photography and its discontents eminently well suited to a democracy: "Tis certain that the Daguerreotype is the true Republican style of painting. The artist stands aside and lets you paint yourself. If you make an ill head, not he but yourself are responsible, and so people who go Daguerreotyping have a pretty solemn time. They come home confessing and lamenting their sins. A Daguerreotyping Institute is as good as a national Fast."[24]

Andrew Jackson, c. 1844–1845. Mathew Brady's studio. Daguerreotype after an original, possibly by Edward Anthony.

Both Mathew Brady and Edward Anthony traveled to the Hermitage, Andrew Jackson's home in Tennessee, to photograph the ex-president, who was quite ill. (He died in June of 1845.) A trip like this would have entailed a large outlay of time and money; a photographic record of Jackson must have seemed both historic and potentially profitable.[25]

ABOVE RIGHT: William Henry Harrison, daguerreotype, c. 1850. Southworth & Hawes.

William Henry Harrison was the first president ever photographed in office — in 1841, a mere two years after the invention of photography. His picture was taken in the U.S. Capitol on the day of his inauguration, or a day or two after, but this image is not it. The original has disappeared; this photograph may be a copy of an oil painting.

Harrison died of a sudden illness on April 4, 1841, less than a month after his inauguration. The nation was stunned. Though he was sixty-eight years old, the oldest president to date, he had campaigned vigorously. He was the first presidential candidate to make campaign speeches (which even later candidates seldom made) and, somewhat less memorably, the first to have campaign songs.[26] Not only was his death an appallingly abrupt end to his term, but he was also the first president to die in office.

OPPOSITE: James K. Polk and cabinet, daguerreotype, 1846. John Plumbe Jr.

(The seated figure on the left is Attorney General John Y. Mason, next to him is Secretary of War William Marcy, then Polk, and on the right, Secretary of the Treasury Robert J. Walker. Standing on the left is Postmaster General Dave Johnson, and on the right is Secretary of the Navy George Bancroft.)

John Plumbe Jr., an entrepreneurial photographer who set out in 1846 to capture all the public buildings in

Washington, also received permission to make this photograph, the first photograph ever taken inside the White House. (In the early days of photography, adequate light in interiors was a real issue.) This photograph was taken in the State Dining Room, which had once been Jefferson's office. Another photographer had tried to take daguerreotypes of the president and his cabinet in the parlor but failed to get a decent image three times in a row.[27]

Group portraits were particularly difficult and were a gauge of a photographer's skill. Mathew Brady, when he wanted to put important figures

together who weren't all in the same place, sometimes made composite portraits from more than one negative, using a paste pot and retouching the results, but the process was time-consuming and not commercially successful.[28]

In February of 1849, Brady got permission to convert the State Dining Room into a temporary photographic studio.[29] This and the fact that there are several pictures of Polk in office indicate that the president was conscious of the service that photography would perform for history and valued it as a means of establishing his place in his own time and after. Polk vastly expanded America's territory in the treaty ending the Mexican war, acquiring both Texas and California, as well as other territories in the Southwest. Later he threatened war over land claims in the Northwest Territory but acquired those lands by treaty instead. The idea of Manifest Destiny became a reality in Polk's administration; he expanded America by a third and assured that there would be cities of major importance on both the Atlantic and the Pacific.

The serious expressions and dignified postures of the nation's leading officials follow a tradition established by painters around the time of the American Revolution and later adopted by photographers — who, in fact, had little choice when the medium was young, for long exposures effectively dictated composed and unsmiling faces.

Apparently Mrs. Polk arranged for this photograph after a cabinet breakfast in order to trick Mason, who had previously refused to be photographed, into having his picture taken, and she locked the sitters in.[30] Indeed, the attorney general looks skeptical: seated slightly apart and turned at a bit of an angle with his head cocked — he must have refused to have it placed in the customary head clamp — he disrupts the rigid frontal formality of official portraiture that the other sitters carefully maintain.

Plumbe had already made a picture of the president within weeks of his inauguration. On February 22, 1845, he advertised "beautiful gold breast pins, containing likenesses of President Polk, furnished to order."[31]

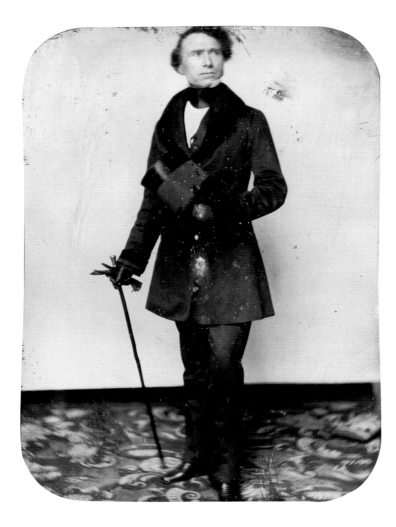

although he was but five feet nine inches high. . . . his deportment was graceful and authoritative."[32] The gloves, hat, cane, and fitted redingote (fashionable outerwear at the time) with fur trim have a very different flavor from the sober suits and vests worn by Polk and his cabinet less than ten years earlier, or Lincoln and his appointees less than ten years later. His pose, too, with his feet nearly in a ballet dancer's third position, departs from the kind of foursquare formality of earlier political photographs or the remnants of eighteenth-century grandeur in earlier paintings like Gilbert Stuart's of George Washington. Men's fashions change, if not so rapidly as women's; so do customs and expectations. In the 1850s, there was in America a new acceptance of a degree of theatricality that had not seemed appropriate to a revolutionary entity laboring to be born.

OPPOSITE: Standing portrait of Abraham Lincoln, 1860. Mathew Brady.

When Lincoln came east from Illinois in 1860 to seek the Republican nomination, he was largely unknown outside his native state. His backers determined to change that, and they had a new instrument of publicity at hand: photography. Two major technological developments — the wet collodion negative process and the *carte de visite* — had vastly increased its reach. Though the Englishman William Henry Fox Talbot had invented a negative process in England even before Daguerre's process was announced to the public, the unique, nonreproducible daguerreotype edged out negative photography for more than a decade. Then in 1851, Frederick Scott Archer, another Englishman, patented a new kind of negative-based photography, the wet collodion process, which revolutionized the medium and turned it into the reproducible form that held the field for the next 150 years. Wet collodion, though an arduous technique, forced daguerreotype studios to close their doors, for it could produce multiple and exact copies of images, which answered, or created, a public craving. Photography became an emblem of the industrial revolution: the camera as another machine capable of the mass production of identical objects.

The second development, the carte de visite, was the invention of the Frenchman A. A. E. Disdéri, who in 1854 patented the process of capturing four, eight, or sometimes more small images on a single plate. The photogra-

Franklin Pierce, c. 1854. Photographer unknown.

Franklin Pierce was forty-seven when elected, the youngest president to date. When Pierce was inaugurated, dissension over slavery was already roiling the country. He tried to keep the nation calm but only succeeded in disrupting it further with his expansionist policies.

The feet of a studio's plain background panel are visible in this picture. Slight variations in Pierce's posture, doubtless guided by the photographer, could practically be a lesson in how to impart movement to a static figure; subtle leftward diagonals countered by rightward movements of the body and clothing, ending with the turn of his head and a gaze toward the left.

In this picture, Pierce seems more like a gentleman fashion plate than a leader of the people. Benjamin Perley Poore in 1886 remarked that "the personal appearance of General Pierce was dignified and winning, if not imposing,

pher developed them and cut them apart. Cartes were the size of visiting cards and were originally used by aristocrats who left their names, newly accompanied by their faces, on silver trays in elegant foyers. The allure of inexpensive images small enough to tuck in a pocket, send through the mail, or collect in albums soon made them the rage among all classes in Europe and America, and photographic images rained down upon the world.

Brady's portrait of the beardless Lincoln was reproduced in large numbers as a carte. The man from Illinois had a reputation in the East as a gangly (he was six feet four), awkward, ugly backwoods lawyer, hardly the ideal prescription for a presidential candidate. Brady posed him carefully, smoothed his ill-fitting suit, pulled up his collar to make his neck look a more reasonable length, and retouched his countenance to make it less swarthy. What he presented was a serious, dignified man, not ugly but plain and respectable, thoughtful, with an intelligent face — in short, presidential timber. The photograph was widely reproduced (including an engraved copy on the cover of *Harper's Weekly*) and in carte form was printed in the tens of thousands. It was then spread even further in lithographic copies by Currier and Ives.

Lincoln the candidate granted interviews to reporters but did not campaign publicly — it was considered bad form — so not many people actually saw him, at a time when it was important to be seen.[33] Suddenly thousands upon thousands could recognize his features, an unprecedented situation. In a democracy, the appearance of a potential leader matters greatly to everyone entitled to vote. This was true in the mid-nineteenth century, when people believed that faces perfectly mirrored souls, and even more so today, when mass visual media exaggerate the value of good looks and onstage performance.

Lincoln's photographed face and his running mate's were reproduced in tintypes too, another recent photographic technique, and were made into the first campaign buttons, as well as into brooches for ladies and tiepins for gents. Photography was off and running, creating celebrities as it went. In England, just a couple of years before Brady's photograph made Lincoln's face so familiar, the poet Alfred, Lord Tennyson was photographed so often that strangers recognized him and stopped him on the streets, which he bitterly resented — although sales of his works increased dramatically.[34]

Years later Brady reported that Lincoln had told him

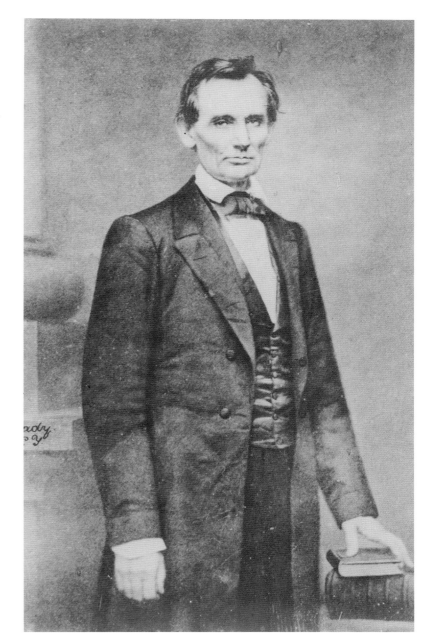

that his Cooper Union speech (in which he came out against allowing Kansas to become a slave state but advocated leaving existing slave states undisturbed) and Brady's photograph had won him the election. The speech gave Lincoln the dimensions of a president, and Brady's photograph, suddenly in great demand, gave him the appearance of one. Flattery or not, Lincoln's remark to Brady had some basis in fact: this was the first photograph ever to influence an election, and it set in motion a change in elections everywhere, as well as a shift to a world enthralled by and enmeshed in photographic imagery.[35]

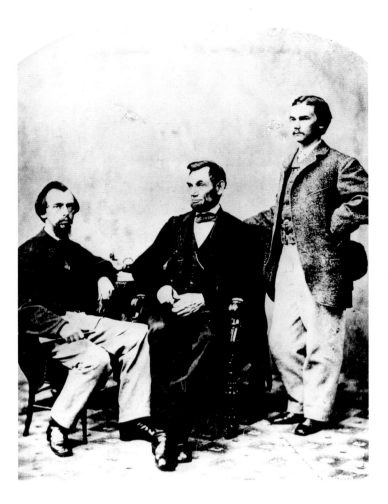

Abraham Lincoln with his secretaries, John G. Nicolay (left) and John Hay (right), August 9, 1863. Alexander Gardner.

Once he became president, Lincoln, by now with a beard, was photographed so often that, by the time of his death, his face and figure were recognized all over the world. He understood a major social change almost from the moment of its inception: the new importance and power of the photographic image in the public arena — a lesson he could have picked up from his experience with Brady's first photograph. As president he took an active role in constructing his own presentation. Here, flanked by his two secretaries, he puts forward the image of a leader prepared to take on heavy responsibilities with the aid of serious assistants. The secretaries wear fashionable baggy pants, but Lincoln always wore a plain black suit as an instantly recognizable sign that he was an ordinary citizen of a people's republic.[36]

Lincoln with his secretaries, painted version, 1863. Alexander Gardner.

This was not altered — many ways existed to change a photograph before digitization. John Nicolay thought the background of the picture was too plain, so he had an artist paint in the president's room from the White House.[37]

Abraham Lincoln in his White House office, 1864.
Anthony Berger.

Anthony Berger was one of the operatives in Brady's Washington studio. This picture, set in Lincoln's office, is one of only two photographs taken of Lincoln in the White House.[38] No self-respecting nineteenth-century photographer would have composed a photograph with a cutoff pair of legs on the side. The picture was a study for a painting and was never intended to be seen by anyone but the artist who had commissioned it.

In 1864 the painter Francis B. Carpenter asked Lincoln for permission to set up a studio in the State Dining Room in the White House so he could paint a picture of the reading of the Emancipation Proclamation, the fateful document that Lincoln signed on January 1, 1863. It was relatively common at the time for painters to work from photographs to ensure accuracy, but they generally did not admit to relying on so inferior an art. Despite the photograph, Carpenter made a number of changes in the painting.

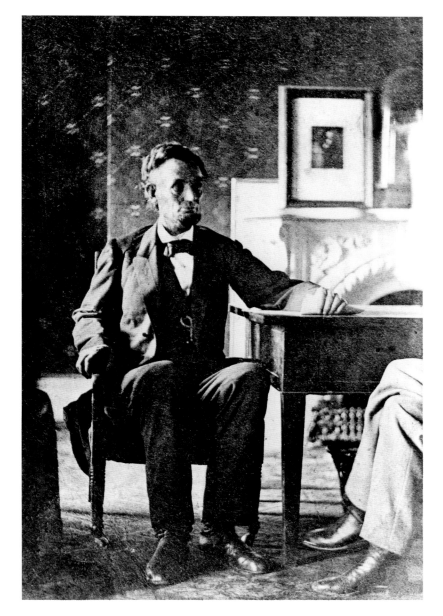

Reading the Emancipation Proclamation, oil painting, 1864.
Francis B. Carpenter.

That extra pair of legs in the photograph above is given to Secretary of State William H. Seward, whom the painter greatly admired and put in an important position in his painting.[39] The books scattered about on the floor and table are evidence that the Proclamation has been carefully researched for precedent and justification. The finished painting was displayed in the East Room, and Lincoln sat before it. The painting has been in the U.S. Senate collection since the nineteenth century.[40]

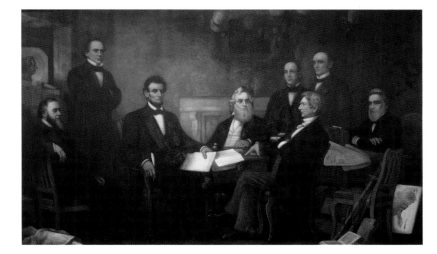

Abraham Lincoln, April 9, 1865. Alexander Gardner.

The presidency is a taxing job at best, and Lincoln's administration, dealing with the only civil war the nation has ever known and the real possibility that the republic might split apart, took an enormous toll on him personally. The high cost is visible in this portrait, taken five days before he was assassinated.

Mr. Berthrong painting a portrait of Benjamin Harrison, 1881. Photographer unknown.

This photograph of a painter and his portrait shows Henry W. "Harry" Berthrong — probably in Indiana, the president's home state — at work on a mammoth portrait of Benjamin Harrison — 25 by 15 feet, to be exact.[41] Clearly, Harrison loomed large in Indiana, and Mr. Berthrong needed an outsize studio for an outsize subject. Harrison's face should have been well known by election time; Republicans had produced 300,000 lithograph pictures of him.[42]

Benjamin Harrison, the grandson of William Henry Harrison, who had died in office barely a month after his inauguration, had time to do somewhat more than his grandfather. He signed the first bill to regulate trusts (though he generally supported big business and promoted high tariffs) and sponsored the first Pan-American Congress.

could not save him from an assassin's bullet. The loyal patriotism of all of America's children and the continuity of ideals across generations are implied even in the amusing juxtaposition of this overly serious little boy and a serious chief executive.

Many American educators and parents thought that a military style of discipline, including wearing uniforms, would benefit the character of boys and young men.[43] This boy took his duties to heart, at least for the photograph.

William McKinley, c. 1897. Photographer unknown.

The lovely light in this image skips gracefully from McKinley's left hand and shining cuff to his watch chain and up to his stark white shirt and spotlighted face. This is not a candid shot of McKinley writing, but a posed picture of a president pretending he is working. The handheld and so-called "detective" cameras of the 1880s — the Kodak, loaded with roll film, came on the market in 1888 — could stop motion and take such pictures, but not very successfully indoors. The explicit subject of this photograph is McKinley, but its implicit subject is a less common topic:

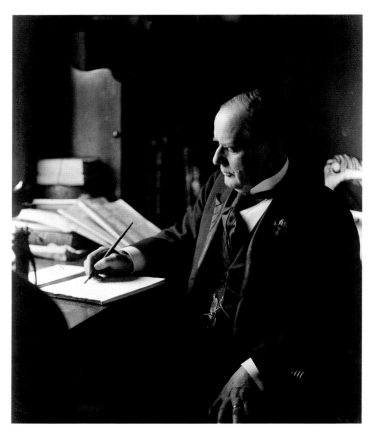

"McKinley's bodyguard," c. 1901. Photographer unknown.

This photograph makes clear an abiding fact: that the image of a person retains much of the force of the person him- or herself and acts as a kind of alter ego. Rulers, knowing this for centuries, had their portraits placed in courtrooms and in official offices in their colonies as signs of true authority. The rest of us know this when we thrill to a lover's picture or weep over an image of someone dear and dead — especially photographs, which so often seem to re-present the person exactly.

The double conceit of "McKinley's Bodyguard" is that a little boy can perform an adult's role and guard the image of the president as if it were the president himself. McKinley needed guarding, but even his grown-up bodyguards

the presidency, the high office that demands hard work, close attention, and intelligence.

McKinley, in fact, was a well-informed man but had a reputation as a president who did not read,[44] conceivably one reason he may have agreed to sit for this picture.

William Howard Taft and Theodore Roosevelt, before March 5, 1909. Photographer unknown.

Taft was Roosevelt's secretary of war and won the Republican presidential nomination in 1908 with TR's enthusiastic support. Roosevelt soon discovered that his protégé was not his clone and that — despite Taft's introduction of budgetary controls, an eight-hour day for government employees, and a campaign-spending disclosure bill, despite his active trust-busting, his efforts for conservation, and his strengthening of the Interstate Commerce Commission — he was overly cautious and prone to political mistakes. TR left the Republican Party in 1912 to run against Taft on the Bull Moose ticket; this split the Republican vote and gave Woodrow Wilson an easy victory.

In this photograph of the two men outside the White House, Roosevelt is bulking up with his usual gesture of the left arm bent outward at the elbow. Taft was a man of excessively bulky proportions to begin with. The camera has performed one of its favorite tricks here, sucking up

images of whatever is in its sights, no matter how unimportant or irrelevant or intrusive it may be. What looks like a picture of two men is actually a picture of three (and perhaps a silhouette of another). The photographer didn't mean to record the man staring out through the glass and doubtless thought he wouldn't show up, but the camera thought differently.

Presidential candidate Warren G. Harding sits for his portrait in the studio of sculptor Helen Osborne, October 14, 1920. Photographer unknown.

In 1920, when the Republican Party nominated Warren Harding for president, a newspaper editor declared that America was "tired of issues, sick at heart of ideals, and weary of being noble." The years of progressive policies and war had evidently taken a toll. Harding avoided all of the above. Both before and after his nomination, he spoke of a return to "normalcy," emphasized harmony, conciliation, and serenity, and dispensed a staple "America First" message.[45] He must have told Americans what they wanted to hear: with Calvin Coolidge as his running mate, Harding beat Ohio governor James M. Cox and Franklin Delano Roosevelt, the thirty-eight-year-old assistant secretary of the navy, 60 percent to 34 percent.[46]

By 1920 it was urgent to get the candidate's face before the voters by every possible means, including sculpture. Photosculpture was invented in 1859 as a cheaper, more accurate way to achieve a likeness than hand modeling or chiseling. Multiple photographs of the subject were taken, then outlines of each view were cut by machine into a rotating pillar of clay to produce a three-dimensional portrait. An artist touched up the result before it was fired. The process was complex and expensive, but nothing was too good for a presidential candidate, for whom recognition was an essential step on the road to veneration. Candidates who patiently sat for portraits were rehearsing one of the requirements for a president.[47]

Calvin Coolidge in Indian headdress, c. 1927. Underwood & Underwood.

Not many United States presidents have posed in a business suit and a magnificent feathered headdress. Calvin Coolidge posed while wearing native dress with members of the Sioux Indian Republican Club of the Rosebud Reservation, and in 1927 the Sioux made him a chief. He is surely the only Sioux chief who has ever been president of the United States.

Franklin Delano Roosevelt, a portrait of the president composed of 20,000 officers and men, November 13, 1942.

Large numbers of military personnel were proud to be an essential part of the Roosevelt administration (and for the camera, of Roosevelt himself) during the Second World War.

Franklin Delano Roosevelt on a commemorative stamp, 1982. United States Postal Service.

Portraits of presidents on stamps, coins, and paper money keep them in the public eye long after they die. The first two postage stamps the U.S. Post Office put out, in 1847, had pictures of George Washington and Benjamin Franklin (the first postmaster general). Until 1869 American stamps featured presidents alone, with Franklin the only exception. When the Post Office switched to non-presidential images in 1869, the stamps were so unpopular that the next year, presidents and Franklin moved back onto envelopes.

U.S. postal guidelines have it that most (extra) ordinary mortals cannot appear on stamps earlier than five years after their death, although stamps commemorating deceased presidents may be issued on the first birth anniversary that follows their death. This rule was broken for FDR; four stamps with his likeness appeared during the seven months after he died. He has continued to be honored on stamps since then — in 1966, 1982 (the one hundredth anniversary of his birth), and 1998. Putting FDR's likeness on stamps is singularly appropriate: he was an avid stamp collector from the age of eight. He carried his stamp collection with him everywhere, to international meetings as well as vacations. During the Depression, he frequently suggested particular subjects for stamps that he thought would bolster public morale, and even designed some himself.[48]

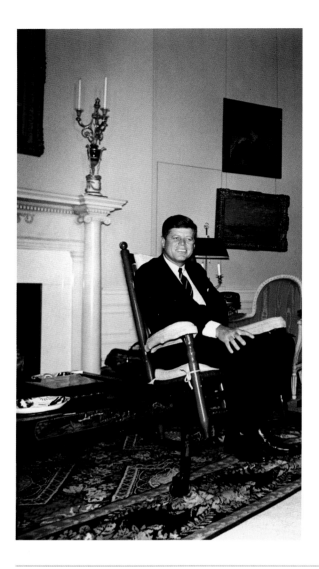

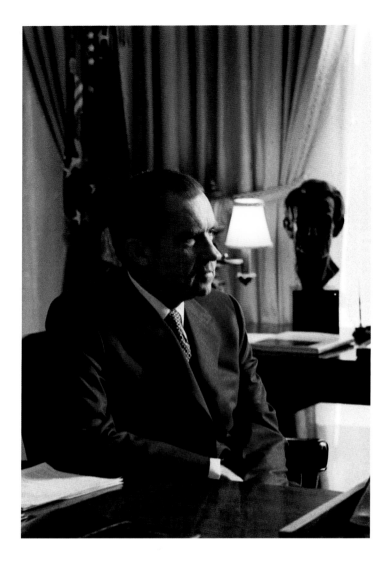

President Kennedy in the Yellow Oval Room, March 19, 1962. Robert Knudsen.

John F. Kennedy, an extremely image-conscious president, was in effect an image all by himself. Elected at age forty-three, he was handsome (and, according to a poll of female college students, had greater sex appeal than Rock Hudson[49]), vigorous, quick on his feet, and had both a glamorous wife and darling young children. His rocking chair rapidly became a symbol of his presidency — he even arranged to sit in it during one of his nationally televised addresses — and it conferred an aura of casualness and informality that balanced a suggestion of majesty in his administration.

The chair was not for image alone. His doctor had advised it to ease the bad back that had plagued Kennedy since he was injured in World War II, and it turned out to

be advantageous publicity as well. The president liked it so much he took it with him when traveling internationally on Air Force One, bought one for Camp David and one for each of the three Kennedy estates, and gave others to friends and heads of state.[50]

President Nixon seated in the Oval Office, September 25, 1970. Official presidential portrait, Oliver F. Atkins.

This is a surprisingly dramatic picture for an official portrait, a photograph that strives as much for artistic effect and mood as for traditional dignity. The photographer invokes a strong play of light and deep shadows rather than presenting a sunny image of the man smiling at his desk or wearing the face he dons for important occasions. Whether the photographer meant it or not, hindsight suggests that the picture's darkness is itself a comment on Nixon's

character. Clearly Nixon did not see it that way; after all, he chose the image.

At the moment this picture was taken, the world was busy, as it has a habit of being, providing occasions for a president to be moody. Nixon's overriding problem was to find a way to end the Vietnam War without losing face entirely. Student unrest and violent demonstrations were a continuing issue. Then, too, Salvadore Allende, a Marxist-Socialist, was likely to be confirmed the president of Chile, setting off alarm bells in an administration that was already nervous about Communism in Latin America.

Intelligence had recently revealed that the Soviets were expanding their base support facility in Cuba. The administration agreed to keep this quiet; the president wanted to avoid even the hint of another Cuban crisis like the one of 1962 that had nearly plunged the world into nuclear warfare. But on the very day this photograph was taken, C. L. Sulzberger warned in the *New York Times* of unconfirmed reports that a Soviet submarine base was being built on the island. To dampen fears of a crisis situation, Nixon and other officials left for Europe the next day as planned.[51]

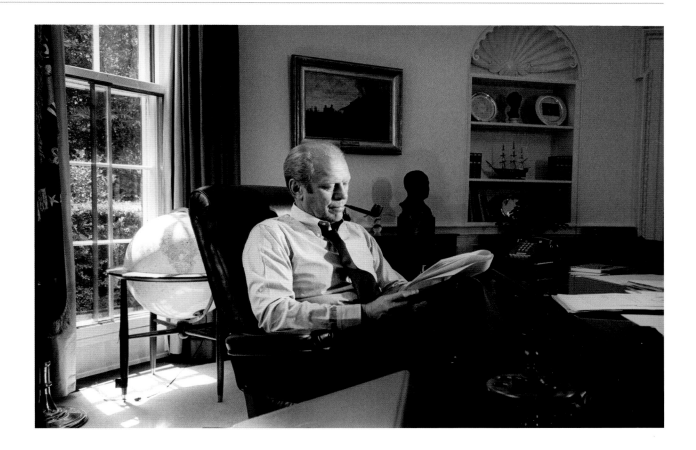

President Ford at work in the Oval Office, August 12, 1976. Karl Schumacher.

Gerald Ford, who had been appointed vice president by Richard Nixon when Spiro Agnew resigned following charges of tax evasion, became president himself on August 9, 1974, after Nixon resigned in the wake of Watergate. Ford inherited widespread distrust of government, an energy crisis, a severe economic decline, and an aggressively oppositional Congress. His press secretary, Ron Nessen, later said, "Ford's role in history was to clean up other people's messes."[52] He immediately impressed a cynical nation by being what he was: an ordinary man — in his speech after his inauguration, he said, "I am a Ford, not a Lincoln"[53] — who was honest, forthright, and believed in open and transparent government. Less than a month after his accession, *Time* wrote that "Washington and the nation seemed satisfied to rejoice in such simplicities as a Chief Executive who worked in his shirtsleeves...."[54]

President Johnson in the Cabinet Room, December 1, 1967. Yoichi Okamoto.

Lyndon Johnson is caught here in a pensive moment. He had a lot to think about. Herbert Hoover called the presidency "a compound hell,"[55] and LBJ was at the edge of a black hole in December of 1967. He had managed to wrestle a civil rights bill and certain of his Great Society programs through Congress, but the economy was troubled and could not support his grand initiatives for social reform and reduction of poverty while a costly war was being waged. There had been 116 anti-Vietnam demonstrations outside the White House in '67, and by year's end, only 28 percent of Americans (including some generals) approved of the way the president was handling the war — and a majority of those polled thought the whole thing was a mistake.[56] On January 30, the Tet Offensive in Vietnam propelled Vietcong troops into Saigon, the South Vietnamese capital. They occupied the U.S. Embassy there for a short time and hardened public opinion in America against the war. Two months after Tet, President Johnson announced he would not run for a second term.

George Bush campaigns in Omaha, Nebraska, October 28, 1988. David Valdez.

George H. W. Bush opposed Ronald Reagan in the Republican primary of 1980 and lost; Reagan then selected him as his vice presidential running mate, a slate that won that election and the 1984 election as well. Bush ran for president in 1988 with Reagan's blessing; he chose Indiana senator Dan Quayle as his running mate. The economy was good, America was not at war anywhere in the world, and Reagan's popularity gave Bush a certain luster.

Images were vital to the campaign. His Democratic opponent, Massachusetts governor Michael Dukakis, ran a lax campaign. Criticized for being soft on defense, he donned a helmet and sat in a tank turret to prove his commander in chief credentials, but he ended up looking somewhat ridiculous. The Bush organization used that image often, and it stuck in people's minds, a classic instance of a publicity maneuver backfiring. As governor, Dukakis had granted weekend

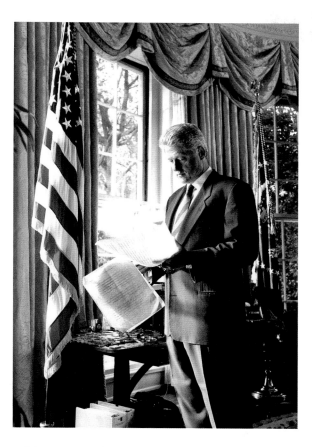

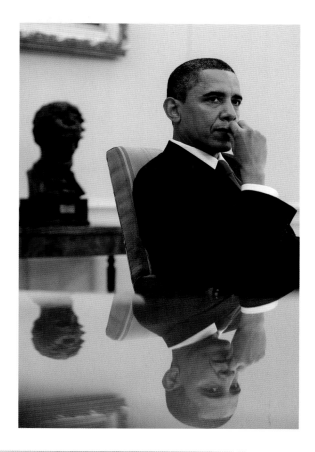

furloughs to felons, one of whom, William "Willie" Horton, failed to return and committed rape and assault before being captured. The Bush campaign repeatedly told this story and ran a television ad with supposed criminals going in and out of a revolving door, further eroding Dukakis's support.[57]

Bush lost the 1992 election to Bill Clinton, but his son, George W. Bush, won the presidency in 2000 and again in 2004.

President Clinton reading in the Oval Office, 1995. Ralph Alswang.

Presidents have always been expected to be readers — in the nineteenth century, being depicted as a reader was a sign of education and intelligence — and the number of documents that cross their desk has never shown signs of diminishing. Clinton was a particularly avid reader; he once said, "I was reading little books when I was three."[58] This image makes the most of sunlight illuminating the president's youthful good looks and innate casualness even when wearing a suit, while also emphasizing the serious nature of his job.

Barack Obama, January 25, 2010. Peter Souza.

A picture of thoughtfulness, doubled on the vertical axis like a royal in a deck of cards. The bust of Lincoln in the background, slightly out of focus but still quite recognizable, puts a sharp focus on the association of the first black president, Barack Obama, with the president who freed the slaves.

The White House pays homage to past presidents, and each new one sits for an official portrait that will be left there. Lincoln is more honored than most. There is the Lincoln Bedroom, which President Truman proposed setting up in 1945 in the space that Lincoln used as his office and Cabinet Room. The Lincoln Bedroom is decorated in the style of the 1860s and has on the wall an engraved copy of Francis Bicknell Carpenter's painting *The First Reading of the Emancipation Proclamation of President Lincoln*. There is usually more than one portrait of Lincoln on display in the house, and the White House has collected numerous documents and objects relating to him, including a campaign button from his first election — the first such button ever to incorporate a photograph of the candidate.[59]

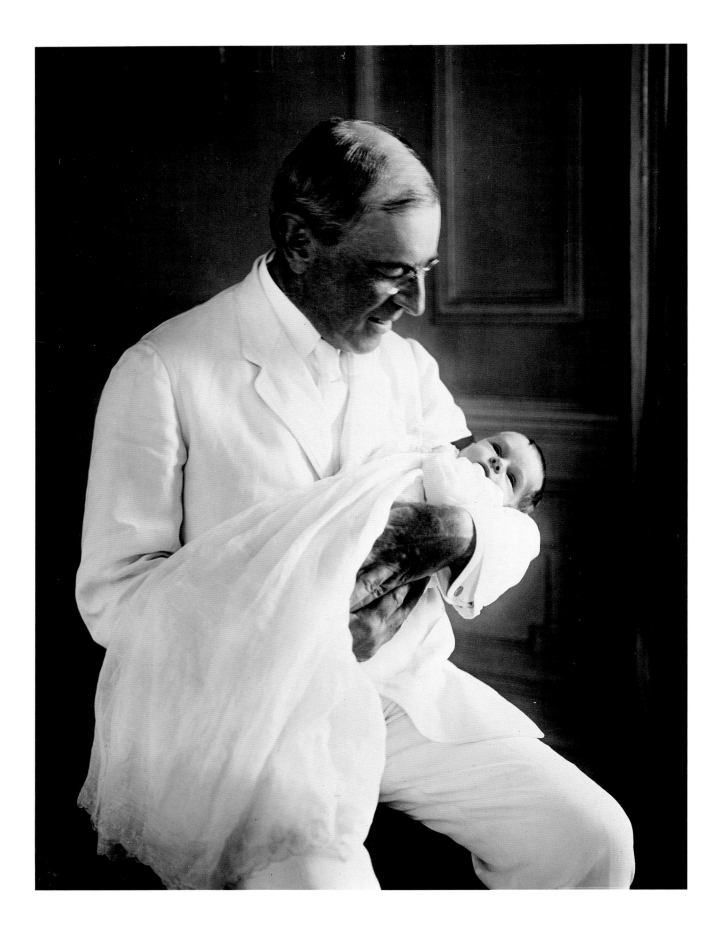

CHAPTER 4: PRESIDENTS' FAMILIES

B Y THE MIDDLE of the nineteenth century, the role of family changed among many sectors of the population as people moved to the city, a merchant class was firmly established, men worked out of the house, and young children were no longer expected to contribute to the household economy. Family became central to urban bourgeois existence in a new way — as a bulwark against the crowded, impersonal, competitive, rapidly changing, and sometimes threatening city. Owners of private houses often built fences facing the street, literal and metaphoric safeguards of their refuge and their privacy.

Kings and queens, though they had traditionally been portrayed as powerful, authoritative figures existing in a rarefied atmosphere, now began to be presented as family men and women with whom the new (and potentially troublesome) bourgeoisie could identify. Queen Victoria, for instance, was portrayed with her children in *carte de visite* photographs, and her children also had portraits taken in this small, inexpensive format that filled so many albums on so many parlor tables.

Presumably, the evidence that leaders had families like everyone else promoted a sense of identification and familiarity among their subjects that was not, in fact, realistic but is one of the side effects of photography. Celebrity photos (and interviews and gossip columns) take power from curiosity and give a faint, vicarious sense of acquaintance. Photography and expanding human interest reports in widely distributed journals supported a relatively new view of a bond between rulers and ruled, although little had actually changed.

The American democracy had a better claim on such a sense of relationship, and photographs and prints of presidents with their families, or of family members alone, accompanied the burgeoning interest in the person of the chief executive. The image of a president as a *pater familias* signified that he was a citizen like us, with the same ideals — a husband and father, not just an authority, not just a cipher, but truly representative of us. The chief executive's family was the chief family of the nation, a model, a kind of national property, a way for both proponents and opponents to judge the president's character, and was, taken all in all, a fascinating topic.

Interest in the president's wife and his children has always been and still remains high. Lincoln was never photographed with his family, but several nonphotographic prints of him with his wife and children were widely distributed after his death. A world that had been so violently torn apart tended to view Lincoln as a stabilizing force and to find some reassurance in images of him in the heart of his family. The success of these prints inaugurated a run of prints of presidents and other important men with their families. Such images were meant to inspire by their example, for settled domesticity was a major component of American self-identification and indeed of patriotism itself.[1] Family life was so central to the concept of a worthy life that President Grover Cleveland, who married while in the White House, once wrote in a letter, "I fully agree with you in your estimate of the infinite distance between the joys and comforts of a happy home and the transient gratification that in the best conditions wait upon the honors of official place."[2]

In the early years of the republic, presidents' wives

OPPOSITE: Woodrow Wilson holding Ellen McAdoo, his first granddaughter, 1915. Clinedinst Photo Studio, Washington, D.C.

White is traditionally a sign of purity (in Western countries), and this image of the president and his first grandchild is strongly reminiscent of a Madonna and child. The baby was the daughter of Eleanor "Nell" Wilson McAdoo and William Gibbs McAdoo, secretary of the treasury, whom Nell married during her father's first term. The child was named for Nell's mother, Wilson's first wife, who died in 1914. The president was Ellen's godfather.

were not always publicly visible, and outside of the capital, not always mentioned in the press. The president was the news; his wife was essentially news about him. It was not even clear what she should be called. At first there had been no special term for presidents' wives; they were Martha (or, briefly, Lady) Washington or Dolley or Mrs. Madison, like other women, and on rare occasions, Mrs. President or even Presidentress. But sometime around 1860, the term "first lady" found its way into print and stuck. Not every wife of a president has been happy with the appellation, which still sounds a faint ring of aristocracy, and Jacqueline Kennedy allegedly said, "The one thing I do not want to be called is first lady. It sounds like a saddle horse."[3]

A few wives were simply unseen. A president could not easily hide himself from view — though even presidents' images were not widely available in daguerreotypes (which, like paintings, were unique), at least not until lithographs or engraved copies of their portraits were made — but their wives' faces were not an urgent matter to voters. Besides, women were seldom public figures. It will be no surprise that Mathew Brady's *Gallery of Illustrious Americans* consisted entirely of men. Helen "Nellie" Taft was the first to ride in her husband's inaugural parade, declare her support for women's suffrage, and earn public credit for successfully lobbying for federal legislation.

Letitia Tyler, President John Tyler's first wife, was hardly even seen in Washington. She was crippled by a stroke in 1839, the year of photography's invention, when portraits were barely possible for the camera. When her husband became president in 1841 and until her death the following year, she did not perform any of the official honors and only once appeared at a social occasion.[4] Zachary Taylor's wife was invisible for other reasons. He had been a hero of the Mexican-American War, and it was reported that Margaret Taylor vowed that if he came home safely, she would never go into society again. She kept her vow. In the sixteen months of her husband's presidency (which was cut short by his death), she did not participate in a single formal White House function, leaving the duties of hostess to her youngest daughter.[5] Nor did she ever sit for a painter or photographer. When the president died suddenly, the engravers who made their livings picturing the news were in a quandary: what did Mrs. Taylor look like? A resourceful artist found a solution in the deathbed scene: he produced a popular engraving that showed the lady in a cap, covering her tearful face with a handkerchief.[6]

Most presidents' wives were not so averse to their likeness or publicity. In 1840, four years before Julia Gardiner married President John Tyler, she was pictured in an advertisement, a rather shocking bit of promotion for a well-brought-up young woman. As first lady, she was photographed and had her image publicly distributed in an engraving. A daguerreotype of Abigail Fillmore, Millard's wife, reportedly sold well in copy daguerreotypes. And in 1856, a wife was inserted into a campaign, though not via an image: John Fremont, the Republican candidate, had buttons made up that said, "Oh Jessie!" — a colloquial expression for "Oh hell!" and the name of Fremont's wife.[7]

It would not be long before photography virtually took over and there was no hiding from the camera. Not that most women wished to. But compare the willed invisibility of Margaret Taylor in 1850 to the broad visibility of Lucy Hayes, wife of President Rutherford B. Hayes, in 1881: "Mrs. Hayes' personal appearance has been so often reproduced through photograph and pen-pictures that it is almost superfluous to give any lengthy description."[8] Lucy Hayes evidently enjoyed being photographed, and opportunities were multiplying. Even Ida McKinley, who was ill throughout her husband's tenure, posed often before a camera.

Some first ladies have been commemorated even more publicly and visibly than in photographs. A statue of Mary Todd Lincoln stands in Racine, Wisconsin; a statue of Eleanor Roosevelt in New York City; and one of Pat Nixon outside a senior citizen center in Cerritos, California. In 2006 a statue of Julia Dent Grant was put up next to the Grant Home State Historic Site in Galena, Illinois; some thought the sculpture looked like Mrs. Butterworth, the lady-shaped bottle of pancake syrup that goes by that name.[9]

Recent scholarship has begun to explore more thoroughly the political roles that first ladies played in their husbands' administrations. Many have supported causes that mattered to them personally. Although in the early years presidents' wives were primarily fashion and social leaders, Abigail Adams so closely advised John that some sarcastically referred to her, rather than addressing her, as "Mrs. President." Dolley Madison supported certain causes: she led an effort to help orphans and advocated equal access for women in

public places. Abigail Fillmore, wife of President Millard Fillmore, acted as his political adviser. Mary Lincoln made efforts on behalf of freed slaves during her husband's administration, though that was not so widely known or credited at the time. Caroline Harrison, wife of President Benjamin Harrison, refused to lend support to Johns Hopkins Hospital's plans for a new wing until they agreed to admit women.

Some first ladies were actively involved in politics. Helen Taft, in the White House from 1909 to 1913, endorsed woman suffrage and lobbied for federal legislation to improve working conditions for laborers.[10] The most active first lady was Eleanor Roosevelt, who fought for her husband's New Deal and her own proposals for the rights of women and for civil rights. Most notably, when the Daughters of the American Revolution denied Marian Anderson, the African-American singer, permission to perform in Constitution Hall in Washington, Mrs. Roosevelt worked quietly behind the scenes to help arrange for her to sing at the Lincoln Memorial.

Bess Truman and Mamie Eisenhower were less public and less activist. Though President Truman referred to his wife as "the boss" when she appeared with him during his presidential campaign, she did not like being in the public eye, did not give speeches or private interviews, and did not hold regular press conferences. Mrs. Eisenhower, who had been a military wife for most of her marriage, stuck to a standard self-presentation as a devoted wife, and held only one press conference during her husband's administration.[11]

In the 1960s, as television took over and the women's movement began to build, first ladies moved toward actively identifying themselves with signature causes. Jackie Kennedy most publicly redecorated the White House, intending to restore its historic character, and in a more understated manner, supported the growing civil rights movement by creating a racially integrated kindergarten in the White House for her daughter, her son, and a few other children and allowing public release of photographs of the group. Lady Bird Johnson campaigned for environmental protection and beautification and is largely responsible for the removal of billboards from federal highways. Betty Ford supported women's causes, including the Supreme Court's *Roe v. Wade* decision giving women the legal right to abortion and the Equal Rights Amendment. Rosalynn Carter testified before Congress in support of aid for mental

health. Nancy Reagan ran a campaign with the slogan "Just Say No" in an attempt to eradicate drug and alcohol usage in school-age children. Barbara Bush devoted herself to adult literacy, Hillary Clinton to health-care reform, and Laura Bush worked to encourage children to read and promoted literacy around the world. If the president has a bully pulpit, many presidents' wives have discovered they too have (or can create) a highly persuasive position that goes beyond their influence on their husbands.

The White House had become more and more central to the news well before the 1890s, when the booming illustrated press finally had the option of reproducing photographs in reasonably large numbers. Presidents often tried to keep the press from their families but seldom succeeded. Woodrow Wilson, who had a generally chilly relationship with reporters, was a Southerner who believed in protecting his ladies. Once, in Bermuda shortly after winning election, he biked to a local market with his daughter Jessie. When they returned, both of them hot and disheveled, they found the press camped out on the front doorstep. Wilson walked over. "Gentlemen," he said, "you can photograph me to your heart's content. I don't care how I look. But I request you not to photograph my daughter. You know how women feel about such things, and I myself would rather not have the ladies of my family made to—" At that moment, a photographer snapped a picture of Jessie. Wilson, eyes blazing, strode over to the photographer, threatened to give him a thrashing, and abruptly strode away.[12]

He was not the last president to threaten the press. Once, when Harry S. Truman's daughter, Margaret, was on a concert tour and her parents were in the audience, the *Washington Post* critic Paul Hume wrote a negative review. Truman informed the man in no uncertain terms, "Some day I hope to meet you. When that happens you'll need a new nose, a lot of beefsteak for black eyes, and perhaps a supporter below!"[13] The press gave this outburst the kind of coverage that would suit a declaration of war, and it suited the public, which responded warmly to the president's care for his daughter.

Except for Buchanan, the nation's presidents have all been married men. Cleveland came to the White House a bachelor but left a married man; a few others, like Andrew Jackson, came as widowers. Many first executives came with their children, and many children were born in the White House. The public generally took

the first children to their hearts. Babies were universally beloved. When Cleveland married and then had a daughter named Ruth, the nation was as excited as a bursting firecracker. Baby Ruth could safely claim to be the only presidential child that ever had a candy bar named after her. A few presidential children have been obstreperous, which only made them more interesting, if not necessarily to their fathers. Ronald Reagan's daughter Maureen once said, "I will feel equality has arrived when we can elect to office women who are as unqualified as some of the men who are already there." Although they were close, Reagan refused to endorse her when she ran for a seat in the Senate in 1982.[14]

The status of children changed over the early years of the republic. Many died early, which remained a personal tragedy but did not have the same financial consequences as before. An urban society (at least the bourgeois contingent) was no longer in such urgent need as an agricultural society was of child labor to support the family, and children began to represent a greater emotional than economic investment. By the 1830s, childhood was no longer a kind of adulthood manqué but a separate stage of life, innocent and in need of parental nurturing, care, and education to produce moral, responsible citizens. Interest in children as children thus intensified. The differences between early American folk paintings of the very young, stiff and dressed as miniature adults, and more sophisticated nineteenth-century paintings that picture youngsters as what we might call childish, sweeter, more "adorable" make this obvious.

Some children of presidents have been highly successful. Two sons of presidents, John Quincy Adams and George W. Bush, and one grandson of a president, Benjamin Harrison, have become presidents themselves; others have achieved military glory or business success; a few have done well as writers, singers, photographers. But restricted lives in a fishbowl have some drawbacks. Doug Wead in *All the Presidents' Children* writes that the pressures on presidents' children contributed to a high rate of alcoholism, illness, or failed lives of one sort or another, and he points out that even considering how many children died young in the nineteenth century, presidents' children born before the Civil War died nine years younger than the national average.[15]

The democratic sense that the man the people had elected belonged to them had its downside too. Frances Cleveland was once so alarmed to see a stranger lift baby Ruth from her carriage that the Clevelands moved to a rented house, returning to the White House for official entertaining. (The stranger had no ill intent, but there was no guarantee the next one would not.) Two more Cleveland girls were born while he was president, and they too were kept away from the public, which brought ridicule on their parents and promoted rumors that the girls were ill or deformed.[16] The American people clearly believed that the president's children were national property.

James K. Polk and Sarah C. Polk, daguerreotype, c. 1848–1849. Photographer unknown.

Mrs. Polk's hand resting on her husband's arm suggests their closeness; that and the way in which the two of them face and gaze off camera in the same direction convey a sense that this is a couple united by common concerns and shared purpose. The image might have been made after Polk's term was over, though he died in 1849, less than a year after leaving office, worn down by the pressures of the presidency.

Sarah Polk was her husband's confidante and adviser and disagreed with him more than once about political matters.[17] Her knowledge of politics, and her willingness to discuss such issues with men, was unusual. In 1881 the author of a book on "the ladies of the White House" wrote, "Women were then, as now, supposed to be too weak to understand the mighty problem of Government, and they evidenced their acquiescence in such a supposition by remaining entirely unacquainted with the politics of the country. Not so Mrs. Polk." The author added that the lady in question did not speak about things she was not supposed to speak about, like pending legislation.[18] Mrs. Polk was by no means the last woman to have her husband's ear on national affairs, but the role of first lady has changed, sometimes from one administration to another, with changing times and the different personalities of the women in question.

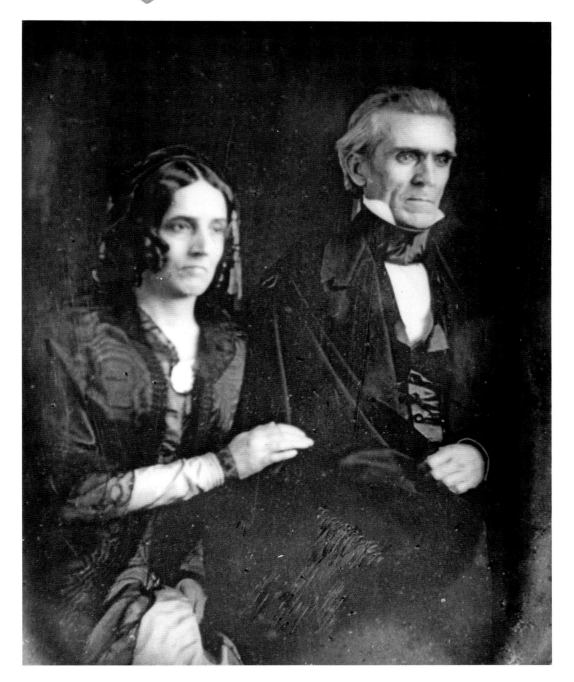

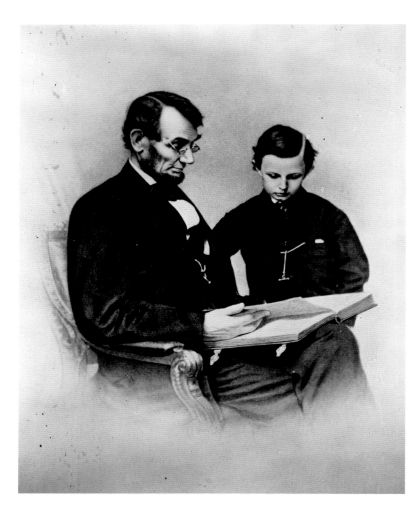

Lincoln and his son Tad looking at a book in Lincoln's lap, February 9, 1864. Anthony Berger.

There is no known photograph of Lincoln with his wife or any family member other than his son Tad. Here he appears to be reading to the boy, but in fact he is not: they are looking at a photographic album that the studio provided as a means of bringing the two sitters close together. A journalist wrote that Lincoln told him he was worried people might think the book was a large bible. The president who said "You can fool some of the people all of the time" never wanted citizens to think he was trying to fool them, even in a photograph.[19]

The American public would have expected to see Lincoln reading, for Americans placed a particularly high value on literacy; an educated populace was thought essential for a democracy. Congress appropriated $2,000 in 1850 for the purchase of books for a White House library. Abigail Fillmore supervised the project. When Harriet Beecher Stowe's *Uncle Tom's Cabin* was published in 1852, the publisher boasted that 10,000 copies had sold in the first two weeks.[20]

American mothers were expected to instruct their children in the virtues of literacy as a contribution to high moral stature in the new republic. In 1832 Sarah Josepha Hale had published these sentiments in the *Ladies' Magazine:* "The happiest and holiest use to which women can devote their talents and education is to help those of the other sex with whom they are connected, their fathers, husbands, brothers, sons. And this kind of literary companionship is more needed in this country than any where in the world."[21] Fathers too played a role, as did schools. In 1868 *Lippincott's Magazine* wrote that one of the things that distinguished the nation from Europe was "the greater diffusion of cultivation — in a wide sense, popular education. Everyone here may learn to read, and everyone may obtain access to literature." And photography could show

everyone, even the poor, the greatest works of art and nature, making of the nation "a culture of the many."[22] A president who read was merely first among equals.

The general expectation that a president would have a certain amount of learning, whether he had had a minimum of regular schooling like Andrew Jackson or Lincoln, is emphasized by the large number of pictures of presidents holding or sitting by books or reading them. Books are common enough props in nineteenth-century photographs and are found in painting too. If the table in a photographic studio was a bit low, a book was a useful stabilizer under a standing figure's hand. Books also advertised the learning of men and the literacy of women and children and stamped the subject as a cultivated person. Presidents were shown with newspapers and documents and with books, books, books.

Prints exist of Jefferson, Madison, Monroe, Polk, and others with books aplenty. Theodore Roosevelt read so avidly that he almost always had an open book on his desk. People who came to petition him learned to talk without stop, because TR had been known to simply start reading if conversation lagged.[23]

OPPOSITE, RIGHT: Tad Lincoln in uniform, 1865. Photographer unknown.

The Lincolns were considered to be what we would now call permissive parents, and Tad was a rambunctious boy. He and some friends once hitched his two pet goats to a dining-room chair and drove it into a sitting room where Mary Lincoln was conducting a number of distinguished guests on a White House tour. After young Willie Lincoln died, both parents were deeply grieved; they gave Tad even more leeway than before, which some would have said was not possible.

It was common enough for boys to dress as soldiers, a role the Civil War would have encouraged, but Tad had more right than most. He was "playfully" commissioned a colonel in the army and had a proper uniform and a sword. Here he is posed with all the solemnity and dignity of an officer. Sometimes he reviewed troops with his father; the troops apparently were not as charmed by this as his father was.[24]

Mary Todd Lincoln, November 1861. Mathew Brady.

Mary Lincoln, who did not like most portraits of her, instructed Brady to destroy all but this one from the sitting she had with him, saying it was "the only one at all passable."[25] Brady, who was as attached to his own work as most photographers are, kept the other pictures in his archive. Despite being "passable," this portrait would have confirmed the opinion early in her residence at the White House that she had excellent taste and beautiful shoulders; later it would have reinforced the criticism that dogged her for extravagance and for wearing gowns that were too low cut (which could mean either off the shoulders or revealing too much bosom, depending on how conservative the observers were).

Legend has it that the young Mary Todd told friends that

the man she married would become president. Uncommonly well educated for her time, she was intensely interested in politics and political issues, and after marrying Abraham Lincoln, she supported his political ambitions.[26] Though her husband did not travel around the country to make speeches during the campaign — a man who openly lusted after public office was thought unworthy of it[27] — he did so once he was president-elect, and then and later his wife often accompanied him and appeared with him on the train platform. Thus, from the beginning, she was more in the public eye than previous political wives. The press paid more attention to her too,[28] and it was not often kind.

Born in Kentucky to a family who owned slaves, she was a fervent abolitionist, reportedly considered the Emancipation Proclamation a personal victory, was the first presidential wife to have black guests (and was a friend to her ex-slave seamstress), and worked during the Civil War on behalf of freed slaves. Yet her family's sympathies were with the South, and three of her half brothers died and other family members were wounded while fighting on the Confederate side. Southerners considered her a traitor to her birth, Northerners suspected her of spying.

Mrs. Lincoln was profligate with money, which sorely troubled her husband, who openly remarked on his love for her. She overran the federal appropriation for redecorating the White House, spent so much on a new set of state china that the Democrats threatened to make it an issue in the 1865 election, and lavished more money on clothes than the family expenses would allow. Early in her tenure, the press praised her taste in clothes, decoration, and entertaining.[29] She looked on these items as a way to foster an image of stability during a fearful time, but others regarded her as a heedless spendthrift at a time when so many families were suffering. Mary Lincoln was quite aware of her bad press and, according to her seamstress, said that she had to dress in costly materials because "the people scrutinize every article that I wear with critical curiosity."[30]

OPPOSITE: **Ulysses S. Grant, Julia Dent Grant, and their son Jesse, early 1865. Attributed to Mathew Brady.**

All happy families may be the same, but you couldn't always tell that from photographs. The Grants were reported to be truly devoted to one another. Here, no doubt partly because of long exposure times, the General looks decidedly unhappy, or perhaps worried. Mrs. Grant, photographed in profile as usual because of one wandering eye, casts her eyes down and appears to be detached from her husband and child. The boy is so artfully posed to look relaxed that he merely looks artfully posed. Photographic "truth" is a slippery concept, and photographic studios, committed as they are to making their subjects look good, do not unfailingly abet the cause.

During Grant's administration, human-interest stories in the news steadily increased, and interest in the White House mushroomed. *Godey's Lady's Book* instituted a monthly column on the subject.[31] News of White House social life spread far beyond the Washington papers, as inexpensive newspapers expanded the reading public and the expanded public increased the demand for such material. More and more women were reading newspapers, so more women reporters were hired by the press, usually to do fashion and society pieces. Emily Edson Briggs, writing under the name "Olivia," reported that Julia Grant was "'fair, fat and forty'; she appears in grace and manner much as any other sensible woman would who had been lifted from the ranks of the people to such an exalted position."[32] The Grants gave reporters wide access to their family and their house,[33] and the press wrote about Grant's children, his horses, and the White House itself. Julia Grant gave occasional interviews to the press, the first president's wife ever to do so, and for the first time, a White House steward spoke to reporters about the household operation.[34]

Julia Grant had been through some hard times, as her husband failed at business more than once and she often followed him to military encampments. The Civil War changed that, making him a national hero, causing the family to be showered with gifts, and leading him to the White House in a walk. There they lived the Gilded Age down to the last speck of gold dust. Their redecoration of the place was truly grandiose, and Mrs. Grant restored gaiety to a mansion that had turned dreary during the war and the impeachment proceedings of Andrew Johnson. Under her aegis, Washington became a social center again and the White House (and she herself) the center of its social life. Her state dinners were exceptionally sumptuous and, one imagines, hard to digest, as they could run to twenty-nine courses. One measure of Gilded Age

opulence was the amount of food people ate: the Grants often breakfasted on broiled Spanish mackerel, steak, bacon and fried apples, buckwheat cakes, and coffee.[35]

A large public loved the Grants — at least until the depth of corruption in his administration became clear — as shining examples of the wealth and luxury the republic had achieved and the citizens hoped to match.

The country, its circumstances, and its mores had changed since Mary Lincoln's day; extravagance could even be considered admirable. Mrs. Grant loved her years in Washington. Her husband, tired by the scandals in his administration, cagily arranged for a public announcement that he would not run for a third term before telling Julia, knowing how much she would want to stay. [36]

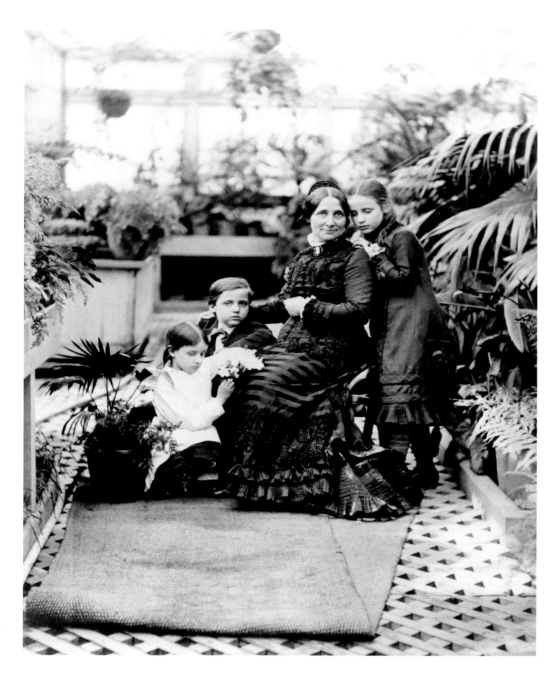

family and an ideal America: "The (private) family, educated by a reverent, revered American motherhood, was construed as a moral linchpin in the structure of (public) liberty."[38] Fathers were increasingly out of the house on business, which meant that patriarchal authority was beginning to be diluted as child rearing passed primarily into mothers' hands.

The pose of this picture, with the mother seated and the children enclosing her, is reminiscent of paintings of the Virgin and child with St. John or saints. The reference may have been unintentional, but it has a permanent place in the unconscious, if not the conscious, mind in a Western, Christian culture. Coincidentally, Lucy Hayes was compared more than once to the Madonna. A reporter who saw her at her husband's inauguration wrote that she had "never seen such a face in Washington" with "eyes we have come to associate with the Madonna."[39] The president's diary referred to his wife's "pale Madonna face," and a friend to whose child she had been kind wrote about her "Madonna love."[40]

A contemporary writer, tracing the evolution of American women, declared that Rutherford B. Hayes's wife had ushered in a new era not only for first ladies but also for women in general, who were henceforth to reach new horizons by devoting themselves to their men:

Lucy Hayes, daughter Fannie (standing), son Scott, and Carrie Davis in the White House conservatory, c. 1877–1881. Theodore Davis.

This image could be taken as an emblem of the cult of motherhood that, according to the author Ann Douglas, "was nearly as sacred in mid-nineteenth-century America as the belief in some version of democracy."[37] A recent study of maternal figures in nineteenth-century American literature concluded that the iconography of motherhood played a major role in the construction of an ideal

In her successful career as the first lady of the land was outlined the future possibilities of her sex in all other positions and conditions. She represented the new woman era.... The women of the Revolutionary period of American history exhibited stronger traits of character than those who succeeded them. There was a necessity for high qualities — the display of courage, heroism and fortitude, and they were discovered in every emergency.... With the end

of the administration of John Quincy Adams a new generation of men and women claimed public notice. . . . Mrs. Hayes is the product of the last half of the nineteenth century. . . . She gave her every thought to the maintenance and advancement of her husband's fame and name as the Chief Magistrate of the United States. . . . She, in lending additional strength to her husband's administration, commanded increased respect for her sex."[41]

Lucy Hayes did have an exceptionally happy marriage to a man who believed that family was the most important thing in life.[42] In 1877 they reenacted their wedding on their silver anniversary, a grand event that mesmerized the nation. She was the first presidential wife to graduate from college, and she helped her husband's reputation in several ways. Though she disliked formal occasions, she was such a warm hostess that even newspapers hostile to her husband frequently complimented her graciousness.[43] Still, her entertainments had a certain notoriety, for her husband had banned alcoholic drinks from the White House after one dinner with six wine glasses at each place raised the ire of temperance organizations, which Republicans could not afford to alienate. Lucy, a Methodist teetotaler, was assumed to be the culprit.[44] Some reports, however, indicate that wine had not been banished at all, and one observer reported that some clever fellow had found a way to conceal frozen punch laced with rum inside oranges, which unaccountably became very popular at White House dinners.[45] In later years, the legend that she wouldn't even allow wine won out, and Mrs. Hayes was referred to as "Lemonade Lucy."

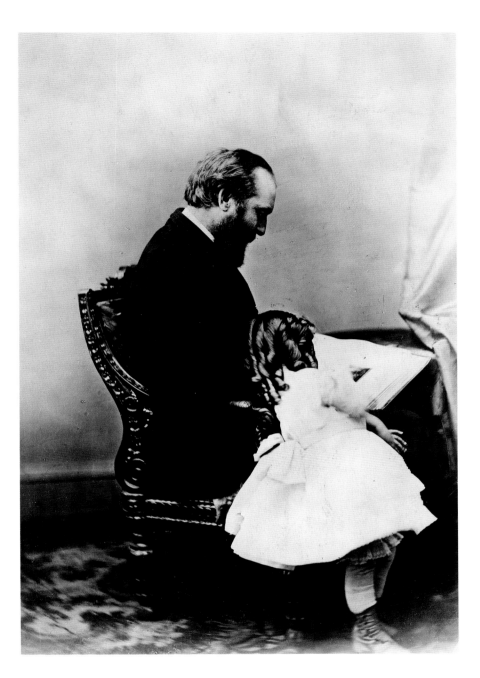

James Garfield and his daughter Mollie, c. 1865. Mathew Brady.

Garfield, here with his daughter Mary, called Mollie, is either reading an illustrated book to her or showing her an album of pictures; in any case, he is involving her with a book. As Mollie was born in 1867, this photograph would have been taken long before he became president in 1881 (and was assassinated the same year). Note the little girl's carefully engineered corkscrew curls.

Today it may seem odd that the child should have her back to us, but that was not wholly uncommon at the time. As photographers seldom relied on a single pose, in another image from the same session she faces us directly. It is more unusual that the child's arm on her father's leg looks too thin for the rest of her and that a piece of a curtain intrudes at the right-hand side of the picture. Studios frequently hung a large, heavy drapery at one side, bestowing a measure of Baroque grandeur on setting and sitter, but the position of this fragment of cloth is neither grand nor reasonable.

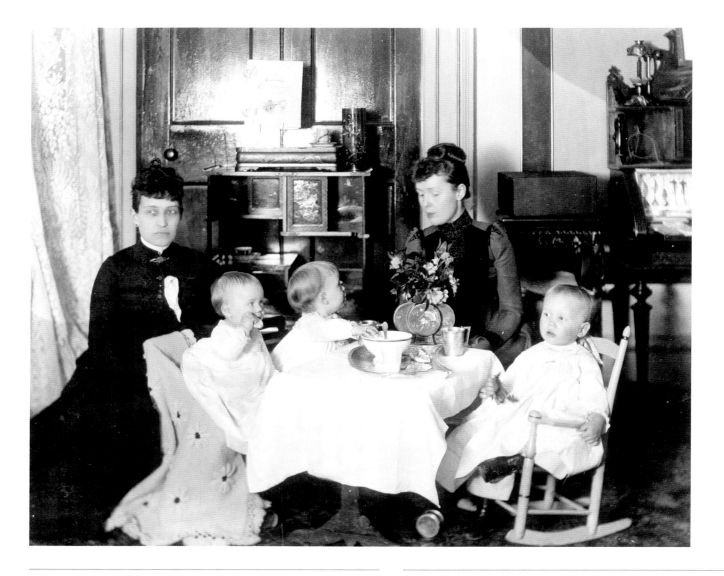

Benjamin Harrison's grandchildren at a party in the nursery, c. 1890. Frances Benjamin Johnston.

The two women are Mary Harrison McKee, the president's daughter, on the left, and Mary Saunders Harrison, his daughter-in-law. The children are Benjamin "Baby" McKee, Marthena Harrison, and Mary Lodge McKee, all still too young to mug for the camera.

The nursery was in the White House, to which Frances Benjamin Johnston had unprecedented access (and the ability to capture a lovely fall of light). Nurseries and tea parties may not have been major legislative news, but the public was interested in every nook and cranny and resident of the White House. Domestic scenes that were published would have made citizens feel privy to a certain intimacy. Besides, all the world loves babies, which is more than can be said for elected officials.

OPPOSITE: Frances Cleveland and the ladies of the cabinet, 1897. Frances Benjamin Johnston.

(Seated, left to right: Nannie H. Wilson, Olive Harmon, Mary Jane Carlisle, Frances Cleveland, Agnes P. Olney, Leila Herbert [daughter of Secretary Herbert]. Standing, left to right: Emma Morton [sister of and hostess for Secretary Morton], Jane P. Francis, Juliet K. Lamont.)

It was part of a president's wife's duties to welcome the wives of officials, diplomats, and distinguished visitors to the White House, to make them comfortable and accord them a sense of importance. There was a long tradition of presidents' wives having cabinet wives to tea once a week, and cabinet wives sometimes stood in receiving lines with the first lady at White House receptions.

Presidents' wives also customarily had weekly receptions for some part of the populace. Frances Cleveland

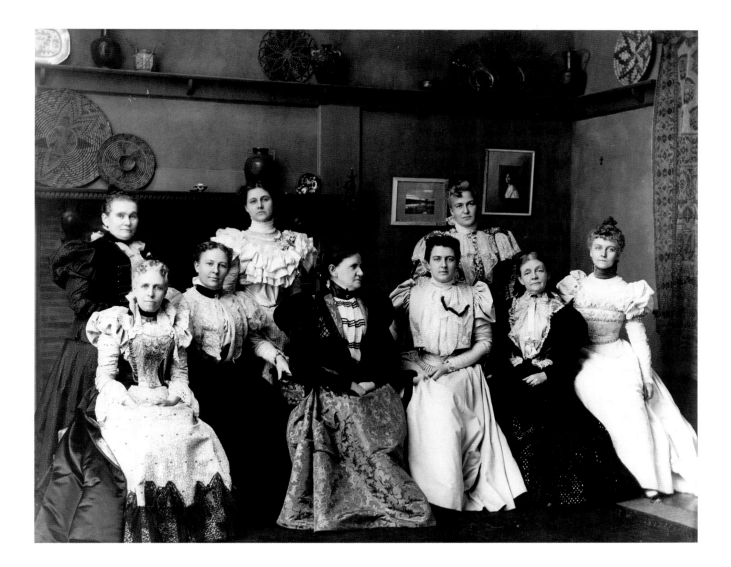

instituted Saturday receptions for the public so that working women would have a chance to be received in the White House, an innovation that was not repeated. An official urged Mrs. Cleveland to give up these receptions because about half the women attending were "clerks from the department store and others — a great rabble of shop girls. And of course a White House afternoon is not intended for them." Frances Cleveland disagreed. She promptly gave orders that there was to be no interference with her Saturday receptions.[46] At her last one, three thousand people turned up, including black men and two American Indians; the glove on her right hand turned black from shaking hands.[47]

Frances Cleveland had attracted enormous attention from the press when, at age twenty-one, she married the forty-nine-year-old bachelor president Grover Cleveland,

whose ward she had formerly been. By the time he campaigned for another term, the national interest in a president's wife was so intense that a campaign button was put out with her face on it, though she was neither running nor, of course, permitted to vote; and another campaign button had both her face and her husband's.[48] She was such a drawing card, and presidents and their wives had become so entrenched in the public mind as celebrities, that in the 1889 campaign, millions of giveaway handkerchiefs, scarves, napkins, pitchers, and bric-a-brac items were distributed with her image on them, sometimes alone, sometimes with her husband. The two of them considered this a kind of huckstering and beneath presidential dignity but could not prevent it.[49] Cleveland lost the election anyway, though he made a comeback four years later, serving two terms separated by one for Benjamin Harrison.

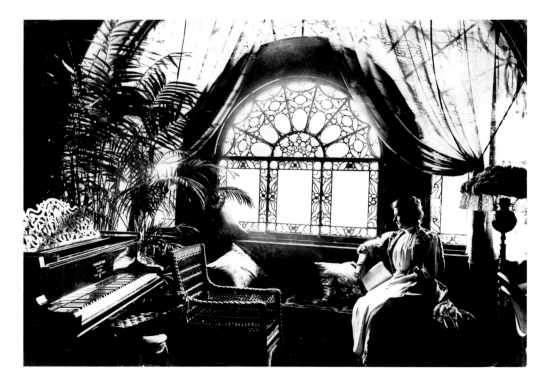

Frances Cleveland in the West Sitting Hall, Second Floor, April 21, 1893. Pirie MacDonald.

Photographers provided information about parts of the White House that tourists did not see, including the family quarters on the Second Floor. Mrs. Cleveland's pose, suggestive of a pensive moment's pause in reading, sets the tone of this picture, which is reinforced by the mellow light that plays over her profile and the furniture of the period.

Ida S. McKinley, c. 1897–1901. Frances Benjamin Johnston.

Ida McKinley, rather pompously overdressed, looks poker-stiff here, as if her dress were keeping her upright with its rigid waist, its collar that holds up a head with no neck, and a train that seems to be there to balance her. She was, as it happens, seldom upright. After her second daughter died, she effectively became an invalid and wholly dependent on her husband, who was so devoted to her throughout his life that his first words after he was shot were a plea to be careful how his wife was told. She spent most of her time in a chair and was medicated to prevent seizures, yet she was singularly determined to fulfill her duties as White House hostess against what would have seemed insuperable odds to another woman.

During her husband's campaign, Ida McKinley appeared in public so seldom that all manner of rumors circulated; the first campaign biography of a candidate's wife was written in response.[50] In the White House, she willed herself to stand beside her husband when it was called for. She suffered from severe headaches and from brief fainting fits — some have speculated that she was epileptic — that increased as McKinley's term went on. Doctors could do nothing for her but offer sedation. When she was suffering, her temper was exceedingly black. When her seizures occurred during official dinners or receptions, the president would act as if nothing was amiss and keep the conversation on track. If he sensed that one of her spells was imminent, he calmly continued the conversation as he placed his handkerchief over her face, removing it when

she recovered. One of his biographers says that a sizable public thought highly of him for his dedication to his wife and admired her for her pluck, and that "...an age accustomed to sickly matrons forgave her everything."[51]

In this photograph of Mrs. McKinley, her husband's picture on the table not only firmly identifies her but also points out her close attachment to him, as she is shown with her right arm and hand effectively pointing at his portrait.

Edith Roosevelt reading to Quentin and Archie in the Green Room, 1902. Frances Benjamin Johnston.

Here the good mother is doing what good mothers did: reading to her children — a fine example for the populace.

In 1886, two years after his first wife died, Teddy Roosevelt married Edith Carow. When McKinley died of an assassin's bullet in 1901, TR, his vice president, automatically rose to the highest office in the land and became the youngest president, at forty-two, that the nation had ever known. The new presidential family included six children. Seventeen-year-old Alice, the only child of TR and his first wife, refused to move into the White House immediately, but the president's five younger children, four boys and a girl, provided plenty of fodder to the press even before Alice came to Washington. Quentin, the youngest, was four in 1901. He was fearless and much given to playing pranks. Once, he hid on top of the North Portico and pushed an enormous snowball down onto the head of the officer on duty. TR, coming out at that moment to greet an important visitor, was irate, not so much at seeing the law felled by a snowball as by the fact that the sight made him laugh uncontrollably.[52]

TR, who courted publicity avidly, tried to keep the press from his family. His wife, a private person who never gave speeches or granted interviews, tried to preserve a relatively normal family life for her five children — though Alice preferred publicity — and posed for pictures taken by and distributed to the press in hopes that that would stop photographers from dogging their heels. Magazines printed these pictures but without much information about the children, and some put pictures of Edith on the cover when there was no story about her inside. So she did preserve some privacy — and earned a reputation for aloofness.[53]

Nonetheless, Edith Roosevelt had a real impact on White House images of first ladies: she established the gallery of portraits of them in a Ground Floor hallway that had been turned into an entry corridor. A long line of presidents' wives would now receive visitors to the President's House. She had an even larger impact on the house itself,

as it was she who oversaw the most extensive renovation and enlargement that the frequently renovated dwelling had undergone. She had an impact on the president too: TR told an aide that he always paid for it if he went against her advice.[54]

Jacob Riis, the crusading reporter and photographer who knew TR well, wrote, "I do not know how other Presidents lived, for I was never there before, but I imagine no one ever led a more plain and wholesome life than the Roosevelts do. I cannot think that there was ever a family there that had so good a time."[55]

Police "roll call inspection" at the White House, 1902. Frances Benjamin Johnston.

Kermit and Archie Roosevelt, almost the only people here without droopy mustaches, were quite accustomed to the staff police who followed them around. Alice Roosevelt, who later said that these police were the only security men on the grounds, apparently didn't know that there were two Secret Service men assigned full-time to protect her father. Congress had requested this protection after McKinley was assassinated in 1901.[56] The Secret Service, which had been founded in 1865 to suppress counterfeit currency, began informal, part-time protection of President Cleveland in 1894 in response to a large number of threatening letters; at the same time, the usual complement of three or four White House guards was increased to twenty-seven.[57]

Like TR himself, his family was so colorful that it might have made news in almost any era, but interest in presidential families reached a new intensity when the Roosevelts' dramatic example presented itself. The children, given more latitude to do whatever they pleased than was common in most families, roller skated, biked, and walked on stilts down the Second-Floor hallway and made news in many ways. When Archie was recovering from measles, he was so eager to see his beloved pony, Algonquin, that a stable attendant, without warning anyone, coaxed the little pony into the elevator to pay a sick call on his master.[58]

Portrait of Alice Roosevelt Longworth, from a hand-colored portrait photograph, May 1903. Frances Benjamin Johnston.

This picture was taken three years before Alice Roosevelt married Nicholas Longworth, a member of the House of Representatives from Ohio, and four years before the Lumière brothers in France brought to market the autochrome, the first successful color process. Hand-coloring was the order of the day; this example is meltingly delicious, and when it appeared on the cover of *Collier's* magazine, it brought Alice's name and beauty before a large public. Alice wears the long court train that was de rigueur for women at White House state functions before World War II.[59] The arrangement of her train makes the figure seem longer, taller than she is in fact, her uplifted head and out-thrust bosom give her a commanding presence, her delicate laces emphasize her femininity and reinforce her natural good looks, and the creamy pastel color gives the picture a decidedly romantic cast. The rather dramatic lift of the subject's chin and tilt of her head hint at Alice's boldness.

The picture is a good deal more romantic than Alice herself. She had ninety-nine ways to attract attention, including a sharp tongue and a dry wit. On her father's inaugural day in 1905, she waved so vigorously at her friends that TR said to her, "Alice, this is *my* inaugural." He shrewdly used her ability to upstage everyone in the room by sending her to the Philippines with Secretary of War William Howard Taft when Taft was on a delicate diplomatic mission that had to be quietly conducted. Alice performed like Alice. She was feted everywhere. A South Pacific native king asked her to join his harem. When she was bored at a banquet, she would stealthily create little paths of food that invited droves of ants to climb the table leg and join the party.

Some years later she remarked that "the Hoover vacuum cleaner is more exciting than the president. But, of course, it's electric." She played hostess to much of Washington society long after her father's presidency, and she had a salon pillow that was embroidered with these words: "If you can't say something good about someone, sit right here by me."[60] The columnist Joseph Alsop, her cousin, referred to her as "Washington's other monument."[61]

Helen Taft, c. 1908. Pach Brothers.

First Lady Helen Taft was the first wife to ride with her husband in the inaugural parade, she spoke out for woman suffrage, and during her husband's administration, she attended not only the public but also the private White House meetings.[62] In 1914, not long after her husband lost his bid for reelection to Woodrow Wilson, she published her autobiography, the first president's wife to publish one in her own lifetime.[63]

If she appears to be carrying an entire garden on her head in this photograph, she was following the dictates of fashion in the era of the Gibson Girl, Charles Dana Gibson's popular creation in magazines of the time. The

Gibson Girl and her many imitators had high pompadours, often achieved by placing a horsehair "rat" above the forehead and rolling the hair back over it. Preserving the hairdo required either a very high or a very broad hat, or one both high and broad; wide hats were excellent foils for the tiny waist that Gibson Girl lookalikes tried to emulate.

Helen Taft is remembered chiefly for being responsible for the planting of Japanese cherry trees around the Washington, D.C., Tidal Basin. When her husband was governor general of the Philippines, she traveled widely and attended receptions in Asian capitals, where the effusive welcome to spring that cherry trees offer delighted her. Mrs. Taft had also traveled to a number of European capitals and felt herself perfectly positioned to endow the White House with a cosmopolitan image. With this in mind, she hired six African-Americans, had them outfitted in blue livery, and trained them to be footmen. The old accusation of imperialism thereupon raised its head, as critics cried that this went against "democratic simplicity."[64]

OPPOSITE, LEFT: Edith Wilson assists President Woodrow Wilson at his desk, 1915. Harris & Ewing.

By 1915 posed pictures of presidents at work were not unusual, yet while some presidents' wives were important confidants of their husbands and even had a kind of backroom influence on policies, it was extremely uncommon to find a picture of a wife assisting, or even present, in the office. In fact, in the history of portraiture, there are not many pictures of wives associated with their husbands' work in any way. In this photograph, Edith Wilson, the president's second wife, appears as his helpmeet and almost as his muse, guiding and overseeing his project.

History has colored this photograph of the Wilsons, making it look like a foreshadowing. In 1919, while strenuously (and unsuccessfully) barnstorming to promote American support of the League of Nations, Woodrow Wilson had a massive stroke that gravely incapacitated him. How gravely was carefully kept from the public and as far as possible from the vice president and Congress. Although it is unlikely that she actually made policy, Wilson's wife, who was continually at his side and zealously kept visitors away, also decided which items were important enough for him to see. Detractors dubbed her the "secret president."

ABOVE, RIGHT: **Florence Kling Harding, 1921.**

Florence Harding, who was photographed incessantly, was surely aware of how striking, even how much more striking, she looked in strict profile, wearing her characteristic pince-nez. The high turtleneck she wears is one element in a clever and effective campaign she concocted to make her look younger, for she was five years older than her husband. She had kidney damage that was intermittently life threatening, but she managed to present a healthy and vigorous front to the world.

Few people today know anything about Florence Harding, as her memory has been eclipsed by that of her husband, Warren Gamaliel Harding, whose name became synonymous with scandal in government soon after he died in office. Yet she was an extraordinary woman and an extraordinary first lady with a long list of firsts to her credit. Perhaps the most minor was a historical coincidence: as women were finally given the vote in 1920, she

was the first woman ever to vote for her husband. She said quite openly that she had made him president, and she didn't mean by voting for him.[65]

Her background was highly unusual for a president's wife. At nineteen Florence Kling had an illegitimate child. The father abandoned her, but she managed to get a divorce based on a common-law marital agreement. As a single mother, she was homeless for a time, and she worked to support herself and her child. After she married Warren Harding, who was editor of a newspaper, she became the paper's business manager and helped to make it successful.[66] She arrived at the White House with a career behind her — the nation was aware that she had worked because she had to — and a close-up knowledge of the workings and the power of the press.

Florence Harding was a feminist whose letters in ardent support of political, social, and economic equality for women were published in national newspapers. She held informal press conferences for women reporters, which no first lady had done before. She told women they should

exercise and participate in sports. She declared that it would be possible one day for women to earn a family's main income. She did not wear a wedding ring. Her views were shocking to some and kept her on the public's mind and in the public eye. The press hailed her as a representative of the new woman.[67]

She was a celebrity herself, and the White House, which always welcomed celebrities, now for the first time entertained Hollywood stars. The upper crust had previously considered Hollywood actors vulgar. In the first decade of the twentieth century, they regarded movies as entertainment for riffraff. But by 1913, foreign films shown in legitimate theaters on Broadway to upper-income audiences began to change that, and a couple of years later, Chaplin's "little fellow," D. W. Griffith's *The Birth of A Nation* (which

was the first film ever screened at the White House, during the Wilson administration), and other stars and feature films were enhancing the reputation and popularity of cinema.[68] The Hardings were going against society's entrenched ideas when they opened the White House doors to Hollywood actors, who eventually made the White House itself a stage for their talents.

She assisted her husband so often and actively and corresponded so vigorously with his cabinet that a 1922 *Life* magazine spread of the year's cartoons of celebrities featured a drawing of "The Chief Executive and Mr. Harding."[69] When he died she continued to manage his image by burning many of his papers — some of which would have shed light on the scandals of the administration.

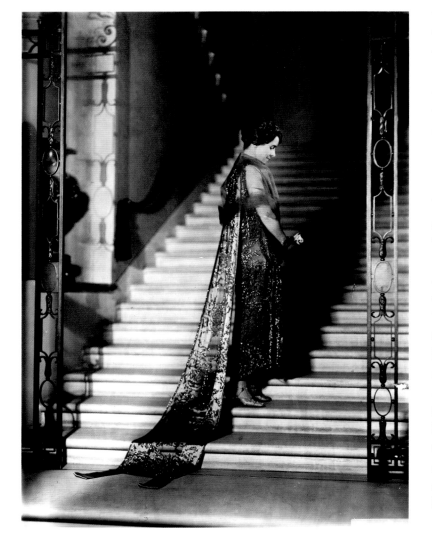

Grace Coolidge, c. 1925. Harris & Ewing.

This formal picture of Grace Coolidge highlights her fashionable elegance, the train effectively making her entire figure a long vertical, in imitation of fashion illustrations of tall, slim women. The photographer has gone all out for drama, with the stairs seen on a diagonal, the dark shadow nearly mirroring their ascent, and the string of lights pointing down at Mrs. Coolidge's head at a sharp angle as if to imply a central point perspective ending exactly there. The lighting is tricky: the dramatic shadow going up the stairs cannot be caused by her figure alone, as part of her train on the floor is also in dark shade.

Grace Coolidge's husband was frugal with both words and money, with one exception: he loved spending money on her clothes. Yet she was not merely an attractive fashion plate. She was in surprising ways a foil for her husband, sometimes known as Silent Cal: she was vivacious, charming, talkative, warm, friendly, enthusiastic, and cheerful; not one of those adjectives could be applied to her husband. They did share a good sense of humor and a strong religious faith, both of which doubtless played a large part in their happy marriage. After they married, he had presented her with fifty-two pairs of socks to darn, which he'd apparently been saving up until he found a wife. Later she asked if he'd married her to get his socks mended; he said he hadn't but that he found it mighty handy.

A teacher of the deaf before marriage, afterward she

lived the life of housewife and hostess that her conservative husband expected of her. In 1921 she did acknowledge that contemporary women were restless. "Soon," she said, "there will not be an intelligent woman who is content to do nothing but live a social life. I should think Washington would be an excellent place to begin." If she herself was restless, she did not let on. She told reporters what they would have expected to hear: that her job was to stay home and raise the two Coolidge boys.[70] She did not discuss politics because her husband had forbidden her to. The issue of how independent a woman should or could be was an old question that was written in boldface in the 1920s as more women entered the workforce. The position of president's wife puts a spotlight on the issue and has continued to bring out an underlying ambivalence in many quarters about a woman's role.

The Coolidges' second son died of blood poisoning in 1924 at the age of sixteen. Both parents were grief stricken, but as shaken as she was, Mrs. Coolidge maintained her poise and continued to fulfill the role of first lady. She was immensely popular in Washington and throughout the nation, and in 1931 she was voted one of the twelve greatest living women in America. The National Institute of Social Sciences gave her a gold medal for her "fine personal influence exerted as First Lady of the Land."[71]

good economic times tend to endear a president to the hearts of his citizens.

Lou Henry Hoover earned the first degree in geology ever given a woman in America (from Stanford, where she met her husband, who earned his in mining engineering) and won an important professional award. She accompanied her husband to China, where he was a leading engineer. They were trapped for ten weeks in a siege during the Boxer Rebellion, when she displayed great courage: an artillery shell exploded in their front hall and destroyed part of the staircase while she was playing solitaire in a nearby room; she continued playing as if nothing had happened.[72] Later, based in London, she traveled with her husband to nearly forty nations and was with him when he led programs to feed occupied Belgium during World War I and the starving masses in Europe and Russia afterward.

Lou Hoover spoke several languages and gave public speeches on two continents in support of various causes. With her husband, she translated a sixteenth-century Latin treatise on mining.[73] Yet in 1921 she said, "my chief hobbies are my husband and my children." Concerned about privacy and wary of the press, Lou Hoover chose to stand back out of her own spotlight, and she did not fascinate the nation or win its approval.[74] It was no longer possible to win a nation's love if you didn't court the press (including photographers) or respond enthusiastically to its courtship.

Pillow with portraits of President Herbert and Lou Henry Hoover, 1929. Leff Vartazaroff.

A handmade pillow, testimony to the reverence that presidential couples could receive and to the strong desire for souvenirs of leadership, takes the chief executive and his wife into the realm of decoration. Celebrity had been down this path before. In the nineteenth century, presidents' portraits were available on pins and clocks and other kinds of ornaments, and actresses' faces could appear on mugs and scarves and neckties. In the case of the pillow, someone who didn't have a photograph or a print of the president and his wife on the wall evidently wanted one on the sofa. Presumably the pillow was made before the stock market crash and the Depression. In the months before that, Hoover presided over a country that was still enjoying a long romance with prosperity, and

The reviewing stands in front of the White House, January 21, 1957. Abbie Rowe.

Perhaps the most propitious event for any first children occurred when President Dwight D. Eisenhower and Vice President Richard M. Nixon reviewed the parade on the day of their official inauguration. They had been inaugurated in a private ceremony in the East Room the previous day because the official date of January 20 fell on a Sunday; the next day, they repeated the ceremony at the Capitol. It was on January 21 that Julie Nixon, the vice president's daughter, viewed the parade with David Eisenhower, the president's grandson. Eleven years later, Julie and David were married. The photograph suggests that the attraction was in the works from the very first moment.

OPPOSITE: *Mona Lisa* **at the National Gallery of Art, January 8, 1963. Abbie Rowe.**

(Left to right: Hervé Alphand, French Ambassador to the United States; Mme. André Malraux, wife of then French Minister of Culture; Jacqueline Kennedy; Mme. Alphand.)

When opportunity knocks, snap a picture of her. Abbie Rowe caught a moment when two of the world's most famous beauties, one of them going on five hundred years old, went just about head to head with each other. This was particularly appropriate, as it was Jacqueline Kennedy who persuaded the French to let the *Mona Lisa* travel to the United States.[75] And there was a bonus here, Mme. Alphand being a third beauty: the "three graces" at the National Gallery.

When Mrs. Kennedy accompanied her husband on a state visit to France in 1961, she thoroughly charmed the culture minister, André Malraux — not to mention the rest

of the country. When the visit ended, President Kennedy said, "I am the man who accompanied Jacqueline Kennedy to Paris."[76]

The following year, a dinner was arranged for Malraux in Washington. He was so charmed yet again by Jacqueline Kennedy that he promised to lend one of France's greatest treasures, the *Mona Lisa*. The curator at the Louvre protested that the painting was too fragile to travel; the curator at the National Gallery of Art thought the same. But Malraux persisted; Charles de Gaulle, the French president, wanted to reinforce his relations with America, and Leonardo's lady came calling in Washington.

She came by ship to New York, accompanied by nine French guards and two Louvre officials. The ship's pastry cook had baked a cake in her image, and after docking they put it atop the special case that had been constructed to house the great and fragile lady so reporters could at least see an image of a painting that was not about to be unpacked on a dock. At the private opening at the museum on January 9, 1963, the president addressed the invited audience and spoke of the American revolution for democracy and the French revolution for liberty and said "politics and art . . . are one," thus enlisting *Mona Lisa* in a new role, as a propaganda instrument in the cold war.[77]

Jacqueline Bouvier Kennedy became an icon on more than one continent as soon as she moved into the White House. Less than three months after her husband was inaugurated, "the Jackie look" was a subject of lively discussion in magazines in Poland,[78] a country whose news was so dependent on the Soviet Union's that it was jokingly referred to as demi-TASS.

Mrs. Kennedy's successful campaign to borrow the *Mona Lisa* was of a piece with her redecoration of the White House, both of them intended to advance the arts, culture, and history in the United States. One half of the youngest, handsomest, most vigorous couple the nation had seen in years, she did not like her privacy invaded any more than Bess Truman did, but the camera (and the rest of the press) couldn't get enough of her. A major accomplishment during her husband's brief administration was a wide-ranging redecoration of the White House. Shortly before she led a televised tour of the renovated house, the *New York Times* declared that she represented a change in the way women were regarded: "It is now all right for a woman to be a bit brainy or cultured as long as she tempers her intelligence with a 't'rific' girlish rhetoric."[79]

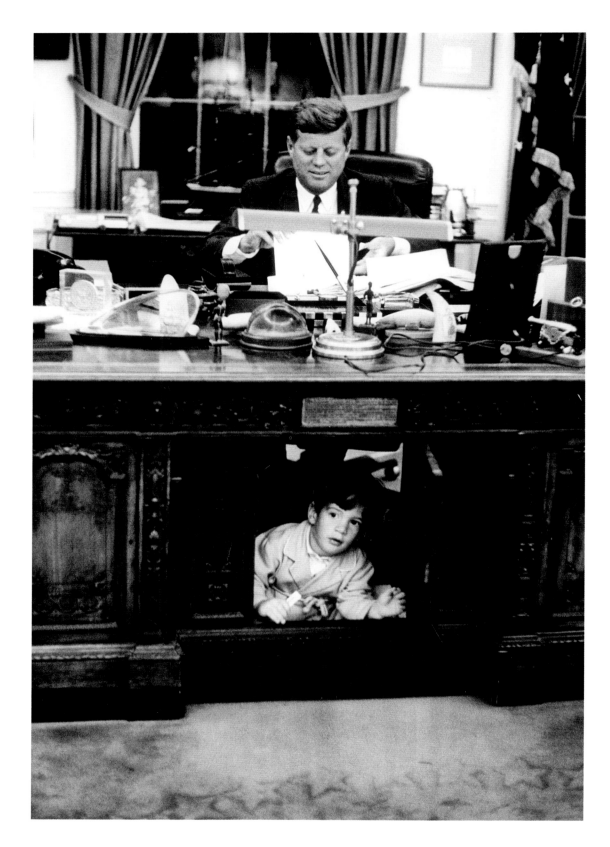

John F. Kennedy Jr., President Kennedy's younger child, peers out from below his father's desk, October 14, 1963. Stanley Tretick, _Look_ magazine.

It is difficult to keep the press away from a subject that is a surefire attention getter. Jacqueline Kennedy did not want her children to be performers in the media circus. Allowing a child into the Oval Office while his father was working was virtually a guarantee of a good picture, and John-John performed so perfectly that this photograph became famous. Her husband knew exactly how much his children's image would contribute to his own.

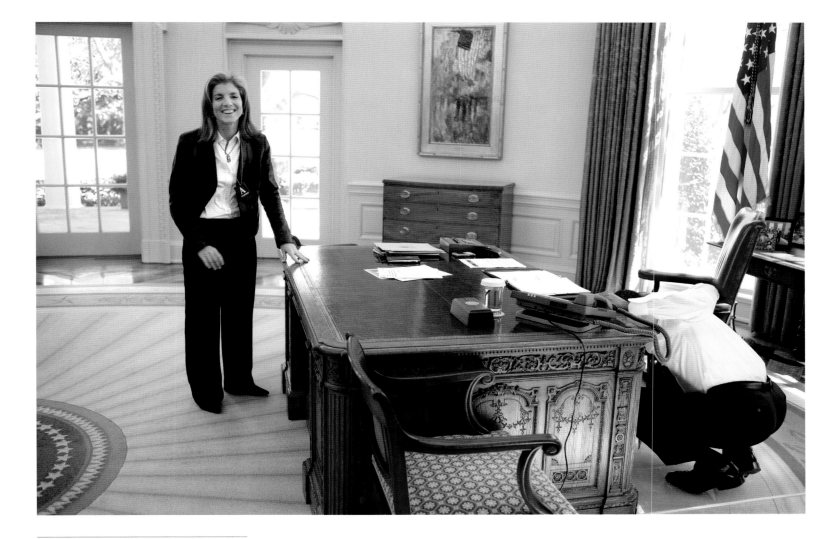

Caroline Kennedy visits President Obama, March 9, 2009. Pete Souza.

When Caroline Kennedy visited President Obama in the Oval Office, she remarked that he was using the same desk her father had used. Obama, remembering the photograph of John-John peering out from the underside of the desk, got down on the floor to locate the trap door in the desk — and found it locked, with nary a child inside.

Lyndon Johnson kissing Patrick Lyndon Nugent, his grandson, with the involuntary participation of Yuki the dog, 1968. Yoichi Okamoto.

Lyndon Johnson had a personality like a weather front. A large man given to large gestures, he could advance unstoppably on people he wanted to corner or convince, and he could sweep in at extreme temperatures. He loved this little boy at least as much as grandfathers generally love their grandsons, and he typically made it known when the boy was still in mid-stride.

Johnson gave Okamoto, his official photographer, exceptional freedom. Oki had unlimited access to presidential appearances and meetings as long as he did not disturb them, and he never did.[80] But during a period when Johnson was demonstrating the need for economy by touring the White House to turn off lights, a *Newsweek* article reported that Okamoto had shot 19,000 negatives over three months, which sounded more than a little extravagant to the president. Johnson fired his photographer. Some months later, Edward Steichen, the photographer, director of the department of photography at the Museum of Modern Art in New York, and organizer of the exhibition *The Family of Man,* was invited to the White House with his wife, and he offered sharp objections to the dismissal. Nineteen thousand photographs meant five rolls of 35mm film a day, not an extravagant number. "Just think," Steichen said, "what it would mean if we had such a photographic record of Lincoln's presidency." Oki got his job back. By the end of Johnson's second term, the government-owned collection reportedly included half a million photographs or more by Okamoto.[81]

Lady Bird Johnson, taken in the second floor Cross Hallway on the evening of an official head of state visit by Prime Minister Thanom Kittikacom of Thailand, May 8, 1968. Robert Knudsen.

As first lady, Mrs. Johnson was honorary chairman of the National Head Start program and energetically promoted the beautification of the city of Washington, and then of the nation and its highways. She once said that "ugliness is so grim. A little beauty, something that is lovely, I think, can help create harmony which will lessen tensions."[82] Her faith in the power of beauty to affect an entire society lay behind her push to make the capital and then the entire nation a more attractive place. Lady Bird's efforts in these areas, and her husband's reliance on her opinions and advice, positioned her as an insider in the Johnson administration.

Lyndon Johnson supported Lady Bird's various programs in his State of the Union speeches or during cabinet meetings; they often appeared to be his own. When it looked as if the bill to remove billboards and beautify the nation's highways might not pass, LBJ told his cabinet and staff members, "You know I love that woman, and she wants that Highway Beautification Act. By God, we're going to get it for her." And he did, though the final vote was a watered-down version.[83]

Nixon family photograph before a portrait of George Washington, 1969. Richard M. Nixon Presidential Library.

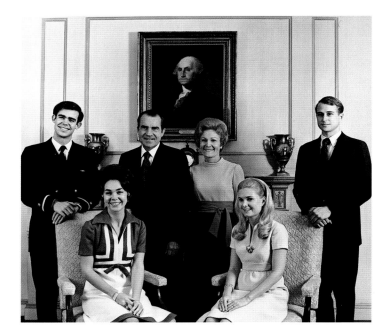

(Standing, left to right: David Eisenhower, President Richard Nixon, Thelma Catherine "Pat" Nixon, Edward Cox. Seated, left, Julie Nixon Eisenhower; right, Tricia Nixon Cox.)

Ordinary citizens posed for family pictures soon after the camera made it possible for people who couldn't afford a painted portrait, and by the turn of the twentieth century, almost anyone could take such a picture him- or herself. In the mid-nineteenth century, pictures of presidential families became important political statements, and long before Nixon's time they had become imperative.

The inclusion of Washington in this family-portrait session works as a place-and-position locator as well as a bid for prestige and authority, and the rest of the family has put on, as families do, their best happy-family faces for the camera. Happy-family portraits are highly desired by most families, but for a president, such a photograph also has solid political benefits: the image of a good family man is an image every president would like to have embedded in the public mind.

Ford and family in Oval Office the day after the election, November 3, 1976. David Hume Kennerly.

President Ford hugs his daughter, Susan, before his wife, Betty, reads his concession speech to the press with the

family, including the president, standing behind her. (Left to right: Mike Ford, Steve Ford, Jack Ford, Susan Ford, Gerald Ford, Gayle Ford [Mike Ford's wife], an unnamed White House staff person.)

Gerald Ford became both vice president and chief executive in a unique manner: he is the only vice president and president who was not elected to either office. He was appointed vice president by President Richard Nixon in 1973 when Spiro Agnew, Nixon's original VP, resigned after being charged with accepting bribes and falsifying tax returns. In August of 1974, Ford was sworn in as president when Nixon himself resigned in the wake of revelations about the break-in at the Democratic National Committee's headquarters in the Watergate office complex in Washington. Investigation discovered that the burglars were agents hired by the Committee to Reelect the President, and President Nixon had been involved in the subsequent cover-up.[84] President Ford granted Nixon a full pardon in September of 1974 in hopes of restoring domestic tranquillity by avoiding an

ugly and prolonged trial. A storm of opposition and controversy followed, which contributed heavily to Ford's defeat in the 1975 election. In later years, many who had been violently against the pardon changed their minds and decided it had been the best course of action for the country.

The 1976 election was very tight. Jimmy Carter won with 40.8 million votes to Ford's 39.1 million. On the day after the election, the Ford family gathered in the Oval Office, site of so many major presidential responsibilities, to mourn its loss. This photograph is yet another instance of the intimacy and emotional range of contemporary coverage of the president. The president, having become a special breed of celebrity a very long time ago, must allow the public to see his sorrows and defeats.

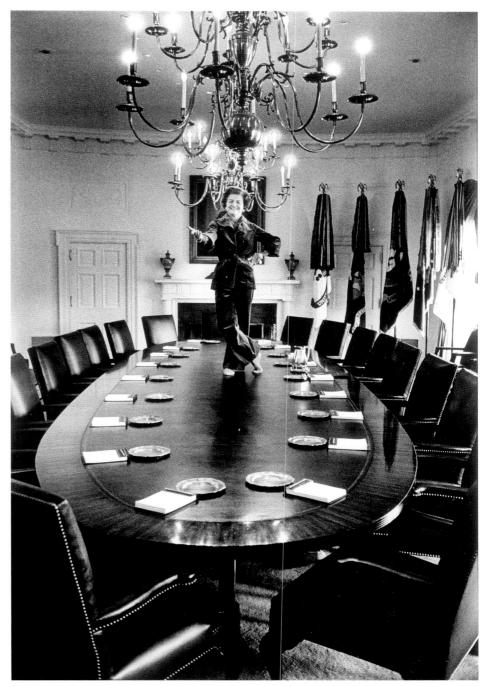

Betty Ford dances on the Cabinet Room table, January 19, 1977. David Hume Kennerly.

While still in her teens, Elizabeth "Betty" Ford studied with Martha Graham and became a member of the Martha Graham Auxiliary Troupe; not much later, she formed her own dance group. So she knew how to dance — and she was a free spirit who expressed herself openly, talking on her CB radio under the handle "First Mama," doing the "bump" with pop singer Tony Orlando at a White House event, dancing with a Chinese ballet company in China when her husband, Gerald Ford, paid the first visit to the country by a U.S. president since the opening of liaison offices, and speaking publicly on controversial matters.[85] This picture was taken as the Fords were about to leave the White House, President Ford having lost the election to Jimmy Carter. Mrs. Ford said she'd always wanted to dance on that table and thought it would cheer up the staff.

Fate all too quickly offered her an opportunity to speak out: less than two months into her husband's brief term in office, Mrs. Ford was diagnosed with breast cancer. She discussed her mastectomy candidly in an effort to educate women on early detection and treatment. Not long afterward, she took up cudgels for women's rights (including abortion rights), talked publicly about the possibility that her children might have smoked marijuana, and most controversially of all, answered Morley Safer's question on *60 Minutes:* What would she do if Susan, her eighteen-year-old daughter, were "having an affair"? Her reply: she would provide "counsel."

George H. W. and Barbara Bush in bed with their grandchildren, August 22, 1987. David Valdez.

(Left to right, not including President and Mrs. Bush: Pierce Bush, Barbara and Jenna Bush, Marshall Bush, Margaret Bush, Jeb Bush Jr., and Sam LeBlond at Walker's Point, Kennebunkport, Maine.)

George H. W. Bush was Ronald Reagan's vice president when this was taken. The president may be the "father of the country" even if he is not George Washington, but the vice president also has a stake in being seen as a family man. Here he is with his family at the Bush compound in Kennebunkport, Maine, which had been the Bush family retreat for generations.

The picture establishes Barbara Bush's popular image as "everybody's grandmother," an image America took to its heart during her husband's presidency. The Bushes had six children, one of whom died young, and Barbara Bush has had a long-term public commitment to the welfare of children. When her husband was vice president, her chief cause was literacy, and it continued to be so when she became first lady. Many photographs show her, characteristically, reading to children.

Easter at the White House, March 27, 1989. Carol Powers.

In 1989 the annual Easter Egg Roll on the White House lawn, traditionally held on the day after Easter, was attended by the president, his wife, the Easter bunny, and his mate.

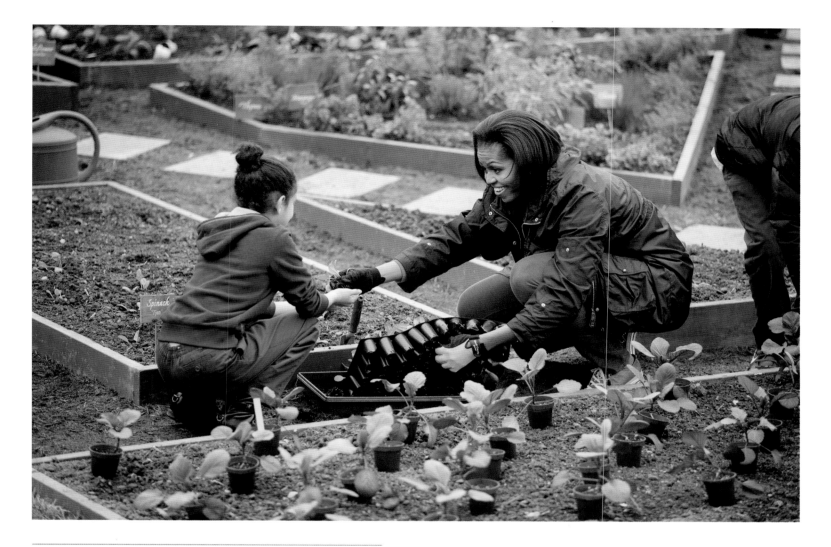

Children from Bancroft Elementary School help First Lady Michelle Obama plant the White House vegetable garden, April 9, 2009. Samantha Appleton.

Not long after she moved into the White House, Michelle Obama invited children from a local elementary school to help break ground and plant a vegetable garden in the White House South Lawn. Less than a year later, in early February 2010, she launched the Let's Move! program to combat the epidemic of obesity that some experts have said threatens to make childrens' lifespans shorter than that of their parents. The program emphasized education about nutrition, healthful diets in homes and schools, and adequate exercise, and the first lady said that if the country worked together, it should be possible to change lifestyles in a generation.[86]

Michelle Obama has visited many schools and traveled extensively, set up an East Wing mentoring program for high-school girls, and advocated for opportunities for all children, anywhere in the world, to get a good education — and then use it to solve the world's problems.

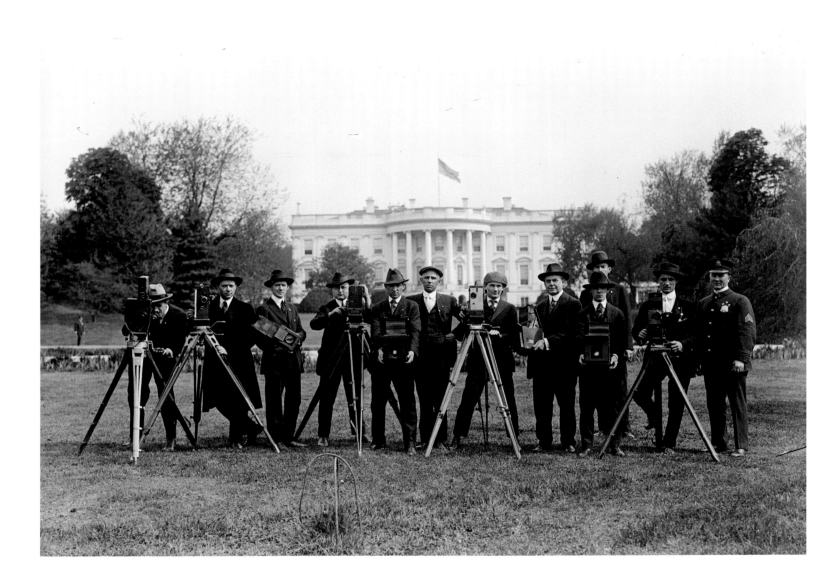

CHAPTER 5: CAMERAS AT THE WHITE HOUSE

FOR THE FIRST half century of its life, photography was a medium for professionals and truly dedicated amateurs: a photographer had to lug around heavy equipment, and he (or occasionally she) had to know the chemistry and techniques of developing and printing images. All this changed in 1888, when George Eastman brought the Kodak to market. It was small, hand-held, and lightweight, and once you had taken the twenty frames on the roll that was already in the camera when you bought it, you sent the whole camera back to the manufacturer, which then printed your pictures for you and loaded the camera with film once more. The new Kodak was immediately aimed at the White House. Many types of hand cameras followed this invention and suddenly almost anyone could be a photographer. Then in 1900, Eastman marketed the Brownie, a $1 camera so easy to operate it was advertised as being for children. The camera craze was off and running on what has so far proven to be an endless and ever-widening track.

Five thousand of the first Kodaks were produced in 1888, 150,000 of the first Brownies in 1900. Popular devotion to cameras, and photographs, raced ahead without a pause for breath. Visitors snapped pictures of the White House as fast as they could, and from time to time, residents of the house took up cameras too. In 1941 *Popular Science Monthly* reported that Americans owned 19.5 million cameras, mostly box cameras.[1] The 2010 PMA U.S. Camera/Camcorder Digital Imaging Survey concludes that 61 percent of American households own one or more camera phones, and that 85 percent of owners say they used the device to take pictures in 2009.[2]

Photographically based imagery of all kinds grew steadily too. After World War I, as newsreels appeared in more and more movie theaters, newsreel cameras came calling frequently at the White House in the 1930s and 1940s, feature films re-created the mansion for drama and comedy, and television cameras started taking tours of it in the company of Harry S. Truman in 1952. The image culture has expanded even faster than the population, and photographic concentration on Washington looks like a continuous growth industry.

As camera use and the love of, numbers of, dependence on, and immersion in photographs increased inexorably with the years — and the ease and habit of taking pictures grew to match — pictures of the largest and the least little items of visual information dealing with the president and his home swelled to high tide. People interested in government and even people inside government joined the crowds with cameras. Cameras, it turns out, have a real advantage in Washington: they never get voted out of office.

OPPOSITE: White House photographers pose on the South Lawn of the White House, May 1918. Harris & Ewing.

Press photographers had recently formed an association and were already out in force. Because of long exposures, tripods or steady hands were imperative.

Amateur photographer taking pictures of Easter egg rolling, 1889. Photographer unknown.

The White House has played host to children at an annual Easter egg roll on the lawn since 1878. The gentleman on the left is using one of the first box cameras, put out by Kodak in 1888. It took round pictures like this one. Whoever photographed him must have been using the same or similar equipment.

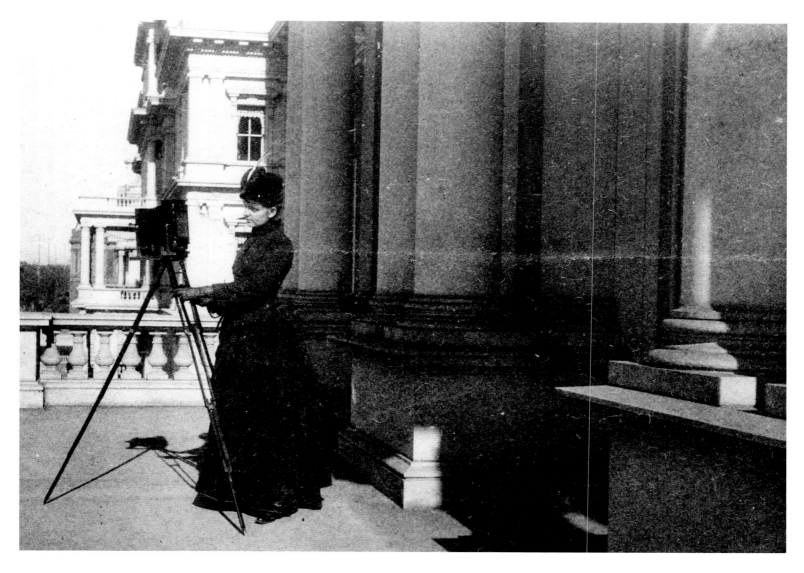

Frances Benjamin Johnston with camera, 1888. Photographer unknown.

Frances Benjamin Johnston, known as "the photographer of the American Court" in the 1890s, on the balcony of the State, War and Navy Building. Her photographs of the White House and its inhabitants during five administrations made ordinary people feel like insiders.

Quentin and Archie Roosevelt play with Johnston's camera, 1902. Frances Benjamin Johnston.

The fascination of a camera — especially when it was still primarily a grown-up's domain.

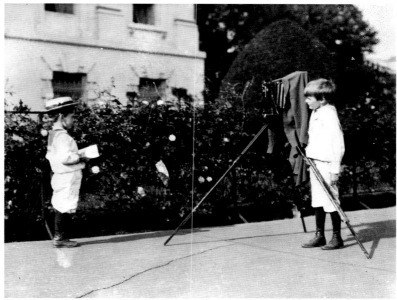

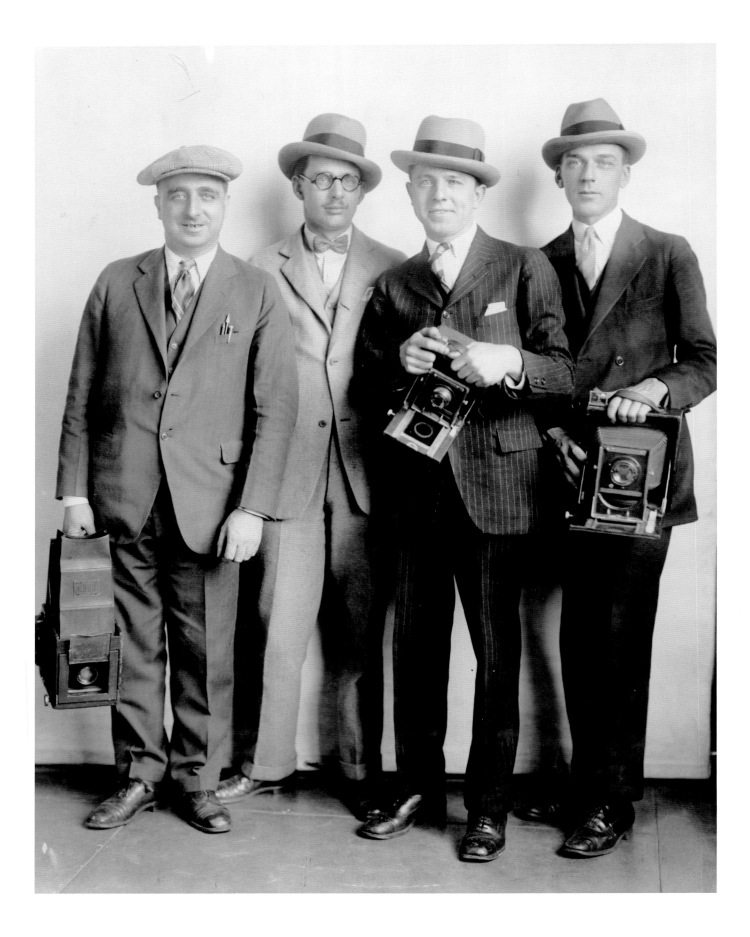

OPPOSITE: Four White House photographers, 1922–1926. Photographer unknown.

Pin stripes, three-piece suits, fedoras, and hand-held cameras. No flash — that hadn't yet been invented.[3]

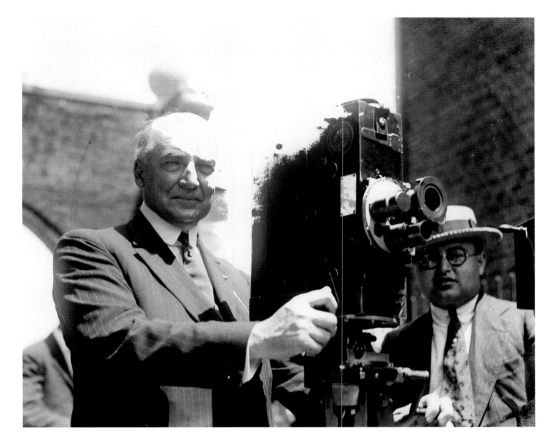

Warren Harding with movie camera, 1921–23. Photographer unknown.

As silent movies gained a mass audience in the 1920s, newsreels conveyed more and more of the news. Here President Harding puts his stamp of approval and authority on a matter of public interest.

Photographer takes a picture of President Harding and Laddie Boy, 1922. National Photo Company.

The Hardings presented Laddie Boy before the public in photograph after photograph to warm up the image of his rather cool master.

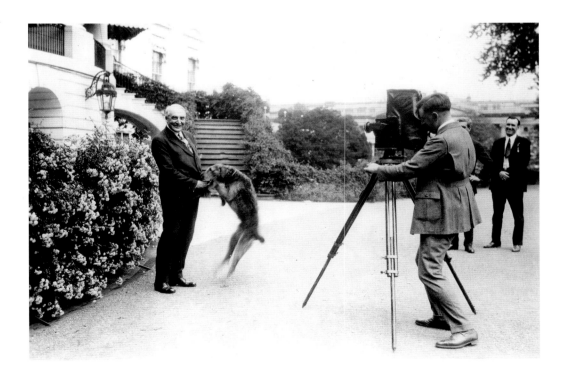

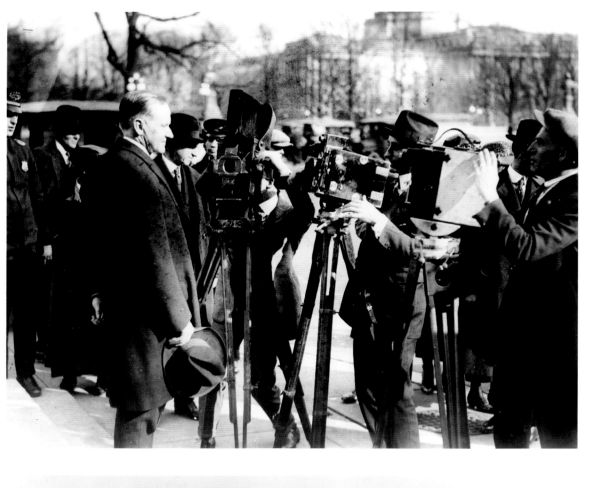

Calvin Coolidge with photographers, 1923–29. Photographer unknown.

The camera is demanding, and presidents learned early on that it was their duty to give in to it.

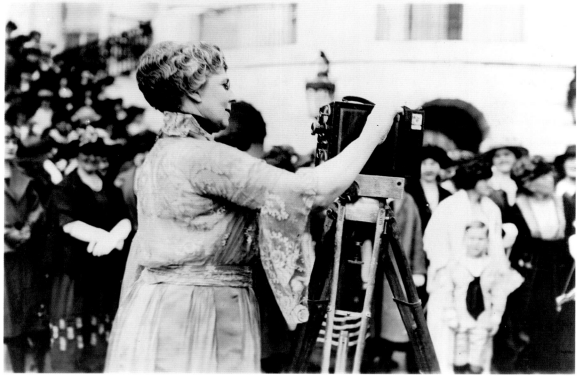

Mrs. Harding behind the camera, 1921 or 1922. Herbert E. French.

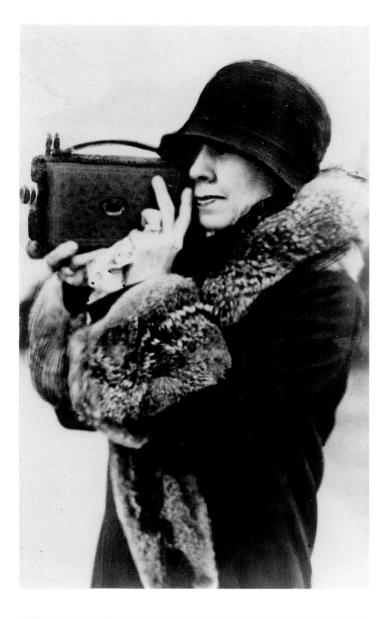

Mrs. Coolidge behind the camera, February 9, 1929.
Herbert E. French.

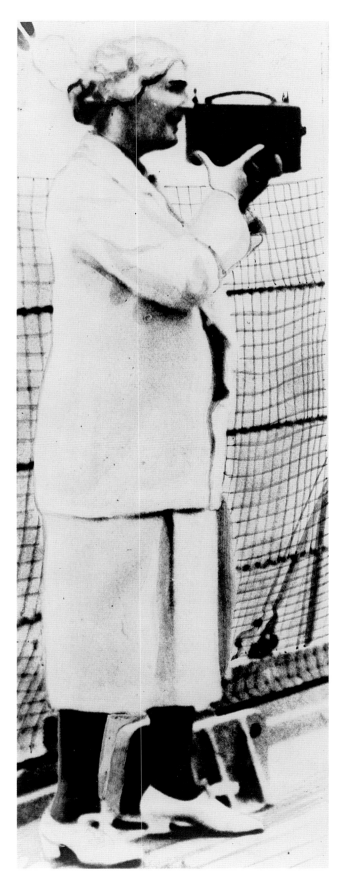

Mrs. Hoover with camera, February 9, 1929. Herbert E. French.

Herbert E. French was the proprietor of the National Photo Company, which had been in business since the late nineteenth century. The company supplied its subscribers with daily photographs of current news events in Washington during the administrations of presidents Wilson, Harding, Coolidge, and Hoover. Presidents' wives wielding cameras may not seem much like current news events, but they were top-notch filler for slow news days.

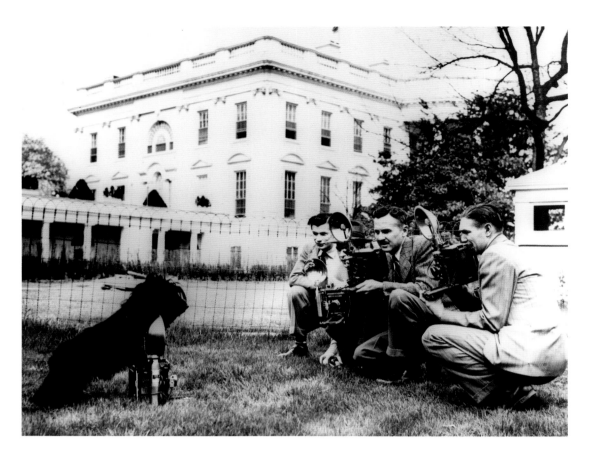

Fala with news photographers at the White House, 1942. Photographer unknown.

Even Franklin Roosevelt's dog could operate a camera.

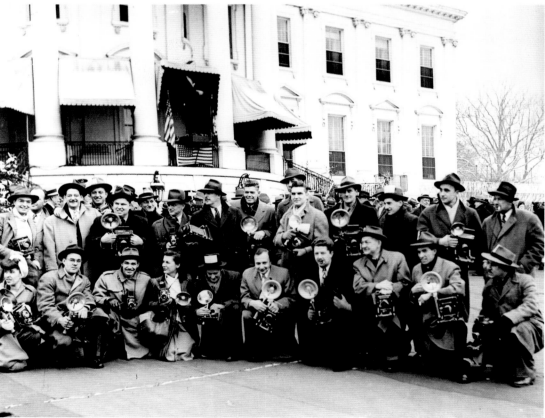

Photographers in front of the White House South Portico, January 20, 1945. National Park Service.

Fedoras and Speed Graphics were de rigueur in 1945 — but two women have crept into the all-male club. Everyone now has an attached flash bulb, an innovation in the late 1920s that was commercially marketed by 1930. National Park Service photographers covered the White House for years before the house hired its own official photographer in President Kennedy's day.

Abbie Rowe and photographers, 1954. Photographer unknown.

These photographers are still using Speed Graphics, the large-format news cameras that were traditional among newspaper photographers long after the 35mm camera came in.

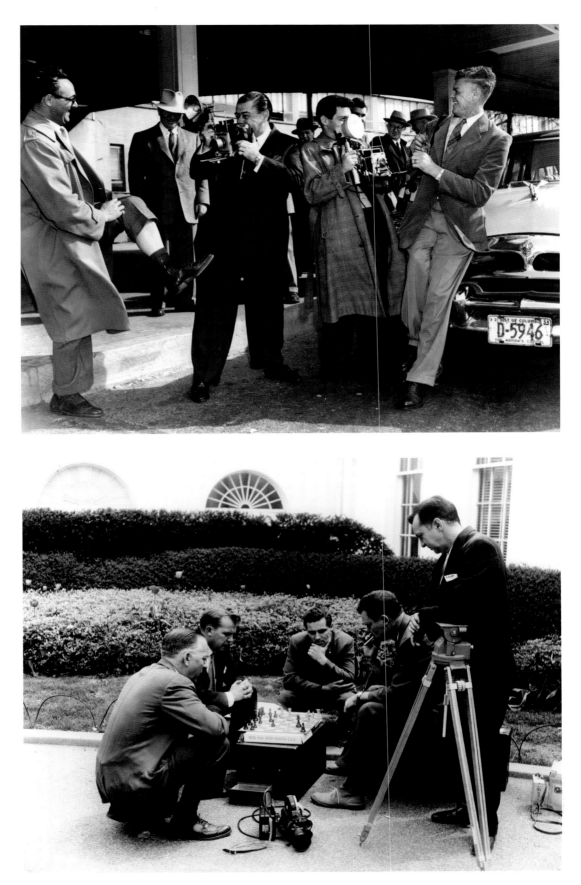

White House photographers' chess game outside the West Wing, April 21, 1961. Abbie Rowe.

News is news, whenever it happens, but the White House has never produced it 24/7 — and in 1961 no one was publishing photographs 24/7 anyway. A lot of a photographer's job was waiting around. When Woodrow Wilson was quite ill, photographers were only permitted to wait on the steps of the State Department building. Every syndicate kept one photographer there, but White House traffic was so slow that they sometimes waited all day without taking a single picture. At times, each of them would give one man a plate of film and escape to the local vaudeville. One day an important visitor saw a lone photographer and paused for a couple of snaps. After the fifteenth plate was inserted into the camera, the visitor said, "Not sure of himself, is he?"[4]

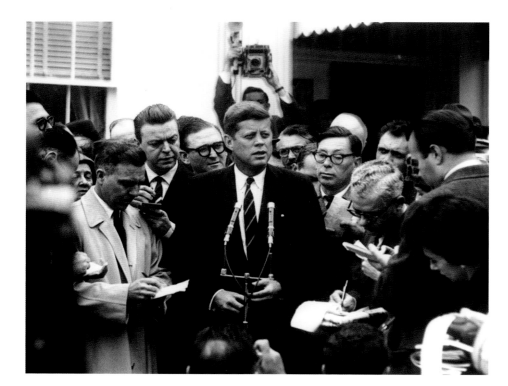

President John F. Kennedy with reporters, 1960. Abbie Rowe.

The press around the president was so thick that all a photographer could do was hoist his camera above his head and hope for the best.

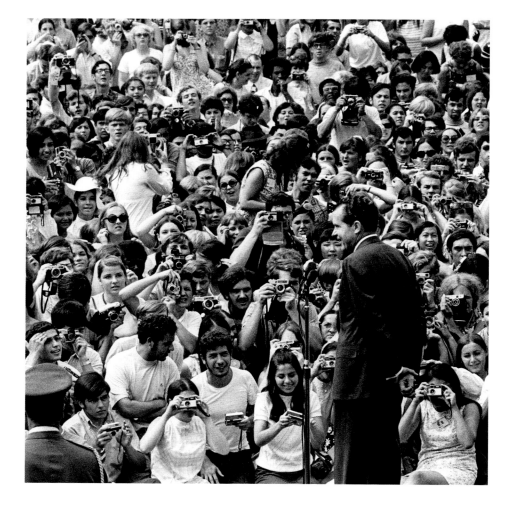

President Richard Nixon welcomes students on the White House lawn, July 22, 1969. Oliver F. Atkins.

The president is just about the only person in the picture without a camera.

OPPOSITE: George Mobley taking the cover photograph for the first White House guidebook, 1962. Robert F. Sisson.

Any angle for a photograph. The fire department gave Mobley training on how to work on a high ladder. The resulting high-angle view graced the cover of the guidebook that was shot at Jaqueline Kennedy's behest and has since been followed in endless editions by endless numbers of tourists.

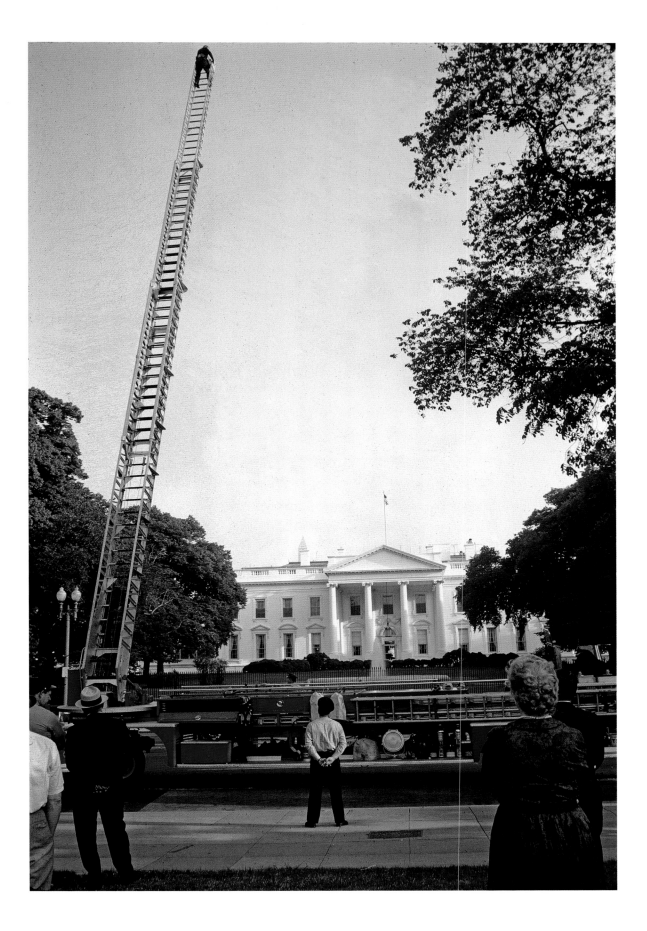

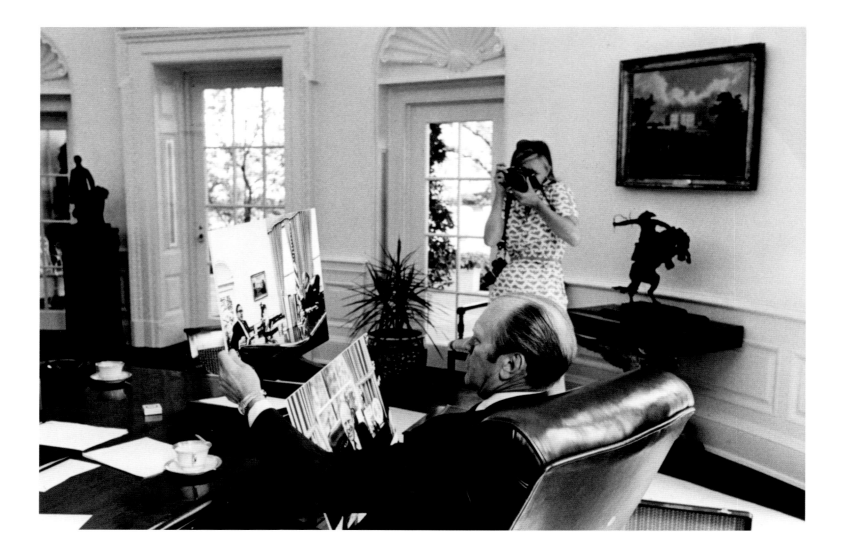

Susan Ford takes pictures of her father, who is looking at pictures she took, 1975. David Hume Kennerly.

Gerald and Betty Ford's daughter, Susan, who had been coached by David Hume Kennerly, the official White House photographer, became an accomplished photographer herself.

OPPOSITE, ABOVE: Tourists at the White House, 2009. Jim Hamann.

Tourists want pictures of themselves before the White House to prove they've been there, however they arrived.

OPPOSITE, BELOW: President Obama and George W. Bush at inauguration ceremony; Malia Obama taking a picture, January 20, 2009. Timothy A. Clary.

Kodak calls this Kodak EasyShare M893 the "Obama Official Family Inaugural Digital Camera." An unusual example of what is called "citizen journalism" — even a spectator who is not literally a participant but still within a news event can take a photograph of it, from a position not generally available to photographers or observers. Malia Obama is using a digital camera. Consumer Electronics Association market research reported that in 2008, seven in ten American households owned one, and the percentage was set to rise; but partly because of saturation, the market would experience a gradual decline.

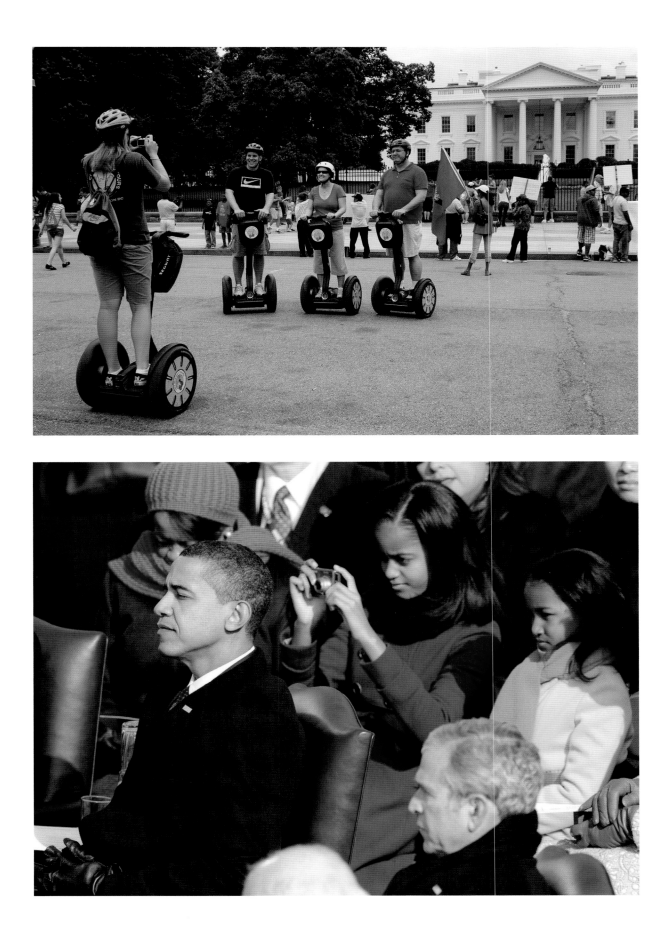

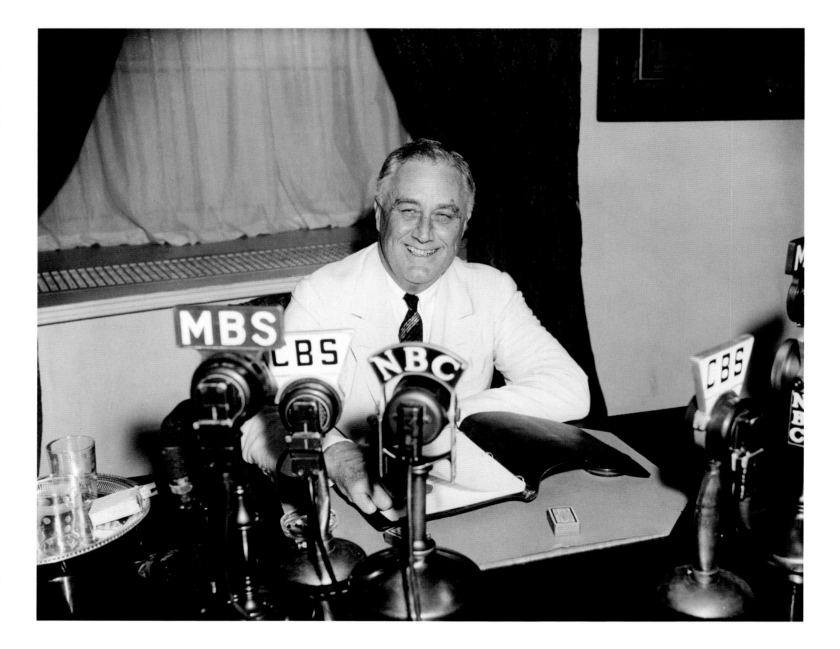

CHAPTER 6: WHITE HOUSE NEWS, MEDIA, AND IMAGE

BAD NEWS AND good news traveled fast across the country in the nineteenth century on steel rails and electric wires. In 1846, during the Mexican-American War, news traveled by pony express to mail coaches, then to a telegraph point, and then by telegraph to New York. Telegraph lines were strung from Washington to New York that same year and were soon springing up across the land, bringing breaking news from Washington to the far reaches of the country. The Civil War was reported as it happened, a first for any war, though the administration made certain it could control the news by making a deal with the Associated Press. The AP became the exclusive provider of news dispatches from Washington during the war, and in return it distributed or refused to distribute reports, and tailored what it did distribute, as the administration directed.[1]

Communication between Europe and North America still took a week at minimum, but in 1866 a cable was successfully laid from Great Britain to Newfoundland. From there, messages had to make their way to the mainland—a twenty-four-hour trip, but almost like lightning when compared to seven days. Other cables soon followed. Early on the government encouraged communication networks by building post offices and post roads, giving newspapers low rates, and supporting the telegraph soon after its invention. The first telegraph message wasn't the proverbial "What hath God wrought?" but the news that Theodore Frelinghuysen had been nominated for vice president at the 1844 Whig Party convention[3]—presidential news got there before God did. As the century and technology progressed, the public and the press concentrated harder on the president and the White House, focusing in depth first on Lincoln and the Civil War and seldom going out of focus after that.

The growth of the printed press and the introduction of the illustrated press in the nineteenth century abetted and encouraged the production of personal images of major figures. Politicians and campaign managers caught on quickly to the importance of an image and how vital it was to establish one that was readily identifiable. When William Henry Harrison ran for the presidency in 1839, his backers promoted him as a log cabin man with a penchant for hard cider. Log cabins were erected and barrels of cider set out in major cities, and little log cabins dangled from the watch chains and earrings of his supporters. Never mind that he was in fact a wealthy planter; the times called for a "common man."[4]

When journals started printing illustrations regularly in the 1840s, the visual images of public figures assumed a new importance, and photography soon raised the ante. Once the small, inexpensive *carte de*

OPPOSITE: **President Franklin Roosevelt broadcasting from the Diplomatic Reception Room, 1933. Harris & Ewing.**

Franklin Roosevelt was inaugurated on March 5, 1933, and gave his first "fireside chat" on the radio on March 12. After that he gave two or three radio addresses each year he was in office, spacing them out so that each would be an event and using them to bolster public support for his programs. By 1934 more than 65 percent of American homes had radios, and in 1935, in big cities, 93 percent.[2]

On the radio, FDR conveyed a sense of forthrightness and sincerity, and even though people generally listened with family and friends or in public places like churches or barracks, he seemed to speak to each listener individually. After his initial chat, a woman from Illinois wrote, "You are the first president to come into our homes....Until last night, the president...was merely a legend....But you are real. I know your voice; what you are trying to do."

In 1928 the *New York Times* foresaw the rise of the sound bite: "It is believed that brief pithy *(continued on next page)*

visite photograph became available around 1860, the celebrity craze was off and running. People began collecting photographs of generals, politicians, actors, artists, and presidents—almost anyone who seemed somehow larger than oneself. A photograph of Lincoln helped elect him in 1860, which must have spurred Lincoln's shrewd cultivation of his image throughout his presidency. Presidents James Polk, Zachary Taylor, and Franklin Pierce were each photographed about ten times, Lincoln more than one hundred.[5]

His timing was appropriate, for the illustrated press, the reproducible photograph, and the Civil War interacted and multiplied one another's effects. Politics, celebrity, and news were in process of being transformed into visual experiences. Illustrated journals published engravings about the Civil War in every issue. *Harper's Weekly,* for instance, could put pictures on press less than two weeks after the news had occurred. The transmission time for news reports had been shrinking ever since the telegraph went into operation in 1843, and the transmission time for visual reports had begun to speed up. The reading public expanded in response. By the late 1850s, magazines in America were reaching as many as 100,000 people a week, and war, then as now, drove circulation to new heights.[6]

By the end of the Civil War, the press was beginning to cover the White House regularly. Reporters expressed a strong sense that American democracy gave them a right to be in and report on the White House. Emily Edson Briggs, who in the 1860s became the first woman reporter assigned to the capital, wrote on social doings at the White House: "[It] belongs to the people. When we go to the Executive Mansion we go to our own house." She extended the argument to a defense of her right to write about anyone there: "Whoever goes to a levee at the Mansion becomes public property and has no more

right to complain because he has been caught in the net of a newspaper's correspondent than the fish who has swallowed the hook of an honest fisherman."[8] In 1879 President Rutherford B. Hayes kept the press, save for one reporter, in the vestibule "with the negro footmen and the band" during a reception for the diplomatic corps. The next day, the *Washington Post,* in a front-page article headlined "Snobbish Reception," let citizens know that it was miffed and they should be too. The paper angrily accused the administration of trying to imitate the courts of Europe, which, when they gave diplomatic receptions, invited "only high officials, and no plebeians or citizens."[9]

As mass readership and illustrated publications continued to increase in number, human interest, gossip, and sensationalism increased along with them and extended to the White House. When Grover Cleveland married in 1886, a story that blanketed the newspapers, he and his bride tried to hide from reporters at a honeymoon cottage, but reporters swarmed after them, kept watch twenty-four hours a day, and filed an estimated 400,000 words over five and a half days.[10] During Cleveland's second term, a writer said, "President Cleveland has not felt able to reciprocate the intimate attitude of the 'new journalism,' which in its first overtures outraged the rights of privacy in a manner never before heard of, and probably never since equaled."[11]

News photography made a leap forward with the invention of the hand camera and halftone reproduction in the latter part of the nineteenth century, and advances in printing presses in the early twentieth century spelled a wider welcome for photography in newspapers. Lenses and film were still relatively slow by standards established in the late 1920s, but candid photography had already staked a claim on territory that would be explored more fully later on. When it came to

(continued from previous page): statements as to the positions of the parties and candidates, which reach the emotions through the minds of millions of radio listeners, will play an important part in the race to the White House." Radio ownership grew during the 1930s: in 1934, 65 percent of homes had a radio; in 1940, 81 percent. Surveys reported that by December of 1941, the month that Pearl Harbor was attacked, a large majority of Americans said that radio rather than newspapers was their main source of news.[7] For

Roosevelt the medium had the extra advantage of allowing him to address the citizenry without their observing his paralysis. His press secretary arranged for broadcasters to turn on the microphone several seconds before FDR began a speech, reckoning that an initial burst of applause would put listeners into a receptive mode.[12] Roosevelt's highly effective use of a relatively new mode of communication, just as it was becoming dominant, transformed the presidential use of mass media.

presidents and other eminences, formality and posed pictures continued to reign at least until the era of the 35mm camera, first marketed in the mid-1920s. This formality was not simply due to technical limitations but owed a good deal to convention and social expectation. Rich people, officials, people who were owed (or thought they were owed) other people's respect still had significant control over how they were presented and represented, control that the camera has since then largely wrested from their hands. Presidents, for instance, were often eager to pose for the photographic press, and photographers were equally eager to stay in their good graces by making them look dignified, authoritative, and appropriately presidential.

The surge in immigration late in the century, bringing in many who were illiterate or couldn't read English but wanted to learn it and wanted to know what was happening, encouraged the publication of pictures. So did the expansion of bus and train commuting within cities, making a rapid read a staple of middle-class life.[13] There were 700 magazines in America in 1865, around 3,300 by 1885. By 1884 magazines like *The Century* and *Harper's* devoted about 15 percent of their space to pictures; by 1893 nearly a third of the pictures in *The Century,* two-thirds in *Scribner's,* and almost all the illustrations in *Cosmopolitan* were halftone photographs.[14]

The nineteenth century's intense belief in the value and verity of observation, fact, and documentation, a belief that had bestowed on photography a reputation for unimpeachable authenticity, reached a peak late in the century. In 1893 Clarence Darrow, in an article on realism in the arts, wrote: "The world has grown tired of preachers and sermons; to-day it asks for facts. It has grown tired of fairies and angels, and asks for flesh and blood."[15]

Interest in, and reporting about, the White House kept mounting. Whatever they do, presidents are news. Sometimes they pose to oblige the press, sometimes they can't help themselves. The photographs in this chapter, some candid, some not, depict our presidents, but the photographers did not take them to acquaint the viewer with the subjects' features. When the images spotlight the chief executive in public moments, as often as not they are about the office more than the personality (much less the soul) of the office holder.

The image of a candidate or a president, whether a portrait or an emblem or what we would now call a brand, was important from the beginning. Engraved portraits of George Washington, which had been popular during his lifetime, remained popular long after his death and still show up daily on dollar bills. There are many ways of impressing an image or perception on a large number of minds, but almost all of them involve repetition and wide distribution—and visual images are particularly likely to stick in the mind. Photography delivered. In Theodore Roosevelt's time, the fourth estate finally got a permanent place at the White House when the president offered a small room set aside for the press in the 1902 temporary West Wing annex.[16] Roosevelt's predecessor, William McKinley, had begun to push his policies before the public when he found himself in a newsworthy situation, but TR made it a practice. He befriended the press in order to get the kind of coverage that would win popular support for his programs.[17] As the technology and reach of the media swelled in the twentieth century, and as the president became ever more the center of government and news, presidential attention to media coverage and ways to obtain and influence it mounted steadily. It is easier, and more likely to intrigue a reader, to focus a story on a man, his actions and personality, than on a policy, particularly one that is complex. Presidential campaigns ultimately became primarily and predominantly media events, and presidencies lean in the same direction. The media and the president frequently have different goals and reciprocal enmities, but they have played with and upon one another as often as against. The media wants both news and stars; the president qualifies on both counts.

TR relished publicity, and photographers were more than willing to oblige him. He once delayed signing a proclamation until the Associated Press could get the photographer to the White House, and when the photographer arrived, the president interrupted a meeting with the secretary of state so equipment could be set up and a photograph taken.

Warren Harding, who had been a newspaper editor, realized that he could get to the public by letting the press in on his leisure time activities as well as standard ceremonies. He gave the newly formed White House News Photographers Association access to all his public and certain private events, and he willingly posed for photographers several times a week.[18] Harry S. Truman

astutely recognized how potent the media were and how embedded in White House doings; when he had the mansion remodeled in 1952, he put in a new staircase with a broad platform a few steps above the State Floor, perfectly suited for "photo-ops."[19]

Television changed the nature of elections, as well as the way people received the news. Truman gave his presidential speeches on television beginning in 1947, and his 1949 inauguration was televised — but few people owned sets at that time. Truman's televised tour of the reconstructed White House in 1952 attracted thirty million viewers, an early instance of a wide TV audience, and when Dwight Eisenhower went on television in 1957 to address a nation made uneasy by images of the Little Rock school desegregation confrontation, it had a calming effect.[20] Ike also was the first president to use television commercials in an election campaign.[21] But the impact of politicians on television was dramatically heightened by Richard Nixon during the 1952 presidential election campaign when an audience twice that of the Truman tour tuned in on his famous "Checkers speech," a brilliant political maneuver using a televised speech to underscore his modest lifestyle and to announce the innocent arrival of "Checkers," a dog given to his daughters, to deflect accusations that he had dispensed favors in return for campaign fund.[22]

Nixon had uncovered television's enormous power, which neither he nor anyone else in the White House or on the track to it ever forgot. What it meant to him was a means of going over the heads of what he perceived as a hostile press and directly to the people, a lesson well learned by candidates and presidents. President Kennedy gave press conferences live on television at least partly in order to circumvent what he saw as the Republican-controlled press.[23]

The power of the visual image, specifically the photograph or the photographically derived image on television, loomed larger and larger in the minds of presidential advisers. In 1964 Horace Busby, special assistant to President Lyndon Johnson, sent the president a memo advising that a happy family image — preferably a photograph, for "pictures are worth a thousand words" — was the best way to ward off political smears, and he specifically recommended a photograph of LBJ walking hand in hand with his wife in the garden or bowling with his daughter.[24]

When Nixon ran for president in 1968, his campaign, having decided that the press did not matter, remade his image for television. At one point his managers, keenly aware that he was not a natural television personality, switched to sixty-second TV commercials composed of still photographs. Nixon wasn't shown, though he delivered in voice-over the same messages he'd been saying for a long time. Images of Americana had been put together to convey the impression that Nixon represented competence, respect for tradition, everything rosy and good. His advisers were certain that the images would supersede the man; one of them said, "He's going to be elected on what he didn't say. He's created an image of himself through cornball."[25] Nixon won the election.

Ray Price, one of Nixon's speech writers, said the image was not merely useful, it was everything: "We have to be very clear on this point: that the response is to the image, not to the man, since ninety-nine percent of the voters have no contact with the man. It's not what's there that counts, it's what's projected — and carrying it one step further, it's not what he projects but what the voter receives."[26]

By the time that Ronald Reagan was president, photo ops were more carefully set up: chalk marks were put down to show the president where he should stand. Still, the triumph of the image has proved a thorny proposition and hard to control for presidents, who must look competent and tough but also "caring" and accessible. Presidential candidates are obliged to appear on popular programs to prove they are "regular guys," even to appear on the comedy programs that exist to make fun of them — to prove they have a sense of humor. In 2008 Hillary Clinton did a stint on *Saturday Night Live;* she, John McCain, and Barack Obama were on the *Late Show with David Letterman,* and all three, as well as Michelle Obama, appeared on *The Daily Show with Jon Stewart* on different nights.

Such shows are where the audience has gone, especially the young audience. *The Daily Show* ordinarily draws about 2 million viewers, but Michelle Obama's appearance attracted 3 million, and Barack Obama broke all records with 3,600,000.[27] Television still dominates election news, though its share as people's main source of such news declined from 68 percent in 2004 to 60 percent in 2008. The television debates, so potent in Kennedy and Nixon's day, were less watched for information about the candidates than news and entertainment programs were.[28]

Today's news leaps onto the internet long before print and often before television, but television still drives online news rather than the other way around. A large portion of political (and other) news on the web consists of videos taken from the tube (which cannot be reproduced here, in something as old-fashioned as a printed book). But the internet has changed the game, and a savvy CNN united the power of television with that of YouTube in 2008 to broadcast two debates, one for the Democrats and another for the Republicans.

In 2008, 42 percent of those age eighteen to twenty-nine said they regularly learned about the campaign from the internet, and more than a quarter of those under thirty got campaign information from social networking sites.[29] Every candidate in 2008 had a website, a social network presence (or two or three), and e-mail and texting programs, and political news remained online once the candidate moved into the White House.

And as with photography, radio, and television, the internet rewarded those who knew how to use it best or were best suited to the web. Lincoln used photography to keep his image before the people, Franklin Roosevelt used radio to establish what felt like person-to-person communication; television fit Kennedy's good looks and quick wit, as well as Reagan's affable actor skills, like a bespoke suit. The internet, so far at least, prizes two distinct abilities: the capacity to spread messages widely and the ability to establish an apparent intimacy, to "friend" a stranger.

Barack Obama's campaign was highly polished at both abilities. His social network site, my.barack obama.com, was overseen by Chris Hughes, the twenty-four-year-old cofounder of Facebook. More than 2 million people logged in through Facebook, another 800,000 on MySpace, and still others on LinkedIn and on Obama's YouTube site. All the campaigns during the 2008 election tried to establish some sort of personal conversation with their adherents, something that's extremely difficult to do with large numbers, and most such attempts went limp or struck digital-age adepts as fake. But the Obama campaign made its site a meeting place for its supporters, where they could plan parties and marches, pass along information, form cooperative teams, and connect one-on-one and face-to-face with people in their vicinity who wanted to work for the candidate: true conversations. Communication of all sorts was well managed. A million people signed up when asked if they wished to receive text messages from the campaign, and the Obama team would send out roughly edited campaign videos to supporters before the press got them, giving loyal followers the sense that they were privileged insiders.[30] Virtually all these tactics were preserved when he became president.

One campaign e-mail showcased a ten-minute video of Obama's dinner with five small donors. In a homey encounter that created a sense of intimacy, the conversation ranged widely from Obama's children to comic books. The candidate looked like a man who was "just folks," someone you'd be inclined to take a meal with at the corner coffee shop. The image was meant to appeal to people who would not ordinarily be very interested in politics: digital politicking to reach the uninvolved.[31] The digital era was beating a path to the White House.

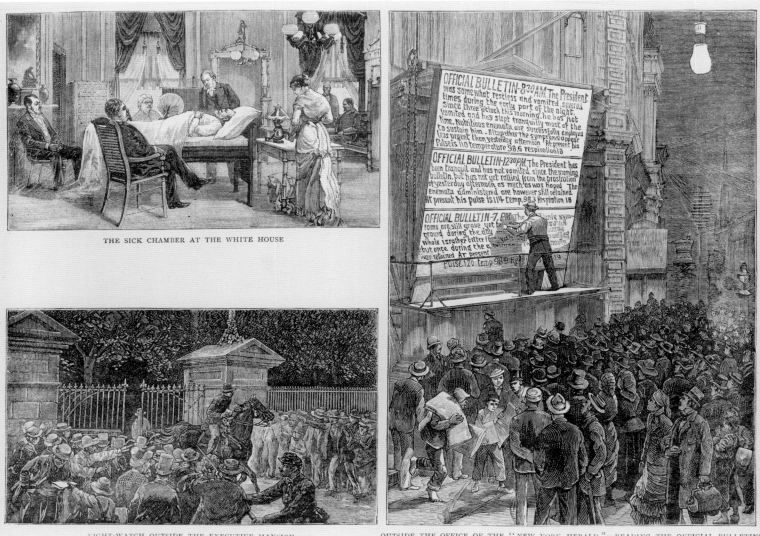

THE SICK CHAMBER AT THE WHITE HOUSE

NIGHT-WATCH OUTSIDE THE EXECUTIVE MANSION

OUTSIDE THE OFFICE OF THE "NEW YORK HERALD"—READING THE OFFICIAL BULLETINS

THE DEATH OF PRESIDENT GARFIELD

SKETCHES TAKEN DURING THE ILLNESS

Death of President Garfield, wood engraving from _The Graphic,_ September 1881. Artist unknown.

When President Garfield was shot in 1881, he lingered a long while before dying. Journalism was in the process of becoming big business. The press naturally made every effort to report crucial news in detail. Life was speeding up and distances shrinking at a bewildering rate, and in so important a matter, people wanted information in "real time." Bulletins were frequently issued from the Executive Mansion, and a newspaper in New York could enlarge and

display the headlines not long after they were released — a forerunner of the LED running-news feeds on big city buildings and the "crawl" beneath certain television newscasts.

OPPOSITE: President Theodore Roosevelt running an American steam shovel at Culebra Cut, Panama Canal, November 1906. Photographer unknown.

Theodore Roosevelt was determined to cut a canal through the Isthmus of Panama, then a part of Colombia.

The Colombian government would not agree to his terms. So in 1903, when a revolution erupted seeking to make Panama an independent republic, TR, without consulting Congress, arranged for American warships to stand off the coast in silent support. The revolutionaries pulled off a bloodless coup, Panama seceded, and the new government soon signed a convention giving the United States the right to construct a canal. When called upon by his cabinet to defend his actions, TR argued that they were entirely moral and essential to American interests. Elihu Root, his secretary of war, said, "Mr. President, you have shown that you were accused of seduction...and proved that you were guilty of rape."[32]

The president went to Panama in 1906 to survey progress on the canal, the first time a sitting president had left the country. Ever curious and adventurous, TR seized an opportunity to take the controls of a gigantic steam shovel. The photograph puts him in the exact middle of the frame and of the machine, visually implying that in the man-machine nexus, humans may be smaller but are central to the power of technology. TR, whose light suit becomes the focus of the image, is juxtaposed with the workman at the upper right, suggesting that although he's more distinguished, he is not above dirtying his hands.

He knew just how valuable photographs of him were, and usually managed to be at the center of events as well as photographs. His daughter Alice is reputed to have said that he wanted to be "the bride at every wedding, the corpse at every funeral, and the baby at every christening."[33]

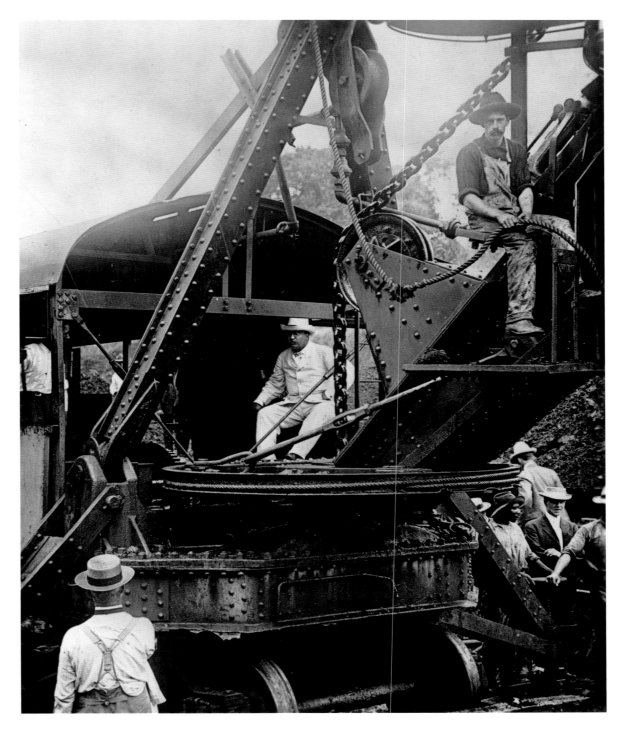

The McKinley stump, Chehalis, Washington, c. 1905. Photographer unknown.

Anything touched by a president took on his aura, and others hastened to borrow some of that aura. McKinley's only association with this stump was that he spoke from it. Taft did too, as did various men with some claim to fame. The sign and the structure are variants of the "George Washington slept here" signs, the boast of many an inn.

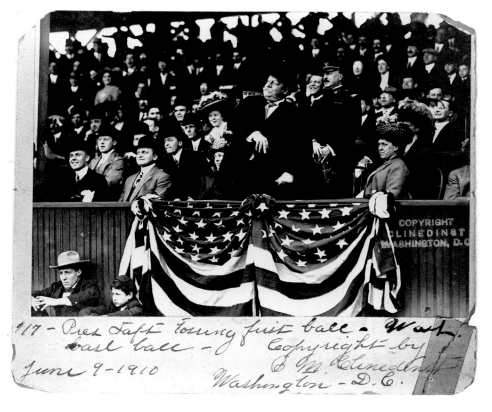

President Taft throwing out the first pitch on opening day in Washington, D.C., April 14, 1910. B. M. Clinedinst.

Photographs of Taft throwing out the ball at professional baseball games — he was the first president to do so — appeared in newspapers everywhere.[34] Presidents have played and loved a game similar to baseball since George Washington's day and have attended major league games since June 6, 1892, when Benjamin Harrison saw Cincinnati beat Washington. Today it's the sports stars who draw the fans, but it took the image of a president who probably didn't play at all to widen baseball's popularity early in the last century.[35]

William Howard Taft on the golf course, c. 1890–1910. Frances Benjamin Johnston.

When photographs of Taft playing golf — a rich man's sport — got into the papers, Theodore Roosevelt advised him to stop them right away. He said he himself didn't even allow photographs of his tennis games. "I'm careful about that; photographs on horseback, yes, tennis, no. And golf is fatal."[36] Taft played on the links and played to the camera anyway, making nine holes safe for future presidents.

Richard Nixon and Bob Hope in the Oval Office, April 20, 1973. Oliver F. Atkins.

Golf became so popular that President Nixon happily stood in for the first hole for another golfer, the comedian Bob Hope. And in 1971 Alan Shepard became the first man to hit a golf ball on the moon, having smuggled a ball and a golf club head on board inside his space suit.[37]

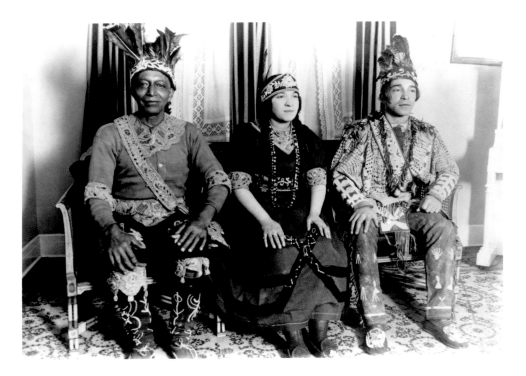

Three "last of the Mohicans" bring a cure to President Wilson, 1920. Photographer unknown.

In 1919, shortly after an arduous (and unsuccessful) cross-country campaign to gain public support for America's entry into the League of Nations, President Woodrow Wilson had a severe stroke. Though his near-total incapacity was kept secret from all but a very few people, citizens were naturally worried about the leader of the country. Native Americans had reason to wish Wilson well. Thirty-two chiefs had gone to his inauguration, many had shown their patriotism by fighting in World War I, and during his administration, "qualified Indians" — supposedly most of them but in fact a limited notion — were granted citizenship.[38]

Native Americans were hardly strangers to the White House. Since Thomas Jefferson's presidency, delegations had presented themselves to the president to negotiate and sign treaties (which were regularly abrogated) and to attend public receptions wearing their native dress and occasionally war paint. After the Civil War, hundreds of delegations were invited, and it was customary for them to visit Washington photo studios to have their portraits taken.[39] They also presented popular subjects for photographers at the White House itself, where they were photographed posing with presidents and other officials.

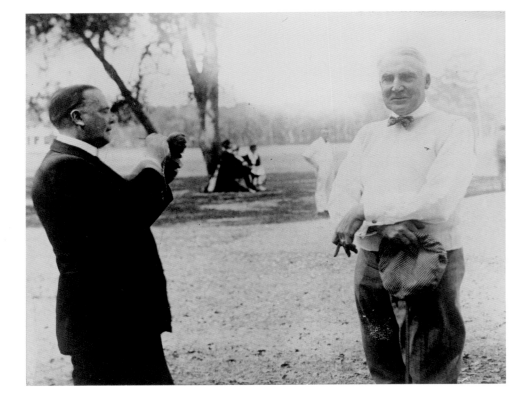

Ben Harney, "noted sculptor," making a working model of President-Elect Harding, February 21, 1921. Underwood & Underwood.

Images of the president were so important, and presidents understood that so well, that it was worth interrupting a game of golf to pose for one.

Albert Einstein and President Harding, April 1921. Photographer unknown.

American presidents have simultaneously lent and borrowed prestige by posing with the famous: Hoover with Amelia Earhart, Eisenhower with Helen Keller, Kennedy with John Glenn, and so on. They do more lending than borrowing with the likes of cowboys, girl scouts, and owners of prize roosters; such pictures, by making the local news, give them what looks like a personal connection to specific constituencies and suggest that the chief executive is in touch with "the people."

Albert Einstein visited the United States for the first time in 1921 and was received at the White House by the president.

President Harding with Confederate veterans and their wives, June 23, 1922. Herbert E. French.

Presidents traditionally honor veterans of American wars, whether the wars were under their administrations or not. This group of aged veterans from a soldiers' home in Mississippi came to the White House with their own band, which played "Dixie."[40] Warren Harding, who had won in a landslide everywhere but the South, had some reason to think these veterans a particularly useful association. Historians generally rank Harding as one of the worst presidents in U.S. history because of the scandalous corruption of his cronies in the administration. He remarked that his enemies did not bother him, but his friends kept him awake at night.

Harding poses with newspapermen at the White House, May 29, 1921. Photographer unknown.

In 1914, when President Woodrow Wilson planned an unprecedented series of regular press conferences but didn't know which reporters to invite, eleven reporters founded the White House Correspondents' Association to ensure that only those correspondents assigned to cover the White House could attend. Once their interests were protected, the WHCA grew silent.[41]

Warren Gamaliel Harding revived the group. He was a newspaper editor for years before ever running for president, knew press techniques from the inside, understood perfectly the power of the press, and during his campaign managed to be "marketed" by the papers like a national product. Carl Sferrazza Anthony, biographer of Florence Harding, noted that Harding's "front porch campaign" was "the first time photography was manipulated as a political tool" — which is not to say used, but manipulated. Harding posed for a long while each week for a photograph that would showcase him in some admirable activity, such as raising the flag on President McKinley's flagpole, which had been moved to the Hardings' lawn. These pictures, precursors of the photo op, were then distributed to newspapers and magazines. His wife, intent on convincing voters that

they were "just folks," made him stop smoking and playing cards until the campaign was over.[42]

Once in the White House, Harding gave press conferences twice a week — Wilson had suspended them in 1916[43] — posed for photographs a couple of times a week, and played golf with a few favored correspondents. When the White House News Photographers Association was founded in 1921 (by seventeen still-picture and motion-picture photographers), Harding recognized the association immediately and set aside a room for photographers.[44]

Sound-movie trucks at the front door of the White House, 1929. Herbert E. French.

The first projected films were shown in France in 1895, and the medium rapidly spread. William McKinley's first inauguration in 1897 was filmed for about a minute, his second in 1901 as well. Films were made of the Spanish-American War in 1898 and of Theodore Roosevelt and the Rough Riders' charge up San Juan Hill; both were staged, as it was difficult and dangerous to get battlefield pictures with large, heavy equipment.[45] Newsreels, silent of course, were shown regularly in movie theaters after 1911. Woodrow Wilson's inauguration was filmed in 1913, and during World War I, newsreels were made on staged battlefronts. Moving pictures began to be an urgent part of the news. In 1915 D. W. Griffith, the movie director, told an interviewer, "The time will come, and in less than ten years, when the children in public schools will be taught practically everything by moving pictures. Certainly they will never be obliged to read history again."[46]

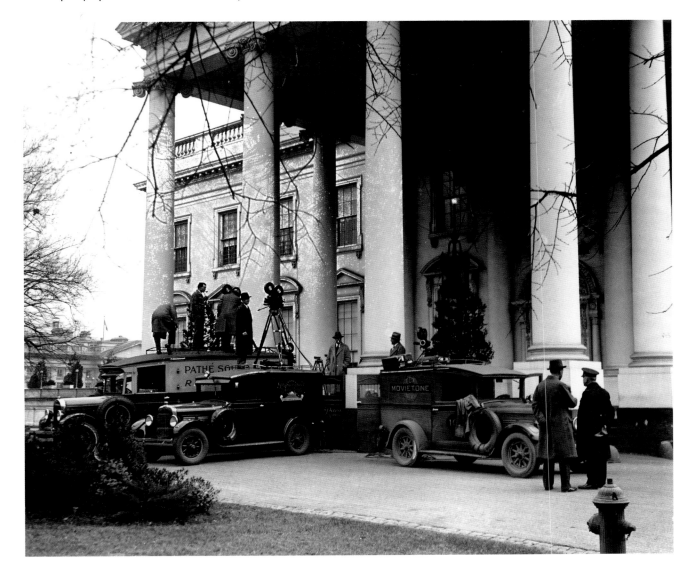

Mr. and Mrs. Coolidge try out skis on the White House lawn, December 18, 1924. Herbert E. French.

Calvin Coolidge came from Vermont, so it's not surprising that he and his wife lent their support to a Vermont sport, at a time when skis were made of wood. Still, the couple look a little silly by today's standards, trying out their skis on the White House lawn while wearing business clothes. Coolidge, despite his reputation for stupendous silences, had a good sense of humor and was more than willing to have his picture taken in wacky getups, including cowboy chaps or Indian headdresses, to photographers' delight.

Calvin Coolidge on his father's farm, c. 1924. George Grantham Bain.

Calvin Coolidge was one of the last American presidents with a real claim on the backwoods, a claim that had been an important part of several presidents' histories in the nineteenth century. He was Harding's vice president, and when the president died suddenly on August 2, 1923, Coolidge was vacationing at his father's Vermont house, which had no telephone, electricity, central heating, or indoor plumbing. Plymouth Notch, the nearby town, had no telegraph station and only a single telephone, located in the general store.

After a telegraph to Coolidge was sent to a town eight miles away, the telegraph operator called the Plymouth Notch store but got no answer, probably because the storekeeper was asleep. He then woke up a stenographer, the vice president's chauffeur, and a newspaperman, the three of whom promptly drove to Plymouth Notch and woke up Coolidge. Coolidge got dressed, went to the general store, and called the secretary of state, who told him a notary public could swear him in. Coolidge père,

a notary, swore in his son as the new president.[47]

When Calvin Coolidge was still vice president, he wore the woolen work smock his father and grandfather had worn to do chores on the farm. Photographs show him behaving like a farmer in this smock — and he wasn't playacting — but the reality seemed like a premeditated image. In his autobiography, he wrote that he realized the public thought this was a "makeup costume," and he said he had been "obliged to forego the comfort of wearing it. In public life it is sometimes necessary in order to appear really natural to be actually artificial."[48]

Calvin Coolidge with his sons, Calvin Jr. on the left, John on the right, 1924. Herbert E. French.

Coolidge worked hard on his image, which for the most part matched his personality. A biographer wrote that he "was, quite simply, the master of the self-made myth."[49] He cultivated the common-man image that had been so popular in the nineteenth century but that was much less prevalent for most of the twentieth. Sitting on the front porch, here at the White House itself, was one way to perpetuate the sense that wherever he landed was a "Yankee homestead," even if he was wearing a suit, tie, and straw hat.[50]

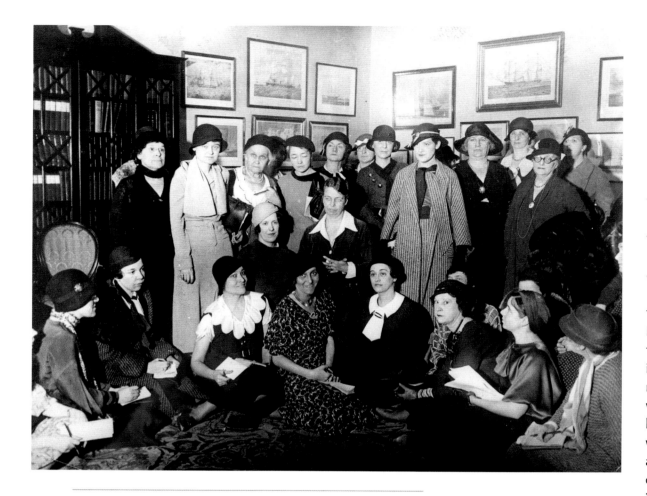

Eleanor Roosevelt with female reporters in the Monroe Room (now called the Treaty Room), 1933. Photographer unknown.

As carefully arranged as the women in this picture appear to be, several have been cut off in the corner or by heads in front of them. Professional women rigorously met expectations of how they should dress; only Eleanor Roosevelt, kneeling in the center with her eyes downcast, is hatless. Women had gone to work in greater numbers in the 1920s, most of them out of necessity. In 1930 well over half of working women were black or foreign born, chiefly employed as household servants or garment workers. The jobs open to professionals were mainly in nursing or teaching.[51] Reporters, a very small and specialized branch of the female working population — most of those covering the political scene in Washington were probably in this room — had a disproportionately large influence. They were doubtless worried about their jobs, as the Depression was causing newspapers to cut back; Mrs. Roosevelt's press conferences made the women reporters valuable. She got

some flak from the male press about the acolytes sitting at her feet in this photograph, but she put the conferences on a regular schedule.[52]

It had been known for years that a man who could control his image was ahead of the game. Eleanor Roosevelt knew what the country had in mind. During FDR's first campaign, she and AP reporter Lorena Hickok forged an image to fit long-standing expectations of a first lady, an image that would resonate for decades: a wife who acted only for her husband's and children's welfare, who did not care about politics, and whose own interests arose only in response to her husband's needs and interests.[53] She and Hickok also created multiple photo opportunities. The AP reporter even tried to advise her subject on how to be photographed to look the part. ER said, "My dear, if you haven't any chin and your front teeth stick out, it's going to show on a camera plate."[54]

Eleanor Roosevelt began earning money some time after her husband contracted polio in 1921. In time she lectured, wrote magazine articles, and made guest appearances on the radio.[55] In the 1920s she also committed herself to feminist causes in the belief that if women were sufficiently active on political issues they could bring about social change, and she continued to support women's causes while she was in the White House.[56]

Mrs. Roosevelt broke the mold for first ladies. In less than a year after the 1932 election, she spoke publicly about the necessity of helping the needy, and she was soon writing and speaking about issues, although she took care not to meddle in legislation that was under consideration. She was the first wife of a president to write a

syndicated newspaper column — "My Day" ran six days a week, beginning in 1935 — to sell articles to magazines, to earn money as a lecturer, and to be a radio commentator. In one three-month period, she traveled 40,000 miles to lecture, attend events, talk to people, and report back to FDR.

As no first lady had before her, ER used her position to express bold political views.[57] Her activism and endeavors (and her encouragement) held up an example for many women struggling to find a way to lead lives of their own. She frequently disagreed with her husband, sometimes publicly, yet they respected each other, and her opinions persuaded him often enough that critics regarded her as a usurper of executive privilege. Blanche Wiesen Cook, one of her biographers, writes that she ran "a parallel administration concerned with every aspect of national betterment. . . . FDR never credited ER with a job well done or publicly acknowledged her political influence. But little of significance was achieved without her input, and her vision shaped the best of his presidency."[58]

The president at work, February 25, 1935. Thomas D. McAvoy.

These are the first truly candid photographs ever taken of the president at work in the White House. Roosevelt, though he considered the press generally hostile and had a distorted picture of its animosity, was uncommonly friendly with reporters, correctly guessing that if he was easily accessible and the press thought him on their side, they were more likely to give him good coverage.[59]

A patrician by birth and upbringing, Roosevelt worked at promoting a sense of friendliness and ease with ordinary citizens. In 1935 he let Tom McAvoy, a *Time* magazine photographer, come into his office with five other photographers and photograph him not while he pretended to work, as McKinley and others had, but while he actually went about his business, which included uncontrolled, in-between moments that had not been evident in earlier presidential portraiture.

In 1925 the Leica had come on the market, and soon, Leicas and other 35mm cameras were finding their way into the hands of a few photographers. The 35mm camera had major advantages: it was small, its shutter was silent, and it was fast enough to photograph in available light, without benefit of flash. McAvoy had such a camera with specially sensitized film; the other photographers with their large Speed Graphics told him he couldn't get anything with that camera in that light, but thirteen of his twenty images were successful and were printed in *Time*.[60]

This was a new breach in the old ideas of privacy and the traditional notions of dignity before the camera, of preparing oneself to meet the public. Through the 1930s,

THE PRESIDENT AT WORK

Photographs on pp. 15, 16, 17 by Thomas D. McAvoy, Copyright TIME Inc.

Harbingers of Ceremony, six photographers were ushered into Franklin D. Roosevelt's office on the afternoon that the Brazilian Trade Agreement was to be signed. Five of them carried the usual equipment which they proceeded to set up in anticipation of the occasion. The sixth, Thomas D. McAvoy, had a tiny camera containing film specially sensitized in an ammonia bath. The President, ignoring the cameramen, continued with his work. He glanced at letters and orders. He squiggled his signature, doing his duty and eager to get it done (*above*) while Gus Gennerich stood ready with a blotter. Secretary Marvin McIntyre hovered helpfully in the background. The Presidential package of Camels lay open on the desk. All this time, Thomas McAvoy was snapping. . . .

Mr. McIntyre handed the President a document that amused him; he shot back a question; perused the paper; pursed his lips; stopped to slake his thirst with a drink of water; wiped his mouth with a handkerchief from his side pocket; finished reading; squiggled a signature. His desk was clear. Then, he straightened up and turned on his charm to greet Ambassador Oswaldo Aranha (a great Roosevelt admirer) who arrived accompanied by Brazil's Minister of Finance, Arthur Souza Costa. The President smiled his most charming smile as he took Senhor Souza Costa's hand. Then the agreement was spread on the desk in duplicate. Senhor Aranha, sitting on the President's right, and Secretary Hull, sitting at his left, put their signatures to it in the presence of a solemn gathering of diplomatic assistants. Last of all, the President turned to Ambassador Aranha with a parting quip.

As the photographers carted away their equipment they looked disgustedly at Cameraman McAvoy.

"In that light and in that box," said one of them, "Boy, you could not get anything."

He had snapped 20 pictures for TIME. Thirteen of them, appearing herewith, were successful.

Although informal photographs of Franklin D. Roosevelt are common, unposed shots showing the natural play of his expression are rare. When Dr. Erich Salomon, inaugurator of candid camera technique and brilliant practitioner of it abroad, was introduced to the U. S. by FORTUNE, many a cameraman promised himself to carry on where the German left off. It was two years later, however, when Cameraman McAvoy by smart thinking and long preparation succeeded in making the first adequate candid camera study of Franklin Roosevelt.

Hey, Hey! *Oh, Mac—*

Hah! *Eh?*

HE GRAPPLES WITH HIS DAILY DUTIES *(Above)*

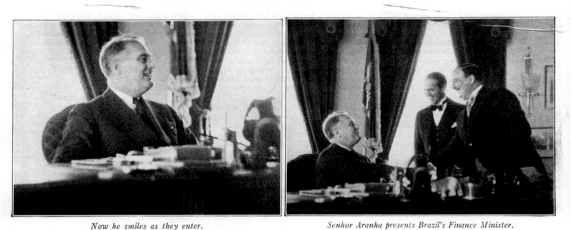

Now he smiles as they enter. *Senhor Aranha presents Brazil's Finance Minister.*

photography was here to stay and had brought in with it a new sense of intimacy with public figures, who began to look more and more like you and me (only more successful), and there was a new expectation that previously private moments like yawns and frowns and awkward poses were no longer privileged matters.

Many candid shots of FDR followed, the first steps on the road to the saturation of photographs and televised images of later presidents, some of whom seem seldom to have been off camera. Once again FDR benefited from a medium that was coming to the forefront by allowing it — or using it — to keep himself before the public and bring his audience closer to him. He used newsreels in a similar way, allowing re-creations of his radio addresses and partial reenactments of meetings to be filmed.[61] Yet, after a time, he discovered that the camera was a tricky instrument. In 1937 some decidedly unflattering pictures of him at a ball game were published. Strong sunlight had washed out his face, and both the photographic enlargement and transmission of the picture over telephone lines came out so badly that the president looked quite ill and many feared he was dying. His press secretary saw to it that that was the end of candid photography at FDR's White House.[62]

newspapers and magazines, and many photographers, scoffed at the 35mm camera as a kind of toy. Larger cameras traditionally used by news photographers could also stop action, and traditions die hard. But true candid

Mm Mm— | *Not so good.*

Tch, Tch— | *There!*

THEN TURNS ON THE CHARM FOR VISITORS *(Below)*

The Ambassador and Mr. Hull take pens. | *The President closes cordially.*

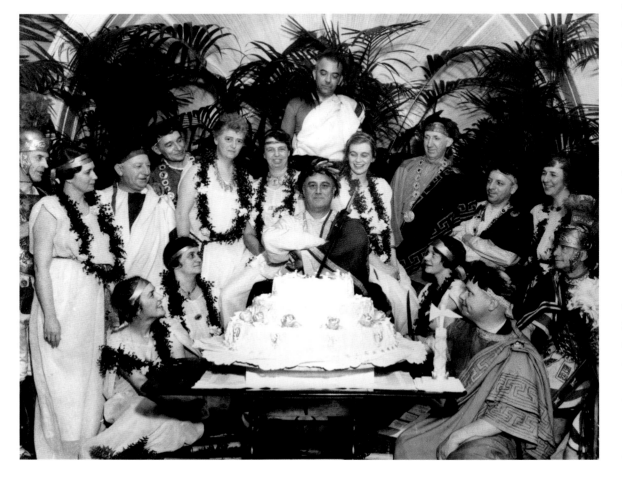

VOLUME 9, NUMBER 14 *copyright* **LOOK** JULY 10, 1945

This photograph of the hearty Roosevelt smile and jaunty cigaret holder inspired cartoonists the world over. It was snapped at Warm Springs, Ga., early in 1939.

Franklin Delano Roosevelt with a smile and a cigarette holder, 1939. Photographer unknown.

This image of FDR (and others of him with the same smile and cigarette holder) became an icon, a cartoonist's standby, the quickest, surest, most telling way to identify not only Roosevelt's person but his personality too. It summed up his self-confidence, his expansive self-presentation, his flashing charm. After his inaugural address, the actress Lillian Gish wrote Roosevelt that he seemed "to have been dipped in phosphorous," so incandescent was his glow, especially in contrast to what one of FDR's biographers referred to as "the dour and uncharismatic Hoover, the scapegoat from central casting."[63]

President Roosevelt knew a thing or two about images and the way he wanted to be perceived. During his entire presidency, though his leg braces, if nothing else, made it obvious that he was a survivor of polio, the public never knew just how handicapped he was. Stephen Early, his press secretary (the first one ever), made a deal with the news services that they could have unprecedented access to the president so as long as they did not reveal the extent of his limitations. When he gave public speeches, careful preparations were made beforehand so that no one would see him lifted onto the stage or off. Photographers did not snap him in his weakest moments. The news was different then.

A master politician, FDR knew how to project his charm, the force of his personality and character, and a certain sense of himself as person and president into people's minds. He once said to Orson Welles, "There are two great actors in the country. You are the other one."[64]

Roosevelt moved fast to address the massive problems posed by the Depression. In his first one hundred days alone, he called Congress into emergency session and won passage of the Emergency Banking Relief Act and bills that created the Federal Emergency Relief Administration, the National Recovery Administration, the Agricultural Adjustment Administration, the Tennessee Valley Authority, and the Civilian Conservation Corps. Then and later, Roosevelt changed the presidency by making the chief executive a major source of legislation. Many historians have called him the true creator of the imperial presidency, and during his tenure that was a common complaint. Though Roosevelt was sensitive, perhaps overly sensitive, to criticism, he never lost confidence in his own abilities, and he celebrated his fifty-second birthday by spoofing criticism that he was acting like an emperor. He dressed as Caesar, surrounded by vestal virgins (played by his staff, virginal or not), and happily posed for a photographer.

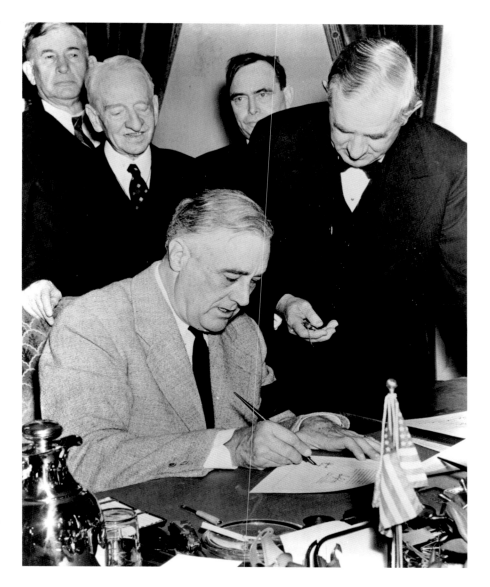

Franklin Delano Roosevelt signs declaration of war against Japan, December 8, 1941. Johnny Thompson.

As early as the 1940 electoral campaign, FDR was convinced that America would eventually have to enter the European conflict, but aware that the country was solidly isolationist, he promised voters that he would not involve the United States in any foreign wars. Once reelected, he played for time, persuading Congress to pass the Lend-Lease Act in 1941 to supply war material to Britain and other countries while he waited for an incident to justify war against Germany. The Nazis had their own ideas: Joseph Goebbels, the German Minister of Propaganda, wrote in his diary in 1941, "The U.S.A. stands poised between peace and war. Roosevelt wants war, the people want peace."

In the fall of 1941, it was clear that the Japanese were massing for an attack somewhere in the South Pacific. No one suspected that Pearl Harbor, in Honolulu, was a target, but on December 7, a massive Japanese air assault devastated the unprepared American navy and air force there, wreaking havoc that same day on Singapore, the Philippines, Guam, Wake Island, and Hong Kong. On December 8, FDR made a passionate speech to Congress, which passed a declaration of war against Japan with only one dissenting vote (by a pacifist). The country's isolationism vanished overnight.

On December 11, Hitler, in a speech laced with fury and vitriol, pronounced Roosevelt solely responsible for World War II and said Germany therefore considered itself at war with America. On the twelfth, at FDR's request, Congress unanimously recognized a state of war against Germany and Italy.[65]

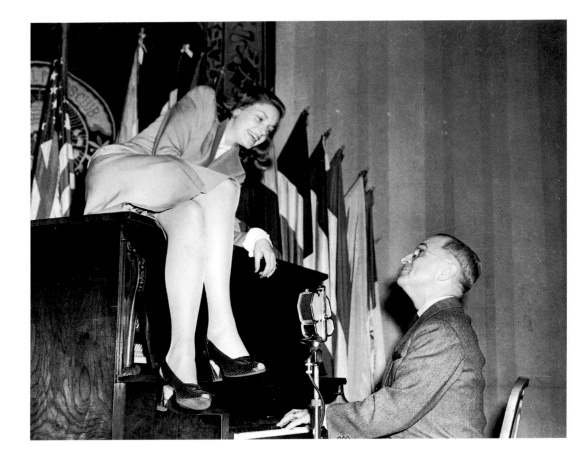

Harry Truman playing the piano, Lauren Bacall lounging atop it, 1945. Harris & Ewing.

Truman was ever ready to sit down at a keyboard and knew how to please a crowd. In 1945, when he was still vice president, he played boisterously at the National Press Club's canteen for servicemen while Lauren Bacall draped herself seductively over the piano. She later told an interviewer he played "badly, the Missouri Waltz, or something."[66]

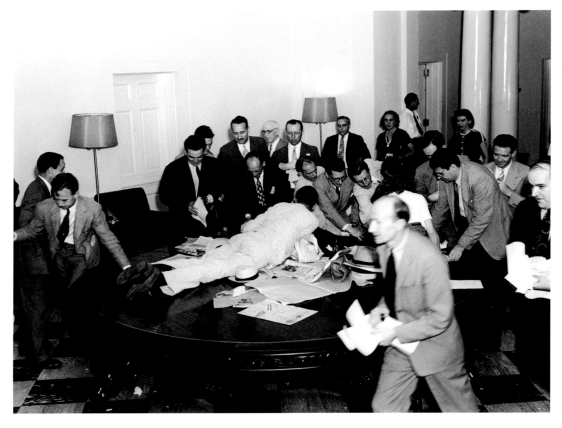

White House press after V-J Day announcement, August 14, 1945. Abbie Rowe.

Seldom has there been bigger news than the end of World War II. When reporters got the news they had been waiting for, that Japan had surrendered, they scrambled to get the information onto the front page, many sprinting for the phones and leaving their hats behind.

President Harry S. Truman takes a picture of the White House News Photographers Association, 1947. Photographer unknown.

The inscription reads, "I take pictures of the 'one more club.' HST." That club made him an honorary member. By 1951 there was no getting away from the "one more club." One hundred and thirty news photographers were covering the president.[67]

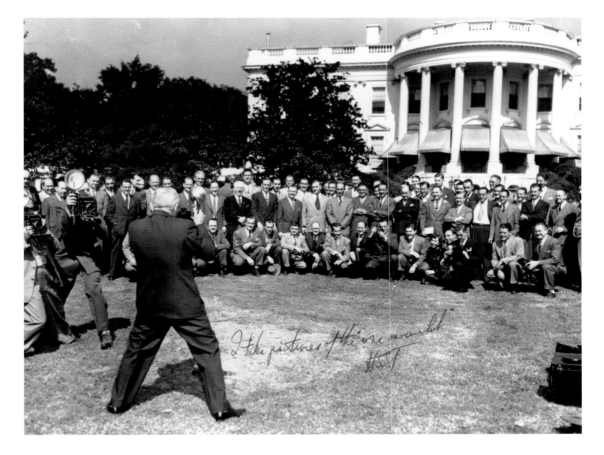

President Truman poses for cartoonists, October 3, 1949. Abbie Rowe.

A president's image in any form, whether in newspapers or post offices, on coins or cuff links, makes the chief executive immediately recognizable and carries with it a significant authority. From the very beginning, presidents posed for painters and sculptors, and for photographers too once the medium was invented — not simply out of vanity but out of political and historical considerations as well. Cartoons and caricatures, which didn't require posing because abbreviated or exaggerated features could be lifted from paintings or photographs or memory, had been powerful political weapons ever since the nineteenth century.[68]

In 1949 Truman posed for cartoonists and gave his imprimatur to an exhibition called "20,000 Years in Comics" at the Library of Congress promoting the U.S. Savings Bond program. More than forty cartoonists, including Herblock, Milt Caniff, and Rube Goldberg, sharpened their pencils for the occasion. Afterward they took off across the states in their plane, *The Flying Cartoonist,* on a nationwide tour endorsing the bond drive.[69]

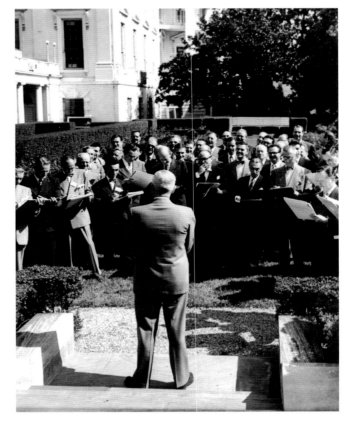

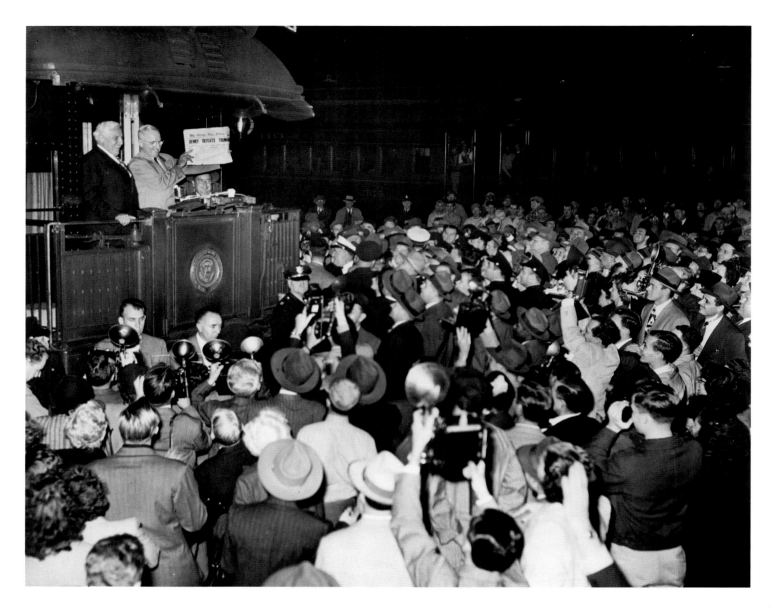

Truman holding the *Chicago Tribune*, November 4, 1948. Photographer unknown.

David McCullough, in his biography of Truman, wrote that the president beat Thomas Dewey in the 1948 election "against the greatest odds in the annals of presidential politics." When he won, the actress Tallulah Bankhead sent Truman a telegram: "The people have put you in your place." The radio comedian Fred Allen said Truman "was the first president to lose in a Gallup and win in a walk."[70]

At a brief stop of his train in St. Louis on November 4, Truman appeared on the rear platform to show his face to the electorate and palaver with reporters. He was handed a copy of the November 3 *Chicago Tribune,* which McCullough calls Truman's least favorite newspaper, and when he saw the headline, DEWEY DEFEATS TRUMAN, he smiled larger than the typeface and brandished the paper aloft, as if to remind anyone watching that no matter what the papers say, it is the voters who have the last say in this country.[71]

President Dwight D. Eisenhower being lassoed in reviewing stand, January 20, 1953. Photographer unknown.

On the day of his inauguration, Ike stood in the reviewing stand in front of the White House for hours as the parade passed by. A California cowboy named Monty Montana, who had been doing his rope trick, lassoing policemen, naval officers, and some women spectators along the route, asked and received the president's permission to lasso him. Though the new president smiled broadly while being lassoed (on the second try), he subsequently had to disentangle himself, and later reports said he was irritated.[72]

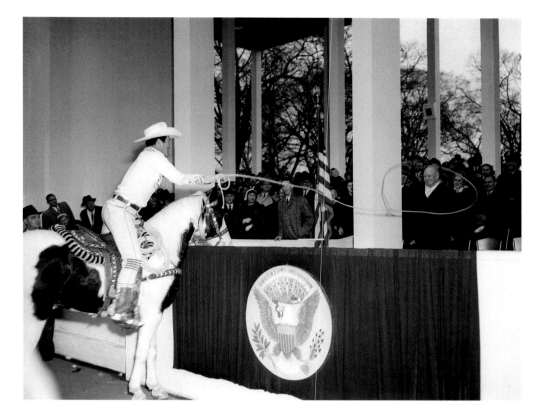

Kennedy and Nixon television debate, October 13, 1960. *U.S. News & World Report.*

The four Kennedy-Nixon televised debates in 1960 were landmark media events. By 1960, 88 percent of American homes had a television set, a higher percentage of the populace than had a telephone.[73] The first debate, on September 26, was not only the first presidential debate ever televised, but it was also a stellar example of television's powerful impact on politics. Nixon had been ill, was pale, and had lost weight. His collar was too big for him, he was sweating, and he refused makeup that would have improved his post-hospital pallor and covered some of his five-o'clock shadow. Kennedy, who had been campaigning in California, was tan, handsome, and fit. People who heard that debate on the radio gave Nixon the edge, but slightly more of the 70 million people who watched it on television thought Kennedy had won.

This picture records not the first but the third debate, when Nixon's appearance had been tuned up and the two candidates were united electronically, though they were speaking on opposite coasts. It is generally believed that the results of the first debate contributed heavily to Kennedy's victory. Nixon had proved earlier that television

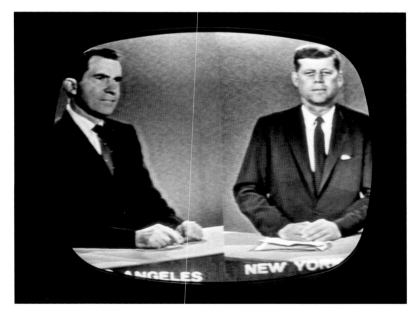

could save, and boost, a presidential candidate; now he also proved that it could doom one.[74]

Kennedy was so clear on the import of a photographic image that once when he had to choose between having a group of photographs published in *Vogue* or in *Modern Screen,* he chose the movie mag because its circulation was bigger.[75]

President Eisenhower and Prime Minister Jawarahal Nehru of India shake hands, December, 1959. Wide World / Associated Press.

Nehru had been in the United States before and met Eisenhower when he was president of Columbia University and presented Nehru an honorary degree. Nehru came to Washington in 1959 to discuss cold war issues. Official handshakes, a traditional gesture of trust and agreement, and even more commonly a mere courtesy, are seldom this joyous and balletic, but in various guises they have been an important component of presidential conduct throughout the nation's history.

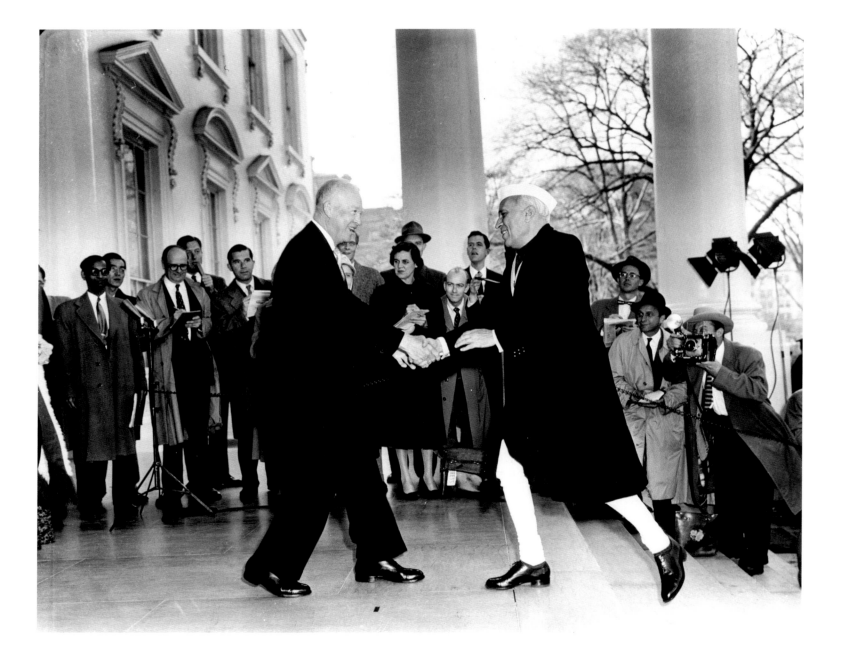

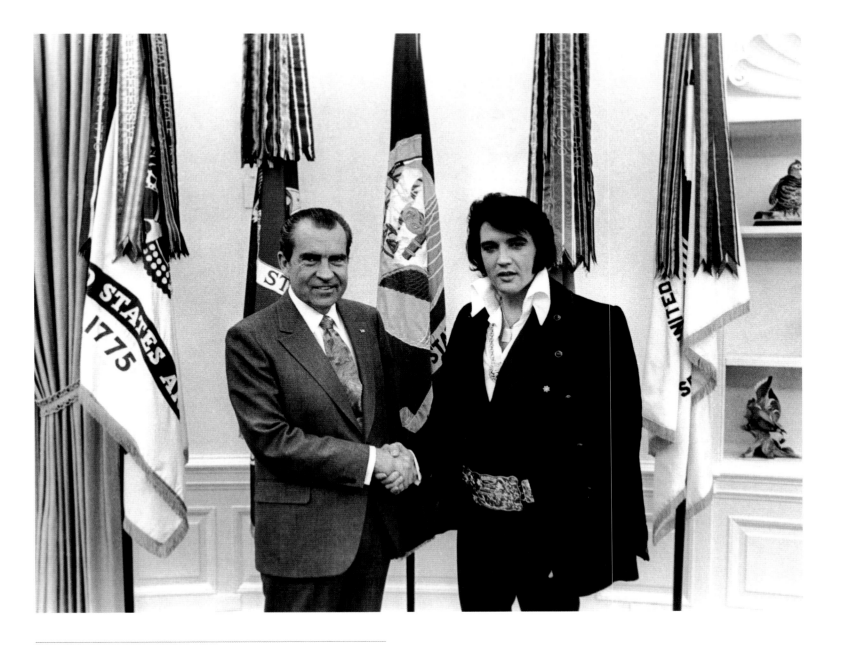

President Nixon shaking Elvis Presley's hand, December 21, 1970. Oliver F. Atkins.

Elvis wrote to Nixon to request a meeting and asked to be made a "federal agent at large" for the Bureau of Narcotics and Dangerous Drugs. The administration took the request seriously. Dwight L. Chapin, a deputy assistant to the president, wrote H. R. Haldeman, Nixon's chief of staff, "If the President wants to meet with some bright young people outside of the Government, Presley might be a perfect one to start with." Haldeman wrote in the margin of this comment, "You must be kidding."

Nixon and Presley had a brief, cordial meeting. They saw eye to eye on the nation's drug problem. Elvis expressed his admiration for the president and presented him with several gifts, including a Colt .45 pistol and family photographs. At one point, Nixon remarked that his visitor was wearing an unusual suit. Elvis replied, "Mr. President, you got your act and I got mine."[76]

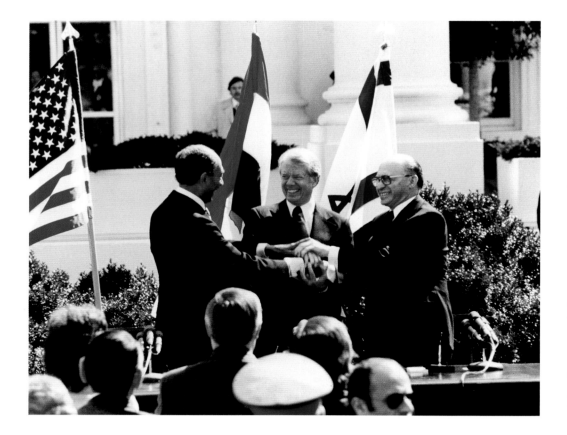

President Jimmy Carter, Egyptian president Anwar al-Sadat, and Israeli prime minister Menachem Begin at the White House signing of the peace treaty between Egypt and Israel, March 26, 1979. Bill Fitz-Patrick.

Some handshakes are less popular than Elvis and Nixon's but have a greater impact on history. In 1977 Anwar al-Sadat, who was hoping for American help to shore up the tottering Egyptian economy, courageously paid a visit to Israel; he was the first Arab leader to do so. In September of the following year, President Carter brought President Sadat and Prime Minister Menachem Begin together at Camp David for almost two weeks of extremely difficult talks that resulted in history-making accords. The following March, a peace treaty was signed and Sadat and Begin shook hands on the White House grounds; President Carter's hands embraced theirs.

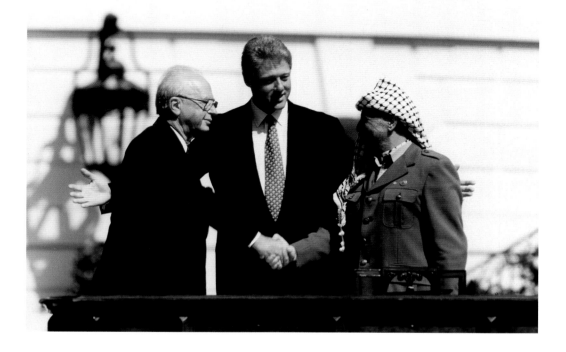

Israeli prime minister Yitzhak Rabin and Palestine Liberation Organization leader Yasser Arafat shake hands within President Bill Clinton's symbolic embrace, September 13, 1993. Vincent Musi.

This handshake sealed a Declaration of Principles for peace between Arabs and Israelis, brokered by President Clinton. The Declaration was greeted with hope and intense anger by elements in both camps; Arafat lived on, though peace did not. A Jewish extremist assassinated Rabin in 1995.

Bill Clinton with Boris Yeltsin, Hyde Park, New York, October 23, 1995. Ralph Alswang.

Here's what Boris Yeltsin, the first freely elected president of Russia, said in 1991 that prompted laughter at that news conference: "If you looked at the press reports, one could see that what you were writing was that today's meeting with President Bill Clinton was going to be a disaster. [*Laughter*] Well, now for the first time, I can tell you that you're a disaster. [*Laughter*]

"How many journalists' brains are used to constantly try to figure out what kinds of different versions and options the two presidents are going to try to come up with regarding Bosnia? I can't say that your brains turned out to be useless. [*Laughter*] Of course, you also helped us, and we are grateful. And so you did help us because when Bill and I sat down to look at the different options, we used even some of your seemingly most unbelievable options. [*Laughter*]"[77]

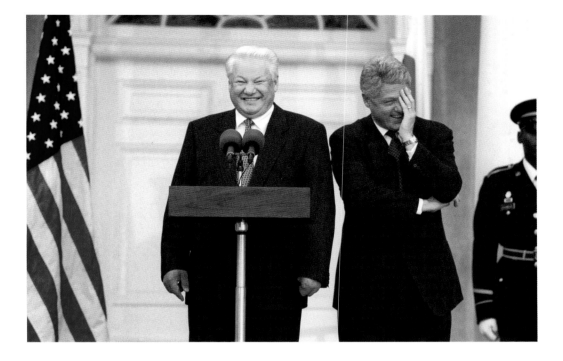

"Court Jester." Ronald Reagan and Queen Elizabeth, San Francisco, 1983. Diana Walker.

When Queen Elizabeth visited America for ten days in 1983, Ronald and Nancy Reagan gave a dinner in her honor in San Francisco. It rained for days in California and the queen offered a toast at the dinner: "I knew before we came that we had exported many of our traditions to the United States. But I had not realized before that weather was one of them." The audience, including the president, laughed uproariously.[78]

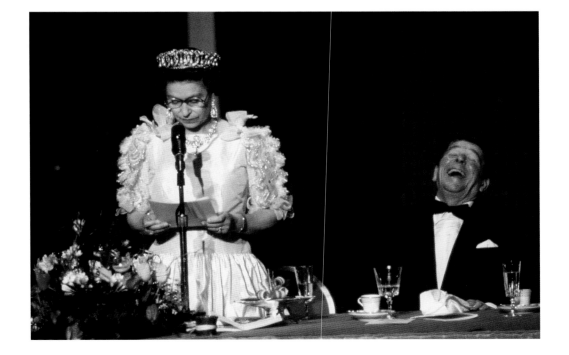

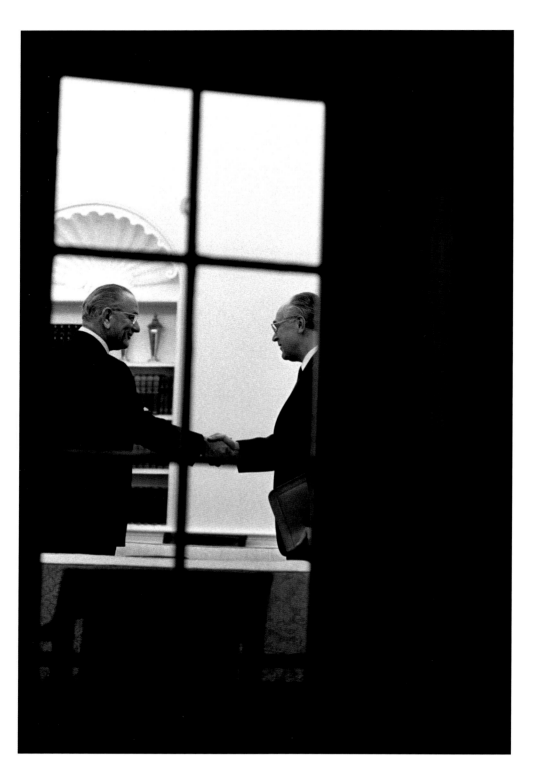

Lyndon Johnson shakes the hand of Anatoly Dobrynin, Soviet ambassador to the United States, October 21, 1967. Mike Geissinger.

On October 21, 1967, Soviet ambassador Dobrynin called Secretary of State Dean Rusk to say he had just received a letter for the president from Soviet premier Aleksey Kosygin, who had asked that he personally deliver it. LBJ and Rusk saw Dobrynin that evening in the Oval Office. Mike Geissinger, an assistant to Yoichi Okamoto, the official White House photographer, was in the office when Dobrynin was announced. Johnson gave Geissinger a sideways nod of the head to indicate that he should leave. Outside in the Rose Garden, the photographer asked for, and received, permission from the Secret Service to photograph through the window. He took this picture of what looks like a warm handshake, as it was obviously supposed to.

No record of the conversation exists. The letter does. Kosygin was concerned about the situation in the Middle East following the Six-Day War in June, when Israel fought Egypt, Jordan, Iraq, and Syria and gained control of the Gaza Strip, the Sinai Peninsula, the West Bank, and the Golan Heights. The Soviet premier urged LBJ to support a U.N. Security Council resolution providing for the withdrawal of Israeli troops to positions they held prior to the outbreak of the war. Johnson subsequently wrote a letter in reply saying that he agreed with this position but only if all nations in the area were guaranteed freedom from claims and acts of war by their neighbors and had "rights to national life" and "innocent maritime passage in international waters," and if other issues such as limitations on the arms race were resolved.[79]

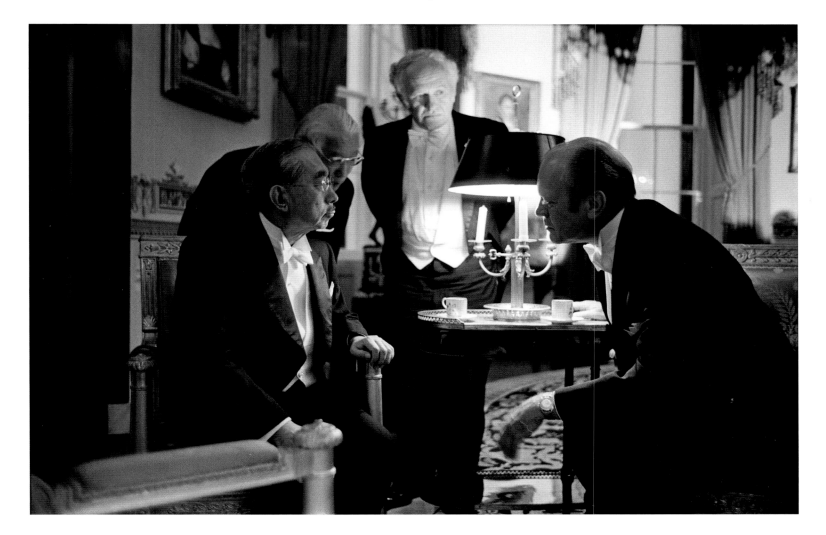

Gerald Ford with Emperor Hirohito of Japan, October 2, 1975. David Hume Kennerly.

Japan surrendered to the Allied powers on August 15, 1945, six days after an atom bomb, the second dropped by the United States, was detonated over Nagasaki. Emperor Hirohito, who had ruled Japan throughout World War II and ultimately accepted the terms of surrender, remained the emperor but retained only a ceremonial role. By 1971 Japan had rebuilt and emerged as an economic power with strong international ties. Relations between the United States and Japan had been strained by Nixon's historic diplomatic overture to China in 1972. President Gerald Ford went to Japan in 1974 to ease the tensions. In 1975 Hirohito returned the gesture of friendship with a visit to the White House. Japanese officials had first visited the United States in 1860, but no Japanese emperor had set foot in the White House before this meeting.

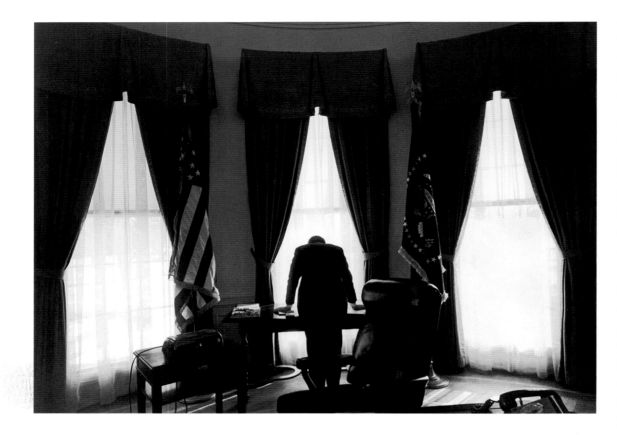

The loneliest job in the world," President John F. Kennedy in the Oval Office, 1961. George Tames.

New York Times photographer George Tames, who took this picture shortly after Kennedy's inauguration, shot into the light from the three windows, leaving the rest of the picture underexposed and dramatically dark. The presidency may well be the loneliest job in the world, but Tames frequently said that Kennedy's posture was not driven by a sense of intolerable burden but by his bad back, which often made it more comfortable for him to read a newspaper while standing up.

President Kennedy speaking at the D.C. National Guard Armory, 1962. Tom Hoy.

Tom Hoy, a photographer for the *Washington Star,* took another picture of Kennedy from behind as the president gave a speech. In this picture, Kennedy is theatrically lit by six huge conical shafts of light that blaze down upon him from above as if he were a revelation. Here is the president as spectacle in a spectacle culture, where he exists for, and because of, the audience.

White House meeting with civil rights leaders, June 22, 1963. Abbie Rowe.

(Front row, starting third from left: Martin Luther King Jr., Robert F. Kennedy, Roy Wilkins, Lyndon Baines Johnson, Walter P. Reuther, Whitney M. Young, A. Philip Randolph. Second row, second from left: Rosa Gragg. Top row, third from left: James Farmer.)

In early May of 1963, as black children and adults marched for civil rights in Birmingham, Alabama, the local sheriff ordered fire hoses and police dogs turned loose on them. Photographs of these brutal events appeared the next day on front pages everywhere, and soon afterward, particularly powerful images by photographer Charles Moore were published in *Life* magazine, which was then the closest thing America had to a national newspaper. President Kennedy called a series of meetings with civil rights leaders, who pressed him to submit a civil rights bill. At the last meeting, on June 21, the president was informed that the rights leaders were organizing a mass march on Washington on August 28 for jobs and freedom.[80] The march on Washington drew an estimated 200,000 people to the capital, and Martin Luther King made the famous "I Have a Dream" speech.

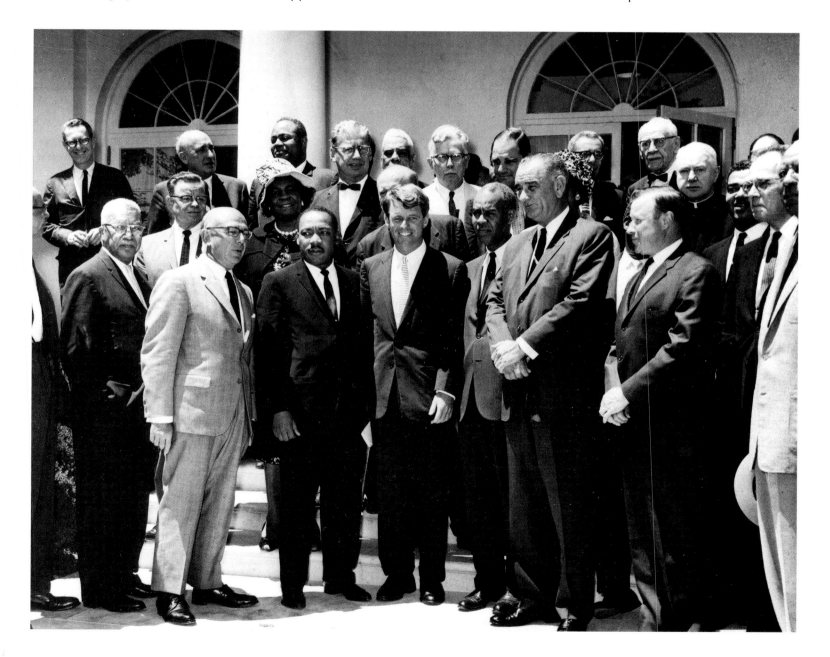

Ronald and Nancy Reagan in a bunker at Omaha Beach, June 1984. Bill Fitz-Patrick.

On June 6, 1984, President Reagan went to Omaha Beach in Normandy to participate in a French-American ceremony celebrating the fortieth anniversary of the Allied invasion of France. Reagan's speech at Pointe du Hoc, where 225 U.S. Rangers had landed and scaled a cliff held by the Germans, was one of his most moving. He pointed out that the Germans turned machine guns and grenades on the invaders and that, after two days, only ninety rangers could still bear arms, but they took the cliff. He said to the survivors who had journeyed there, "You were here to liberate, not to conquer, and so you . . . did not doubt your cause." [81]

The president and his wife are looking out to sea from a German bunker, exactly as a young German soldier named Pluskat would have done on that day when he sighted the armada of Allied ships approaching the beach. Cornelius Ryan, in his book on the D-day landings, writes that Pluskat called his superior, a Major Block, who initially scoffed at the report of thousands of ships on the water. After a while he hesitated, then said, "'What way are these ships heading?'

"Pluskat, phone in hand, looked out the aperture of the bunker and replied, 'Right for me.'" [82]

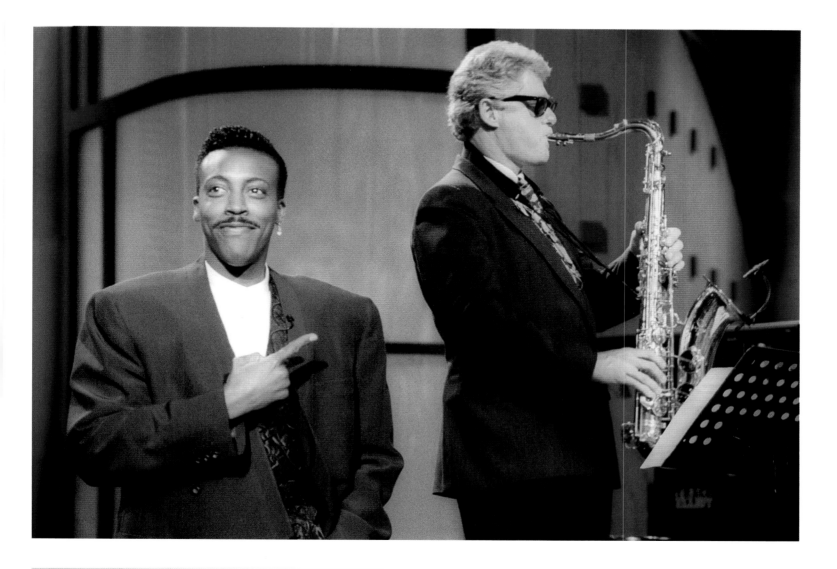

Bill Clinton and Arsenio Hall, June 1992. Reed Saxon.

During the 1992 presidential campaign, Bill Clinton, the relatively unknown governor of Arkansas, ran for the Democratic nomination, won it, and went on to defeat President George H. W. Bush for the presidency. In June Clinton made a surprise appearance on *The Arsenio Hall Show* and played two pieces on his saxophone, including "Heartbreak Hotel," the song that made Elvis Presley famous. Wearing shades and channeling Elvis on Hall's territory, Clinton deployed a cool, laid-back, decidedly hip image, not exactly a standard one for presidents or would-be presidents.

Bill and Hillary Clinton with Stephen Hawking, Oval Office, March 5, 1998. Sharon Farmer.

Although almost completely paralyzed by amyotrophic lateral sclerosis (commonly known as Lou Gehrig's disease), Stephen Hawking is one of the world's leading theoretical physicists. On March 6, 1998, he gave the Millennium Lecture in the East Room. Millennium Lectures at the White House present prominent scholars, creators, and visionaries and are broadcast to the public by satellite and cybercast. It is noteworthy that in this picture of three important individuals, the most prominent figure is an American eagle.

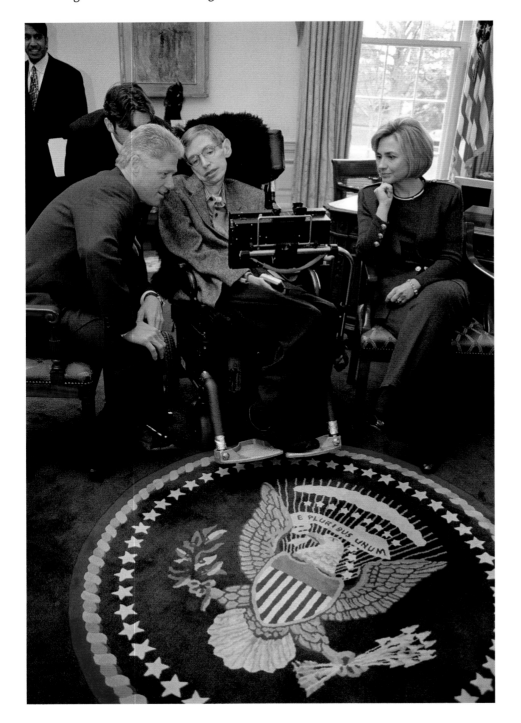

OPPOSITE, ABOVE: **George W. Bush and Condoleezza Rice in the Oval Office, September 12, 2001. Eric Draper.**

This photograph of President Bush and his national security adviser was taken the day after Al-Qaeda hijackers flew suicide planes into the World Trade Center in New York and the Pentagon in Washington, and were prevented from destroying another Washington target only when passengers of that plane tried to take control of it and it crashed. In an instant, America changed, and perhaps the Western world did too; it was no longer possible to imagine that anyone would be safe from terrorism. The fact that the picture foregrounds the representative of the country's security and leaves the president in the background, plus the isolation of the two figures, hints at the heavy burden that has been laid on both of them. This picture shows, among other things, the difficulties of leading an entire country under threat, difficulties that could be read in Lincoln's aging face in 1865 but that only found copious visual expression when photography became a central information system.

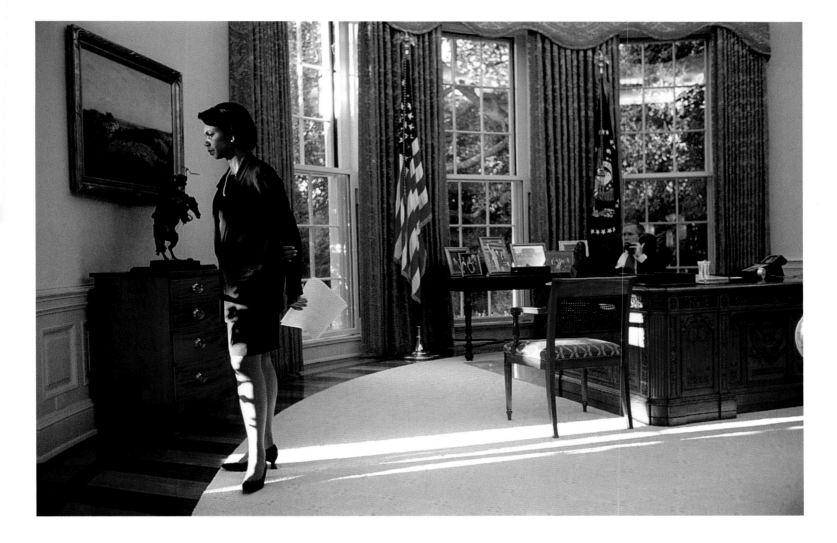

President George W. Bush clears cedar at his ranch in Crawford, Texas, August 9, 2002. Eric Draper.

The "common man" theme in presentations of candidates and presidents recurs from time to time with references to a strong and "manly" male prototype — a cowboy, a rancher, or a war hero — as a counterweight to the word "elite." President Bush, who bought his ranch in Crawford, Texas, in 1999, clearly enjoyed being there. There were numerous photographs taken of the president wearing a cowboy hat, clearing brush, and chopping wood on the ranch that became known as the western White House. The Texas rancher image ran counter to the president's Ivy League education with a B.A. at Yale and an M.B.A. at Harvard.

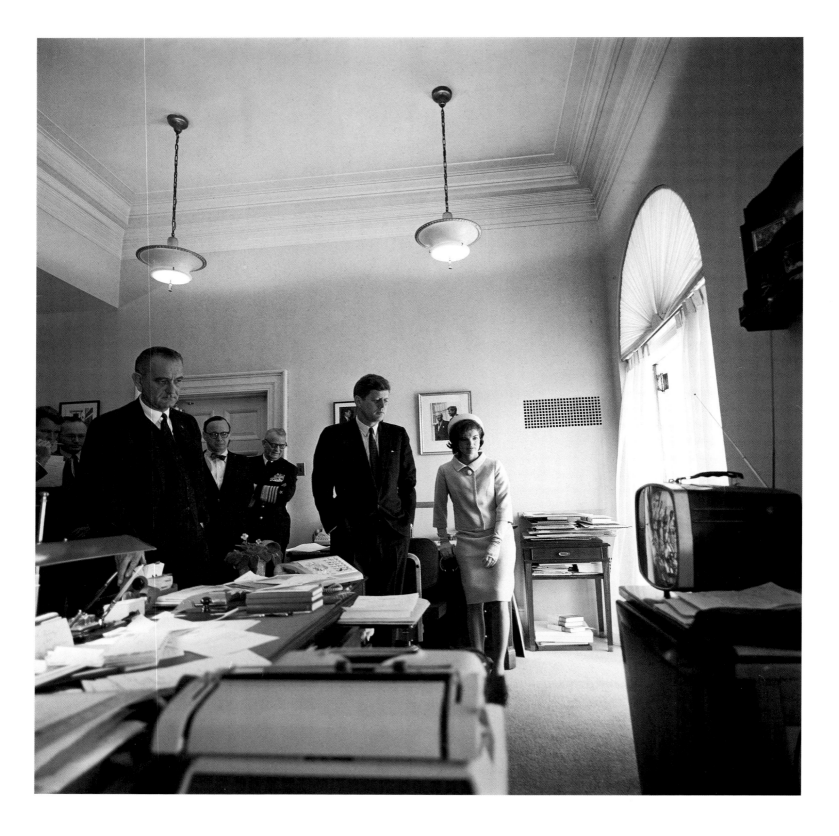

CHAPTER 7: THE WHITE HOUSE AND TECHNOLOGY

THE PRESIDENT AND the federal government have encouraged technological invention almost from the moment the nation was founded. Invention requires capital, and in the late eighteenth century, the government was one of the few possible sources. In 1798 President John Adams funded Eli Whitney (inventor of the cotton gin) in his unsuccessful attempt to manufacture muskets with interchangeable parts.[1] During the Civil War, President Lincoln encouraged and implemented technological advances against strong resistance from his chief of ordnance, bureaucrats, and military officers. Lincoln and the secretary of the Smithsonian Institution, who were both impressed with a balloonist who said he could do aerial reconnaissance and even air-to-ground telegraphic communications, initiated the first successful military air force in American history. The president struggled, with limited success, to provide his army with breech-loading rifles, infinitely superior to muzzle loaders in both range and accuracy; their use would undoubtedly have ended the war sooner. He approved the use of rifled cannon, more powerful than smoothbore; supported the use of mortar boats, which could fire heavier shells than ordinary cannon could, for river warfare; and endorsed the building of the ironclad ship *Monitor,* which quelled the dire threat of the South's ironclad *Merrimac.* As historian Robert V. Bruce put it, Lincoln was "the nearest thing to a research and development agency" the government had during the Civil War.[2]

Yet for most of American history, presidential influence on and involvement with the development of technology have been mixed and seldom crucial. The White House did not often spearhead the technological revolution that, by the end of the nineteenth century, had radically changed America's society and economy.

Samuel F. B. Morse pestered Congress in 1837 for financial support to implement his invention of the telegraph. Many representatives thought the idea so ridiculous that they said they might as well fund mesmerism. Finally, in 1843, Congress narrowly passed a bill awarding Morse $25,000 to finance and run the first public telegraph line in the world, but the business soon passed into private hands.[3] The White House installed its first telegraph office in 1866.[4] During the Civil War, President Lincoln received war dispatches at the War Department. In December of 1901, Guglielmo Marconi, the Italian inventor of wireless transmission (for which he would win a Nobel Prize), demonstrated that wireless signals could be transmitted across the Atlantic. In January 1903, President Theodore Roosevelt sent his first wireless message overseas to King Edward VII of England. Radio transmission became generally available to the public four years later.[5]

The White House and its residents made efforts to

OPPOSITE: **President John Fitzgerald Kennedy watching the flight of the first American in space in the office of the president's secretary, May 5, 1961. Cecil Stoughton.**

(Left to right: Attorney General Robert F. Kennedy, McGeorge Bundy, Vice President Lyndon B. Johnson, Arthur Schlesinger Jr., Admiral Arleigh Burke, President Kennedy, Mrs. Kennedy.)

The president, vice president, and advisers are watching America's first real success in space, the fifteen-minute sub-

orbital flight of Mercury astronaut Alan B. Shepard Jr. This was a much-needed boost to the nation's confidence and self-esteem, which had been shattered by Soviet triumphs in space, but the Soviets would continue to outperform America for several years until the successful American-manned moon orbit of 1968 and the triumphal moon landing of Neil Armstrong and Buzz Aldrin in 1969.

The journey began when the Soviets launched Sputnik, the first earth-orbiting satellite, (*continued on next page*)

keep up with new technologies that might be useful for comfort, convenience, or efficiency, although sometimes the center of government lagged behind other sectors of the nation. In 1840 a hot-air central heating system was installed for some of the rooms.[6] The first gaslights were installed in the White House during James Polk's term. Baltimore had had gas streetlights beginning in 1816, but lights in homes were not common for some years and gas was unreliable for a long while. Polk's wife refused to let the Blue Room be outfitted with gas chandeliers, which was just as well, for when the newly installed gas lights were first turned on, they suddenly went out, and the only lights left burning were the candle-lit chandeliers in that room.[7]

Polk's successor, Millard Fillmore, kept up with contemporary innovations. During his administration, a hot-water furnace that was more efficient and more healthful than the existing heating plant was installed. Fillmore also installed a bathroom on the Second Floor, where the living quarters were (and still are) located. Earlier, when residents wished to bathe, portable tubs had to be brought up and kettles of heated water had to be hauled up from the East Wing bathing room. Both hot and cold water were directly piped into the new bathroom.[8]

President Rutherford B. Hayes was almost too quick to express an interest in Alexander Graham Bell's invention of the telephone, which was widely, and immediately, understood to have enormous potential. Bell patented the phone in 1876, and in 1879 the White House put in one of the first models. This was a crude instrument, but it wouldn't have mattered much had it been more sophisticated, for telephones were so rare at the time that there was almost no one to call or be called by.[10] Telephone wires and telephone use increased steadily, particularly after 1893 when Bell's patent expired, and in 1915 Woodrow Wilson participated in the first transcontinental phone call between New York and San Francisco via a loop that extended to the White House and to Jekyll Island, Georgia.[11]

Thomas Edison invented a primitive phonograph in 1877, another invention recognized instantly as a momentous change. When he went to Washington in 1878 to demonstrate this breakthrough to the Academy of Science and to members of Congress, he got a message at 11:00 p.m. that President Hayes would be pleased to see him. Edison took his phonograph to the White House posthaste and demonstrated it till 12:30 a.m., at which point Mrs. Hayes and several other ladies rose from their beds, dressed, and came in to hear for themselves. Edison left at 3:30 in the morning.[12]

Two years later, the White House staff started using typewriters, a relatively early adoption of the machine that could write faster than the hand. The first American typewriter had been patented in 1868, but it was not very successful until the Remington company made a deal with the inventors and, in 1873, began mass producing a machine that used the inventor's QWERTY keyboard, improved with a shift key that made both capitals and small letters possible.[13]

In the summer of 1881, when James Garfield was suffering terribly from the gunshot wound that eventually

(continued from previous page): on October 4, 1957, wresting technological leadership from America and raising military fears in the face of unanticipated Soviet missile power. Though President Eisenhower swiftly appointed the first presidential science adviser to assist on defense matters, he said publicly that the United States was not in a space race. But by November, Lyndon Johnson, then Democratic majority leader in the Senate, began hearings on space and essentially forced the Republican president to engage in a race he didn't want. In April 1958, Ike proposed a space agency to Congress, primarily to be civilian; Johnson shepherded a law establishing NASA that same year.[9]

It was not clear whether John F. Kennedy, elected in 1960 with Johnson as his vice president, would have a more aggressive attitude toward the space race than Eisenhower, but on April 12, 1961, the Soviets sent Yuri Gagarin into orbit on history's first manned space flight, forcing Kennedy's hand. On April 20, JFK asked Johnson for a review of the American program; eight days later, LBJ reported that a moon landing was the first dramatic space project with the potential of besting the Soviet Union.[14]

On May 5, America's first manned space mission sent Alan Shepard on a fifteen-minute suborbital flight — a triumph, but a minor one in comparison to the Soviet accomplishment. On May 25, Kennedy challenged the nation, in an address to Congress, to commit to landing on the moon before the decade was out.[15] Which it did, though he would not live to see it.

killed him, naval engineers built a structure that held cloths saturated with ice water; a fan blew hot air above. It was thus at the White House that the principles of air-conditioning were put to an early test.[16] Electrical air-conditioning as we know it wasn't invented until 1902 and wasn't used much until the mid 1920s, when department stores and especially movie theaters began to install it. As early as 1911, the Oval Office was cooled by air blown from fans, over a ton of ice that had to be replaced each day, and into the room.[17]

As for the convenience of an elevator, business was years ahead of the presidency. By 1857 a New York City department store had one, but it wasn't until Garfield's administration in 1881 that the first one was ordered for the White House. It wasn't installed because he had been shot and it was feared the noise would disturb him, but after he died, it was put into operation—and caused great trouble and aggravation.[18]

The White House was also behind the curve on electric lighting. Electric streetlights were permanently installed on Pennsylvania Avenue in the late 1880s, when most people who were using electric lighting at home were still doing so in combination with gaslights. The White House had electricity installed in 1891, but the Harrisons wouldn't use it because they were afraid of getting shocks from the switches. They knew how to delegate authority: someone else turned the lights on and off.[19] And things picked up with Grover Cleveland: in 1895 electric lights appeared on the White House Christmas tree. In 1922 the White House acquired its first electric vacuum cleaners, and in 1926 its first electric refrigerator. From President Polk's time till then, the White House had used iceboxes.

The president and his White House were seldom any further ahead on the technological front than they were on social policy, the first usually being left to business and the second to changes in society and the climate of opinion. There were notable exceptions, some of which were commemorated in photographs, and the exigencies of war more than once thrust the federal government into the business of promoting new and recent technologies. John Adams needed muskets, Lincoln needed a lot of things, including trains. Although the states had helped facilitate rail construction for years before the federal administration got involved, in 1862, during the Civil War, Lincoln lent $65 million directly to the first transcontinental railroad. It was soon clear that

troops could get to the front much faster by train than on foot, a decided advantage for the North. The speedy and efficient transport of people and goods prompted the federal government to give the railroads more than 100 million acres outright between 1861 and 1870.

The telegraph proved itself useful repeatedly in war. The war of the United States against Mexico in 1847 was the first war in history that the public could learn about through rapid news coverage, and the Civil War the first in which military strategy depended on the rapid transmission of battle information. When Congress declared the Spanish-American War in 1898, President McKinley's White House telecommunications center was turned into a cutting-edge operation. A switchboard with twenty telegraph wires gave the president access to French and British cable lines to Cuba and elsewhere in the Caribbean, plus direct access to U.S. cable lines to officers in the field. Within twenty minutes, McKinley could exchange messages with a general in Cuba. McKinley used both the telephone and the telegraph extensively to manage this war; for the first time, the president's presence was communicated to the battlefield in real time though he was far removed from the scene.[20]

World War II was the turning point in the union of government and technology, and of government and science as well. Both have been closely tied ever since. As a world war loomed and then became a reality, the president and the federal government turned into major promoters of new and improved technologies for war, many of which were of enormous benefit to the postwar world. Franklin D. Roosevelt, who had already supported the Tennessee Valley Authority and the remarkable engineering feat that tamed the Tennessee River, established two national scientific research committees before America even entered the war.[21]

Roosevelt was even more directly responsible for the invention of the atomic bomb. In October of 1939, a letter from Albert Einstein about the peaceful and military potentials of nuclear energy was delivered to FDR, who immediately directed that action be taken. As Richard Rhodes tells it in *The Making of the Atomic Bomb*, by October of 1941, two months before Pearl Harbor, "the United States was not yet committed to building an atomic bomb. But it was committed to exploring thoroughly whether or not an atomic bomb could be built. One man, Franklin Roosevelt, decided that

commitment — secretly, without consulting Congress or courts. It seemed to be a military decision and he was Commander in Chief."[22]

Since that time, every president and/or his administration has been heavily involved in scientific and technological progress, to a degree seldom seen in the preceding years. The cold war — the struggle for dominance between the United States and the Soviet Union that narrowly missed turning into the more usual kind of war — fostered numerous important technological advances, not least the development of the computer.

In the 1992 presidential campaign, voters were offered a new medium for information about candidates and their positions: the internet. SunSITE, which billed itself as having "enhanced search and retrieval capabilities," went online and contacted the campaign committees of each presidential candidate, offering to make available on the web any information the committees wished to present. The Bill Clinton committee took immediate advantage of this service, contributing a good deal of its material for distribution. The experience of the campaign was carried over into the White House once Clinton was elected; his administration distributed on the internet such information as the text from presidential conferences and documents like the federal budget.[23] In 1994 Clinton and Al Gore, the vice president, also established whitehouse.gov, the first official White House website, and in 1996 the president ordered the heads of every federal agency to use current information technology to make agency information fully available to the public. At that moment, less than 10 percent of Americans had internet access, but connection to the net was growing at an exponential rate and the number of visitors to the Clinton-Gore White House website multiplied by more than three every year the administration remained in office.[24]

Barack Obama's election campaign in 2008 made highly successful and innovative use of the internet, and as president he maintains multiple presences on the web. Whitehouse.gov continues to deliver the news in many forms, and Obama has used it to hold what the White House says was the first-ever "online town hall" meeting by a president; citizens' questions were solicited on the site. Another Obama site, Organizing for America, is set up to help communities organize to bring about change. The president has a White House blog, a Facebook page, a LinkedIn site, a Twitter site, a Flickr site where citizens can post photographs, as well as a White House Flickr stream with photographs added daily. Several sites have interactive capacities, and Michelle Obama has several sites of her own. The Obama presidency is the most visible and connected administration in history.

For many years, presidents and their administrations chose to tinker with technology, invest in it heavily, or utilize its new developments, depending on circumstances, urgencies, and personalities. At length the government became essential to an enormous part of the progress of science and technology. The camera recorded some steps along the way when photographers smelled news, at least news that wasn't classified information, and at times when it seemed like anything going on at the White House might be of interest, which was often enough.

Theodore Roosevelt and two men standing in front of a train, c. 1905. Photographer unknown. National Photo Company.

In these photographs, Roosevelt, with two companions, dominates the tracks and faces us squarely, as if to say, "We're in charge of the rails." This may not have been the photographer's intended message, but it's entirely appropriate. Railroads were the biggest business in the nation, and monopoly ownerships imposed outrageous rates on the movement of crops, goods, and people. They also used their economic muscle to do as they pleased and keep government off their backs. The Interstate Commerce Commission (ICC) established in 1887, as it turned out, wasn't strong enough to keep the railroads in check. TR's first successful act of trust busting was an attack on one of the railroad monopolies. He pushed through Congress two bills that beefed up the ICC, largely in order to give it stronger regulatory power over the railroads.

Railroads were central to America's economy and history. From the 1840s on, several presidents and congresses supported the project of building a transcontinental rail-road, offering surveys, loans, and free land — the project finally succeeded in 1869. The Industrial Revolution rode in along the country's railroad tracks, which carried raw materials from the West and goods to market everywhere. What's more, rail lines in effect created the West by bringing immigrants to populate it and tourists to visit, and by building towns and luring people to them until the towns turned into cities. They grew exponentially. By the middle of the century, America had laid 9,000 miles of track, all of it east of the Mississippi; by the end, that number had increased to 175,000 miles. And while the railroads were engaged in changing the tempo of life and the mobility of the citizenry, they were also uniting a country and helping to weld it into a nation. But a great price had been exacted from railroad workers, farmers, businesses, and riders.

Trains reached major status in presidential campaigns shortly before TR took office. In 1900 William Jennings Bryan was the first presidential candidate to make whistle-stops a key element in his campaign. Though he lost, the whistle-stop immediately became an important fixture in campaigns.

President Taft on the telephone, c. 1908. Harris & Ewing.

After Bell's telephone patent expired in 1893, there was a spurt in phone ownership in businesses and homes. By 1895 America had one phone for every 208 people, while Britain had one for every 250, Germany one for every 397, and France one for every 1,216.[25] McKinley, who didn't like to leave written records, was the first president who made extensive use of the telephone. Then, between 1904 and 1911, the number of telephones in the United States just about doubled, from 3.36 million to 7.6 million. Taft's being photographed with one was evidence of his support of an expanding technology. He gave a speech by long-distance phone from Boston to a New York banquet.[26]

A president's use of technology could still depend on personal preference and circumstances. Teddy Roosevelt had no phone on his desk in the executive office because he thought phones more suitable for clerks. Calvin Coolidge also thought a telephone was beneath a president's dignity and unacceptable because it did not guarantee privacy. He, too, had no phone on his desk, and he seldom used the one installed in a small booth outside his office.[27]

One particular telephone was crucial during the cold war: kept in a drawer in the Oval Office, it would warn the president of an imminent Soviet nuclear attack. John F. Kennedy discovered to his consternation that the "red phone" was missing. It turned out that his wife, who famously redecorated the White House, had replaced the desk that President Eisenhower had used with one given by Queen Victoria to President Rutherford B. Hayes in 1880. Jacqueline Kennedy's assistants, unaware of the phone's purpose, found the phone in the drawer and, thinking an extra telephone quite unnecessary, removed it.[28]

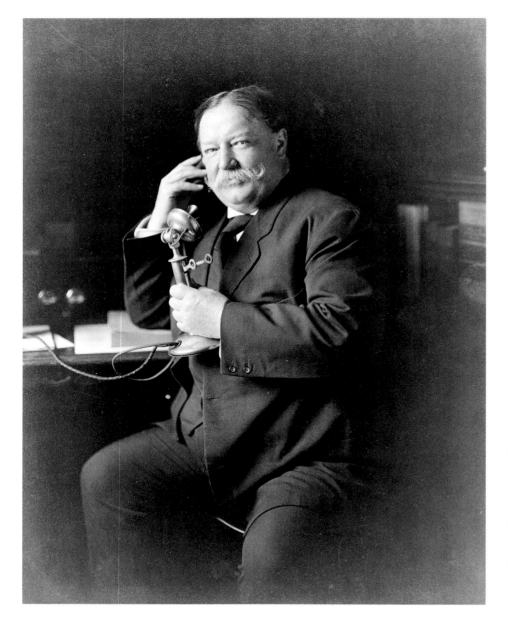

OPPOSITE: First official White House fleet of horseless carriages, 1909. Photographer unknown.

(From left: a White Steamer, a Baker Electric, and two Pierce Arrows.)

Although the first American auto race was held in 1895 (and won by a car going an average of eight miles an hour), and although the U.S. Army experimented with automobiles now and then beginning in 1899,[29] cars were considered a distinct sign of privilege for most of the first decade of the twentieth century. Theodore Roosevelt refused to own one. He rode trolleys instead, those being more suitable for a populist.[30]

William Howard Taft changed that scenario and set the country on a course to car ownership. He got Congress, despite some grumbling resistance, to allot $12,000 for some of the

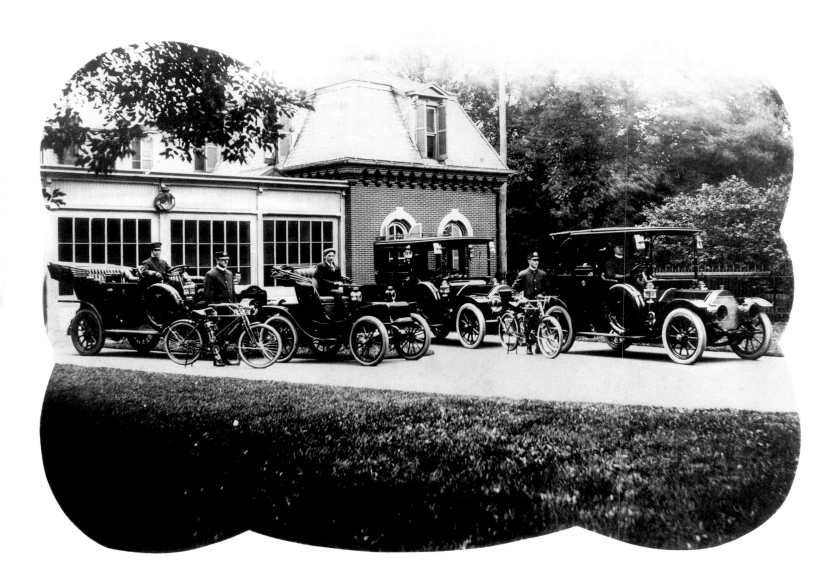

world's best cars, at a time when the middle class was beginning to take to cars — already by 1908, gasoline, formerly considered a waste product of production distillation, was edging up to $0.20 a gallon. But for several years, the streets of Washington were still shared by automobiles and horse-drawn carriages. Taft believed that the new industry contributed mightily to the nation's wealth and said he was sure that "the automobile coming in as a toy of the wealthier class is going to prove the most useful of them all to all classes rich and poor."[31]

The influence of the president was incalculable. In February of 1909, *Motor Age* wrote, "When the President turns his horses out to die, then everybody who wants to imitate the President does the same thing, and the example extends itself down, not only to everybody who can afford to buy a motor car, but to a good many people who cannot afford to buy one."[32] The White House cars were said to denote not privilege but American republicanism. Mrs. Taft had a Baker Electric Victoria that she drove in the summer; the *New York Times* proclaimed, "No greater contrast can be found between the pomp and state of a European court [where carriages were pulled out for formal occasions] and the democracy of America than to see the wife of the President driving her own automobile in the streets of Washington."[33]

By 1910 it was claimed that motoring could cure throat trouble and help stave off insomnia. Furthermore, French scientists said that car travel tended to increase red blood corpuscles and that the vibration would rejuvenate a sluggish blood flow.[34]

Horse-drawn carriage for Elizabeth Jaffray, White House housekeeper from 1909 to 1926, c. 1920–1926. Ralph Waldo Magee.

Not everyone was convinced. The White House housekeeper, who preferred a carriage as "part of the dignity and tradition of the White House," had two carriages maintained for her use into the 1920s.[35] Carriages also returned to Washington on gasless days during World War I.

Harry Atwood flies over the White House, 1911. Harris & Ewing.

Airplanes, like automobiles, were considered rich men's toys. Rich men's automobile clubs even promoted their use. Theodore Roosevelt was not interested; neither was the U.S. government. In 1905 the U.S. War Department turned down the Wright brothers' offers to share their scientific knowledge of flight three different times.

Taft was secretary of war in 1908, when the War

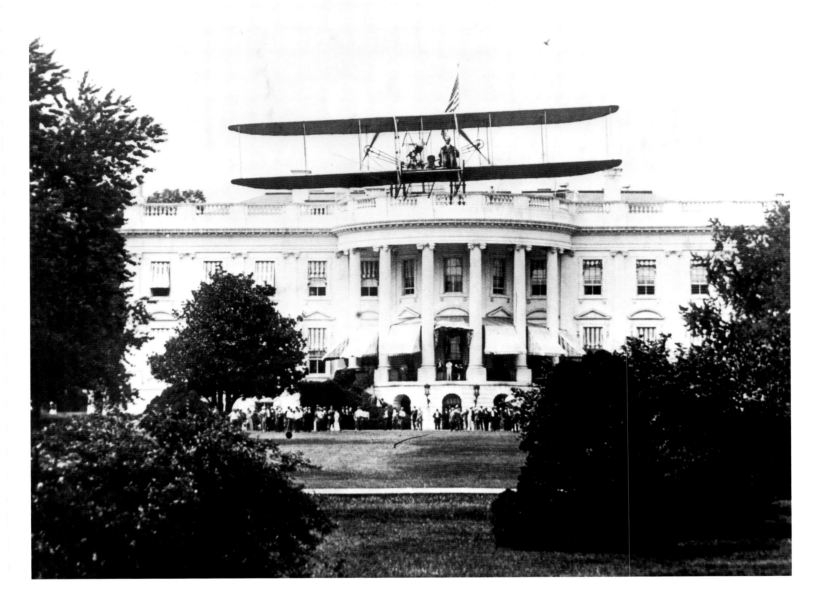

Department invited the Wrights to demonstrate their planes. The unhappy result was that Orville crashed, lost a propeller, killed an Army observer who was on the plane with him, and ended up in the hospital himself. The following year, he came back; Taft, by then president, approved the return visit. The U.S. Army gave the new technology its first official recognition, including a contract, and Taft gave the brothers a gold medal.[36] The president backed the army's purchase of planes and establishment of a pilot school, but he would not go up in an airplane himself because he said his shape was "unaerodynamic."[37]

Harry Atwood, a student of the Wrights, was an aviation pioneer who set several records. In 1911, when Washington had no airport and Atwood had already buzzed the Capitol and the Washington Monument, he was invited to the White House and, characteristically, flew in quite dramatically. Setting down on the South Lawn, he coasted to a stop thirty feet from the president, who then rewarded him (possibly for stopping in time) with a gold medal.[38]

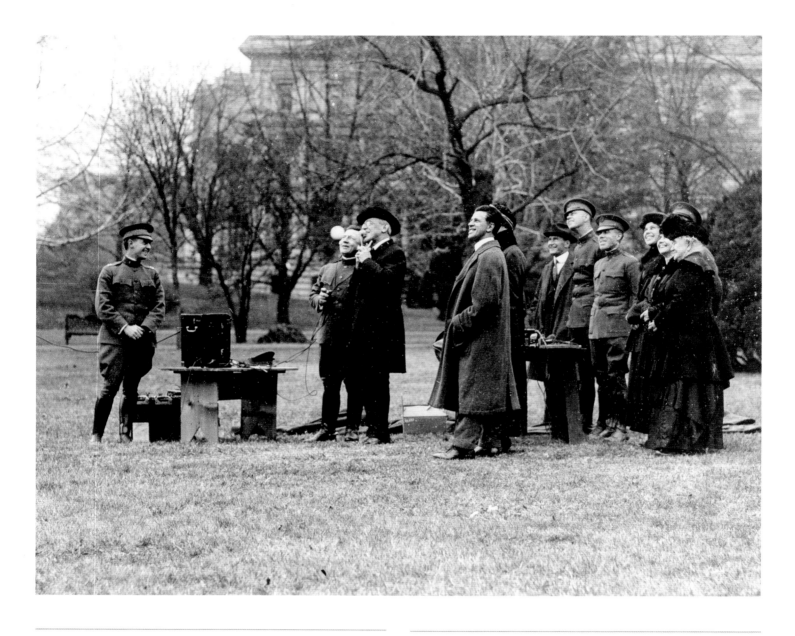

President Wilson talks with a pilot flying overhead, November 22, 1918. Photographer unknown.

Just before and during World War I, as aircraft entered warfare, great efforts were made to develop air-to-ground and ground-to-air radio telephony, principally for planes and dirigibles on reconnaissance missions. In 1911 an army plane transmitted a message over 2 miles, in 1912 over 50, and by 1916 over 140. Eleven days after the Allied powers signed an armistice with Germany, President and Mrs. Wilson gave a public demonstration of the new communications system. The technology was still primitive, but America's radio-broadcast system developed out of it in the 1920s.[39]

OPPOSITE, ABOVE: **Warren Harding speaking into a funnel microphone, recording a campaign speech, June 29, 1920. Harris & Ewing.**

Edison recorded Rutherford B. Hayes soon after he invented his first phonograph in 1877, but the recording is lost. Three different recordings were made of "President McKinley's last speech," but it wasn't the president who recorded them. In the early twentieth century, presidential candidates rather than presidents recorded their speeches — speeches by Taft are the first ones extant — which were for sale, with a photograph of the candidate, and were played in churches and other

gathering places in towns the candidate couldn't visit by train.

Harding is recording on an acoustical device, which had no amplification or microphone. Electrical recording, which could pick up inflection and sometimes even the background noise of crowds, came in 1925. But the 1920 campaign was the last time that candidates made recordings; radio took over in the next election.

The speech Harding is recording, titled "Americanism," set forth his opposition to America's entry into the League of Nations.[40] Harding was actively involved in promoting the new American technological industries that were becoming important after the war, including radio, automobiles, movies, and air travel.[41]

"The Missing Link Is Supplied."
Puck, 1908. John S. Pughe.

Warren Gamaliel Harding and his opponent, James M. Cox, both recorded campaign speeches in 1920. This 1908 cartoon suggests that if a mechanical hand for shaking hands were attached to the phonograph, the candidates would be spared the trouble of making personal appearances. The idea of candidates as mechanically reproduced images was in the air long before television.

Radio will bring Cleveland convention to Coolidge, June 7, 1924. Photographer unknown.

Broadcast changed radio from a military to a mass medium, and election news was so big that it prompted the first radio news "flash" when a Pittsburgh station broadcast Warren Harding's victory in 1920. In 1924, 2.4 million American households had radio receivers, double the number of the previous year, and radio covered both the Republican and Democratic National Conventions and broadcast the voices of both candidates.[42]

Radio radically changed a president's potential for communicating his message to citizens. In 1829 Andrew Jackson spoke to approximately 10,000 people who came to his inauguration. One hundred and twenty-five thousand heard Warren Harding. Only a few years later, Calvin Coolidge broadcast a speech to 23 million listeners.[43] Then, in 1933, Franklin Roosevelt's inaugural speech was sent around the world by short-wave radio.[44]

Coolidge used radio to enhance his popularity, broadcasting speeches nationally about once a month. He once told Senator James Watson, "I am very fortunate that I came in with the radio. I can't make an engaging, rousing, or oratorical speech to a crowd as you can...but I have a good radio voice, and now I can get my messages across to them without acquainting them with my lack of oratorical ability."[45] The influence of the media on political viability and the potential of the presidency as a bully pulpit were advanced exponentially by this new development.

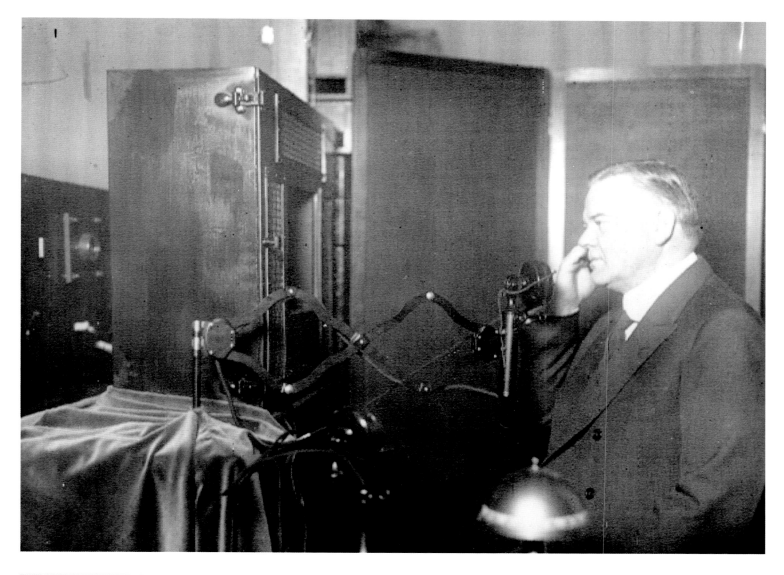

Secretary of commerce Herbert Hoover demonstrating long-distance television broadcasting, 1927. Photographer unknown.

This photograph commemorates the first public demonstration of long-distance television in the United States. The system was developed by the American Telephone and Telegraph Company (AT&T). The Bell System sent live TV images of Herbert Hoover (who would become president in 1929) over telephone lines from the capital to an auditorium in Manhattan. The picture tube did not yet exist; Hoover's image appeared as tiny dots of light on the 2 × 2½" face of a neon glow lamp. Hoover said that this latest scientific discovery was "a marvelous agency for whatever use the future may find." The *New York Times* reported that AT&T "has no idea today whether it will

ever be commercially valuable." Mrs. Hoover, who was also present at the broadcast, was not sanguine about the medium. "What will you invent next?" she asked. "I hope you won't invent anything that reads our thoughts." [46]

In 1929 Hoover would become America's first engineer president, riding a post–World War I wave of belief in the power of technology to better the world.

At the 1939 World's Fair in New York, Franklin Roosevelt made a 30-second television broadcast that could be seen by only a handful of people who happened to own television sets and live in the area.[47] World War II interrupted the progress of the medium, but Harry S. Truman put the presidency behind it again by broadcasting his speeches beginning in 1947. Americans didn't yet own many sets, but TV ownership continued to grow and leaped upward in the 1960s.

Vice President Charles Curtis and hot-weather cabinet, July 11, 1929. Herbert E. French.

Movie theaters and some department stores were air conditioned from the mid-1920s on. The chamber of the House of Representatives was air conditioned in 1928, but the White House did not install air conditioning until 1933, when a few rooms on the upper floors, where the family lived, were given individual units. Central air-conditioning was added in 1950 during the Truman renovation.[48]

Eleanor Roosevelt choosing air travel, Dallas, Texas, June 5, 1933. Photographer unknown.

In the 1920s, air travel was expensive, extremely uncomfortable, and thought to be dangerous; travelers were largely the rich or businessmen on expense accounts.[49] Franklin Roosevelt put his seal of approval on it before he ever became president: in 1932 he flew to Chicago through a rain storm to accept the Democratic nomination, making news and presenting himself as an active man on the cutting edge.[50] Once he was in the White House, his wife made a point of making air travel more popular, evidently successfully. Although Eleanor Roosevelt generally refused offers to endorse products in advertisements, she lent her name without charge to airline-industry ads to promote flying among women. She took flying lessons herself and once staged a publicity stunt for

airline travel: she flew with Amelia Earhart from Washington to Baltimore and back one evening, both of them in evening dresses. Press Secretary Steve Early sent out advance memos telling photographers that stills and movies were permitted. Mrs. Roosevelt, without removing her white gloves, piloted the plane herself for a time. She told reporters, "It does mark an epoch, doesn't it, when a girl in evening dress and slippers can pilot a plane at night."[51]

In the mid- and late 1930s, the introduction of the Douglas DC-2 and DC-3 made plane travel much more comfortable. U.S. airlines reported an increase in the number of air passenger miles from 95,000 in 1932 to 677 million revenue miles by 1939.[52]

***Akron*, the world's largest dirigible, pays first call on capital, November 2, 1931. Underwood & Underwood.**

Dirigibles, which first flew in the 1890s, played an important role in reconnaissance during World War I. First Lady Lou Hoover christened the *Akron,* built in Akron, Ohio, for the navy in August of 1931. It crisscrossed the country several times, to the marveling eyes of citizens. This airship was large enough to house five small fighter planes that could launch from and return to the airship in mid-ocean. This was its first visit to the capital, where it presented a moving spectacle as it floated slowly and majestically over Washington's public buildings.

The Akron was lost in a storm at sea in 1933. After the *Hindenburg* crashed and burned in New Jersey before a crowd of reporters and photographers in 1937, dirigibles ceased carrying passengers, giving airplane travel a boost.

President Eisenhower leaving the White House by helicopter for Gettysburg, Pennsylvania, May 20, 1958. Warren K. Leffler.

Helicopters were envisioned long before they were invented — by Leonardo da Vinci, among others. The first one to lift off the ground was designed by a Frenchman and flew in 1907, for a few seconds. Another Frenchman flew for more than seven minutes in 1924, and in the 1930s, the aircraft finally became practical. During the Korean War, helicopters proved invaluable for evacuating the wounded. In 1957 Dwight David Eisenhower took the first presidential copter flight from the White House lawn aboard a Bell H-13J in an emergency evacuation exercise.

After that, helicopters became routine presidential vehicles. By 1958 the Sikorsky CH-34C was the primary presidential chopper. Ike, obscured here by the White

House (as presidents sometimes were), by the grounds, and by a photographer, was on his way to Gettysburg, where he had a farm and hosted dignitaries.[53]

OPPOSITE, ABOVE: **Him and Her play in the office while President Lyndon B. Johnson reads a Teletype printout, April 16, 1966. Yoichi Okamoto.**

LBJ, who listened to news via a transistor radio held to his ear even during strolls in the White House grounds or around his ranch, was devoted to the tickers that continually printed out breaking stories from the wire services of the Associated Press, the United Press, and Reuters. He later said, "Those tickers were like friends tapping at my

door for attention. I loved having them around. They kept me in touch with the outside world. They made me feel that I was truly in the center of things. I could sit beside the ticker for hours on end and never get lonely."[54]

The Teletype machine was the successor to the stock ticker. A machine to print telegraph messages directly had been developed in the first decade of the twentieth century and came into limited use in the second, reaching maturity in the 1920s when the financial industry and news organizations began using the technology. By around 1990, the machine the president is consulting had been rendered obsolete by fax and the internet. In January of 2006, Western Union sent its last telegram.[55]

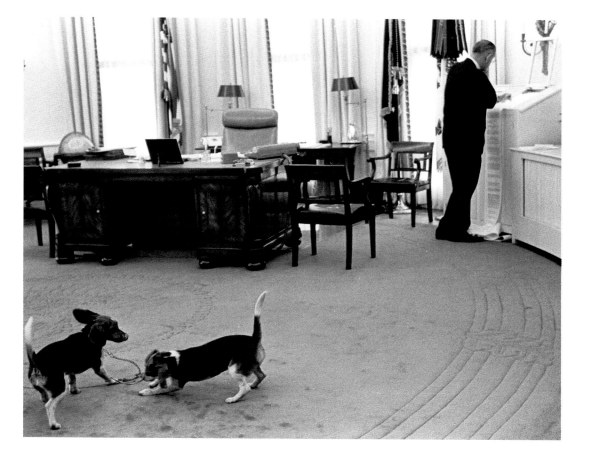

Communications office, February 1957. Thomas J. O'Halloran.

In the 1950s, the vital communications office was overcrowded. On the left in the picture are magnetic tape recorders; on the right, magnetic wire recorders. Wire recorders became commercially successful in the 1930s and were used by America in World War II to record and broadcast battle sounds to fool the Germans into thinking Allied troops were in places they were not. Magnetic tape had many advantages over wire and soon after the war largely replaced it.[56]

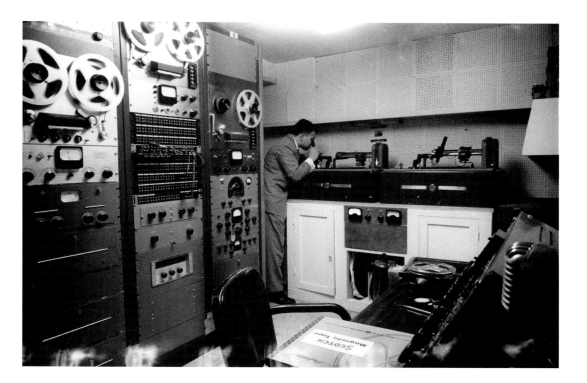

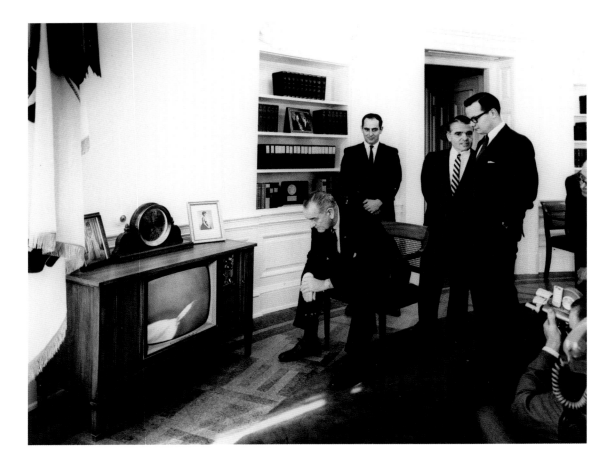

President Johnson with an unidentified Secret Service agent, Special Consultant Jack Valenti, and Special Assistant Bill Moyers watching the Saturn rocket liftoff, January 29, 1964. Abbie Rowe.

When Lyndon Johnson became president after Kennedy's assassination, he was already deeply committed to the Apollo program to go to the moon. The Saturn rocket, first launched on October 27, 1961, was a major component of that program; in 1969 it would take men there.

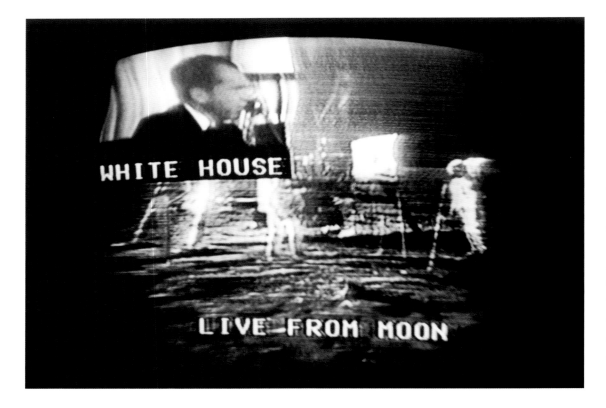

Richard Nixon speaks to a man on the moon via radio telephone, July 21, 1969. Kenneth Garrett.

When Apollo 11's lunar lander put Neil Armstrong and Edwin "Buzz" Aldrin down on the moon, the first men to ever walk on its surface, President Richard M. Nixon called to congratulate them. "Hello, Neil and Buzz," he began, "I am talking to you by phone from the Oval Room in the White House, and this certainly has to be the most historic telephone call ever made from the White House."

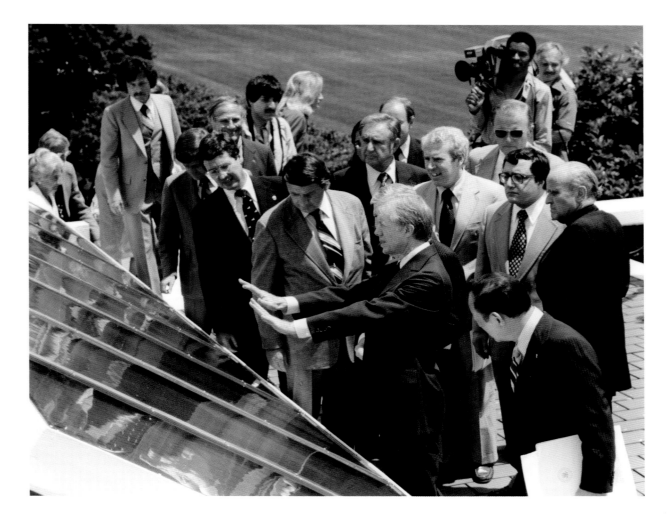

Jimmy Carter at a solar-panel dedication ceremony, June 20, 1979. Bill Fitz-Patrick.

In April of his first term, Jimmy Carter went on television to address the nation. "Tonight I want to have an unpleasant talk with you," he said, "about a problem unprecedented in our history. With the exception of preventing war, this is the greatest challenge our country will face during our lifetimes. The energy crisis has not yet overwhelmed us, but it will if we do not act quickly."[57] He set forth a National Energy Plan. Even in 1977, this was hardly a new issue. President Nixon had established an energy-policy office and called for energy self-sufficiency, and President Ford had created a new International Energy Agency. Within months of his national address, Carter signed an act setting up the Department of Energy, raising energy issues to cabinet level. Later in 1977, the Department launched the Solar Energy Research Institute, which was committed to harnessing energy from the sun.[58]

Jimmy Carter tried to live his policies: he wore sweaters, had a wood stove in his living quarters, and did not turn on Christmas lights in 1979 and 1980.

In 1979 he proposed a "new solar strategy" where 20 percent of American energy would be derived from solar power by the year 2000, to ensure the security of the nation's energy supply. He also granted tax reductions for the installation of solar panels and, to set an example, had solar panels installed on the roof of the West Wing. In 1986, when the roof was leaking, President Reagan had the panels removed. They were not put back. Reagan also slashed the energy budget.[59]

In 2002, under President George W. Bush's auspices, three solar-energy systems were installed on the White House grounds, one on the roof of the central maintenance building, one to provide hot water for the grounds maintenance staff, and one to heat a hot tub and shower in the cabana adjacent to the outdoor pool.[60]

President Reagan making a call to the space shuttle *Columbia* from the Oval Office, November 11, 1982. Michael Evans.

President Nixon had endorsed the idea of a space shuttle in early 1972. NASA expected the first mission to launch in 1978, but budget cutbacks delayed the initial flight of *Columbia,* the first reusable spacecraft carrying a crew, until 1981. STS-5 (Space Transportation System 5), also on the *Columbia* shuttle, launched on November 11, 1982, deployed two commercial communications satellites, and carried several experiments. It landed back on earth on November 22.

President Reagan is speaking to the shuttle crew of Vance D. Brand, Robert F. Overmyer, Joseph P. Allen, and William B. Lenoir not long after the successful launch. Four years later, after the tragic explosion of *Challenger,* NASA canceled the *Challenger* spacecraft and suspended all shuttle flights for two years.[61]

President Ronald Reagan and his staff watching a televised replay of the explosion of the *Challenger,* January 28, 1986. Pete Souza.

(Left to right: Larry Speakes, Dennis Thomas, Jim Kuhn, President Reagan, Pat Buchanan, Don Regan.)

People everywhere watched the liftoff. Schools turned on televisions so that children could watch the ascent of the shuttle that carried Christa McAuliffe, the first civilian and the first teacher to go into space. Seventy-three seconds after launch, the entire television audience saw the *Challenger* explode. The tapes were replayed constantly; viewers saw not just the terrifying fireball but the excitement turning to shock and horror on the faces of those at Cape Canaveral. The seven crewmembers died, doubling the number of astronauts who had died in the entire twenty-five years of space exploration.

President Reagan, scheduled to deliver the State of the Union, instead went on national television to speak about the disaster. Addressing school children particularly, he said, "The future doesn't belong to the faint-hearted; it belongs to the brave. The *Challenger* crew was pulling us into the future, and we'll continue to follow them." [62]

President Obama, speaking to astronauts aboard the International Space Station, hands the phone to a middle-school student, February 17, 2010. Bill Ingalls, NASA.

Ham radio first flew on the shuttle in 1983 and has since been used by dozens of astronauts to speak to thousands of school children as well as to their own families. In 1985 one astronaut with ham television gear beamed images to more than 6,000 waiting young people and picked up (from the Johnson Space Center ham operation) the first live television images ever received on a shuttle. Radio experimentation now regularly brings television and e-mail from the space station in a program participated in by nine countries and a Russian space firm.[63]

President Obama has spoken more than once with astronauts on board the space station, and he has included both school children and members of Congress in these conversations. On his first call to the station, in March of 2009, he told the astronauts how proud he was of their work — and that he was glad they were using the hands-free phone while traveling at 17,000 miles an hour. On the second call, in February of 2010, he again told them how proud he was, and he assured them that his commitment to NASA was unwavering. "The rumor was," he said at one point, "you could see the Great Wall from space, but I'm not sure that's true."[64] It's true, they told him, and they could also see San Francisco's Golden Gate Bridge and the Grand Canyon. During both calls, the president asked for questions from students and handed them the phone so they could address the astronauts directly.

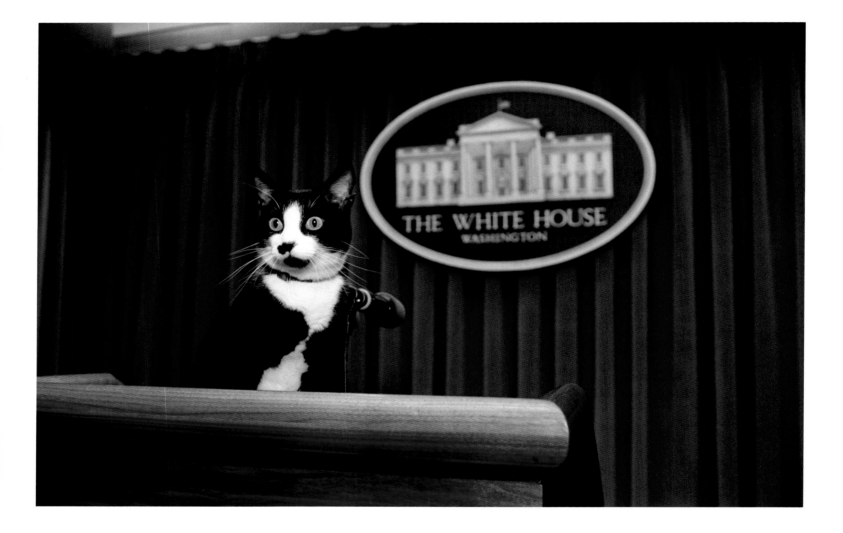

CHAPTER 8: ANIMALS AT THE WHITE HOUSE

IF YOU WERE to add up all the animals that have been short-term or long-term inhabitants of the White House, the sum would describe a kind of animal kingdom. From the moment the new country was born, people considered pets appropriate gifts for a president. Washington, who was in office before the White House was habitable, was presented with several hunting dogs, including one from the king of Spain; he also had three American Staghounds named Sweet Lips, Scentwell, and Vulcan.[1] Soon enough, horses (lots of horses), cows, pigs, goats, dogs (lots of dogs), cats, rats, hamsters, and guinea pigs came to stay. Over time, uncommon faunas also found their way across oceans to the seat of government. The White House has played temporary host to a zebra, a pair of lion cubs, a pair of tiger cubs, a bobcat, a pygmy hippo, an elephant or two, an antelope, a cinnamon bear, and silkworms, among others.

The Executive Mansion had a stable but no provision for lions or elephants, so all this exotica was trotted off to zoos, though special arrangements were occasionally made. An alligator was rumored to have resided at the White House when the Marquis de Lafayette, who toured the States in 1824 and 1825 and received gifts of animals, supposedly brought the reptile with him when he was a guest of President John Quincy Adams — but it is unclear whether the beast actually accompanied the noted Frenchman.[2]

Pet keeping had become strongly associated with childhood by the nineteenth century, and presidents arrived at the residence with their own pets and especially with their children's. Tad Lincoln, for instance, had two pet goats that his father was quite fond of. The goats recognized the president's voice and would come to him when called, then father and son would play with them on the White House lawn.[4] By the 1870s, it was assumed that all children had, or should have, pets, which would nurture their capacity for love. One writer asked, "Who can doubt that many a heart, both of the happy and sad, has been made better by the multitudes of parrots, lap-dogs, canaries &c. which have been objects of affection."[5]

Then, as now, people thought of their pets as in effect honorary family members. In the 1840s, as the craze for portraits settled on America, many brought their dogs, and later their cats, with them to photography studios. By the last decade of the century, pet portraits were as important to family albums and archives as likenesses of relatives were.[6] As the nation's interest expanded from the president and his house to everything about him and everything in it, his children became one focal point; their pets could not be far behind. The early news about White House pets was exclusively written news, for an animal's antics could only be photographed if a photographer with a fast camera was on the spot to

OPPOSITE: **Socks at lectern, 1994. Barbara Kinney.**

While Bill Clinton was governor of Arkansas, young Chelsea Clinton saw two stray kittens playing, reached out her arms, and Socks jumped into them — and got himself adopted. Later he moved into the White House. Socks didn't have free run of the Executive Mansion, so he didn't exactly stray into the press briefing room to answer reporters' questions; the photographer staged the shot.[3]

Children wrote Socks piles of letters; Republican representative Dan Burton once publicly criticized the use of White House staff, stationery, and postage to answer a cat's mail.[7] The cat also was featured in an episode of the television show *Murphy Brown* titled "Sox and the Single Girl."[8] Socks was the sole first pet until the Clintons acquired Buddy, a Labrador retriever. Try as he might, President Clinton never could get the two animals to reconcile.

record it, and there were neither photographers nor fast cameras on the White House lawn when Lincoln and his son gamboled with goats.

The president whose children were the biggest news — partly because there were so many of them and they were so colorful, partly because the media was expanding so rapidly — was Theodore Roosevelt. Roosevelt knew how to use the press to his advantage, and the press was eager to help the cause. In TR's administration, the White House pets themselves became celebrities. One writer refers to pets such as those of the Roosevelt children as "community pets," pets that symbolized a bond between famous people and the public.[9] People who were expected to provide their own children with pets could readily identify and feel a relationship with a president and his pet-keeping children. The Roosevelt children's pets were more interesting than most. A little girl gave TR Josiah the badger when the president was whistle-stopping in the West, and it went home with him. The family also had a grouchy black bear for a while; it was named Jonathan Edwards after the stern preacher who was an ancestor of Mrs. Roosevelt's. Alice Roosevelt kept snakes and was particularly fond of a green one she named Emily Spinach after her very thin aunt Emily; she liked to take Emily Spinach to parties in her purse. At various times, there were also a lion, a hyena, a wildcat, a coyote, a zebra, a barn owl, and rats.[10]

Quentin Roosevelt was partial to snakes. Once he brought four of them home with him on approval from a pet store and walked into the Oval Office to show his father. TR was holding a meeting at that moment with several senators and party leaders. When Quentin hugged his father, he dropped the four snakes on a table, prompting the distinguished guests to dash pell-mell out of the room. The snakes stayed behind to do battle with each other; the president and his son rounded them up — and promptly relieved them of all governmental duties and returned them to the pet shop.[11]

The children had more ordinary pets as well, including five guinea pigs named Admiral Dewey, Dr. Johnson, Bishop Doane, Fighting Bob Evans, and Father O'Grady. The boys barged in on their father another time when he was entertaining an important visitor and cried out, "Poppa, Poppa, Father O'Grady just had children!"[12]

Subsequent presidents quickly learned that celebrity pets were useful image makers. Herbert Hoover, who already had a distinguished career in several administrations before his election as president, was perceived as a cold politician. His German shepherd, King Tut, was called upon to warm his image up. During Hoover's presidential campaign, thousands of autographed photographs of him with the dog were sent to voters. King Tut remained a public figure while residing in the White House. At night he took guardian duty upon himself, regularly patrolling the White House fences. The *New York Times* reported that the job took its toll on King Tut, who became thin and nervous and died at the age of eight. [13]

Pets, of course, had value beyond their image-enhancing function.

Some White House pets had distinctions that went beyond their presidential connections. In 1961 Nikita Khrushchev, the Soviet leader, gave Caroline Kennedy a dog named Pushinka, whose mother was Strelka, one of two dogs that, for the first time, went into orbit and returned alive — a gift with a political message in her pedigree. Kennedy's two children were also given a rabbit that played a toy trumpet and drank beer.[14]

George H. W. Bush's dog, Millie, achieved fame by writing her own book (assisted by Barbara Bush), and George W. Bush's dog, Barney, won an audience via his yearly Christmas videos on the internet. After Barack Obama won the presidency, Barney bit a reporter, which was also captured on video.

It is said that the Lord is aware of just how much a president wants his beloved pet with him when he assumes high office:

The story goes that God spoke to the new president. And God said, "I have good news and bad. The good news is that you will be permitted to bring your dog, your cat, or whatever to the White House — there is no lease restriction."

"Oh, thank you, Sir," said the new president, "and what is the bad news?"

"The bad news is that the dog will be happier there than you."[15]

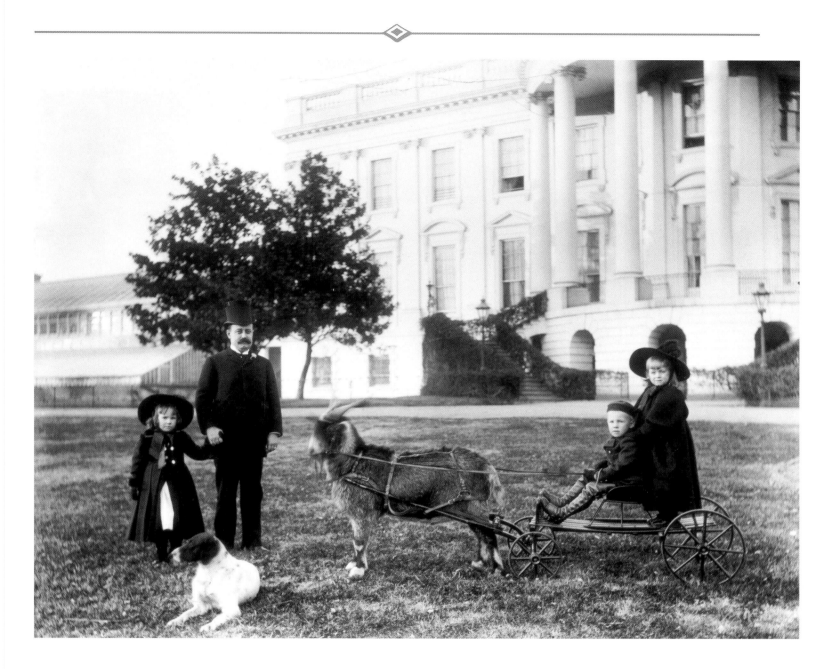

Major Russell Harrison with President Benjamin Harrison's grandchildren, c. 1889–1892. Frances Benjamin Johnston.

Benjamin "Baby" McKee, the president's favorite grandchild, and Marthena Harrison are in the cart on the South Lawn. Mary McKee waits her turn, and the patient goat, His Whiskers, waits for a "gee-up." The placement of the figures is quite careful, the groups being closed at both sides as if by parentheses by the near verticals of the girls' dark coats and the circles of their hat brims. Everyone cooperated in fine fashion with the photographer, the Major and the children presenting their full faces even if not posed frontally, the goat obligingly holding still in perfect profile, and the dog turning its head to match.

Theodore Roosevelt Jr. and Eli Yale, June 17, 1902. Frances Benjamin Johnston.

Eli Yale was a blue macaw, doubtless happy in these lush surroundings of the White House conservatory. Seamen had brought exotic birds like this one (and other nonnative animals) to American port cities for decades, but bird dealers and general pet stores in big cities were not well supplied with creatures from Asia and South America until the 1890s.[16]

President Taft's cow, Pauline Wayne, grazing on the lawn of the State, War, and Navy Building, c. 1909. National Photo Company.

The White House kept cows for over one hundred years, for dairy companies did not make deliveries of fresh milk throughout the country during the nineteenth century. William Howard Taft was the last president to keep a cow, and Pauline shared space in the stable-cum-garage with Taft's White Steamer automobile, his two Pierce Arrows, and a Baker Electric.[17]

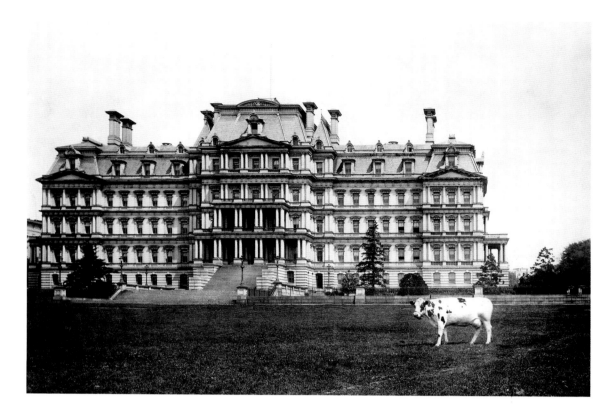

Feeding Wilson's sheep, c. 1917–1921. Photographer unknown.

During World War I, President Woodrow Wilson kept sheep in order to save manpower by eliminating grass cutting. Wilson's sheep included a tobacco-chewing ram named Old Ike. They did crop the grass — and a lot of expensive shrubs and an entire bed of fine perennials as well, so the grounds keepers were less than enamored of them. Their wool was sheared repeatedly and auctioned off to benefit the Red Cross. In 1920, when there was no longer so great a shortage of manpower, Wilson gave the sheep away.[18]

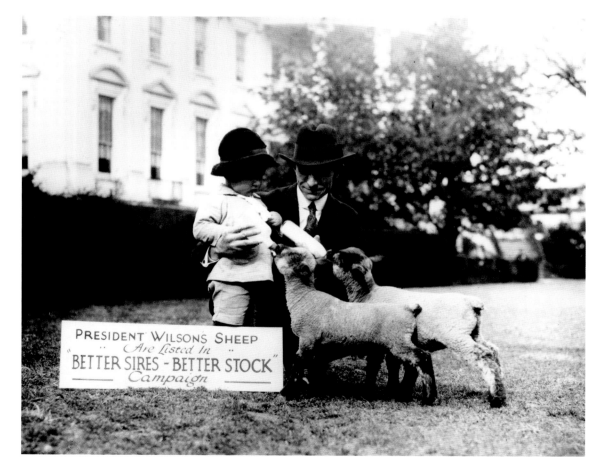

PRESIDENT WILSON'S SHEEP
Are Listed In
" BETTER SIRES - BETTER STOCK "
Campaign

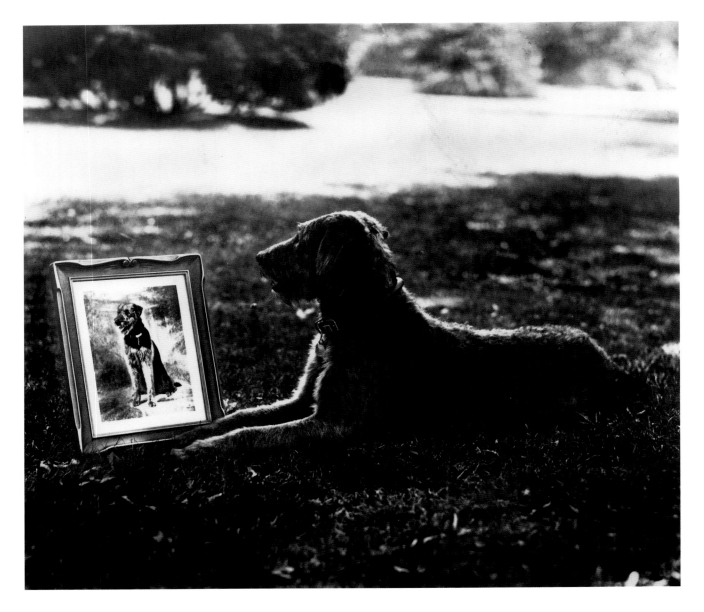

Laddie Boy with his portrait, July 31, 1922. Herbert E. French.

Presidential pets became celebrities because their masters were, and because the press needed fodder. Warren Harding's Airedale was boosted to fame by a White House that was fully aware of how useful a dog could be to a president's image. In 1919 an advertising man had written that candidates "needed to be 'humanized'" to appeal to "the great silent majority of Americans."[19] Harding and his wife, Florence, had no children to be their ambassadors to the press, so Laddie Boy was appointed, and the public seemed to accept the three of them as a family. Florence was chief celebrity promoter; she used the dog both to warm up her husband's image and to promote animal rights, a radical notion at the time. She appealed for the end of vivisection, and for public education on the humane care of animals, and she made Laddie Boy, who apparently liked being photographed, the poster child for the cause.[20]

Laddie Boy was continually fawned over by the press. He was "interviewed" in the editorial section of the *Washington Star* on Sunday, July 17, 1921, freely offering his opinion on matters like Prohibition and the Harding cabinet and advocating an eight-hour day for guard dogs. Harding himself was the ghostwriter. A member of the Newsboys Association raised 19,134 pennies from newsboys; these were melted down and made into a statue of the dog.[21]

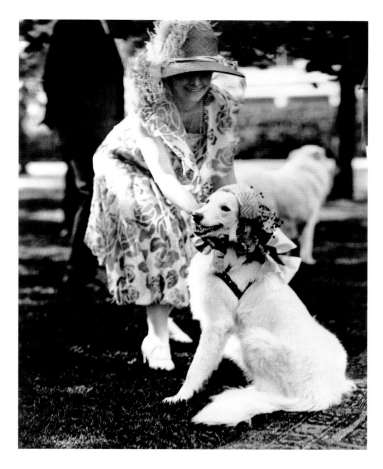

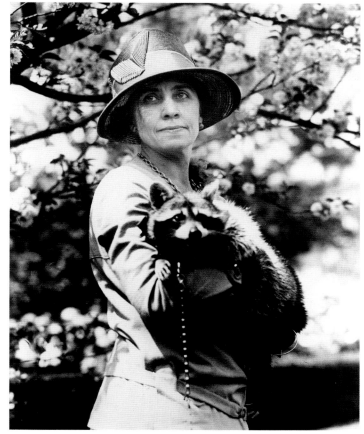

The Airedale's fame was so great that it extended to his relatives: a man who owned Dickie Boy, a brother of Laddie Boy, answered charges in court that his dog had butchered seventy or eighty chickens by asking the judge whether he could believe that the brother of the president's dog would stoop to such shenanigans. The judge said he thought not and dismissed the case for lack of evidence.[22]

Celebrity breeds celebrity: Laddie Boy was marketed as a stuffed toy, and a pet-food company named a dog food after him. His fame may have gone to his head, as he seems here to have fallen in love with his portrait, which is photographed in full light while the dog himself is merely backlit.

Grace Coolidge's collie, Prudence Prim, wearing a bonnet at a garden party, 1926. Photographer unknown.

From early in the history of photography, dog owners dressed their dogs in hats, jackets, trousers, skirts, and whatever promised to make an amusing picture — the lighter side of the way we anthropomorphize our pets. Grace Coolidge's white collie, an elegant animal to begin with, looked particularly soigné in her bonnet.

The Coolidges were second only to the Theodore Roosevelts in the variety of their menagerie. At various times, they had birds, including two canaries named Nip and Tuck; a goose that was only theirs for a short while before taking its leave; a donkey; and other brief occupants such as lion cubs, a pygmy hippo, a wallaby, a bobcat, and a bear, all of which were dispatched to zoos.

Grace Coolidge with her raccoon, Rebecca, 1927. National Photo Company.

A raccoon was sent to the Coolidge White House for the president's Thanksgiving dinner table, but the animal was pardoned without ceremony — perhaps the Coolidges didn't like raccoon — and became a household pet. Coolidge himself used to take her out on a leash for walks.[23]

White House opossum, May 6, 1929. National Photo Company.

When President Hoover came across an opossum that had strayed onto the White House grounds, the animal was adopted and his picture promptly made it into the papers. Here "Billy" is in the arms of Officer Snodgrass of the White House Police. A local high-school baseball team had recently misplaced its good-luck possum and lost every game since its disappearance. A delegation of athletes and rooters came to the White House and discovered to their grave disappointment that Billy was not their missing good-luck charm, but they asked to borrow him, and Hoover promptly assented.

The loan worked like a charm: the high school won championships in several sports that season. The athletic association wrote the president a letter of gratitude and returned the borrowed wildlife to the White House in hopes that it would bring luck there as well. Hoover wrote back, "I am glad to have your formal report on the efficiency of Billy Opossum — it will be incorporated into his service record." He promised to keep Billy in good health and spirits for the future need of the athletic teams. [24]

President Franklin Roosevelt and his dog, Fala, c. 1940. Photographer unknown.

Fala, a Scottish terrier, was given to FDR as a puppy in 1940. The dog rapidly became devoted to the president, who took him to press conferences, fishing trips, meetings, international conferences, and tours of defense plants, and sometimes spoke about him in the fireside chats addressed to citizens on the radio. At night Fala slept on a chair at the foot of FDR's bed, and in the morning a bone arrived for him on the president's breakfast tray. Fala was a charmer and happy to entertain guests with doggy tricks, including a knack he had of curling his lip into what looked like a smile.

Here he's viewing the world from Roosevelt's Ford, which the president drove with special hand controls because of his paralysis from polio. The dog was a faithful and highly visible retainer, and he was much loved by the public, which, in the tradition established by Harding's dog, sent Fala letters and gifts. Fala attended FDR's funeral and seemed never to have fully recovered from the loss of his master.[25]

Winston Churchill and President Roosevelt, Fala at his feet, aboard a ship in 1941. Photographer unknown.

Not long after World War II began, Fala became not only the ultimate symbol of American dogs but an international symbol as well. In July 1941, before America had entered the war but while it was providing aid to Great Britain, FDR secretly met with Winston Churchill on a ship off the Newfoundland coast. The two men made a joint declaration, the Atlantic Charter, regarding the purposes of the war against fascism. A photograph of the prime minister and the president aboard the ship, with Fala at FDR's feet, was published all over the free world.[26]

In the 1944 presidential campaign, the dog became the focus of Republican attacks on FDR. His opponents charged that the dog had been accidentally left behind on the president's trip to the Aleutian Islands and that Roosevelt had spent millions of taxpayer dollars sending a destroyer to pick the dog up. The accusation was false. FDR responded in a speech to the Teamsters Union that became famous as "the Fala speech." "These Republican leaders," he said, "have not been content with attacks on me, or my wife, or on my sons. No, not content with that, they now include my little dog, Fala. Well, of course, I don't resent attacks and my family doesn't resent attacks, but Fala does resent them."[27] The speech made hash of FDR's attackers and energized his supporters.

President Eisenhower receives the gift of an elephant, October 12, 1959. Abbie Rowe.

It is singularly appropriate for a Republican president to receive the gift of an elephant, although this 440-pound animal was a gift to the United States, not the president, as a symbol of friendship from the French Community of African Republics. The White House, which has been home to many an animal, has no room for a creature as large as this one, which took up residence at the National Zoo in Washington.[28]

Lyndon Johnson howls with Yuki the dog, Johnson's grandson Patrick Lyndon Nugent watches, 1968. Yoichi Okamoto.

Yuki was a mutt that President Lyndon Baines Johnson's daughter Luci Johnson Nugent found at a Texas gas station and dubbed Yuki, Japanese for "snow." The president became immensely fond of the dog, so Luci decided to leave Yuki with her father.[29] Johnson, who never hesitated to perform for the cameras — or for anyone nearby, for that matter — "sang" with Yuki no matter whether there were ambassadors or children nearby.

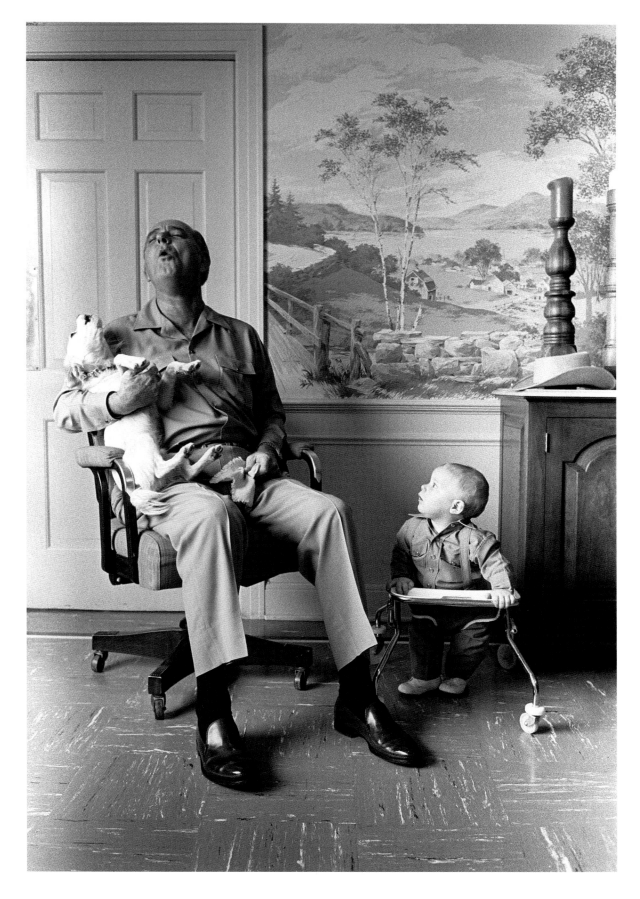

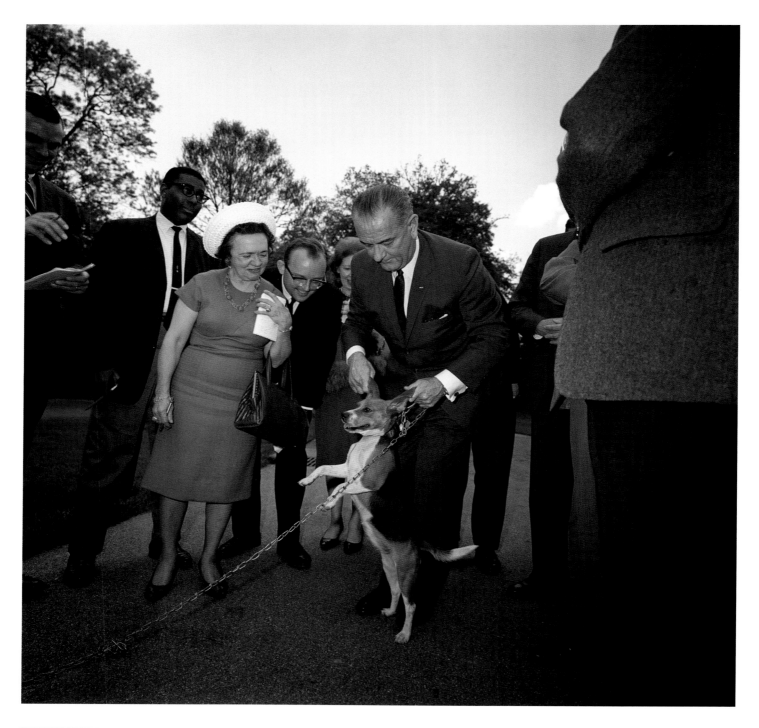

President Johnson playing with pet beagle, May 20, 1964. Cecil Stoughton.

LBJ, walking the White House grounds with some businessmen and bankers, entertained them by pulling Him, his beagle, up by the ears. The dog yelped. The president then pulled his other beagle, Her, up by the ears; she too yelped. He claimed this was good for the dogs, but dog lovers yelped even louder and the press considered it something of a scandal. A commentator in *Life* magazine wrote, "The *New York Herald Tribune* attempted to mitigate the offense by suggesting that Johnson thought the dog was only a senator, but political analysts soon pointed out that only 32% of senators look like dogs and scarcely 26% act like them."[30]

President Nixon's dogs with their own Christmas tree, December 19, 1969. Joseph J. Scherschel.

These three dogs — a Yorkshire Terrier named Pasha, a French Poodle named Vicky, and an Irish setter named King Timahoe — were treated to a tree, a dog-size Santa, and their very own Christmas stockings.

Bo Obama on the South Lawn of the White House, c. 2009. White House photograph, Chuck Kennedy.

During his presidential campaign, Barack Obama promised his daughters, Malia and Sasha, a puppy if he won. And when he did win, the news covered the search for the right dog as if it were an urgent foreign-policy matter. The Obama website was flooded with queries and comments.

At his first press conference as president-elect on November 7, 2008, Obama fielded a question about what breed the family would choose. He said they were looking for a hypoallergenic dog because daughter Malia is allergic and that they also would like to adopt a shelter dog, but, as the president said at that news conference, "obviously, a lot of shelter dogs are mutts, like me."[31]

When the momentous decision was reached to acquire a Portuguese water dog, Senator Edward Kennedy, who owned several, presented them with a six-month old puppy, which was also major news in all the media. The two girls named the dog Bo, an apparent reference to the singer "Bo" Diddley, because Michelle Obama's father is nicknamed Diddley and because their cousins have a cat named Bo.[32] Bo, aka Bo Obama, is a modern multimedia dog; he has his own website and book.

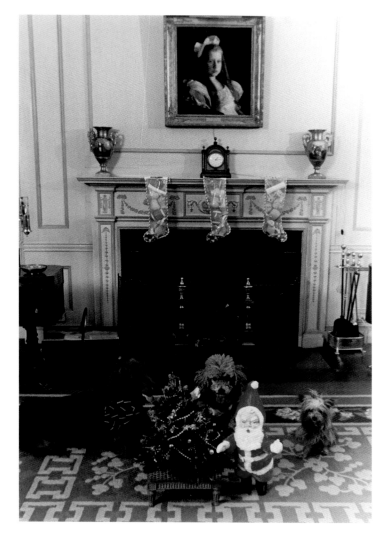

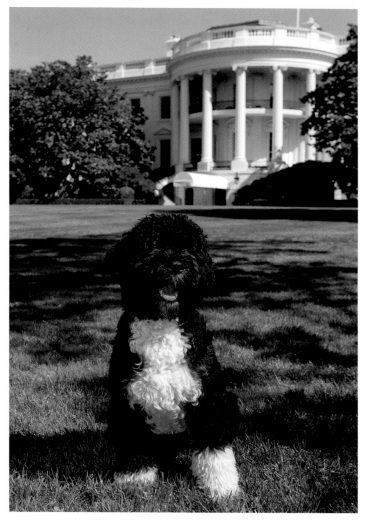

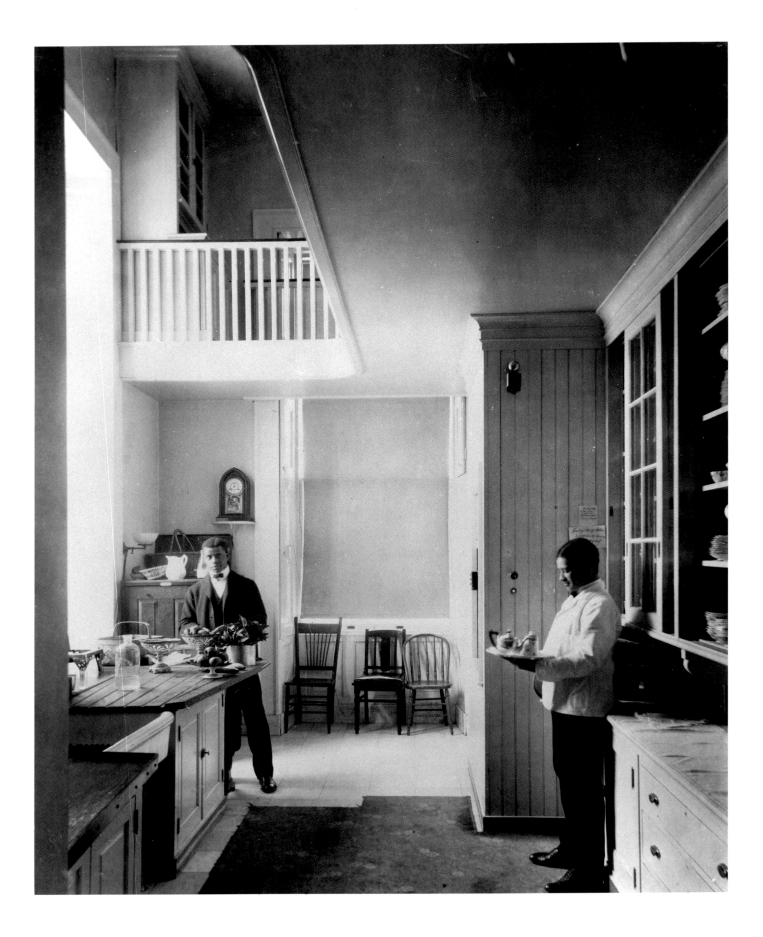

CHAPTER 9: THE PEOPLE'S HOUSE

IN 1801, WHEN the White House was still not entirely finished, Thomas Jefferson opened it to visitors for the first time. It took some effort to keep the public in the public rooms downstairs and out of the Second Floor family quarters. The house belongs to the government and the government belongs to the people, so they tended to treat the house, and mistreat it, as their own. As late as 1846, strangers occasionally barged in on the president's family or friends in the Second Floor parlor or even the bedrooms.[1] The house was thronged with visitors, especially at New Year's Day, the Fourth of July, and during postinauguration receptions, and there were recurrent complaints about riffraff not belonging at such dignified occasions.

The house was closed to public tours during the Civil War, the two World Wars, and various reconstructions. Presidents have put varying restrictions on which rooms will be open to the public, and permissions for public entry were stringently tightened after 2001. But people who could not get to Washington, or who got there but did not get beyond an official tour of the state rooms, wanted to know what really went on in the residence-cum-office that handled the country's business and its fate. As newspapers increasingly attracted readers using "soft" features like human interest and gossip, and as the White House and the president edged ever more irrevocably into celebrity status, making everything about them news of one sort or another, previously hidden or ignored aspects of White House life were brought to public view. This included photographs and stories, with domestic staff supplying the stories themselves. In 1868 Mary Lincoln's seamstress wrote an early insider's tale, but the book quickly went out of print. Before the tell-all tales of the late twentieth century, writers often felt obliged to justify their revelations. In 1908 the author of a book about domestic life in the White House wrote, referring mainly to his anecdotes about presidents' children, "A President's family belongs so much to the public by custom and necessity that I cannot fairly be accused of overstepping the proper limits of a correspondent's field of observation in thus glancing behind the partitions that separate the official from the domestic part of the Executive Mansion."[2] Although photographs of children, servants, and interiors generally required more permissions than the words of reporters did, the public was endlessly curious, and photographers were endlessly eager to satisfy them. Photographs of White House offices, furnishings, kitchens, bathrooms, bedrooms, and just about anything and anyone in residence fed citizens all kinds of information they would otherwise not have had about the house they leased to a leader every four years with an optional clause for renewal.

OPPOSITE: White House butler's pantry, c. 1904. Levin C. Handy.

A butler's pantry with all the dinnerware is on the Main, or State, Floor. The photographer has made expert use of the soft light coming in from the left.

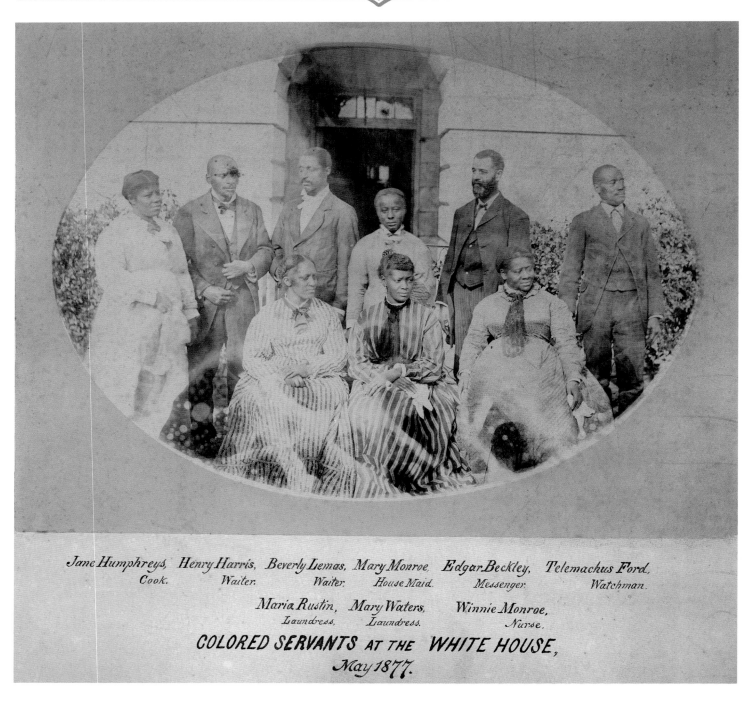

Jane Humphreys, Henry Harris, Beverly Lemas, Mary Monroe Edgar Beckley, Telemachus Ford,
Cook. Waiter. Waiter. House Maid. Messenger. Watchman.

Maria Rustin, Mary Waters, Winnie Monroe,
Laundress, Laundress. Nurse.

COLORED SERVANTS AT THE WHITE HOUSE,
May 1877.

White House domestic staff, May 1877. Photographer unknown.

This is the earliest known photograph of a group of African-American White House workers, taken at a time when the staff was predominantly but not exclusively black. Presidents brought with them or hired their own servants, including kitchen staff. In the early days, southern presidents brought their slaves. In 1865, Paul Jennings, who had been one of James Madison's slaves, wrote the first documented memoir by a White House worker.[3] The U.S. Census of 1830 reported fourteen slaves living in the White House, five of them younger than ten. By 1849 Zachary Taylor kept his slaves hidden from public view because voices were being raised in Washington against slaves in service and the slave trade in the city.[4] For most of the

nineteenth century, the staff was racially and ethnically mixed — as it was in most upper-class private homes in Washington.

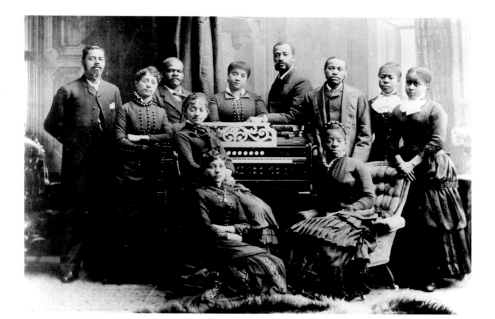

Jubilee singers of Fisk University, 1883. Photographer unknown.

President Chester A. Arthur invited the Jubilee Singers of Fisk University, here elegantly posed and looking self-assured and distinguished, to sing at the White House. Fisk, which opened in 1866, was intended for all races but initially served mainly ex-slaves. The Jubilee Singers, who toured the United States and Europe beginning in 1871, were highly successful, singing before kings and queens (and a president) and earning a good deal of money for the university. African-Americans frequently gave musical performances at the White House and a few attended receptions in the nineteenth century, but receiving black guests was a contentious issue into the twentieth century.

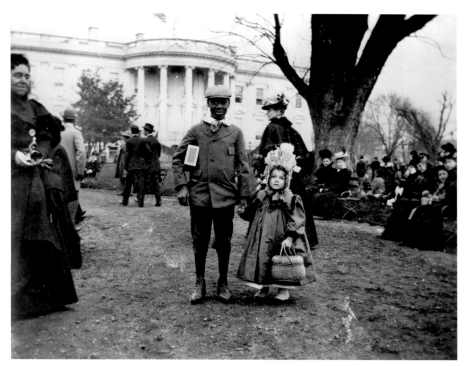

Easter Egg Roll on the White House lawn, 1898. Frances Benjamin Johnston.

Traditionally, an Egg Roll was held on the grounds of the Capitol on the Monday after Easter. In 1878 Congress, unhappy about turf damage and the eggshells and litter left on the lawn, passed a law prohibiting the use of the Capitol as a playground. Rutherford B. Hayes's administration came to the children's rescue. Children were invited to roll eggs on the White House lawn and the grounds of the National Observatory.[5] The White House has hosted children the day after Easter ever since, with time-outs for the two World Wars and occasional uncooperative weather. Harry Truman reluctantly maintained the wartime ban on egg rolling after World War II had ended and the United States was sending food to Europe; the custom was revived in 1953.

In the post–Civil War years, this event welcomed all races, which meant including ex-slaves. Washington had been a magnet for black migration before, during, and after the Civil War. No child could enter the Egg Roll without an adult, no adult without a child. Some children discovered this was a way to make money: they milled around in the crowd outside the gates until a childless adult agreed to pay them a nickel or whatever the going rate was. The temporarily adopted children took their new "parent" in and immediately left to find another. Such financial arrangements created some unusual family groups.[6]

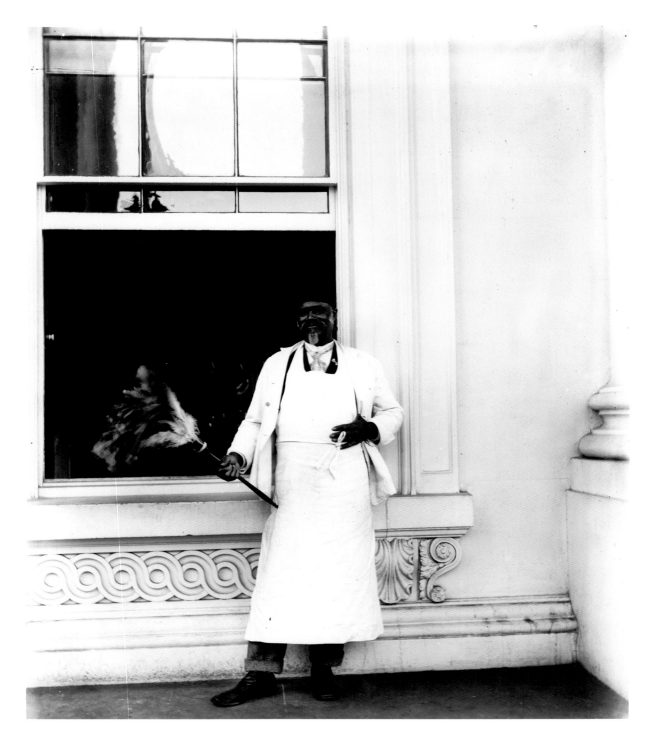

Jerry Smith, White House footman, with a feather duster on the North Portico, c. 1900. Frances Benjamin Johnston.

The fellow striking a debonair pose with his feather duster at the ready had been at the White House since the end of the 1860s when Ulysses Grant was president. He worked there as butler, cook, doorman, and footman until he retired thirty-five years later. He was a popular character, and on slow news days reporters begged him for stories about White House ghosts. These reports claimed Jerry Smith had seen both Lincoln and Grant, and that McKinley tried to speak to him but could only produce a buzzing sound.[7]

Benjamin Harrison's cook, Dolly Johnson, at work in the White House kitchen, c. 1891–1893. Frances Benjamin Johnston.

Dolly Johnson first came to the White House in 1889 as chief cook for Benjamin Harrison and was still there in 1902, when Johnston photographed her again. The previous cook was Mme. Madeleine Pelouard from France, well known for her "complicated French menus," but Washington journalist Frank Carpenter thought that "the plain dishes of Dolly Johnson" would better suit the president's taste.[8]

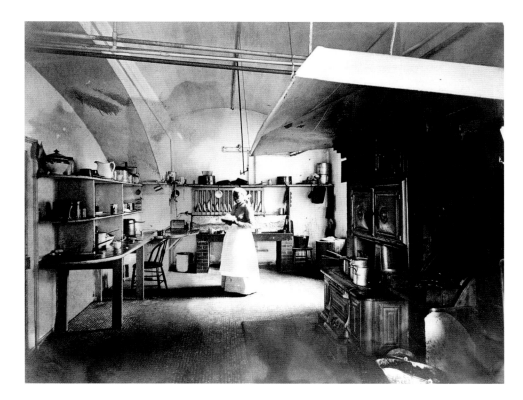

White House chef and his staff, c. 2000. Maggie Knaus.

(Left to right: Rachel Walker; John Moeller; Executive Chef Walter Scheib, who was White House chef from 1994 to 2005; Christeta "Chris" Comerford, who became George W. Bush's chef in 2005; Adam Collick.)

Kitchens change with taste and technology — and so does posing for the camera, which now calls for smiles whereas seriousness was the order of the day when exposures were long. Stainless steel was first installed in FDR's "New Deal Kitchen," which, with multiple electric stoves and mixers, eight electric refrigerators, and five electric dishwashers, could provide a meal for one thousand people — but the staff was uncomfortable with all those newfangled appliances and preferred to wash dishes and slice and chop by hand.[9] The last time the White House kitchen had a major renovation was in 1971, during Richard Nixon's administration.

A BATHROOM IN THE WHITE HOUSE

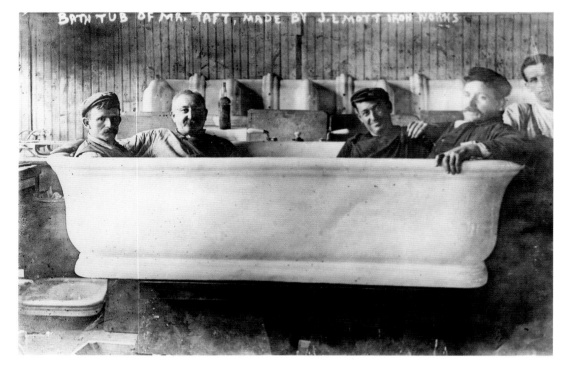

"A Bathroom in the White House," illustrated postcard, 1907.

Other than indelicate topics — and time changes the definition of indelicate — all the nooks and crannies of the White House were objects of curiosity, which fed the ambitions and bank accounts of photographers (and illustrators, who often copied photographs). Picture postcards had been popular in America since 1893, when images of the World's Columbian Exposition in Chicago found a wide audience. This postcard's title identifies the location, and the teddy bear in the tub decorously identifies the president who bathed in said tub. While president, Roosevelt went on a bear hunt and, finding a wounded bear, ordered it put out of its misery. Political cartoonist Clifford Berryman published two drawings of Roosevelt and a bear cub — in the first one, the bear appears vulnerable; in the second, childlike and alert. Some attribute the first stuffed "Teddy Bears" to Morris Michtom; others, to Richard Steiff; but there is no doubt that the name has stuck. No other presidential memento has ever occupied so many cribs.[10]

Workers sit in Taft tub, c. 1909. Photographer unknown.

William Howard Taft, who was famous for his hearty appetite, approached 355 pounds near the end of his administration. The press often poked fun of Taft's weight, and a going joke was that the president was the most polite

man in Washington: when he stood up on a bus, three ladies sat down.[11] A bathtub, specially built for him for a voyage on a ship, literally weighed a ton. Reporters assumed it would be installed at the White House, but there is no evidence that it went there with him. By 1919 it was in the War Department; Taft had been Theodore Roosevelt's secretary of war.[12]

Sleeping porch on the roof of the White House, c. 1909. National Photo Company.

Washington summers are hot, and the best the White House had to offer under President Taft was primitive air conditioning — a set of fans that blew over ice that was replaced each day. A screened sleeping porch was the solution of choice for hot evenings, and one was erected on the roof of the South Portico where privacy and the architectural design could both be preserved.

Automatic fire escape on the roof of the White House, c. 1909. National Photo Company.

The gizmo in the foreground is an early fire-escape mechanism. The south facade has a fine view of the Washington Monument (opened to the public in 1888); a president can look out at any time and see the memorial to the first in his line.

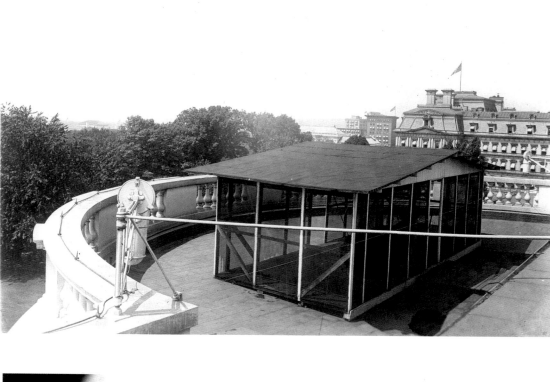

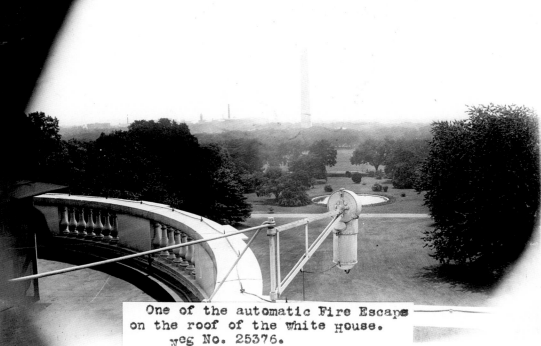

One of the automatic Fire Escape on the roof of the white house. Neg No. 25376.

Laundry room in the West Terrace of the White House, c. 1917. Harris & Ewing.

The utility rooms in the White House continued to be photographed with compositions as studied, and lighting as eloquent, as interiors in seventeenth-century Dutch paintings, subtly conveying the message that every corner of the White House spoke of the republic's virtuous simplicity and intrinsic worth.

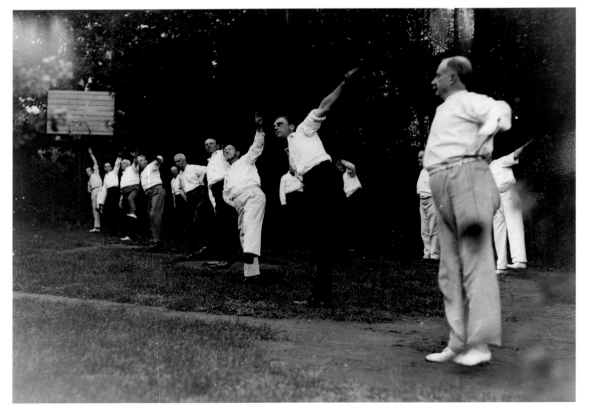

Franklin Delano Roosevelt exercising with Wilson's cabinet c. 1920. National Photo Company.

Roosevelt was President Woodrow Wilson's assistant secretary of the navy. History has turned this casual, slow-news-day photograph into a poignant reminder of how much the future president lost to polio. Other cabinets besides Wilson's have exercised together. When Herbert Hoover invited his cabinet to breakfast and exercise every morning, it was dubbed "the medicine ball cabinet."

Taxidermist with trophy animals, 1923. Herbert E. French.

Although the 1902 renovation under Theodore Roosevelt was neoclassical, architect McKim decorated the walls of the State Dining Room with thirteen game trophy heads, so that bear, bison, and moose presided over foreign dignitaries and crème brûlée at state dinners, an idea that was neither Greek nor Founding Father. Visitors might have thought that President Roosevelt, a brash and avid hunter, had bagged them; they had actually been bought from a Manhattan decorator.[13] Mrs. Woodrow Wilson thought they were gruesome and had them removed.[14] The taxidermist at the Smithsonian took care of preserving and restoring any such White House trophies; some went to TR's home and some to the Smithsonian in the 1930s.

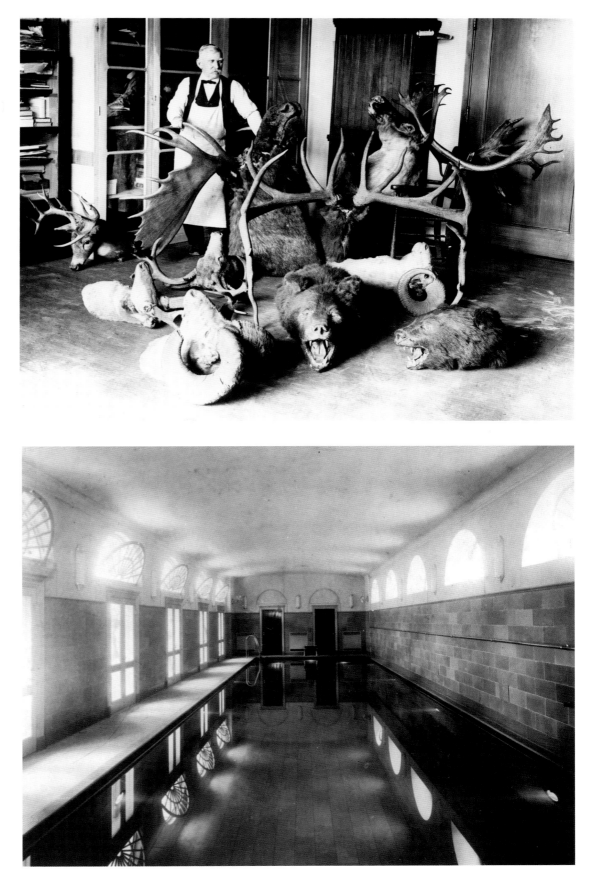

White House indoor pool, 1933. Photographer unknown.

This pool, designed by Lorenzo S. Winslow and engineered by Douglas H. Gillette, was installed for Franklin Roosevelt, a polio survivor whose chief exercise was swimming. In 1970 Richard Nixon had a new press-briefing room built over it to accommodate a growing press corps and expanding media.

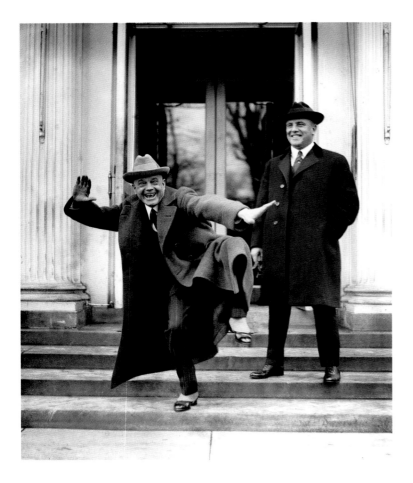

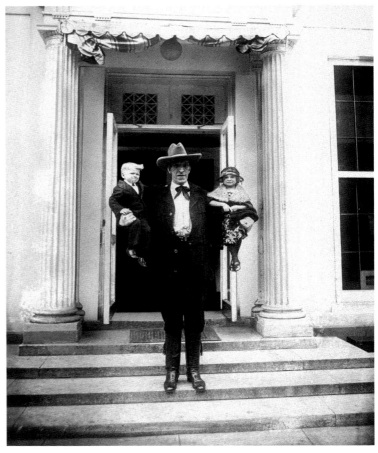

Billy Sunday cutting up on the North Portico, February 20, 1922. National Photo Company.

Billy Sunday (1862–1935) was a famous baseball player from 1883 to 1891, most of that time playing for the Pittsburgh Pirates. In 1886 he was "born again," and in 1897 he held his first revival meeting. Sunday became a noted, fiery, and influential preacher who drummed home the message that liquor was evil, and he helped lay the social groundwork for passage of the Eighteenth Amendment (Prohibition) in 1919, ratified by three quarters of the states that same year. He visited the White House several times and, from the look of things, was obviously capable of having an uninhibited, fine old time there without the aid of whiskey.

Circus giant George Augur with Harry and Gracie Doll, May 17, 1922. Photographer unknown.

The White House has received many distinguished guests from every walk of life. Not only did Einstein come to call, so did Mme. Curie (she brought a vial of radium), Helen Keller, Charles Lindbergh, prime ministers, ambassadors, Indian chiefs from many a tribe, civil rights leaders in the 1960s, and foremost entertainers. The Lincolns held a reception for the dwarf Tom Thumb and his bride on their honeymoon. George Auger was known as the Cardiff Giant and was variously said to be between eight feet and eight feet six inches tall. He and Harry and Gracie Doll, a brother and sister who sometimes performed as Hans and Gretl, all toured with the Barnum and Bailey Circus. Photographers liked them in any setting, but the White House was catnip to the news.

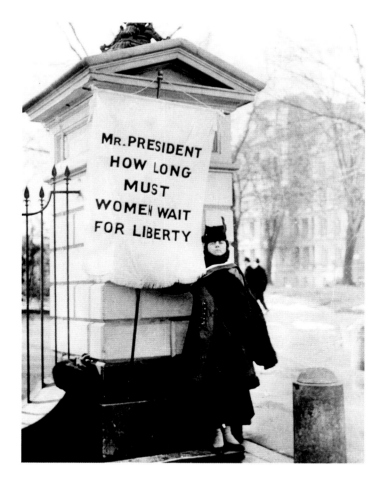

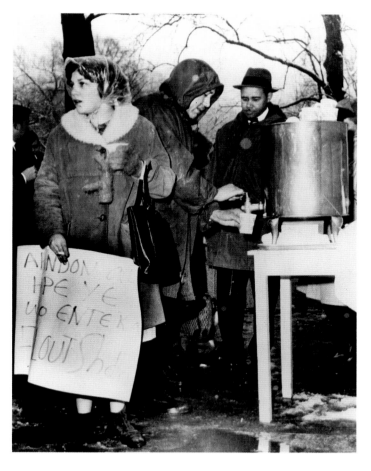

Suffragist before the White House, c. 1917. Photographer unknown.

Women agitated for the vote for almost a century before getting it. Late in the nineteenth century and early in the twentieth, some western territories and states had given women the vote. In 1916 women controlled one fourth of the votes necessary for Woodrow Wilson's election; nonetheless, he was hostile to the idea of suffrage. A group of activist women organized a daily picketing program in front of the White House. Many were arrested and mal-treated in custody; some of the protesters were abused by crowds in the street. In 1918, when Wilson badly needed support for America's role in World War I — women argued that if we could defend democracy abroad, we should do so at home — he came around, but the Senate narrowly defeated a bill to amend the Constitution. Finally, in 1920, after the war was over, the Nineteenth Amend-ment was ratified.[15]

John H. Johnston, White House butler, provided hot coffee to protesters in Lafayette Park, February 1962. United Press International.

The White House was and is so central to the nation's policies and self-identification that protesters — against wars, racial injustice, farm policies, whatever — naturally gather there. These college students, who were peace-fully picketing the White House on behalf of peace — they were against the resumption of nuclear testing and were protesting civil-defense programs despite the nasty weather — were served coffee at President John F. Kennedy's request. Later they were invited to meet for an hour with three of the president's top advisers.

Two boys and a portrait of President Cleveland, December 29, 1965. James P. Blair.

At a Christmas party for children of the diplomatic community, James P. Blair, a *National Geographic* photographer, snapped a picture of these two young boys in the entrance hall, all dressed up on a two-seater couch too big for one of them and too grand for both. Perhaps bored, they turn to look at the portrait above their heads. It's a picture of President Grover Cleveland, the only president who ever won two terms spaced years apart.

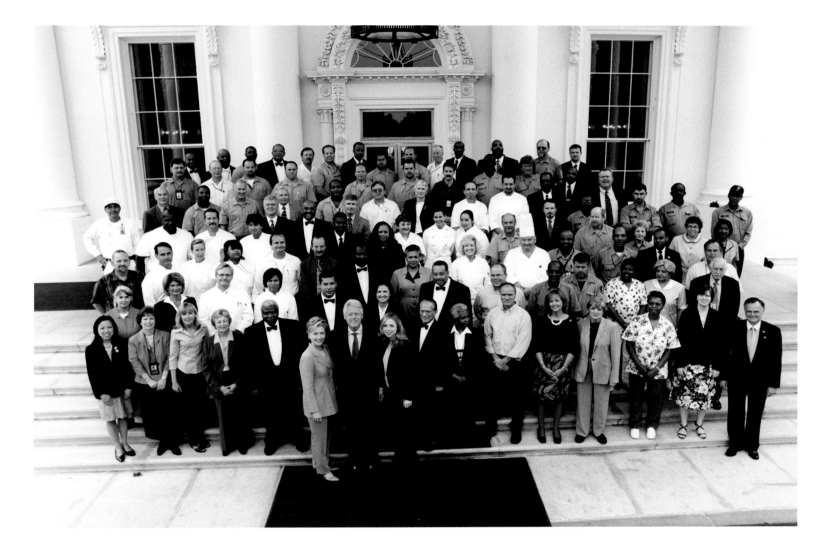

The Clinton family poses with the resident staff under the North Portico of the White House, June 2004. Tina Hager.

Bill, Hillary, and Chelsea Clinton posed with the staff when the Clintons returned to the White House for the unveiling of their official portraits. The staff, so vital to the running of the White House, tries (and generally succeeds) to maintain the friendliest possible relations with the president and his family, whatever the politics of the hour. White House workers may have more than one job — nurse and cook, for instance — and often do unofficial duties when children are in residence. Teddy Roosevelt's valet, James Amos, umpired TR's children's baseball games. John F. Kennedy's usher, Nelson Pierce, taught Caroline Kennedy how to do somersaults.

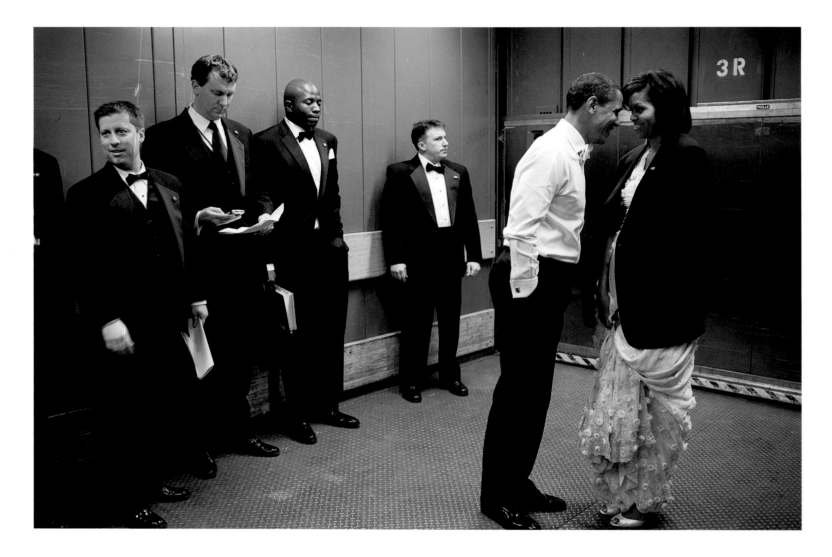

President Barack Obama and First Lady Michelle Obama share a private moment in a freight elevator at an Inaugural Ball, Washington, D.C., January 20, 2009. Pete Souza.

An official White House photographer is free to make permanent a fleeting, highly personal moment, a moment that even the Secret Service men consider so private they are trying their best not to watch. Photographers stare; it's their business, and they pass permission on to us. This picture registers a long-brewing cultural change that has been abetted but not caused by photography: an elastic definition of what kinds of behavior are acceptable in public — the French were famous for kissing on the street long before Americans took it up — and the shrinking territory of both a leader's and an ordinary person's privacy.

ACKNOWLEDGMENTS

NEIL HORSTMAN, president of the White House Historical Association, called me one day from Washington to introduce himself and his organization and to say they had an idea for a book of photographs that they would like to discuss with me. So I met with Neil and William B. Bushong, WHHA historian and webmaster, who said that although they had published many illustrated books and a quarterly magazine, they had never published a book that was just about photographs related to the White House and its history. They wanted to know if I agreed that such a book was lying in wait among the thousands of images in their archive. "Show me some photographs," said I. They did—to my everlasting delight. I said yes, yes indeed, a book was lying there, and it was growing impatient.

Here it is. I am enormously grateful to Neil and Bill for their original notion and their unlimited enthusiasm, time, energy, and knowledge throughout the four years it took to put some gems of the WHHA's trove of images between covers. The Association's highly accomplished staff made important contributions: dauntless researchers Sally Sims Stokes and Gwendolyn White; Hillary Mannion, a demon picture researcher; Maria Downs, director of public affairs; and Brenda Fike and Billy Phillips, who repeatedly pitched in on a moment's notice.

I am also indebted to the WHHA's experts who reviewed the manuscript: William Seale, Betty C. Monkman, and Ann Grogg, all immensely knowledgeable about the White House and American history. And my thanks to David A. Mindell, Frances and David Dibner Professor of the History of Engineering and Manufacturing at MIT, for enlightening comments on the chapter on technology.

Michael Sand, editor of this book, has my lasting admiration for his keen intuition about what worked and what didn't, his astute judgment of what to cut and what to keep, and for always having the right answer when I asked for advice. I'm greatly beholden to Lance Hidy for having tackled a complex book-design assignment and come up with a treat, to Ben Allen for his capable and respectful copyediting, and to Melissa Caminneci, editorial assistant at Little Brown, who did so much to keep the project moving along.

Thanks also to Lisa Halliday, formerly of the Wylie Agency, for making the arrangements of a happy partnership between the WHHA and myself.

The most lasting thanks of all belong to my husband, Larry Young, always, for his loving encouragement, advice, and support.

—VG

NOTES

Introduction

1. William Seale, *The President's House: A History* (Washington, D.C.: White House Historical Association, 2008), I, 78. See also John Bryan, *Robert Mills: America's First Architect* (New York: Princeton Architectural Press, 2001), 17–18.

2. Richard Rudisill, *Mirror Image: The Influence of the Daguerrotype on American Society* (Albuquerque: University of New Mexico Press, 1969), 165; Samuel C. Busey, "Early History of Daguerreotypy in the City of Washington," *Records of the Columbia Historical Society* 3 (1900), 86.

3. For a study of the conflicting interests behind the debate to establish the nation's capital, see Kenneth Bowling, *The Creation of Washington, D.C.* (Fairfax, VA: George Mason Press, 1993).

4. Paul H. Caemmerer, *Life of Pierre Charles L'Enfant*, (New York: Da Capo, 1970), 402–403. The letter of May 30, 1800, to the commissioners was a self-endorsement of L'Enfant's plan for Washington, D.C.

5. Seale, *President's House*, I, 81.

6. "Speech of Mr. Ogle, of Pennsylvania, on the Regal Splendor of the President's Palace: Delivered to the House of Representatives," April 14, 1840, reprinted in *White House History*, Collection Set 2, Numbers 7–12 (Washington, D.C. White House Historical Association, 2004), 228; see also Mal Laracey, *Presidents and the People: The Partisan Story of Going Public* (College Station: Texas A & M University Press, 2002), 81. The "bosom" was a landscape feature on the South Lawn known as the Jefferson mounds, two hillocks built to create more visual privacy on the south side of the residence. The quotation was from Ebert B. Smith, *Francis Preston Blair* (New York: Free Press, 1980), 138–139.

7. Seale, *President's House*, I, 160–161 and 626.

8. Gloria Gilda Deák, *Picturing America,*

9. *1497–1899* (Princeton: Princeton University Press, 1988), 217.

10. Seale, *President's House*, I, 107–113.

11. Anthony Pitch, "The Burning of Washington," *White House History*, Collection Set 1, Numbers 1–6 (Washington, D.C.: White House Historical Association, 2004), 198–207.

12. For the L'Enfant plan's symbolic connection to the Constitution, see Pamela Scott, "'This Vast Empire': The Iconography of the Mall, 1791–1948," In Richard Longstreth, ed., *The Mall in Washington* (Washington, D.C.: National Gallery of Art, 2002), 37–40.

13. Quoted in Rudisill, *Mirror Image*, 7; see also Oswaldo Rodriguez Roque, "'The Oxbow' by Thomas Cole: Iconography of an American Landscape Painting," *Metropolitan Museum Journal* 17. (1983): 63–73.

14. "The White House and its Memories," *Magazine of American History* 17, no. 5 (May 1887), 361–362.

15. "Whose White House?" *Washington Post*, January 23, 1946, 6; see also Elizabeth Beard Goldsmith, "Tempest in a Teapot: Truman's Failed Attempt at an Office Addition," *White House History*, Collection Set 1, Numbers 1–6 (Washington, D.C.: White House Historical Association, 2004), 263–272.

16. Esther Singleton, *The Story of the White House* (New York: Benjamin Blom, 1907, reissued 1969), I, 197. Singleton cites the source as a "news letter describing General Jackson's first Inauguration."

17. Seale, *President's House*, I, 174–177.

18. Singleton, *Story of the White House*, II, 216.

19. Betty C. Monkman, *The White House: Its Historic Furnishings and First Families* (New York: Abbeville Press, 2000), 132–133.

20. David F. Sinclair, "The Monarchical Manners of the White House," *Harper's Weekly*, June 13, 1908, 14–15.

21. For a discussion of the nation's growth and the need for a White House renovation, see George Kennan, "The White

22. House: The Plans for its Reconstruction," *Outlook* (1902), 287–300.

23. John W. Hardwick, "From Cleveland to McKinley in the White-House," *The Chautauquan* 24 (1897), 695–696.

24. Lewis L. Gould, *The Presidency of William McKinley* (Lawrence: Regents Press of Kansas, 1980), 1.

25. Nathan Miller, *Theodore Roosevelt: A Life* (New York: William Morrow, 1994), 416–17.

26. May Woods and Arete Swartz Warren, *Glass Houses: A History of Greenhouses, Orangeries & Conservatories* (London: Aurum Press, 1988), 168.

27. Seale, *President's House*, I, 638–640.

28. Quoted in Margaret Truman, *Harry S. Truman* (New York: William Morrow, 1973), 398.

29. William Seale, *The White House: The History of an American Idea*, (Washington, D.C.: White House Historical Association, 2000), 237–277.

30. Ibid., 875; see also "Truman Asks Congress to Establish Agency to Supervise Renovation of the White House," *New York Times*, March 26, 1949, 6.

31. William G. Allman, "To Own a Piece of the White House: The Souvenir Program of the Truman Renovation," *White House History*, Collection Set 1, Numbers 1–6 (Washington, D.C.: White House Historical Association, 2004), 305; and Edwin Bateman Morris, comp., *Report of the Commission on the Renovation of the Executive Mansion* (Washington: Government Printing Office, 1952), 103–105.

32. Seale, *The White House: The History of an American Idea*, 237–277; see also David McCullough, *Truman* (New York: Simon and Schuster, 1992), 886–887.

33. Seale, *The White House: The History of an American Idea*, 233–235.

34. "National Historic Landmarks Survey: List of National Historic Landmarks by State" (PDF), National Park Service (November 2007), http://www.cr.nps.gov/nhl/designations/Lists/LIST07.pdf, accessed July 1, 2010.

35. For a study of the renovation, see James

A. Abbott and Elaine M. Rice, *Designing Camelot: The Kennedy White House Restoration* (Hoboken, NJ: Wiley, 1997).

34. Nash Castro, "The Association's Twentieth Year," *White House History*, Collection Set 1, Numbers 1–6 (Washington, D.C.: White House Historical Association, 2004), 27–31.

35. "Richard F. Shepard, "Foreign TV Seeks White House Tour," *New York Times,* February 16, 1962, 43; John P. Shanley, "Julie Harris, as 'Victoria,' Wins TV Emmy; Drama and Its Star Honored at Annual Awards Ceremony; Mrs. Kennedy, Glenn, and Sarnoff Cited — 'Defenders' Scores," *New York Times,* May 23, 1962, 91.

36. Robert W. Mayer, "Photographing the American Presidency," *Image* 27 (1984), 29.

37. "White House Statistics," information sheet provided by the National Park Service, on file in the White House Curator's Office, the White House, Washington, D.C.

38. Charles William Janson, *The Stranger in America* (New York: B. Franklin, 1807; reprint 1971), 213.

39. Montgomery Schuyler, "The New White House," *Architectural Record* (April 1903), 358–388 and 369.

40. See Bob Zeller, *The Blue and the Gray in Black and White: A History of Civil War Photography* (Westport: Praeger, 2005), 102. Brady might not have taken this picture himself. His eyesight had been quite limited for a decade, but every photograph that came from his studio bore his name, as was typical of the times. The widespread theory that Alexander Gardner and Timothy O'Sullivan, two of Brady's best operators, left because they received no credit for their work is based on mixed evidence at best.

41. E. V. Smalley, "The White House," *The Century Magazine* 27 (1884), 803.

42. "The President's House," *United States Magazine* 21 (Sept. 1856), 196; Seale, *President's House,* I, 252, 325, and 476; "Lafayette," in Singleton, *Story of the White House,* 28–29.

43. See R. M. Johnston, *Bull Run: Its Strategy and Tactics* (Boston: Houghton Mifflin, 1913), 269–276.

44. Seale, *President's House,* I, 240, 814.

45. William Culp Darrah, *Stereo Views: A History of Stereographs in America and Their Collection* (Gettysburg, PA: Times & News Publishing, 1964), 189.

46. Kennan, "The White House: The Plans for its Reconstruction," *Outlook* (1902), 287–300.

47. Seale, *The White House: The History of an American Idea,* 211–215.

48. See Seale, *President's House,* 873–877; McCullough, *Truman,* 877.

49. See Robert Debs Heinl Jr., "'Twas the Night Before Christmas…," *American Heritage* 22 (December 1970), http://www.americanheritage.com/articles/magazine/ah/1970/1/1970_1_105.shtml. Heinl was an eyewitness to the scene at age thirteen.

50. For Mesnier's own story, see "My White House Years," *White House History* 20 (Spring 2007), 30–49.

51. For information on this model and on the rooms and objects in it, see Gail Buckland, *The White House in Miniature* (New York: W.W. Norton, 1994). My thanks to the author for her assistance.

Chapter 1

1. Benjamin Perley Poore, *Perley's Reminiscences of Sixty Years in the National Metropolis* (Philadelphia: J. W. Keeler, 1886), vol. 2, 456.

2. Betty C. Monkman, *The Living White House* (Washington, D.C.: White House Historical Association, 2007), 102; William H. Crook, *Memories of the White House: The Home Life of Our Presidents from Lincoln to Roosevelt,* (Boston: Little, Brown, 1911), 145.

3. "The City of Washington, No. III," *United States Magazine* 3 (Sept. 1856), 203.

4. Betty C. Monkman, *The White House: Its Historic Furnishings and First Families* (Washington, D.C.: White House Historical Association, 2000), 40.

5. White House servant Paul Jennings, who claimed to have been an eyewitness, maintained half a century later that Mrs. Madison had had no time to save the painting. Jennings related that a gardener rescued the painting after she left. Paul Jennings, *A Colored Man's Reminiscences of James Madison* (Brooklyn: Beadle, 1865), 12–13. Mrs. Madison wrote to her sister about having the frame broken so she could take the painting with her. "Dolley Madison to Anna Payne Cutts, 23 August 1814," Dolley Madison Papers, Library of Congress. For a reprint of Jennings's memoir and a discussion of the significance of the Madison letters, see *White House History,* Collection 1, Numbers 1–6, 50–56 and 228–233.

6. Seale, *President's House,* I, 157.

7. Quoted in the first edition of *The White House: An Historic Guide* (Washington, D.C.: White House Historical Association, 1962), 101.

8. Monkman, *The White House: Its Historic Furnishings and First Families,* 82–83; *The White House: An Historic Guide,* 37.

9. "The City of Washington, No. III," *United States Magazine* 3 (1856), 199. Congressman Charles Ogle's speech, often called the "Gold Spoon Oration," blasted the excesses of the Van Buren White House. The 1840 speech's actual title was "The Regal Splendor of the President's House." It is reprinted in its entirety in *White House History,* Collection Set 2, Numbers 7–12, 227–275.

10. "The City of Washington, No. III," *United States Magazine* 3 (1856). See also Singleton, *The Story of the White House,* 115 and 119.

11. Seale, *President's House,* I, 342–343.

12. Monkman, *The White House: Its Historic Furnishings and First Families,* 133.

13. Ibid., 135.

14. Seale, *President's House,* I, 470–471; "Washington Gossip," *New York Times,* Feb. 7, 1875, 2.

15. For a brief illustrated history of the hand-tinting of photographs, see Gordon Baldwin and Martin Jurgens, *Looking at Photographs: A Guide to Technical Terms,* Rev. ed. (Los Angeles: J. Paul Getty Museum, 2009). Edward Steichen led a group of photographers who took the first color photographs of the White House interiors in early 1940; see A. E. Scott, "Twenty-five Years of Growing Pains: A History of the White House News Photographers Association," copy on file at the White House Historical Association, Washington, D.C.

16. "From the White House Garret," *Washington Post,* April 15, 1882, 2.

17. Seale, *The White House: The History of an American Idea,* 135–143.

18. Pete Daniel and Raymond Smock, *A Talent for Detail: The Photographs of Miss Frances Benjamin Johnston, 1889–1910* (New York: Harmony Books, 1974), 5–7; see also Bettina Berch, *The Woman Behind the Lens: The Life and Work of Frances Benjamin Johnston, 1864–1952* (Charlottesville: University Press of Virginia, 2000), 14–38.

19. Monkman, *The White House: Its Historic Furnishings and First Families,* 169.

20. Michael Carlebach, *American Photojournalism Comes of Age* (Washington: Smithsonian Institution Press, 1997), 39. See also Paul J. Vanderwood and Frank N. Samponaro, *Border Fury: A Picture Postcard Record of Mexico's Revolution and U.S. War Preparedness, 1910–1917* (Albuquerque: University of New Mexico Press, 1988), 6–7. Before 1898, the post office made free home delivery only to towns of 10,000 or more, then about a quarter of the nation's population; see Hal Morgan and Andreas Brown, *Prairie Fires and Paper Moons / The American Photographic Postcard: 1900–1920* (Boston: David R. Godine, 1981), xiii.

21. Lately Thomas, *The First President Johnson: The Three Lives of the Seventeenth President of the United States of America* (New York: William Morrow, 1968), 614–15; Crook, *Memories,* 70–71.

22. Seale, *The President's House,* II, 712.

23. Oliver Jensen, "History in the Camera's Eye," *White House History,* Collection 1, Numbers 1–6 (Washington, D.C.: White House Historical Association, 2004), 21–26.

24. Michael Baruch Grossman and Martha Joynt Kumar, *Portraying the President: The White House and the News Media* (Baltimore: Johns Hopkins University Press, 1981), 235.

25. Anne H. Lincoln, *The Kennedy White House Parties* (New York: Viking, 1967), 98.

26. Elise K. Kirk, *Music in the White House* (Urbana-Champaign: University of Illinois Press, 1986), 124–25.

27. Rex W. Scouten, "President Truman's Televised Tour," *White House History,* Collection Set 1, Numbers 1–6 (Washington, D.C.: White House Historical Association, 2004) 296–300.

28. Quoted in Kirk, *Music in the White House,* 72.

29. Ibid.

30. Ibid.

31. Maria Downs (social secretary during the Ford administration), in interview with the author, March 15, 2009.

32. "Operation Big Daddy," *Time,* Jan. 27, 1967, 29.

Chapter 2

1. Seale, *President's House,* I, 479.

2. William S. McFeeley, *Grant: A Biography* (New York: W.W. Norton, 1981), 401–404. Whatever Sartoris was, even the papers after a while began to hint, discreetly, that the marriage was unhappy. The couple had four children before being divorced in 1890, which remained tactfully unreported in the major papers.

3. Martha J. Lamb, "The White House and Its Memories: Historic Homes of Our Presidents," *Magazine of American History* 17 (1887), 400.

4. "Simple Though Impressive: Funeral Services Over the Remains of Caroline Scott Harrison," *Washington Post,* Oct. 28, 1892, 1.

5. Seale, *President's House,* 24–25, 289, 372, and 398; and Willetts, *Inside History of the White House* (New York: The Christian Herald, 1908), 447–454.

6. "Funeral of President Harrison," *The New World,* April 17, 1841, 252; Seale, *President's House,* I, 234–236.

7. Thomas Schlereth, *Victorian America: Transformations in Everyday Life, 1876–1915* (New York: Harper Collins, 1991), 291–292.

8. Seale, *President's House,* 234–236; *The New World,* April 17, 1841, 252; Poore, *Perley's Reminiscences,* vol. 1, 266; Singleton, *Story of the White House,* vol. 2, 95.

9. Vicki Goldberg, *The Power of Photography: How Photographs Changed Our Lives* (New York: Abbeville Press, 1991), 217.

10. Ibid., 220–221.

11. Paul Johnson, *A History of the American People* (New York: Harper Collins, 1997), 558. Some historians believe that Cleveland accepted paternity to protect his married law partner who may have been the real father. Paternity was never proved, so Cleveland was one of several possible fathers.

12. See August Heckscher, *Woodrow Wilson* (New York: Charles Scribner's Sons, 1991), 333, 348, 354, and 356–7; John Milton Cooper Jr., *Woodrow Wilson: A Biography* (New York: Alfred A. Knopf, 2009), 303; and http://www.pbs.org/wgbh/amex/wilson/portrait/wp_edith.html, accessed Nov. 9, 2010.

13. Michael Teague, *Mrs. L: Conversations with Alice Roosevelt Longworth* (New York: Doubleday and Company, 1981), 126–128.

14 . Edmund Morris, *Theodore Rex* (New York: Random House, 2001), 436–37.

15. "Washington Social Life," *New York Times,* Feb. 28, 1876, 5.

16. Elizabeth Shelton, "Lynda Johnson is Married to Marine Captain Robb," *Washington Post,* December 12, 1967, A1; Bernadine Morris, "Copy of Lynda's Wedding Dress to Be in Stores Thursday," *New York Times,* Dec. 12, 1967, 54.

17. On the Barralet engraving, see Phoebe Lloyd Jacobs, "John James Barralet and the Apotheosis of George Washington," *Winterthur Portfolio* 12 (1977), 115, 123, 133–34.

18. Sarah Vowell, *Assassination Vacation* (New York: Simon & Schuster, 2005), 123.

19. Wendy Wick Reaves, *Private Lives of Public Figures: The Nineteenth-Century Family Print* (Westport: Chesebrough-Pond's, 1986), 16.

20. Vowell, *Assassination Vacation,* 164–165 and 169.

21. Leroy Hayman, *The Death of Lincoln* (New York: Scholastic School Services, 1972), 20.

22. Crook, *Memories,* 39.

23. Hayman, *The Death of Lincoln,* 77.

24. Seale, *President's House,* I, 421.

25. "The Obsequies: Funeral of Abraham Lincoln," *New York Times,* April 20, 1865, 1.

26. Dorothy Meserve Kunhardt and Philip B. Kunhardt Jr., *Mathew Brady and His World* (Alexandria, VA: Time-Life Books, 1977), 257.

27. William C. Harris, *Lincoln's Last Months* (Cambridge: Belknap Press, 2004), 234.

28. "The Obsequies: Funeral of Abraham Lincoln," *New York Times,* April 20, 1865, 1.

29. Elise Madeleine Ciregna and E. Richard McKinstry of the Winterthur Museum supplied the information on plant symbolism.

30. Crook, *Memories,* 268.

31. Susan Butler, *My Dear Mr. Stalin: The Complete Correspondence of Franklin D. Roosevelt and Joseph V. Stalin* (New Haven: Yale University Press, 2008), 31; "Mr. Eden Going to Funeral; Commons Tribute on Tuesday; Mr. Churchill to Speak," *The Times* (London), April 14, 1945, 4.

32. See Wilbur Schramm, "Introduction: Communication in Crisis," in Bradley S. Greenberg and Edwin B. Parker, *The Kennedy Assassination and the American Public Social Communication in Crisis* (Stanford, CA: Stanford University Press, 1965), 14; Val Adams, "Networks

Drop Regular Shows," *New York Times,* Nov. 23,1963, 9; "As 175 Million Americans Watched," *Newsweek,* Dec. 2, 1963, 90. For a more detailed account, see Goldberg, *The Power of Photography,* 220–226.

Chapter 3

1. Thomas Carlyle, "The Hero as Divinity," Lecture delivered May 5, 1840, printed in Carlyle, *On Heroes, Hero Worship, and the Heroic in History* (New York: John Wiley, 1859), 26.
2. David Hackett Fischer, *Liberty and Freedom* (New York: Oxford University Press, 2005), 189.
3. George Juergens, *News from the White House: The Presidential-Press Relationship in the Progressive Era* (Chicago University Press, 1981), 39.
4. Morris, *Theodore Rex,* 184.
5. Rudisill, *Mirror Image,* 170.
6. Ibid., 14.
7. Clifford Krainik, "Face the Lens, Mr. President: A Gallery of Photographic Portraits of 19th Century U.S. Presidents," *White House History*, Collection 3, Numbers 13–18 (Washington, D.C.: White House Historical Association, 2004) 224–241; Martha Cole, "John Q. Adams Photo Found," *Washington Star,* Nov. 30, 1970.
8. Pauline Maier et al., *Inventing America* (New York: W. W. Norton, 2005) vol. 2, 680.
9. Gould, The *Presidency of William McKinley,* vii.
10. "Political Portraits with Pen & Pencil. No. XXXIV, John Tyler," *Democratic Review* 11 (Nov. 1842), 502.
11. Robert A. Mayer, "Photographing the American Presidency," *Image* 27 (1984), 33.
12. Rudisill, *Mirror Image,* 171.
13. Ibid., 173.
14. Ibid., 73.
15. Ibid., 166.
16. Alan Trachtenberg, "The Daguerreotype and Antebellum America," in Grant B. Romer and Brian Wallis, eds., *Young America: The Daguerreotypes of Southworth and Hawes* (Göttingen: Steidl, 2005), 17.
17. John Stauffer, "Daguerreotyping the National Soul: The Portraits of Southworth and Hawes, 1843–1860," in Romer and Wallis, eds., *Young America,* 58–59.

18. Wendy Wick Reaves and Sally Pierce, "Translations from the Plate: The Marketplace of Public Portraiture," in Romer and Wallis, eds., *Young America,* 98.
19. Vicki Goldberg, ed., *Photography in Print* (Albuquerque: University of New Mexico Press, 1988), 49–69; see especially page 65.
20. Beaumont Newhall, "A Daguerreotype of John Quincy Adams by Philip Haas," *Metropolitan Museum Journal* 12 (1977), 151–54. Newhall notes that the plate was not manufactured until 1850 at the earliest.
21. Rudisill, *Mirror Image,* 167.
22. Elizabeth Anne McCauley, *Likenesses: Portrait Photography in Europe 1850–1870,* (Albuquerque: Art Museum, University of New Mexico, 1981), 2.
23. Bevis Hillier, *Victorian Studio Photographs* (Boston: David R. Godine, 1976), 26.
24. Rudisill, *Mirror Image,* 191.
25. Ibid., 167.
26. Poore, *Perley's Reminiscences*, vol. 1, 233. On Harrison's campaign speeches, see Clifford Krainik, "Mudslinging Log Cabin Style: Imagery from the Election of 1840: Myth and Reality," *White House History,* Collection 2, Numbers 7–12 (Washington, D.C.: White House Historical Association, 2004), 205.
27. James K. Polk, *The Diary of James K. Polk During His Presidency*, ed. Milo Milton Quaife (Chicago: A.C. McClurg, 1910), vol. 1, 473–74.
28. Kunhardt and Kunhardt, *Mathew Brady and His World,* 72.
29. Krainik, "Mudslinging," 112.
30. Seale, *President's House,* I, 254; Clifford Krainik, "The Earliest Photographs of the White House, 1840s," in Seale, ed., *The White House: Actors and Observers* (Boston: Northeastern University Press, 2002), 42.
31. Krainik, "Mudslinging," 109.
32. Poore, *Perley's Reminiscences,* vol.1, 426.
33. See Fischer, *Liberty and Freedom,* 181–82. Lithographs and engravings, and small sculptures hawked by itinerant peddlers in rural areas, had previously been the only way to see the candidates, and these images were not always reliable. See also Richard Brilliant, *Group Dynamics: Family Portraits & Scenes of Everyday Life at the New York Historical Society* (New York: New Press, 2006), 50.
34. Peter Hamilton and Roger Hargreaves, *The Beautiful and the Damned: The Cre-

ation of Identity in Nineteenth Century Photography* (Aldershot, Hampshire: Lund Humphries, 2001), 19.
35. For a more complete discussion of this photograph, see Goldberg, *The Power of Photography,* 77–78.
36. Krainik, "Face the Lens, Mr. President," 28; Fischer, *Liberty and Freedom,* 348.
37. Stefan Lorant, *Lincoln: A Picture Story of His Life* (New York: Norton, 1969), 197. In Lorant's *Lincoln: His Life in Photographs* (New York: Duell, Sloan and Pearce, 1941), in the compendium of portraits in the back, number 88 is a Gardner photo, from April 9, 1865, of Lincoln seated with an elbow on a book and Tad standing and leaning on table; number 88a is the same picture with a painted backdrop of the unfinished Washington Monument, the Potomac, and a curtain.
38. Philip B. Kunhardt et al., *Lincoln: An Illustrated Biography* (New York: Gramercy, 1999), 281.
39. Ibid., 281. Kunhardt says they are Nicolay's legs; Lorant says they are Carpenter's in *Lincoln: A Picture Story*, 324.
40. Seale, *President's House,* I, 413.
41. "Henry W. Berthrong Claimed by Death; Civil War Solider, Painter of Note and Athlete Long Employed at Custom House in Boston," *Boston Globe,* April 29, 1928. Berthrong was known for his enormous portraits of candidates all over the country.
42. Harry J. Sievers, *Benjamin Harrison: Hoosier Statesman* (New York: University Publishers, 1959), vol. 2, 421.
43. See Richard G. Davies, "Military Schools," in Priscilla Ferguson Clement and Jacqueline S. Reinier, eds., *Boyhood in America: An Encyclopedia* (New York: ABC-CLIO, 2001), II, 444–449.
44. Gould, *The Presidency of William McKinley,* 242.
45. Lewis L. Gould, *The Modern American Presidency,* 2nd ed. (Lawrence: University Press of Kansas, 2009), 55
46. Andrew Sinclair, *The Available Man: The Life Behind the Masks of Warren Gamaliel Harding* (New York: Macmillan, 1965), 23.
47. Robert Sobieszek, "Sculpture as the Sum of its Profiles: François Willème and Photosculpture in France," 1859–1868, Art Bulletin 62 (1980), 617–30.
48. http://www.usps.com/communications /organization/csac.htm; http://www. usps.com/postalhistory/ stampsandpostcards.htm?from=Postal

History&page=Center_StampsandPost cards; http://en.wikipedia.org/wiki/US_Presidents_on_US_postage_stamps; http://www.smithsonianmag.com/arts-culture/From-the-Castle-FDRs-Stamps.html; http://alphabetilately.com/commems.html; all accessed November 10, 2010

49. James N. Giglio, *The Presidency of John F. Kennedy* (Lawrence, Kansas: University Press of Kansas, 1991); and http://www.time.com/time/magazine/article/0,9171,827922,00.html, accessed July 10, 2010.

50. http://www.kennedyrockers.com/history.htm, accessed July 21, 2010.

51. Stephen E. Ambrose, *Nixon, Volume Two: The Triumph of a Politician, 1962–1972* (New York: Simon and Schuster, 1989), 375–376 and 382; Robert Dallek, *Nixon and Kissinger: Partners in Power* (New York: Harper Collins, 2007), 223–35.

52. Yanek Mieczkowski, *Gerald Ford and the Challenges of the 1970s* (Lexington: University Press of Kentucky, 2005), 7.

53. John Robert Greene, *The Presidency of Gerald R. Ford* (Lawrence: University Press of Kansas, 1995), 13.

54. "The Administration: Gerald Ford: Off to a Fast, Clean Start," *Time*, Aug. 26, 1974.

55. Dallek, Robert, *Flawed Giant: Lyndon Johnson and His Times, 1961–1973* (New York: Oxford University Press, 1998), 391.

56. Vaughn Davis Bornet, *The Presidency of Lyndon B. Johnson* (Lawrence: University Press of Kansas, 1983), 257; Joseph A. Califano Jr., *The Triumph & Tragedy of Lyndon Johnson* (New York: Simon & Schuster, 1991), 250.

57. See Gould, *The Modern American Presidency*, 205.

58. Nigel Hamilton, *Bill Clinton: An American Journey / Great Expectations* (New York: Random House, 2003), 44.

59. See *Abraham Lincoln: Selections from the White House Collection* (London: Scala, 2009). Carpenter's painting is in the Capitol.

Chapter 4

1. Reaves, *Private Lives of Public Figures: The Nineteenth-Century Family Print*, 2–4.

2. Ibid., 2.

3. Dorothy Schneider and Carl J. Schneider, *First Ladies: A Biographical Dictionary*, 2nd ed. (New York: Facts On File, 2005), 391.

4. Laura C. Holloway, *The Ladies of the White House; or, In the Home of the Presidents* (Philadelphia: Bradley & Company, 1881), 27.

5. John S. D. Eisenhower, *Zachary Taylor* (New York: Macmillan, 2008), 89.

6. Anthony, *First Ladies: The Saga of the Presidents' Wives and Their Power, 1789–1961*, 132 and 146.

7. Anthony, *First Ladies*, 161.

8. Holloway, *Ladies of the White House*, 643.

9. Bob Secter, "Statue of Mrs. Grant Kicks Up Controversy," *Chicago Tribune*, Jan. 5, 2007.

10. Christopher J. Cyphers, *The National Civic Federation and the Making of a New Liberalism, 1900–1915* (Westport: Praeger, 2002), 84.

11. Schneider, *First Ladies*, 268.

12. George Juergens, *News from the White House: The Presidential-Press Relationship in the Progressive Era* (Chicago: University of Chicago Press, 1981), 133.

13. Harry S. Truman letter to Paul Hume, December 6, 1950. In 2002 the estate of Harlan Crow, a real estate businessman, purchased the letter, and it is now owned by the Harlan Crow Library, a private library in Highland Park, Texas. The Truman Library posted a copy of the correspondence, http://www.trumanlibrary.org/trivia/letter.htm, accessed Aug. 3, 2010.

14. Doug Wead, *All the Presidents' Children: Triumphs and Tragedies in the Lives of America's First Families* (New York: Atria Books, 2003), 144.

15. Ibid., 77.

16. Betty Boyd Caroli, *American First Ladies* (Pleasantville: Reader's Digest, 1996), 8.

17. Anthony, *First Ladies*, 140.

18. Holloway, *Ladies of the White House*, 402.

19. Lorant, *Lincoln: A Picture Story*, 209.

20. Seale, *The President's House*, I, 292. For more on the advertising campaign for *Uncle Tom's Cabin*, see Claire Parfait, *The Publishing History of* Uncle Tom's Cabin, *1852–2002* (Aldershot, UK: Ashgate, 2007), 52–60.

21. Sarah Josepha Hale, "Literary Notices: *Madame Roland*," *Ladies' Magazine and Literary Gazette* 5 (1832), 333.

22. Edward W. Earle, ed., *Points of View: The Stereograph in America: A Cultural History* (Rochester: The Visual Studies Workshop Press in collaboration with The Gallery Association of New York State, 1979), 12–13.

23. Morris, *Theodore Rex*, 108.

24. Wead, *All the President's Children*, 92.

25. Jean H. Baker, *Mary Todd Lincoln: A Biography* (New York: Norton, 1987), 195.

26. Catherine Clinton, *Mrs. Lincoln: A Life* (New York: HarperCollins, 2009), 95.

27. Fischer, *Liberty and Freedom*, 181–82.

28. Anthony, *First Ladies*, 169.

29. Betty Boyd Caroli, *First Ladies* (New York: Oxford University Press, 1987), 71.

30. Elizabeth Keckley, *Behind the Scenes* (New York: G. W. Carleton, 1868), 105. Keckley was Mary Lincoln's seamstress.

31. Caroli, *American First Ladies*, 87.

32. Emily Edson Briggs, *The Olivia Letters, Being Some History of Washington City for Forty Years, as Told by the Letters of a Newspaper Correspondent* (New York: Neale, 1906), 169.

33. Seale, *President's House*, I, 473–74.

34. Ibid., 474.

35. Ishbel Ross, *The General's Wife: The Life of Mrs. Ulysses S. Grant* (New York: Dodd, Mead, 1959), 213; Singleton, *Story of the White House*, I, 129.

36. Ross, *General's Wife*, 244–245.

37. Ann Douglas, *The Feminization of American Culture* (New York: Knopf, 1977), 74.

38. Stephanie A. Smith, *Conceived by Liberty: Maternal Figures and Nineteenth Century American Literature* (Ithaca, NY: Cornell University Press, 1994), 3.

39. Caroli, *First Ladies* (1987), 86.

40. Ari Hoogenboom, *The Presidency of Rutherford B. Hayes* (Lawrence: University Press of Kansas, 1988), 219; Charles Richard Williams, ed., *The Diary and Letters of Rutherford B. Hayes, Nineteenth President of the United States* (Columbus: Ohio State Archeological and Historical Society, 1922), IV, 480 and IV, 501.

41. Holloway, *The Ladies*, 628–631.

42. Hoogenboom, *The Presidency*, 219.

43. Hoogenboom, *The Presidency*, 218.

44. Lewis L. Gould, ed., *American First Ladies: Their Lives and Their Legacy* (New York: Garland, 1996), 224.

45. Poore, *Perley's Reminiscences*, vol. 2, 349.

46. Seale, *President's House*, I, 568.

47. Anthony, *First Ladies*, 281.

48. Caroli, *American First Ladies*, 55.

49. Henry F. Graff, *Grover Cleveland* (New York: Times Books, 2002), 93.

50. Anthony, *First Ladies*, 283.

51. H. Wayne Morgan, *William McKinley and His America*, rev. ed. (Kent, OH: Kent State University Press, 2005), 39 and 234–35.
52. Sylvia Jukes Morris, *Edith Kermit Roosevelt: Portrait of a First Lady* (New York: Modern Library, 2001), 316.
53. Caroli, *First Ladies* (1987), 120.
54. Morris, *Edith Kermit Roosevelt*, 127.
55. Jacob A. Riis, *Theodore Roosevelt, The Citizen* (New York: The Outlook, 1904), 330.
56. Pete Daniel and Raymond Smock, *A Talent for Detail: The Photographs of Miss Frances Benjamin Johnston, 1889–1910* (New York: Harmony Books, 1974), 153.
57. Willetts, *Inside History*, 186.
58. "Pony in White House," *Washington Post*, April 27, 1903, 2.
59. James M. Goode, "The Theodore Roosevelt Years," *White House History*, Collection Set 1, Numbers 1–6, (Washington, D.C.: White House Historical Association, 2004), 115–125.
60. Stacy Cordery, *Alice: Alice Roosevelt Longworth, from White House Princess to Washington Power Broker* (New York: Viking, 2007), 553, n56, and photo insert, "The famous pillow, at her home in Dupont Circle," 430. Several versions of this pillow may have existed.
61. Wead, *All the Presidents' Children*, 45–47, 233.
62. Gould, *American First Ladies*, 334–335.
63. Caroli, *American First Ladies*, 196.
64. Gould, *American First Ladies*, 333.
65. Carl Sferrazza Anthony, *Florence Harding: The First Lady, the Jazz Age, and the Death of America's Most Scandalous President* (New York: William Morrow, 1998), xvii.
66. Ibid., xvii.
67. Ibid., xi–xii, 314.
68. See Richard Griffith and Arthur Mayer, *The Movies* (New York, Simon and Schuster, 1957), 19, 28, 36–37, 59.
69. Ibid., xviii, 344.
70. Robert Sobel, *Coolidge: An American Enigma* (Washington: Regnery, 1998), 247.
71. Quoted in "Medal is Awarded to Mrs. Coolidge," *New York Times*, May 8, 1931, 13.
72. Anne Beiser Allen, *An Independent Woman: The Life of Lou Henry Hoover* (Westport: Greenwood, 2000), 33.
73. Ibid., 50.
74. Ibid., 184.
75. Schneider, *First Ladies*, 275.
76. "Nation: La Presidente," *Time*, June 9, 1961.
77. Margaret Leslie Davis, "National Treasures: The Two First Ladies," *Vanity Fair*, November 2008; also Deirdre Fernand, "How the Mona Lisa Came to Camelot," *London Sunday Times*, Dec. 7, 2008, http://www.monalisaincamelot.com/review_sundaytimeslondon.pdf, accessed Aug. 24, 2010.
78. Caroli, *First Ladies* (1987), 297.
79. Ibid., 225.
80. Joanna Steichen, *Steichen's Legacy* (New York: Alfred A. Knopf, 2000), 258; Howard Chapnick, *Truth Needs No Ally: Inside Photojournalism* (Columbia: University of Missouri Press, 1994), 151.
81. Richard Bradley, *American Political Mythology from Kennedy to Nixon* (New York: Peter Lang, 2000), 74.
82. Lewis L. Gould, *Lady Bird Johnson: Our Environmental First Lady* (Lawrence: University Press of Kansas, 1999), 51.
83. Marvin Watson and Sherwin Markman, *Chief of Staff* (New York: St. Martin's Press, 2004), 96–97.
84. Keith W. Olsen, *Watergate: The Presidential Scandal that Shook America* (Lawrence: University of Kansas Press, 2003), 22–43.
85. Jennifer Steinhauer, "Back in View, a Candid First Lady Whose Legacy Rivals Her Husband's," *New York Times*, December 31, 2006, 1. On her dancing in China, see Michael Baruch Grossman and Martha Joynt Kumar, *Portraying the President: The White House and the News Media* (Baltimore: Johns Hopkins University Press, 1981), 230.
86. "Remarks of First Lady Michelle Obama: Let's Move Launch," Feb. 9, 2010, at The White House: Briefing Room: Speeches and Remarks, http://www.whitehouse.gov/the-press-office/remarks-first-lady-michelle-obama/, accessed Feb. 12, 2010.

Chapter 5

1. Alison Nordstrom supplied information about the Kodak and Brownie figures. See also Edwin Teale, "America's Five Favorite Hobbies," *Popular Science Monthly*, May 1941, 98–99.
2. Kristy Clairmont, "PMA Data Watch: Camera Phone Penetration Continues to Rise," *PMA Newsline Daily Photo News*, March 15, 2010, http://pmanewsline.com/2010/03/15/pma-data-watch-camera-phone-penetration-continues-to-rise/, accessed July 10, 2010.
3. Alma Davenport, *The History of Photography: An Overview* (University of New Mexico Press, 1999), 26–27. According to Davenport, the Austrian Paul Vierkötter invented a type of flash in 1925, and Jacob Riis used a rudimentary flash powder method in the late nineteenth century. In 1931 Harold Edgerton came up with a single-flash strobe.
4. Hugh Miller, "News Photography in Washington Isn't Nearly as Old as the Century," *Washington Post*, Jan. 1, 1950.

Chapter 6

1. Paul Starr, *The Creation of the Media: Political Origins of Modern Communications* (New York: Basic Books, 2004), 186; L. A. Gobright, *Recollection of Men and Things at Washington* (Philadelphia: Claxton, Remsen and Haffelfinger, 1869), 318 and 337.
2. Starr, *Creation of the Media*, 354.
3. E. L. Morse, "The District of Columbia's Role in the History of the Telegraph," *Records of the Columbia Historical Society* 3 (1900), 171.
4. Richard W. Waterman, Robert Wright, and Gilbert St. Clair, *The Image-Is-Everything Presidency: Dilemmas in American Leadership* (Boulder, CO: Westview Press, 1999), 25.
5. Clifford Krainik, "A 'Dark Horse' in Sunlight and Shadow: Daguerreotypes of President James K. Polk," *White House History*, Collection Set 1, Numbers 1–6 (Washington, D. C.:White House Historical Association, 2004), 106–115; Mayer, "Photographing the American Presidency," *Image* 27 (1984), 8. According to Robert A. Mayer, 120 photographs of Lincoln exist out of 136 that are thought to have been taken.
6. Frank Luther Mott, *The History of American Magazines* (Cambridge, MA: Harvard University Press, 1938), vol. 2, 1850–1865, 10.
7. Starr, *Creation of the Media*, 379; Hadley Cantril and Mildred Strunk, *Public Opinion 1935–1946* (Princeton: Princeton University Press, 1951), 524.
8. Seale, *President's House*, 474.
9. "A Snobbish Reception: Mr. Hayes Imitates the Court Manners of Europe," *Washington Post*, Feb 26, 1879, 1.

10. George Juergens, *News from the White House: The Presidential-Press Relationship in the Progressive Era* (Chicago: University of Chicago Press, 1981), 7.

11. C. C. Buel, "Our Fellow-Citizen of the White House," *The Century Illustrated Magazine* 53 (March 1897), 662.

12. Grossman and Kumar, *Portraying the President*, 23.

13. Michael Schudson, *Discovering the News: A Social History of American Newspapers* (New York: Basic Books, 1978), 97–98 and 103.

14. John Tebbel and Mary Ellen Zuckerman, *The Magazine in America: 1741–1990* (New York: Oxford University Press, 1991), 57, 64, and 75.

15. Schudson, *Discovering the News,* 73.

16. Morris, *Theodore Rex*, 14.

17. See Timothy E. Cook, "The Uses of News: Theory and (Presidential) Practice," in Doris A. Graber, ed., *Media Power in Politics,* 3rd ed., (Washington, D.C.: CQ Press, 2000), 218.

18. Sidney M. Milkis and Michael Nelson, *The American Presidency: Origins and Development, 1776–1990*, (Washington, D.C.: CQ Press, 1990), 246–247.

19. William P. O'Brien, "The White House and Harry S. Truman," *White House History,* Collection Set 1, Numbers 1–6 (Washington, D.C.: White House Historical Association, 2004), 260. See also Rex W. Scouten, "President Truman's Televised Tour," *White House History,* Collection Set 1, Numbers 1–6 (Washington, D.C.: White House Historical Association, 2004), 296–300.

20. Seale, *President's House,* II, 1052.

21. Fischer, *Liberty and Freedom,* 145.

22. Scouten, "President Truman's Televised Tour," 296. See also Carl Flaningam, "The 'Checkers' Speech and Televised Political Communication," paper presented at the Annual Meeting of the Central States Speech Association, Lincoln, NE, April 7–9, 1983.

23. Cook, "The Uses of News," 219.

24. Quoted in Grossman and Kumar, *Portraying the President,* 229.

25. Joe McGinniss, *The Selling of the President 1968* (New York: Trident, 1969), 84.

26. David Greenberg, *Nixon's Shadow: The History of an Image* (New York: Norton, 2003), 141.

27. Leigh Holmwood, "Barack Obama Gives *Daily Show* Biggest Ever Audience," *The Guardian,* October 31, 2008, http://www.guardian.co.uk/media/2008/oct/31/ustelevision-barackobama/, accessed Sept. 21, 2010.

28. "Internet's Broader Role in Campaign 2008: Social Networking and Online Videos Take Off," The Pew Research Center for the People & the Press, January 11, 2008, http://people-press.org/report/384/internets-broader-role-in-campaign-2008, accessed Sept. 12, 2010.

29. Ibid.

30. Dennis W. Johnson, "An Election Like No Other?" in *Campaigning for President* 2008: *Strategy and Tactics, New Voices and New Techniques*, ed. Dennis W. Johnson (New York: Routledge, 2009), 13,17. About "conversations," see, in the same book, Julie Barko Germany, "The Online Revolution," 147–160.

31. Costas Panagopoulos, *Politicking Online: The transformation of Election Campaign Communications* (New Brunswick: Rutgers University Press, 2009), 3.

32. Quoted in H. R. Brands, *T.R.: The Last Romantic* (New York: Basic Books, 1998), 488.

33. Wead, *All the Presidents' Children,* 107.

34. "Taft Tosses Ball; Officiates at the Opening Game of the Season; Victory for Washington; Crowd Cheers President's Fine Delivery of the Sphere," *Washington Post,* April 15, 1910, 2.

35. Michael L. Bromley, *William Howard Taft and the First Motoring Presidency* (Jefferson, NC: McFarland, 2003), 154.

36. Quoted in Mark Sullivan, *Our Times* (New York: Scribner, 1936), vol. 3, 306.

37. John Noble Wilford, "Alan B. Shepard Jr. Is Dead at 74; First American to Travel in Space," *New York Times,* July 23, 1998, A1.

38. Gerald Vizenor, "Ishi Bares His Chest: Tribal Simulations and Survivance," in *Partial Recall,* ed. Lucy R. Lippard (New York: The New Press, 1992), 70.

39. Herman J. Viola, *Diplomats in Buckskins: A History of Indian Delegations in Washington City* (Norman: University of Oklahoma Press, 1995), 180–187.

40. "Harding at Ceremony for Confederate Dead," *New York Times,* June 5, 1922, 10; "Veterans at White House," *New York Times*, June 24, 1922, 26.

41. Stephen Ponder, *Managing the Press: Origins of the Media Presidency, 1897–1933* (New York: Palgrave Macmillan 2000), 83–84.

42. Anthony, *Florence Harding,* 205–206.

43. "Harding Arranges Press Conferences," *New York Times,* March 23, 1921.

44. Harding set aside a room for photographers, see http://www.whnpa.org/about/index.htm#HISTORY; Mayer, "Photographing the American Presidency," n. 46, says that was done in 1929, and refers to John G. Morris, "Shooting the American Presidency," *Pop Photo* 81, no. 2 (Aug. 1977), 80.

45. Richard Shenkman, foreword to *Hollywood's White House: The American Presidency in Film and History*, ed. Peter C. Rollins and John E. O'Connor (Lexington: University Press of Kentucky, 2003) xii.

46. Peter Edidin, "Confounding Machines: How the Future Looked," *New York Times,* Aug. 28, 2005, 4 and 12.

47. Robert Sobel, *Coolidge: An American Enigma* (Washington: Regnery, 1998), 230–231.

48. Ibid., 231.

49. Ibid., 236.

50. Waterman, *The Image-is-Everything Presidency,* 17; Donald R. McCoy, *Calvin Coolidge: The Quiet President* (New York: Macmillan, 1967), 157. Coolidge eventually gave up the porch because the crowds that gathered to watch were too large for comfort. Maintaining an image has its costs.

51. Maurine H. Beasley, *Eleanor Roosevelt and the Media: A Public Quest for Self-Fulfillment* (Urbana-Champaign: University of Illinois Press, 1987), 22.

52. Blanche Wiesen Cook, *Eleanor Roosevelt,* (New York: Viking, 1992), vol. 2, 40–41.

53. On ER's compromises and coauthorship of her image, see Cook, *Eleanor Roosevelt,* vol. 1, 473–474.

54. Lorena A. Hickok, *Reluctant First Lady* (New York: Dodd, Mead, 1962), 86.

55. See Cook, *Eleanor Roosevelt*, vol. 1, 318.

56. Ibid., 338ff., 362.

57. See Cook, *Eleanor Roosevelt*, vol. 1, 499–500.

58. Cook, *Eleanor Roosevelt*, vol. 2, 30.

59. Graham J. White, *FDR and the Press* (Chicago: University of Chicago Press, 1979), vol. 1, 98–99.

60. A. E. Scott, "Twenty-Five Years of Growing Pains: A History of the White House News Photographers Association," Copy on file the White House Historical Association, Washington, D.C.

61. Grossman and Kumar, *Portraying the President,* 23.

62. Mayer, "Photographing the American Presidency," 25.

63. Ted Morgan, *FDR: A Biography* (New York, Simon and Schuster, 1985), 376.

64. Richard Shenkman, "Introduction" in *Hollywood's White House: The American Presidency in Film and History,* Peter C. Rollins and John E. O'Connor, eds. (Lexington: University Press of Kentucky, 2003), xiii.

65. Doris Kearns Goodwin, *No Ordinary Time: Franklin and Eleanor Roosevelt: The Home Front in World War II* (New York: Simon and Schuster, 1994), 240, 288, 285; Patrick J. Hearden, *Roosevelt Confronts Hitler: America's Entry into World War II* (DeKalb: Northern Illinois University Press, 1987), 189–201; Waldo Heinrichs, *Threshold of War: Franklin D. Roosevelt and American Entry into World War II* (New York: Oxford University Press, 1988), 215–220.

66. Franklin D. Mitchell, *Harry S. Truman and the News Media: Contentious Relations, Belated Respect* (Columbia: University of Missouri Press, 1998), 26–27.

67. Dennis Brack, "White House News Photographers and the White House," in *The White House: Actors and Observers,* William Seale, ed. (Boston: Northeastern Press, 2002), 170–171.

68. See Elizabeth C. Childs, "The Body Impolitic: Censorship and Daumier," in *Suspended License: Censorship and the Visual Arts,* Elizabeth C. Childs, ed. (Seattle: University of Washington Press, 1997), 162.

69. "President to Pose for Cartoonists," *Washington Post,* Sept. 28, 1949, 15; "Cartoonists and Their Model at the White House," *New York Times,* Oct. 4, 1949, 1.

70. McCullough, *Truman,* 710.

71. Ibid., 718.

72. Edward T. Folliard, "Ike Takes Helm in a 'Time of Tempest,'" *Washington Post,* Jan. 21, 1953; John Tierney, "The Inauguration," *New York Times,* Jan. 16, 2005, 1; Harold Hinton, "Long, Long, Gay Parade Cheers President," *New York Times,* Jan. 21, 1953. The *Washington Post* calls the man Marty Montana; other sources spell his name Monty, Monte or Montie.

73. David Farber and Beth Bailey, *The Columbia Guide to America in the 1960s* (New York: Columbia University Press, 2001), 396.

74. Michael Schudson, "Trout or Hamburger: Politics and Telemythology," in Graber, *Media Power in Politics,* 199–200. Schudson casts some doubt on the usual interpretation of the debate's result.

75. As recounted by Jacques Lowe, who photographed JFK for years. See Vicki Goldberg, "The Pictures That Serve a President's Image," *New York Times,* Oct. 12, 1997.

76. Alysha E. Black, "Making the Most of the Archives: Finding White House Documentary Sources at the National Archives," *White House History,* Collection 2, Numbers 7–12 (Washington, D.C.: White House Historical Association, 2004), 147.

77. "The President's News Conference with President Boris Yeltsin of Russia in Hyde Park, New York, October 23, 1995," *Public Papers of the Presidents of the United States: William J. Clinton, 1995* (Washington, D.C.: Government Printing Office, 1997) vol. 2, 1661.

78. http://www.reagan.utexas.edu/archives/speeches/1983/30383b.htm, accessed Nov. 12, 2010.

79. My thanks to Robert Caro for assistance with this matter, and especially to Laura Eggert, archives technician at the LBJ Library.

80. Adam Fairclough, *Martin Luther King, Jr.* (Athens: University of Georgia Press, 1995), 84; Richard Reeves, *President Kennedy: Profile in Power* (New York: Simon & Schuster, 1994), 521.

81. http://www.americanrhetoric.com/speeches/ronaldreaganddayaddress.html, accessed Dec. 13, 2010.

82. Cornelius Ryan, *The Longest Day: June 6, 1944* (New York: Simon & Schuster, 1963), 174.

Chapter 7

1. David A. Hounshell, *From the American System to Mass Production, 1800–1932: The Development of Manufacturing Technology in the United States* (Baltimore: Johns Hopkins University Press, 1994), 25, 27, and 44. Developments in interchangeable musket parts moved ahead in the 1830s and 1850s at the Springfield Armory in Massachusetts.

2. Robert V. Bruce, *Lincoln and the Tools of War* (Indianapolis: Bobbs-Merrill, 1956), 12, 62, 85–88, 99–117, 122, 161, 172, and 225.

3. See Poore, *Perley's Reminiscences,* vol. 1, 309–310, and Paul Starr, *The Creation of the Media: Political Origins of Modern Communications* (New York: Basic Books, 2004), 161–162.

4. Seale, *President's House,* II, 426.

5. R. W. Burns, *Communications: An International History of the Formative Years* (London: Institution of Engineering and Technology, 2004), 375–376; Seale, *President's House,* II, 689.

6. For central heating, see Seale, *President's House,* I, 216.

7. Paul H. Bergeron, *The Presidency of James K. Polk* (Lawrence: University Press of Kansas, 1987), 237; and Seale, *President's House,* I, 261–263.

8. Seale, *President's House,* I, 173, 198–200, and 316.

9. See David Callahan and Fred I. Greenstein, "The Reluctant Racer: Eisenhower and U.S. Space Policy," in *Spaceflight and the Myth of Presidential Leadership,* Roger D. Launius and Howard D. McCurdy, eds. (Urbana-Champaign: University of Illinois Press, 1997), 15; Roger D. Launius, "Eisenhower, Sputnik, and the Creation of NASA: Technological Elites and the Public Policy Agenda," *Prologue, Quarterly of the National Archives and Records Administration* 28 (1996), 127–143.

10. Kenneth E. Davison, *The Presidency of Rutherford B. Hayes* (Westport: Greenwood Press, 1972), 94.

11. "He Phones Sea to Sea," *New York Times,* Jan. 26, 1915, 1. The patent date was March 8, 1893. See "The Telephone Patents; What Patent Office Men Say of the Situation," *New York Times,* March 9, 1893; Seale, *President's House,* II, 794.

12. Davison, *Presidency of Rutherford B. Hayes,* 85.

13. See James W. Cortada, *Before the Computer: IBM, NCR, Burroughs, and Remington Rand and the Industry They Created, 1865–1956* (Princeton: Princeton University Press, 2000), 15–17.

14. Robert Dallek, *Lyndon B. Johnson: Portrait of a President* (New York: Oxford University Press, 2004), 132.

15. Mark E. Byrnes, *Politics and Space: Image Making by NASA* (Westport: Praeger, 1994), 39.

16. Seale, *President's House,* I, 523–525.

17. Ibid., I, 524; Bromley, *William Howard Taft,* 278.

18. Seale, *President's House,* I, 534.

19. Ibid., I, 596.

20. Kevin Phillips, *William McKinley* (New York: Times Books, 2003), 97.

21. See Library of Congress, Science Reference Services, Technical Reports and Standards: The Office of Scientific Research and Development (OSRD)

Collection, http://www.loc.gov/rr/scitech/trs/trsosrd.html, accessed Jan. 17, 2011.

22. Richard Rhodes, *The Making of the Atomic Bomb* (New York: Touchstone / Simon & Schuster, 1986), 379.

23. Judson Knott and Paul Jones, "SunSITE: Serving Your Internet Needs Since 1992," *D-Lib Magazine*, Feb. 1996, http://www.dlib.org/dlib/february96/02knott.html, accessed Jan. 21, 2011.

24. See Robert J. Klotz, *The Politics of Internet Communication* (Lanham: Rowman & Littlefield, 2004) 97–98.

25. Starr, *Creation of the Media*, 200.

26. Statistics: Starr, *Creation of the Media*, 202; speech by Taft from Bromley, *William Howard Taft*, 352.

27. TR: Phillips, *William McKinley*, 183; Coolidge: Sobel, *Coolidge*, 235.

28. Robert E. Hunter, "Who's in Charge Here?" in *Hollywood's White House*, ed. Rollins and O'Connor, 206.

29. Ruth Schwartz Cowan, *A Social History of American Technology* (New York: Oxford University Press, 1997), 226; Bromley, *William Howard Taft*, 40.

30. Bromley, *William Howard Taft*, 5.

31. Ibid., 2, 5, and 221.

32. Ibid., 274.

33. Ibid., 44, 94, and 104.

34. Ibid., 274.

35. Lydia Barker Tederick, "A Glimpse of Calvin Coolidge's White House: The Photographs of Ralph Waldo Magee," *White House History*, Collection 2, Numbers 7–12 (Washington, D.C., White House Historical Association, 2004), 86–103.

36. Bromley, *William Howard Taft*, 93 and 163.

37. Ibid., 306.

38. Ibid.

39. Rebecca Robbins Raines, *Getting the Message Through: A Branch History of the U.S. Army Signal Corps* (Washington, D.C.: Center of Military History, U.S. Army, 1996), 139, 172; for vacuum tube production during World War I, see Leonard Reich, *The Making of American Industrial Research: Science and Business at GE and Bell, 1876–1926* (Cambridge: Cambridge University Press, 1985), 93, 180–81. See also Linwood S. Howeth, *History of Communications-Electronics in the United States Navy* (Washington, D.C.: U.S. Government Printing Office, 1963), chapters 23 and 24; George R. Thompson, "Radio Comes

of Age in World War I," in *The Story of the U.S. Army Signal Corps*, Max L. Marshall, ed. (New York: Franklin Watts, 1965), 157–66; Susan J. Douglas, *Inventing American Broadcasting, 1899–1922* (Baltimore: Johns Hopkins University Press, 1987), chapter 8.

40. Warren G. Harding, "Americanism," speech recorded June 29, 1920. Text and audio available at "American Leaders Speak: Recordings from World War I and the 1920 Election, 1918–1920," Library of Congress, American Memory, http://lcweb2.loc.gov/cgi-bin/query/D?nfor:2::./temp/~ammem_hxUm::.

41. Anthony, *Florence Harding*, xx.

42. Starr, *Creation of the Media*, 328.

43. Milkis and Nelson, *American Presidency*, 250.

44. Ibid.

45. Cook, *Eleanor Roosevelt*, vol. 2, 27.

46. "Far Off Speakers Seen As Well As Heard Here in a Test of Television," *New York Times*, April 8, 1927, 1.

47. Orrin E. Dunlap Jr., "Ceremony Is Carried by Television As Industry Makes Its Formal Bow," *New York Times*, May 1, 1939, 8.

48. William C. Allen, *History of the United States Capitol* (Washington, D.C.: U.S. Government Printing Office, 2001), 402; Seale, *President's House*, II, 1028 and 1050.

49. Beasley, *Eleanor Roosevelt and the Media*, 132.

50. George Juergens, *News From the White House: The Presidential-Press Relationship in the Progressive Era* (Chicago University Press, 1981), 32.

51. Cook, *Eleanor Roosevelt*, vol. 2, 50.

52. Walter Russell Mead, *God and Gold: Britain, America, and the Making of the Modern World* (New York: Random House, 2008), 157.

53. W. H. Lawrence, "President Evacuated from Capital by Helicopter Before Mock Attack," *New York Times*, July 13, 1957, 1; "President Lands at White House," *New York Times*, July 16, 1957, 3.

54. John Tebbel and Sarah Miles Watts, *The Press and the Presidency: From George Washington to Ronald Reagan* (New York: Oxford University Press, 1985), 498.

55. Anton Huurdeman, *The Worldwide History of Telecommunications* (New York: Wiley, 2003), 301; Shelly Freierman, "Telegram Falls Silent Stop Era Ends Stop," *New York Times*, February 6, 2006, C7.

56. David L. Morton Jr., *Sound Recording: The Life Story of a Technology* (Baltimore: Johns Hopkins University Press, 2006), 124–125, 133.

57. Jimmy Carter, "Address to the Nation on the Energy Problem," April 18, 1977, *Public Papers of the Presidents of the United States: Jimmy Carter, 1977* (Washington, D.C.: Government Printing Office, 1978), 656.

58. Richard H. K. Vietor, *Energy Policy in America Since 1945: A Study of Business-Government Relations* (New York: Cambridge University Press, 1987), 259–262.

59. Eugene Frankel, "Technology, Politics, and Ideology: The Vicissitudes of Federal Energy Policy, 1974–1983," in *The Politics of Energy Research and Development*, John Byrne and Daniel Rich, eds. (Piscataway: Transaction, 1986), vol. 3, 80–83.

60. Lisa Guernsey, "From a White House Roof, Solar Power Proclaims Gains," *New York Times*, Feb. 27, 2003, G8, http://www.jimmycarterlibrary.org/newsreleases/2007/07-18.pdf.

61. http://www.nasa.gov/mission_pages/shuttle/shuttlemissions/archives/sts-5.html, accessed Oct. 27, 2010; Roger D. Launius and Howard E. McCurdy, eds., *Spaceflight and the Myth of Presidential Leadership* (Urbana: University of Illinois Press, 1997), 7.

62. For the complete speech, see http://www.americanrhetoric.com/speeches/ronaldreaganchallenger.htm, accessed May 2, 2010.

63. Helen R. Quinn, Heidi A. Schweingruber et al., *NASA's Elementary and Secondary Education Program: Review and Critique* (Washington, D.C.: National Academies Press, 2008), 76–78.

64. The White House, Office of the Press Secretary, "Remarks by the President in Conversation with International Space Station Crew and Space Shuttle Endeavour Crew Via Satellite," Feb. 17, 2010, at NASA News Features, http://www.nasa.gov/topics/shuttle_station/features/wh_call_sts130_iss_transcript.html, accessed March 3, 2010.

Chapter 8

1. Paul Leicester Ford, *The True George Washington* (Philadelphia: Lippincott, 1896), 197.

2. Margaret Truman, *White House Pets* (New York: David McKay, 1969), 2, 4, 57, 89–90, and 102.

3. I am grateful to Barbara Kinney for this information.

4. Keckley, *Behind the Scenes*, 133.

5. Katherine C. Grier, *Pets in America: A History* (Chapel Hill: University of North Carolina Press, 2006), 12 and 177.

6. Ibid., 99 and 103.

7. Edward Walsh, "Pit Bull in The Chair; Rep. Burton Known as Tenacious Crusader," *Washington Post*, March 19, 1997.

8. Thomas Riggs, ed., *Contemporary Film, Theatre, and Television* (Detroit: Gale, 2002), 135.

9. Grier, *Pets in America*, 219 and 224.

10. Morris, *Edith Kermit Roosevelt*, 267–269.

11. Truman, *White House Pets*, 22.

12. Ibid., 30; Grier, *Pets in America*, 215.

13. "Favorite Hoover Dog a Victim of Strain; Responsibilities of His Position Thought Primary Cause of King Tut's Death," *New York Times*, June 5, 1930, 21.

14. Truman, *White House Pets*, 158 and 159.

15. Traphes Bryant with Frances Spatz Leighton, *Dog Days at the White House: The Outrageous Memoirs of the Presidential Kennel Keeper* (New York: Picket Books, 1975), xii-xvi.

16. Grier, *Pets in America*, 45 and 48.

17. Truman, *White House Pets*, 8, 15, and 16.

18. Ibid., 135.

19. Edwin Diamond and Stephen Bates, *The Spot: The Rise of Political Advertising on Television* (Cambridge, MA: MIT Press, 1984), 42. The advertising man who said this was Bruce Barton (head of Batten, Barton, Durstine and Osborn).

20. Anthony, *Florence Harding*, 276.

21. The statue is bronze, an alloy of copper and tin. The sculptor was Bashka Paeff. It was intended that Mrs. Harding receive the statue, but she died before it was ready. It was displayed in several venues including the 1926 Sesquicentennial Exposition in Philadelphia. It is part of the collections of the Smithsonian Institution.

22. "Laddie's' Brother Gets in Trouble," *Ellensburg Daily Record*, July 29, 1931.

23. Truman, *White House Pets*, 99.

24. Ibid., 118; "White House 'Possum Is Lent to Boys by Hoover for Mascot," *New York Times*, May 26, 1929; "Hoover Promises to Keep School 'Possum Mascot Fit," *Washington Post*, July 14, 1929.

25. Grier, *Pets in America*, 224.

26. See Truman, *White House Pets*, 72.

27. Franklin Delano Roosevelt, "'The Fala Speech'; Campaign Address at the Teamsters Union Dinner, Sept. 23, 1944, Washington, D.C.," quoted in William D. Pederson, *The FDR Years* (New York: Infobase Publishing, 2006), 422.

28. Phil Casey, "Dzimbo Scorns Protocol: Ike's Gift Elephant Visits White House for a Fifth of Milk and Munch of Hay," *Washington Post*, Oct. 13, 1959.

29. Roy Reed, "A Stray Dog Named Yuki Becomes the President's Latest Pet," *New York Times*, Sept. 28, 1967, 39.

30. Robert Wallace, "A National Yelp Over an Earlift," *Life*, May 8, 1964, 34A.

31. Lynn Sweet, "President-elect Obama First Press Conference," transcript, November 7, 2008, http://blogs .suntimes.com/sweet/2008/11/ presidentelect_obama_first_pre.html/.

32. Manuel Roig-Franzia, "The First Puppy Makes a Big Splash," *Washington Post*, April 12, 2009.

Chapter 9

1. Seale, *President's House*, II, 264.

2. Willets, *Inside History*, 113.

3. Paul Jennings, "A Colored Man's Reminiscences of James Madison," *White House History*, Collection Set 1, Numbers 1–6 (Washington, D.C.: White House Historical Association, 2004), 50–55.

4. Seale, *President's House*, II, 282.

5. Seale, *President's House*, I, 504.

6. C. L. Arbelbide, "With Easter Monday You Got Egg Roll at the White House," *Prologue, Quarterly of the National Archives and Records Administration* 32, no. 1 (Spring 2000), http://www .archives.gov/publications/ prologue/2000/spring/white-house- egg-roll-1.html.

7. Catherine Frances Cavanagh, "Stories of Our Government Bureaus, VII — Strange Stories of the White House," *The Bookman* 33 (July 1911), 523.

8. Frank G. Carpenter, *Carp's Washington* (New York: McGraw-Hill, 1960), 302. (Published posthumously; Carpenter died in 1924.)

9. Tederick, "A Look at the White House Kitchens," 16.

10. See Wendy Mitman Clarke, "Crazy for Bears," *Smithsonian* 32 (Oct. 2001), 87–92.

11. See Philip Kunhardt Jr. et al., *The American President* (New York: Riverhead Books, 1999), 418–429.

12. "Taft Bathtub Weighs Ton," *Washington Post*, Jan. 21, 1909; "The Taft Tub," *Washington Post*, June 22, 1919.

13. James M. Goode, "The Theodore Roosevelt Years," *White House History*, Collection Set 1, Numbers 1–6 (Washington, D.C.: White House Historical Association, 2004), 124.

14. Seale, *President's House*. Information on the Smithsonian's contribution to White House taxidermy came from Pamela M. Henson, historian, Institutional History Division, Smithsonian Institution Archives, and Frank Greenwell, taxidermist emeritus, Smithsonian Institution.

15. The woman in the picture is Alison Hopkins; the photograph was published in *The Suffragist* 5 (Feb. 7, 1917), 4; See also Keyssar, *The Right to Vote* (New York: Basic Books, 2001), 162–221.

Index

1. My thanks to Gwen White and Sally Stokes for the information about the Sociable.

2. "The History of the Bicycle," http://www .washingtonpost.com/wp-dyn/content/ article/2010/09/14/AR2010091406212. html, accessed Oct. 27, 2010. My thanks to Michael Sand for this reference.

ADDITIONAL READING

White House History

Jensen, Amy LaFollette. *The White House and Its Thirty-Five Families.* New York: McGraw-Hill, 1971.

Kirk, Elise K. *Musical Highlights from the White House.* Malabar, FL: Krieger Publishing Company, 1992.

———. Music at the White House: A History of the American Spirit. Chicago: University of Illinois Press, 1986.

Klapthor, Margaret B. *The First Ladies.* Washington, D.C.: White House Historical Association, 1995.

———. *Official White House China: 1789 to the Present.* Washington, D.C.: Smithsonian Institution Press, 1975.

Kloss, William, Doreen Bolger, David Park Curry, Betty Monkman, and John Wilmerding. *Art in the White House: A Nation's Pride.* Washington, D.C.: White House Historical Association, 1992.

Seale, William. *The President's House: A History.* 2 vols. Washington, D.C.: White House Historical Association, 1986.

———. *The White House Garden.* Washington, D.C.: White House Historical Association, 1996.

———. *The White House: The History of an American Idea.* Washington, D.C.: American Institute of Architects Press in association with the White House Historical Association, 1992.

Singleton, Esther. *The Story of the White House.* 2 vols. New York: McClure Company, 1907.

West, J. B. *Upstairs at the White House: My Life with the First Ladies.* New York: Coward, McCann & Geoghegan, 1973.

White House Historical Association. *The White House: An Historic Guide.* Washington, D.C.: White House Historical Association, 2011.

Willets, Gilson. *Inside History of the White House: The Complete History of the Domestic and Official Life in Washington of the Nation's Presidents and their Families.* New York: The Christian Herald, 1908.

Photography and Illustration

Brilliant, Richard. *Group Dynamics: Family Portraits & Scenes of Everyday Life at the New-York Historical Society.* New York: New-York Historical Society, in association with the New Press, 2006.

———. *Portraiture.* London: Reaktion Books, 1991.

Daniel, Pete, and Raymond Smock. *A Talent for Detail: The Photographs of Miss Frances Benjamin Johnston, 1889–1910.* New York: Harmony Books, 1974.

Darrah, William Culp. *Stereo Views: A History of Stereographs in America and Their Collection.* Gettysburg, PA: Times and News Publishing, 1964.

Earle, Edward W., ed. *Points of View: The Stereograph in America—A Cultural History.* Rochester, NY: Visual Studies Workshop Press, in collaboration with the Gallery Association of New York State, 1979.

Elwall, Robert. *Building with Light: The International History of Architectural Photography.* London: Merrell, in association with RIBA, 2004.

Faber, John. *Great Moments in News Photography: From the Historical Files of the National Press Photographers Association.* Nashville: Thomas Nelson, 1960.

Fischer, David Hackett. *Liberty and Freedom: A Visual History of America's Founding Ideals.* New York: Oxford University Press, 2004.

Fox, Stephen. *The Mirror Makers: A History of American Advertising and Its Creators.* New York: William Morrow, 1984.

Goldberg, Vicki. *The Power of Photography: How Photographs Changed our Lives.* New York: Abbeville Press, 1991.

Hamilton, Peter, and Roger Hargreaves. *The Beautiful and the Damned: The Creation of Identity in Nineteenth Century Photography.* Aldershot, Hampshire: Lund Humphries, in association with The National Portrait Gallery, London, 2001.

Kismaric, Susan. *American Politicians: Photographs from 1843 to 1993.* New York: Museum of Modern Art, 1994.

Kunhardt, Dorothy Meserve, Philip B. Kunhardt, Jr., and the editors of Time-Life Books. *Mathew Brady and His World.* Alexandria, VA: Time-Life Books, 1977.

Kunhardt, Philip B., Jr., Philip B. Kunhardt III, and Peter W. Kunhardt. *Lincoln: An Illustrated Biography.* New York: Gramercy, 1999.

Linkman, Audrey. *The Victorians: Photographic Portraits.* London: Tauris Parke Books, 1993.

Maddow, Ben. *Faces: A Narrative History of the Portrait in Photography.* Boston: New York Graphic Society, 1977.

McCauley, Elizabeth Anne. *Likenesses: Portrait Photography in Europe, 1850–1870.* Albuquerque: Art Museum / University of New Mexico, 1980.

Newhall, Beaumont. *The Daguerreotype in America.* New York: Duell, Sloan and Pearce, 1961.

Reaves, Wendy Wick. *Private Lives of Public Figures: The Nineteenth-Century Family Print.* Westport, CT: Chesebrough-Pond's, in collaboration with the National Portrait Gallery, Smithsonian Institution, Washington, D.C., 1986.

Romer, Grant B. and Brian Wallis, eds., *Young America: The Daguerreotypes of Southworth and Hawes.* Göttingen: Steidl, published in conjunction with the exhibit *Young America,* jointly organized by the George Eastman House, Rochester, NY, and the International Center of Photography, New York, 2005.

Rudisill, Richard. *Mirror Image: the Influence of the Daguerreotype on American Society.* Albuquerque: University of New Mexico Press, 1971.

Sandweiss, Martha A., ed., *Photography in Nineteenth-Century America.* Fort Worth, TX: Amon Carter Museum, and New York: Harry N. Abrams, 1991.

Taft, Robert. *Photography and the American Scene: A Social History, 1839–1889.* New York: Dover, 1938.

Trachtenberg, Alan. *Reading American Photographs: Images as History, Mathew Brady to Walker Evans.* New York: Hill and Wang, 1989.

Welling, William. *Photography in America: The Formative Years, 1839–1900.* New York: Thomas Y. Crowell, 1978.

IMAGE CREDITS

The White House Historical Association photograph collection is digitized and largely includes commissioned photography and historic images from the White House Collection along with numerous interiors and exteriors of the house taken by *National Geographic* photographers to illustrate the association's guidebooks. The association also selected and added to the digital collection thousands of public domain images pertaining to White House history from the Library of Congress (LOC), the National Archives and Records Administration (NARA), and presidential libraries (NARA), as well as private collections and stock-image sites, for internal research and use within their publications and exhibits.

Frontispiece

p. ii: John F. Kennedy Presidential Library

Foreword

p. ix: Library of Congress

Introduction: The White House

p. 2: Library of Congress
p. 4: The White House
p. 5: The White House Historical Association
p. 7: Harry S. Truman Presidential Library
p. 8: Harry S. Truman Presidential Library
p. 9, left: National Park Service
p. 9, right: Harry S. Truman Presidential Library
p. 11: The White House

p. 12: National Archives and Records Administration
p. 13: National Archives and Records Administration
p. 14, left: National Archives and Records Administration
p. 14, right: Library of Congress
p. 15: Sagamore Hill National Historic Site, National Park Service
p. 16, top: National Archives and Records Administration
p. 16, bottom: Library of Congress
p. 17, top: National Archives and Records Administration
p. 17, bottom: William Seale Collection
p. 18: *U.S. News & World Report* / Library of Congress
p. 19, top: Harry S. Truman Presidential Library
p. 19, bottom: White House Photo
p. 20, top: The White House replica created by the Zweifel family, photo by Kathleen Culbert-Aguilar
p. 20, bottom: George Bush Presidential Library
p. 21, top: George W. Bush Presidential Library
p. 21, bottom: George W. Bush Presidential Library

Chapter 1: The East Room

p. 22: The White House Historical Association
p. 23: The White House Historical Association
p. 24: Historical Society of Pennsylvania
p. 25, top: Library of Congress
p. 25, bottom: The J. Paul Getty Museum, Los Angeles
p. 26: The White House
p. 27, top: Library of Congress
p. 27, bottom: National Archives and Records Administration
p. 28: The White House
p. 29: Library of Congress
p. 30, top: The White House
p. 30, bottom: Library of Congress
p. 31: John F. Kennedy Presidential Library
p. 32: Library of Congress
p. 33: The White House Historical Association
p. 34: Lyndon B. Johnson Presidential Library
p. 35, top: Gerald R. Ford Presidential Library

p. 35, bottom: Ronald Reagan Presidential Library

Chapter 2: Weddings and Funerals

p. 36: Richard M. Nixon Presidential Library
p. 39, top: Library of Congress
p. 39, bottom: Library of Congress
p. 40: Library of Congress
p. 41: The White House
p. 42, left: Library of Congress
p. 42, right: Terra Foundation for American Art, Chicago / Art Resource, New York
p. 43: Library of Congress
p. 44: The White House Historical Association
p. 45: Library of Congress
p. 46: The White House
p. 47: ©Bettmann/Corbis
p. 48: Library of Congress
p. 49: National Archives and Records Administration

Chapter 3: Presidents' Portraits

p. 50: Library of Congress
p. 55: The Metropolitan Museum of Art / Art Resource, New York
p. 56, left: Library of Congress
p. 56, right: The Metropolitan Museum of Art / Art Resource, New York
p. 57: James K. Polk Ancestral Home, Columbia, Tennessee
p. 58: Courtesy of George Eastman House, International Museum of Photography and Film
p. 59: Library of Congress
p. 60, left: Library of Congress
p. 60, right: McLellan Lincoln Collection, John Hay Library, Brown University
p. 61, top: Lloyd Ostendorf Collection, used with permission
p. 61, bottom: Collection of the U.S. Senate
p. 62: Library of Congress
p. 63: Library of Congress
p. 64, left: Library of Congress
p. 64, right: Library of Congress
p. 65: Library of Congress
p. 66, top: Library of Congress

p. 171: Library of Congress
p. 172: *U.S. News & World Report* / Library of Congress
p. 173, top: Lyndon B. Johnson Presidential Library
p. 173, bottom: *U.S. News & World Report* / Library of Congress
p. 174, top: Lyndon B. Johnson Presidential Library
p. 174, bottom: © Kenneth Garrett
p. 175: Jimmy Carter Presidential Library
p. 176, top: Ronald Reagan Presidential Library
p. 176, bottom: Ronald Reagan Presidential Library
p. 177: NASA

Chapter 8: Animals at the White House

p. 178: William J. Clinton Presidential Library
p. 181: Library of Congress
p. 182: Library of Congress
p. 183, top: Library of Congress
p. 183, bottom: National Archives and Records Administration
p. 184: Library of Congress
p. 185, left: Library of Congress
p. 185, right: Library of Congress
p. 186, top: Library of Congress
p. 186, bottom: Library of Congress
p. 187: Franklin D. Roosevelt Presidential Library
p. 188: Dwight D. Eisenhower Presidential Library
p. 189: Lyndon B. Johnson Presidential Library
p. 190: Lyndon B. Johnson Presidential Library
p. 191, left: The White House Historical Association
p. 191, right: White House Photo

Chapter 9: The People's House

p. 192: The White House
p. 194: Rutherford B. Hayes Presidential Center
p. 195, top: Fisk University Franklin Library, Special Collections
p. 195, bottom: Library of Congress
p. 196: Library of Congress
p. 197, top: Library of Congress
p. 197, bottom: The White House Historical Association
p. 198, top: The White House Historical Association
p. 198, bottom: Culver Pictures, Inc.
p. 199, top: Library of Congress
p. 199, bottom: Library of Congress
p. 200, top: Library of Congress
p. 200, bottom: Library of Congress
p. 201, top: Library of Congress
p. 201, bottom: National Archives and Records Administration
p. 202, left: Library of Congress
p. 202, right: Library of Congress
p. 203, left: Library of Congress
p. 203, right: United Press International
p. 204: The White House Historical Association
p. 205: The White House
p. 206: White House Photo

Index

p. 222: National Archives and Records Administration
p. 227: National Archives and Records Administration

Jacket Captions and Credits

Front, center image:
White House North Portico at night, November 4, 2005. William Phillips. The White House Historical Association.

Front, top to bottom:
President Barack Obama takes aim with a photographer's camera backstage prior to his remarks about providing mortgage payment relief for responsible homeowners at Dobson High School, Mesa, Arizona, February 18, 2009. Official White House photo by Pete Souza.
The Burned White House, 1815, p. 4.
Princess Diana dances with John Travolta at a gala dinner at the White House, November 9, 1985, p. 35.
Lincoln's funeral in the East Room, April 19, 1865. *Harper's Weekly,* May 6, 1865, p. 44.

Ad for Lincoln Tea, c. 1893–1910. Warshaw Collection of Business Americana-Tea, Archives Center, National Museum of American History, Smithsonian Institution.
Bill Clinton with Boris Yeltsin, Hyde Park, New York, October 23, 1995, p. 147.
William McKinley, c. 1897, p. 64.
Five ex-presidents in the Reagan Library Oval Office, Simi Valley, California, November 4, 1991, p. 20.
Socks at Lectern, 1994, p. 178.
White House chef and his staff, c. 2000, p. 197.
President Franklin Roosevelt broadcasting from the Diplomatic Reception Room, June 24, 1938, p. 118.

Back, center image:
White House photographers pose on the South Lawn of the White House, May 1918, p. 104

Back, top to bottom:
Frances Benjamin Johnston with camera, 1888, p. 107.
Laura Bush examining a model of the White House at the Republican National Convention, September 2, 2008, p. 21.
Puck advertisement for Duke's Cameo Cigarettes featuring President Cleveland, c. 1893. Valentine Richmond History Center.
Communications office, February 1957, p. 173.
President George W. Bush clears cedar at his ranch in Crawford, Texas, August 9, 2002, p. 155.
Suffragist before the White House, c. 1917, p. 203.
Lincoln and his son Tad looking at a book in Lincoln's lap, February 9, 1864, p. 78.
President Jimmy Carter, Egyptian president Anwar al-Sadat, and Israeli prime minister Menachem Begin at the White House signing of the peace treaty between Egypt and Israel, March 26, 1979, p. 146.
Franklin Pierce, c. 1854, p. 58.
The East Room decorated for the Army and Navy Reception, Executive Mansion, one half of a stereograph, 1900, p. 30.
President Ford at work in the Oval Office, August 12, 1967, p. 69.

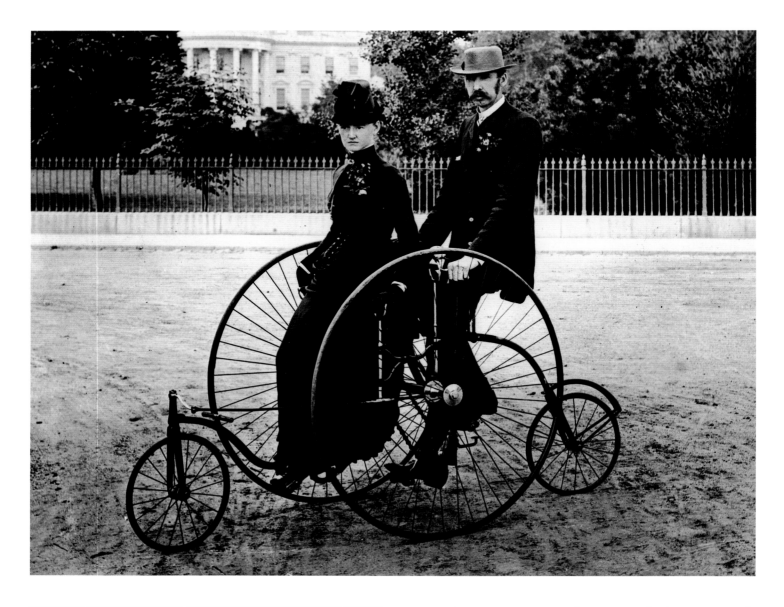

**A couple in front of the White House on a "Sociable,"
n.d. Photographer unknown.**

If you want to get to the White House and don't want to
campaign, pedal. The vehicle in the picture is not a bicy-
cle — note that it has four wheels, not two — but a Socia-
ble, which allowed women to ride decorously on a side
seat. This couple was evidently proud of both their vehicle
and their ability to pilot it to the White House, and a pho-
tographer gave them the opportunity to add to that pride
a permanent association with the executive mansion.[1]

Bicycling was a very popular sport in the late nineteenth
century, especially after 1885, when the big front wheel of
the velocipede was replaced with identical front and back
wheels, making riding easier. Bicycle clubs proliferated
(along with camera clubs), and by 1900, they were peti-
tioning the government to pave more roads. The 1900
census declared that "few articles...have created so great
a revolution in social conditions as the bicycle" — for now
men and women exercised together, long skirts had to be
divided, and women gained unprecedented freedom of
movement.[2]

INDEX

Self-portrait in White House bathroom ceiling mirror, 1951. Abbie Rowe.

Abbie Rowe, assigned by the National Park Service to the White House, photographed the extensive Truman renovation in 1948–1952. Having done his job dutifully and well, he did what photographers on assignment long to do: he experimented.